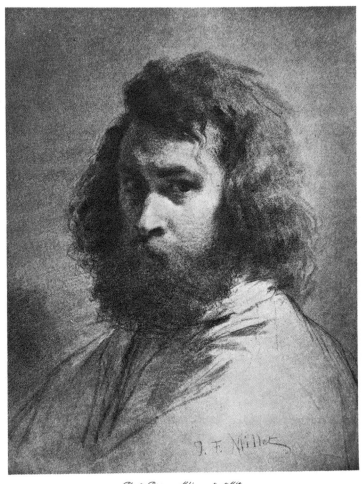

Phot. Braun Clément et Cie

Jean François Millet, 1846-47

JEAN FRANÇOIS MILLET

AMS PRESS

NEW YORK

Reprinted from the edition of 1896, New York

First AMS EDITION published 1971

Manufactured in the United States of America

International Standard Book Number: 0-404-00297-8

Library of Congress Catalog Number: 73-155629

AMS PRESS INC.
NEW YORK, N.Y. 10003

JEAN FRANÇOIS MILLET

Ibis Life and Letters

BY

JULIA CARTWRIGHT

(Mrs. Henry Ady)

Author of " Sacharissa," " Madame," " The Pilgrim's Way," etc., etc.

"Il faut pouvoir faire servir le trivial à
l'expression du sublime, c'est là la vraie force."
—J. F. Millet

**With Nine Photogravures by the Swan Electric Engraving Co.,
and Messrs. Braun Clement & Cie., of Paris**

ARDVA·QVÆ·PVLCRA

London

SWAN SONNENSCHEIN & CO Lim?
NEW YORK: THE MACMILLAN COMPANY
1896

PREFACE

THE world moves on so fast and new phases of art succeed each other with such surprising rapidity in the present day, that to many ears the name of Jean François Millet may have a remote and antiquated sound. Only twenty years have passed since the great peasant-painter died. But he has already taken his place among the classics, and the enormous prices that are paid for his works in England and America, as well as in France, prove how fully his genius is now recognised. He stands supreme among his contemporaries as the first painter of humanity who gave expression to modern ideas in noble and enduring form, and whose work will live when the passing fashions and momentary fancies of the day are forgotten.

The life of Millet was partly written by his friend, Alfred Sensier, and completed and published after the author's death by M. Paul Mantz, in the year 1881. Sensier began his work during the painter's lifetime, and his book contains a large number of letters and recollections from Millet's own pen. These, we need hardly say, are of the utmost value and interest. But the book itself has long been out of print, and is chiefly known to English readers by the abridged translation, made by an American writer, which originally appeared in *Scribner's Magazine*, and was afterwards published by Macmillan. Of late years many other important contributions to the subject have been made by French and American writers who were personally acquainted with Millet, and whose recollections reveal

him under new and different aspects. As long ago as September, 1876, Mr. Edward Wheelwright published a most interesting account of his intercourse with the Barbizon painter in the *Atlantic Monthly*, and in 1889, another American artist, Mr. Wyatt-Eaton, gave the world some valuable recollections of Millet during the last years of his life in the *Century Magazine*. Still more recently, Mr. T. H. Bartlett has published two papers in *Scribner's Magazine* (1890), giving further particulars of the painter's life at Barbizon, and including twenty-seven letters, or fragments of letters, which did not appear in Sensier's book. Many of these are of especial value, and help to explain passages in Millet's career which had been hitherto involved in obscurity. Other letters have appeared in different French periodicals, and M. Piedagnel has written a charming account of a visit which he paid to Millet in 1864, in his little volume of *Souvenirs de Barbizon*. Two papers on Millet's early life and his later years at Barbizon by the painter's own brother, Pierre Millet, were also published in the *Century Magazine* for January, 1893, and April, 1894.

A monograph on the art of Millet from the pen of the well-known writer, M. Yriarte, appeared in the *Bibliothèque d'Art Moderne* (Paris, 1885), and an admirable essay on the painter has been written by M. Charles Bigot in his *Peintres Français Contemporains* (Paris, 1888). Among English writers who have treated the same subject we may name Mr. David Croal Thomson, whose excellent articles on Millet in the *Magazine of Art* have been reprinted in his book on the " Barbizon School " (1889), and Mr. William Ernest Henley, who has done more than any living writer to make the great French master's work known in this country. His "Early Life of Millet" in the *Cornhill* for 1882 attracted considerable attention at the time, and his biographical introduction to a volume of Twenty-two Woodcuts and Etchings, reproduced in *fac-*

simile (1881), is one of the ablest essays that has ever been written on the subject.

The biographical facts and letters which have been collected from these different sources, have been supplemented by a variety of information received from members of his family and personal friends, which helps to fill up the outline and complete the picture. One by one the men and women who were his contemporaries are dropping out, and it becomes the more important to collect these scattered memories before the generation which knew Millet has quite passed away. The smallest details which throw light on the character and genius of such a man are precious, and every incident in his life deserves to be remembered. For in Millet's case the man and the artist were closely bound together, and his art was in a special manner the outcome of his life. Himself a peasant of peasants, he has illustrated the whole cycle of the life of the fields in a series of immortal pictures. " Man goeth forth to his labour until the evening " is the text of all his works. The impressions which he has recorded are those which he received himself, in the days when he laboured with his own hands in the fields of his father's home—the only side of life, he often said, with which he was really familiar. But his theme was new and strange, and because the young Norman artist dared to take an independent line, and paint the subjects which appealed to him, he had to face, not only the prejudices of an ignorant public, but the scorn and hatred of the official world.

We have only to turn back to the journals and periodicals of those days, and study old volumes of *La Gazette des Beaux-Arts*, to see how fierce was the opposition which he had to encounter. His finest masterpieces were rejected by the jury of the Salon, and the pictures which now fetch their thousands were sold for a few pounds to buy bread for his children. But, pitiful as the story is, it is none the

less noble and inspiring. His sufferings saddened his days
and shortened the number of his years, but they did not
crush his spirit or weaken the message that he had to give.
On the whole, we may count him more fortunate than
many whose lives have been spent in happier conditions;
for he worked in obedience to a deep and unchanging con-
viction, and clung in his darkest hours with despairing
tenacity to the principles for which he had ventured all.
"A peasant I was born, and a peasant I will die ! " he cried;
" I will say what I feel, and paint things as I see them."

Apart from his artistic genius, Millet's personality is one
of rare charm. He had all the courage and independence
of his Norman ancestors, together with their simple faith
and goodness. But although a peasant by birth and edu-
cation, he was a man of remarkable culture. He had read
widely, and thought deeply, and was' gifted not only with
a poetic imagination of the highest order, but with fine
literary instincts. His letters are full of grave and preg-
nant sentences, his conversation surprised men of letters by
its terseness and originality. And if the natural melan-
choly of his nature was deepened by the hardships which
he endured, and the persecution to which he was exposed,
a deep undercurrent of hope runs alike through his life and
through his art. The sense of tears may be felt in all that
he ever painted, but it is lightened throughout by the
radiance of the divine hope that cheers the poet's dream.
He belongs to " the great company of grief," who have
stamped their thoughts on the heart of this generation, who
learnt in suffering what they taught in song, and who, out
of the seeming failures of a short and sorrowful life, have
reared the fabric of an art that will live for all time.

J. C.

CONTENTS

LIST OF ILLUSTRATIONS

. A limited Large Paper Edition has also been issued, printed on the best
hand-made paper, 4to, and with the Illustrations on India paper.

vii

66164

PART I

GRÉVILLE

1814—1837

" Oh ! encore un coup, comme je suis de mon endroit."
 —J. F. Millet.

I

THE life of Millet falls naturally into three divisions.
The first part contains the story of his early youth
and education in his native village of Gréville. The
second includes the twelve years of his stay in Paris,
and training as an artist. The third corresponds with
his residence at Barbizon, where he spent the last twenty-
six years of his life, and where all his great works were
painted. Each period has its peculiar interest and im-
portance. First we see him as the child growing up in
his peasant-home, and receiving those impressions which
were to last during his whole life-time. Then we follow
him through the struggles of his *Lehr-* and *Wanderjahre*,
and watch the painful steps by which he served his
apprenticeship to art and life. Finally, we see him
go forth as the complete and finished master to give
his message to the world. There can be no doubt
which is the most attractive part of the story. The
days of youth, before we enter on the storm and
stress of the battle of life, are naturally pleasant to
look back upon. And in Millet's case this part of the
story is more than commonly interesting and instructive.
For the circumstances of his birth and childhood had a
remarkable share in shaping the bent of his genius. To
the early influences of his peasant-home, he owed the
strength of his character and convictions; and in the
country scenes amidst which he was born and bred, he
found the inspiration which governed his whole career.

Although after the first eighteen years of his life he was never again at his native place excepting for a short visit, nothing could ever weaken the memory of these first impressions, and to the end of his life he remained the peasant of Gréville. " Oh! once more, how I belong to my native soil!" he exclaimed, when in 1871, three years before his death, he paid his last visit to Normandy; and no truer word was ever spoken.

Jean François Millet was born on the 4th of October, 1814, at Gruchy, a small hamlet of Gréville, a village ten miles west of Cherbourg, in the department of La Manche, and at the north-west extremity of that narrow strip of coast which runs out into the English Channel to end in the steep headland of La Hague. A wild and rugged coast it is, bristling with granite rocks and needles, and stern and desolate to the sailor's eye as he sails along its perilous shores, but pleasant and fruitful enough inland: a country of rolling down and breezy moorland, where quaint old church-towers of grey stone stand on the hill-tops, and low roofs cluster among the apple-orchards and grass meadows in the sheltered valleys. The whole district has a special interest for Englishmen, as the cradle of some of our older families, and many of these villages, like Gréville itself, still bear the names of the barons who sailed of old with the Conqueror to found a new kingdom on the shores of Britain.

Gruchy itself is a straggling street of houses perched on the top of the cliffs, a few hundred yards from the sea. On one side rise grey boulders clad with bracken, brightened here and there with patches of golden gorse or purple heather, through which we can look down on the waves breaking in foam on the rocky shore below, and catch a glimpse of the mountain sheep cropping the short grass. On the other are orchards and pastures, with oak and elm trees bent into fantastic shapes by the

wind, and deep winding lanes with high hedges, such as we see in Kent or Sussex. The house where the painter was born is still standing. It is the last of a row of four houses, built of huge blocks of rough grey stone, and thatched with straw. An old vine with gnarled stem grows up the wall, and on a block of granite let in over the door we read the words:—

"Ici est né le Peintre Jean François Millet,
le 4 Octobre, 1814."

The house has been divided of late years, but a portion is still occupied by the widow of Millet's younger brother. Little is changed since the painter's days. The quaint old well, with the hive-shaped roof and flight of steps, which figures in more than one of Millet's drawings, is still standing, and the ivy which he begged might be spared when he gave up his share in the old home still grows thickly over the worn, grey stones. The large kitchen within, the wooden dresser and settle and the great open fireplace, are all the same as they were in François' childhood. Upstairs we are shown the room where he was born, and some etchings and early drawings from his hand. Close by is a low wall which he helped to build, and a barn-door on which he roughly scrawled the figure of a grinning devil with a pitch-fork. Beyond is the *douet*, or washing-place, where the women of Gruchy still beat their linen with the big, round stones in the pathway. And as we stand at this lonely spot, where briars and ivy grow tangled together over crumbling walls, we can look down across the fields, where the painter sowed and reaped, to the wide stretch of sea and the far horizon which filled his young soul with dreams.

The wild and desolate aspect of the coast has left its stamp upon the people of the district. These bleak moors

and rugged cliffs, the abiding presence of the sea, and the frequent shipwrecks on that perilous shore have made them familiar from childhood with thoughts of death, and with the nearness of the unseen world. Even now they are a primitive and God-fearing race ; frugal and thrifty in their ways, strong to bear the hardships of their daily lot, and faithful to their ideas of right and wrong. Much more was this the case eighty years ago, when in those troubled days, at the close of Napoleon's wars, Jean François Millet first saw the light in the old, grey house facing the rising sun at the end of Gruchy street.

Here, after the patriarchal fashion of the place, three generations lived under the same roof. Jean Louis, the painter's father, came of a good old yeoman stock, and united in his person the qualities of two remarkably vigorous peasant races, the Millets of Gréville and the Jumelins of Saint Germain-le-Gaillard, a village in the Vallée Hochet, fifteen or sixteen miles distant. Nicolas Millet, the painter's grandfather, had been dead some fifteen years, but his widow, Louise Jumelin, shared her son's home and brought up his children. Jean Louis himself was a tall, slight man, with soft black eyes, long dark curling hair, and beautiful hands. A singularly refined and gentle soul, his tastes and sympathies were of a distinctly artistic nature, although his life was spent in tilling the fields. He loved music, had a fine voice himself, and taught the village choir so well that people came from all parts of the countryside to hear the singing in Gréville church. For their use he made a collection of simple chants, several of which his son preserved, written, it is said, in a hand worthy of a mediæval scribe. He modelled in clay, carved flowers and animals in wood, and was never tired of studying the forms of trees and plants.

" See how fine these are," he would say to his little son, as they went out to work, taking up a blade or two of

grass in his hand. And again, "Look what a tall and well-shaped tree that one is—as beautiful as a flower!" And when they were looking out of the window together, he would say, "Look how well that house lies half buried in the field! It seems to me that it ought to be drawn in this way."

His gentle, thoughtful nature endeared him to all. At his approach rude jests were silenced, and unseemly laughter died away. "Hush!" some one would say, if a coarse joke were made in his presence; "here comes Millet."

One day, as little François stood at his father's side, watching the setting sun sink into the waves, the glory of the scene stirred him to enthusiastic admiration, and he poured out his heart in an ecstasy of childish rapture. Jean Louis took his cap off reverently and said, "My son, it is God." The boy never forgot that word.

Jean Louis had married young by the express wish of his parents, who feared to see their only son torn from his home and forced to serve in the wars of Napoleon. But since newly married men were exempt from military service at that time, and Jean Louis was attached to a well-born maiden in the neighbouring village of Ste. Croix, both families agreed in hurrying on the union of the young people, who were married in 1811. The object of the young man's choice was a fair young girl named Aimée Henriette Adelaïde Fleury du Perron, a member of an old yeoman family, who had known better days. Millet remembered hearing his mother speak of the fine house in which her parents lived, with its massive granite buildings and large courtyard shaded by tall trees. She herself was a simple and devout soul like her husband, whose time and thoughts were divided between her children and the field-work in which she took her share. At the same time, her letters to her son show that she was by no

means devoid of intelligence or education, and it is a
mistake to suppose, as some writers have done, that she
was a mere household drudge. To the end of her life she
kept her youthful air and graceful and refined appear-
ance. She was always well dressed, her son Pierre tells
us, and had a marked preference for bright colours and
gaily-flowered china. Like a good mother she was especi-
ally anxious for her children's material welfare, and did
her best to keep up the position of the family in the eyes
of the world. Millet was tenderly attached to his
mother, and has left us a good likeness of this patient
and loving woman in his *Cueilleuse d'Haricots*, where
Aimée Millet is seen gathering beans in front of her
home at Gruchy.

But it was the grandmother, Louise Jumelin, who played
the chief part in Millet's earliest recollections. A woman
of strong character and deep feeling, stern in her ideas
of duty, but gifted with a boundless capacity for loving,
Louise Jumelin was an interesting and striking per-
sonality. The members of her family had all of them
made their mark in the world. One brother was a monk,
another a chemist of some repute in Paris, a third had
spent some years as a planter in Guadeloupe, but in Mil-
let's childish recollection, his chief distinction lay in the
fact that he had once walked to Paris on foot in two days
and nights. Another brother, a miller in the neighbour-
hood of Gréville, was a great reader, and studied Mon-
taigne and Pascal, the philosophers of the last century, and
the writers of Port Royal, during his leisure moments.
Her old sister, Bonne, was devoted to the Millet children,
and Bonnette, as they called her, remained one of the
painter's fondest recollections to his dying day. Louise
Jumelin herself had inherited the strong head and warm
heart of her family. She had all their religious fervour
and no small share of culture. She took the saints as her

model and carried out her ideal in every detail of daily life. Nothing would ever induce her to swerve a step from what she held to be right; and if she was in any doubt she went at once, in her simple faith, to consult the village curé. But this mystic vein of piety was blended with an ardent love of natural beauty, and the fire of her zeal for God was tempered with the tenderest human love and pity. "Hers was a beautiful religion," says Millet, "for it gave her strength to love so well and so unselfishly. The saintly woman was always ready to help others, to excuse their faults, to pity and relieve them." And his brother Pierre, who was many years younger, tells us, in his recollections of his grandmother, that her aged face wore an expression of Christian goodness which agreed perfectly with her character.

Such was the remarkable woman to whom the care of the painter's childhood was entrusted, after the Norman custom, in order that the mother might be left free to work in the fields, and tend the sheep and cattle on her husband's farm. He was the second child, but eldest boy of Jean Louis' family, and his birth was accordingly welcomed with joy by his grandmother, who was proud of her first grandson, and looked on him from the first as her especial property. She it was who held him at the baptismal font and gave him the name of François, after the Saint of Assisi, on whose fête-day he was born—Francis, who called the birds his brothers and sisters, and praised God for the sun and stars and all living creatures. No more fitting patron could have been chosen for the great peasant painter, and no better or holier influence could have watched over his early years than that of this good grandmother. He remembered how she used to rock him in her arms, and sing him to sleep with songs of old Normandy. On bright spring mornings she would rouse him from his slumbers, saying, as she bent over him in

her high, white linen cap, "Wake up, my little Francis!
The birds have long been singing the glory of our good
God." As the boy grew older, she taught him to see the
hand of a great and loving Father in all the wonders of
sea and shore, and to dread a wrong action more than
death itself. And in so doing she laid the foundation of
that moral uprightness and simple faith which marked
the character of the man. To the end of her life she
followed him with her prayers and counsels, and long
after she was dead Millet recalled her words and cherished
her memory with the tenderest affection.

Another aged relative to whom Millet always said he
owed much was his great-uncle, the Abbé Charles Millet,
a priest of the diocese of Avranches, who had been forced
to hide himself in his brother's house during the Revolution.
He had steadily refused to take the oath to the Constitution,
and had in consequence narrowly escaped with his life.
When the Reign of Terror was over, he lived on at Gruchy
with his brother and nephew, inhabiting a room over the
old stone well, opposite the house. He taught Jean Louis
to read, and acted by turns as parish priest and field-
labourer.

"He might often be seen," writes Sensier, "reading his
breviary on the upper pastures overlooking the sea, or
else guiding the plough, or carrying blocks of granite
to rear walls round the family acres. If he had a
furrow to plough, or a garden to hoe, he put his breviary
into his pocket, tucked his cassock into his girdle, and
went to work with goodwill." But whether at home or
abroad little François was the good Abbé's constant com-
panion. He taught the boy to read, and watched over
his early years with the most anxious affection. But
he died when his great-nephew was only seven years
old, and the event made a profound impression on the
thoughtful child.

There was yet one other member of the little household at Gruchy who played an important part in François' life. This was his sister Emilie, the eldest of Jean Louis' eight children. She was a girl of sweet and gentle disposition, much beloved by all her family, and especially by her brother François, to whom she bore a marked resemblance. She was the favourite companion of the painter's boyhood, and treasured up stories of his sayings and doings, which she loved to repeat in after years. In her eyes François was always a remarkable child, unlike other children in his ways and thoughts. François, who was eighteen months younger, looked up to Emilie as a cherished elder sister, and made a charming drawing of her sitting at her spinning-wheel, in the white linen cap, homespun skirt, and sabots of the Norman peasant-girl. The affection between the brother and sister lasted to the end of their lives, and survived many years of trial and separation. When in 1866 Emilie, who had become the wife of a neighbouring farmer, named Léfèvre, fell dangerously ill, Millet hastened to Gréville without delay, and has left a touching account of her death in his letters.

II

IN later years, Millet often spoke of his boyhood, and
loved to recall each little incident of these youthful
days upon which he looked back as the happiest time of his
life. At Sensier's request he wrote out several pages of his
earliest recollections, which are so full of interest, and give
so vivid a picture of his childish memories, that we quote
them word for word :—

" I remember being awakened one morning by voices in the room
where I slept. There was a whizzing sound which made itself heard
between the voices now and then. It was the sound of spinning-
wheels, and the voices were those of women spinning and carding
wool. The dust of the room danced in a ray of sunshine which
shone through the high narrow window that lighted the room. I
often saw the sunshine produce the same effect again, as the house
faced east. In one corner of the room there was a large bed,
covered by a counterpane with broad red and brown stripes, which
hung down to the floor. There was also a large brown cupboard
against the wall, between the feet of the bed and the window. All
this comes back to me as in a vague, a very vague, dream. If I
were asked to recall in the faintest degree the faces of those poor
spinners, all my efforts would be in vain, for although I grew up
before they died, I only remember their names because I heard
them afterwards spoken of in my family. One of them was my old
great-aunt Jeanne. The other was a spinner by profession, who
often came to the house, and was called Colombe Gamache.

" This is the oldest of all my memories. I must have been very
little when I received that impression, and it was a long time before
I became conscious of any more distinct images. I only remember
confused impressions, such as the sound of steps coming and
going in the house, the cackle of geese in the yard, the crowing

of the cock, the swing of the flail in the barn, and similar noises which fell on my ears constantly and produced no particular emotion.

"There is a little fact which stands out more clearly. The Commune invested in some new bells: two of the old ones had been melted down to make guns, and the third had been broken, as I heard afterwards. My mother had the curiosity to go and see the new bells, which were placed in the church to be baptized before they were hung in the tower, and took me with her. She was accompanied by a girl named Julie Lecacheux, whom I knew very well afterwards. I remember how much I was impressed at finding myself in so vast a place as the church, which seemed even more immense than our barn, and how the beauty of the big windows with their lozenge-shaped panes struck my imagination. We saw the bells, all three resting on the ground, and they also appeared enormous, since they were much bigger than I was; and then (what no doubt fixed the scene in my mind) Julie Lecacheux, who held a very big key in her hand—probably that of the church—began to strike the largest bell, which rang loudly, filling me with wonder and admiration. I have never forgotten the sound of that key on the bell.

"I had an old great-uncle who was a priest. He was very fond of me, and took me about everywhere with him. Once he took me to a house where he often went. The lady of the house was aged, and lives in my mind as the type of a lady of the old *régime*. She caressed me, gave me a slice of bread and honey, and into the bargain a fine peacock's feather. I remember how good that honey tasted, and how beautiful the feather seemed! I had already been filled with wonder on entering the yard at the sight of two peacocks perched on a big tree, and I could not forget the fine eyes on their long tails!

"My great-uncle sometimes took me to Eculleville, a little hamlet of Gréville. The house to which he took me was a sort of château, known as the mansion of Eculleville. There was a maid named Fanchon. The owner, whom I never knew, had a taste for rare trees, and had planted some pines. You would have to go a long way in our neighbourhood before you could find so many together. Fanchon sometimes gave me some pine-cones, which filled me with delight.

"This poor great-uncle was so afraid of any harm happening to me that he was miserable if I was not at his side. This I had been often told; but as I by this time was able to run, on one occasion

I escaped with some other boys, and climbed down the rocks to the
sea-shore. After trying in vain to find me, he ended by coming
down to the sea, and caught sight of me bending over the pools left
by the retreating tide, trying to catch tadpoles. He called me in so
terrified a voice, that I jumped up without delay, and saw him on
the top of the cliffs beckoning to me to return at once. I did not
let him call twice, for his look frightened me; and if I could have
found any other way than the path at the top of which he was
awaiting me, I would have taken it. But the steepness of the cliff
forced me to take this path. When I had reached the top, and was
out of danger, he flew into a violent rage. He took up his three-
cornered hat and began to strike me with it; and as the cliff was still
very steep on the way back to the village, and my little legs could
not carry me very fast, he followed me, beating me, with a face as
red as a turkey-cock. So he pursued me all the way to the house,
saying with each blow of his hat, 'There! I will help you to get
home!' This filled me with great dread of the three-cornered hat.
My poor uncle on his part had the most frightful nightmare all the
following night, and kept waking up every minute in terror, crying
out that I was falling over the cliff. Since I was not old enough to
appreciate a tenderness which took the form of blows, this was by
no means the only alarm which I gave him. It appears that once
during mass I chattered with some other children. He coughed,
as a sign to stop me, but I soon began again. Then he came down
the church, and taking me by the arm, made me kneel down under
the lamp in the middle of the choir. I do not know how it happened,
for I never in all my life had the least wish to resist punishment, but
somehow I caught my foot in his surplice and tore it. Over-
whelmed with horror at this act of impiety, he left me without giving
me the intended penance, and returned to his place, where he re-
mained, more dead than alive, until the end of mass. I had no
notion what a crime I had committed, and was very much surprised
when, on our return from mass, my great-uncle began with emotion
to tell the whole family what an abominable outrage I had com-
mitted on his person—an act, in fact, little short of sacrilege. Such
a crime, committed against a priest, made him prophesy fearful
things of my future. It would be impossible to paint the conster-
nation of the whole family. For my part, I could not understand
why I had suddenly become an object of horror, and my dismay was
great. There, however, my recollections of this unhappy affair end.

Time has dropped his veil over that, as over other things, and I cannot remember if I was ever further punished.

"This I remember hearing about my great-uncle, who was the brother of my paternal grandfather. He had been a labourer in his youth, and had become a priest rather late in life. I think he had a small parish at the time of the Revolution. I know that he was persecuted at that time, and I have heard how a party of men came to search my grandfather's house, when he was hidden there. They prosecuted their search in the most brutal fashion; but being of an ingenious turn of mind, he managed to make a hiding-place which communicated with his bed, where he took refuge when his enemies came. One day they arrived so unexpectedly that his bed had not yet had time to get cold, and when they were told that he was gone, they exclaimed, 'He was here just now; the bed is still warm, but he has managed to escape!' And all the while he could hear them talking. In their fury they turned the whole house upside down, and then went away.

"My uncle said mass, when he could, in the house; and I have still the leaden chalice which he used. After the Revolution he lived on with his brother, and held the office of Vicar of the parish. Every morning he went to church to say mass; after breakfast he went to work in the fields, and almost always took me with him. When we reached the field, he took off his cassock, and set to work in shirt-sleeves and breeches. He had the strength of Hercules. Some great walls which he built to support a piece of sloping ground are still standing, and are likely to last for many years to come. These walls are very high, and are built of immense stones. They give one an impression of Cyclopean strength. I have heard both my grandmother and father say that he would allow no one to help him to lift even the heaviest stones, and there are some which would require the united strength of five or six ordinary men with levers to move them.

"He had an excellent heart. He taught the poor children of the village, whose parents could not send them to school, for the love of God. He even gave them simple Latin lessons. This excited the jealousy of his fellow-priests, who complained of him to the Bishop of Coutances. I once found, among some old papers, a rough draft of a letter which he addressed in self-defence to the bishop, saying that he lived at home with his peasant brother, and that in the Commune there were some poor children who had no

sort of instruction. He had therefore decided to teach them as much as he could, out of pity, and begged the bishop, for the love of God, not to prevent these poor children from learning to read. I believe the bishop at length consented to let him have his own way—a truly generous permission !

"As he grew old my great-uncle became very heavy, and often walked faster than he wished. I remember how often he used to say, 'Ah ! the head bears away the limbs.' At his death I was about seven years old. It is very curious to recall these early impressions, and to see how ineffaceable is the mark which they leave upon the mind.

"My childhood was cradled with tales of ghosts and weird stories, which impressed me profoundly. Even to-day I take interest in all those kind of subjects. Do I believe in them or not ? I hardly know. On the day of my great-uncle's funeral I heard them speaking in mysterious terms of his burial. They said that 'some heavy stones, covered with bundles of hay, must be placed at the head of the coffin, for that would give the robbers trouble. Their tools would get caught in the hay, and would break on the stones, so that it would be impossible to hook up the head, and pull the body out of the grave.' I afterwards learnt the meaning of this mysterious language. From the day of the funeral several friends, and the servant of the house, who were given hot cider to drink, spent each night, armed with guns and any other weapons they could find, keeping watch at the grave where my great-uncle had been buried. This guard was kept up for about a month. After that, they said, there was no more danger. The meaning of all these precautions was, that there were men about who made a profession of digging up dead bodies for the use of doctors. Whenever any one died in the Commune, they would come at night to steal the body. Their practice was to take a long screw, and, working through the ground and the lid of the coffin, hook up the head of the dead man, and so draw out the body without disturbing the earth on the surface. They had been met leading the corpse covered over with a mantle, supporting it in their arms, and speaking to him as if he were a drunken man, telling him to stand up. At other times they have been seen on horseback, carrying the dead man in the saddle, with the arms tied round the rider's waist, and always covered up with a great cloak, but often the feet of the corpse could be seen below. Some months before the death of my great-uncle I

had been sent to school, and I remember well that on the day he
died, the maidservant was sent to bring me home, lest at so solemn
a moment I should be seen playing on the road. Before I went to
school I had begun to learn my letters, and, perhaps, to spell, for
the other children thought me already very clever. God knows
what they called clever !

"My first arrival at school was for the afternoon class. When I
reached the court, where the children were at play outside, the first
thing that I did was to fight. The bigger children, to whose care I
had been trusted, were proud of bringing a child to school who was
only six and a half, but who already knew his letters ; and I was so
big and strong, that they assured me there was not one boy of my
age, or even of seven, who could beat me. There were no other
children there under seven ; they were determined to prove the
truth of this assertion, and at once brought up a boy who was
supposed to be one of the strongest, and made us fight. I must
confess that we had no very good reasons for disliking one another,
and that the fight was of a mild nature. But they had a way of
putting you on your mettle. A stalk of straw was laid on one boy's
shoulder, and the other was told : 'I bet you dare not knock that
straw off !' and for fear of being thought a coward you knocked
it off. The other boy naturally would not submit to such an insult,
and the fight began in good earnest. The big boys excited the one
whose side they had taken, and the combatants were not parted
until one of the two was victorious. The straw was tried in my
case. I was the strongest, and covered myself with glory. My
partisans were exceedingly proud of me, and said : 'Millet is only
six and a half, and he has thrashed a boy of more than seven years
old !' "

In this way François made his first acquaintance with
school life. He wrote well and easily from dictation,
probably, as he says, because he read constantly, and the
words and sentences were fixed in his eyes, rather than
in his mind. But he could not learn by heart, and spent
his time in making capital letters of antique type, and
drawing over his copybooks when he ought to have been
learning his lessons. He was hopelessly bad at sums,
and always declared that he never could get beyond

C

simple addition. Subtraction and other rules were utterly
beyond him, and all his reckoning was done in his head,
after a fashion of his own. But he read every book that
he could lay hands upon, and watched the clouds and
the waves, the shapes and colours of the objects about
him, and pondered them in his heart. Nature herself
became his teacher, and in her own way she taught him
lessons which he could not have learnt from any other.

III

A T twelve years old François was prepared for his
first communion, and went with his comrades to
be catechised in the church of Gréville. His thoughtful
answers attracted the notice of Abbé Herpent, the young
vicar of the parish, who offered to teach him Latin,
saying that it might help him to become a priest or a
doctor. But the boy declined his offer with thanks. "I
do not wish to be either," he replied, with decision. "I
mean to stay at home with my parents."

"Well, then, I will teach you all the same," said the
young priest. François made no further objection and
joined the class which was held daily at the Abbé's house.
He learnt to construe the *Epitome Historiæ Sacræ* and
the *Selectæ e Profanis*, and if he did not always under-
stand the grammar, was invariably quick to seize the
meaning of a difficult passage. One day a discussion
arose over the myth of Argus. The Vicar insisted that
on the death of Argus, Juno had given him the eyes of
her favourite bird, the peacock. François, on the contrary,
declared that Juno had given the peacock the eyes of
Argus, and pointed to the peacock's tail as a proof of his
argument. The kind Abbé smiled at the little fellow's
obstinacy, and said that the question must be referred to
his superior, the Curé of Gréville, but upon further re-
flection came to the conclusion that François was right,
and wisely dropped the subject. He did his pupil a
greater service by introducing him to Virgil, which he

read partly in French and partly in Latin, in the old edition of Abbé Desfontaines. The Bucolics and Georgics were a revelation to this peasant child. They opened his eyes to the beauty and meaning of a hundred things in nature, and made him understand the life of the fields in a way that he had never done before. From that moment Virgil became one of the strongest influences of his life—a book to be ranked next to the Bible in his affections. Certain lines took hold of his imagination with strange power, and to his dying day he never forgot the thrill of emotion which ran through him when he read the words:

" Majoresque cadunt altis de montibus umbræ."

Even at this early age, the impressions of which Millet was conscious were all of a serious nature. The sighing of the wind in the oaks and apple-trees, the vast gloom of the church on a winter's night, the weird tales of ghosts and body-snatchers that haunted the village, were the things which struck his childish fancy. He loved the old elm-tree in his father's garden, " gnawed by the wind and bathed in aerial space." The tall laurel with its shining green leaves seemed to him worthy of the Sun-god Apollo. Above all, the sea filled him with an awful sense of the majesty of nature and the littleness of man. He was never tired of listening to the sound of the waves breaking upon the rocks, never weary of gazing over the wide stretch of boundless sea that seemed to him to speak of the infinite. The terrible storms that broke upon that iron-bound coast made a profound impression upon his sensitive nature. There was one especially which he never forgot, and of which he has left us a vivid description.

" It was All Saints' Day. In the morning we saw that the sea was rough, and people said there would be trouble. The whole

hear another crash, as in the case of the first ship, but this one stood firm and did not move. The waves beat against her sides in vain. She stood as it were turned to stone. Every one made for land, for she was only two gunshots from the shore. One of our boats was made fast alongside, and filled with people instantly. Another boat, belonging to the ship, put off at the same time, boxes and planks were thrown into the sea, and in half an hour every one was safe on shore. This last ship was saved by a strange chance. The bowsprit and forepart had been wedged in between two rocks, and the wave that dashed her on the reefs had saved her by miracle. This ship was English and the man whom we saw blessing his companions was a bishop. They were taken to the village and from there to Cherbourg. We soon hurried back to the beach. The third ship was thrown on the rocks and dashed to pieces. No one was saved this time, and the bodies of the unhappy crew were thrown up on the sand. Then came a fourth, fifth and sixth vessel, all of which were lost with their crew and cargo alike, upon the rocks. The tempest was furious. The wind was so violent that it could not be resisted. It stripped the houses of their roofs and tore off the thatch. So fierce was the gale that many birds, even the seagulls, which are used to storms, perished in the whirlwind.

" The night was spent in trying to protect our own houses. Some of us laid big stones upon the roofs, others fastened ladders and poles to the roofs to secure them. The trees were bent to the ground, their boughs cracked and broke. All the fields were covered with branches and leaves. It was a terrible scene.

" The next morning, All Saints' Day, the men of the village came back to the beach. It was covered with dead bodies and wreckage which were brought together and laid at the foot of the rocks. Other vessels came into sight and were all dashed to pieces on our coast. So great was the desolation, it seemed as if the end of the world had come. Not one was saved. The rocks shivered them as if they had been glass, and cast the fragments over the cliffs.

" As I was passing by a hollow in the cliff, I saw a large sail spread, as I thought, over a bale of merchandise. I lifted the sail and saw a heap of corpses. I was so frightened that I ran home, and found my mother and grandmother on their knees, praying for the shipwrecked sailors.

" The third day, one other vessel came. This time some of the crew were saved. About ten men were brought off the rocks, all

parish came to church. In the middle of mass a man ru
all dripping with salt water. It was an old sailor, well kn
his courage in all the country-side. He began to say that
come up from the beach, and had seen several vessels wh
wind was driving upon the rocks, where they would certa
wrecked. 'We must go to their help at once,' he said alou(
I have come to tell all those who are willing to go with m
there is only just time to put out to sea, if we are to try an
them.' Fifty men volunteered to go at once, and followed t
sailor without a word. We descended the cliffs to the beac
there we saw a terrible sight: several vessels rushing, one aft
other, at fearful speed, upon our rocks. Our men put three
out to sea, but before they had rowed ten strokes one boat
another was upset by a huge breaker, while a third was thrown
the beach. Happily no one on board perished, and all our
reached the shore safely; but it was plain that our boats coul
of no use to the unhappy souls at sea. Meanwhile the vessels (
rapidly nearer until they were only a few yards from the black r(
covered with cormorants. The first had lost its masts, and lo(
like a great rolling mass. We all saw it advancing, and no
dared speak a word. It seemed to me, child that I was, as if d
were playing with a handful of men, who were about to be crus
or engulfed in her cruel grasp. Suddenly an immense wave
up like a raging mountain, caught the vessel and carried it towa
the beach. Then another, yet more immense, dashed it agains
rock on the water's edge. There was an awful crash, then anotl
and in one moment the ship filled with water and was dashed
pieces. The sea was strewn with wreckage, with planks, masts a
drowning men. Many tried to swim and sank. Our men thr(
themselves into the waves, and with the old sailor at their he;
made desperate efforts to save the poor fellows. Some were rescue
but many more were drowned or dashed to pieces on the rock
The sea threw up hundreds of corpses, as well as quantities of carg(
For many days afterwards our people picked up these sad fragment
on the beach, and stowed them away in their cellars, all damaged a
they were by the salt water. But this was not all. A second vesse
approached. Its masts were gone. Every one on board was as
sembled on the crowded deck. We saw them all on their knees
and in their midst a man in black in the act of blessing them. Then
a wave, as big as the cliffs, rolled her towards us. We seemed to

bruised or wounded. They were carried to Gruchy and nursed during more than a month, and after that taken to Cherbourg. But these unfortunate men were not yet saved from the sea. They embarked on a boat that was going to the Havre. A storm got up and they were all lost.

"As for the dead, all the horses in the village were employed, during the first week, in bearing the corpses to the churchyard. They were buried in unconsecrated ground, and I was told they were not good Christians.

"A few days after that, I picked up on the sand a small piece of carved wood, which must have belonged to one of the vessels which had been wrecked on our coast. When my mother saw it, she scolded me well, and making the sign of the cross, told me to take it back to the place where I had found it and to ask God's pardon for my theft. This I did at once, feeling much ashamed of my action.

"Since that time I have seen many tempests at my home, but no other has ever left so awful a picture of destruction upon my mind, or so vivid an impression of the littleness of man and of the power of the sea."

The horrors of that week might well have impressed any child, but perhaps few could have given so clear and exact a record of the shipwreck thirty or forty years afterwards. But it was already plain to more than one observing eye that François Millet was no ordinary child.

When his first teacher, Abbé Herpent, left Gréville for the neighbouring village of Heauville, he asked Jean Louis Millet to allow the boy to accompany him and go on with his lessons. François left home sadly enough, and felt in his exile "like Ovid among the Scythians." At the end of four or five months he came back to Gruchy for the New Year, and begged so hard to be allowed to stay at home, that the plan was abandoned. Fortunately, the new vicar, Abbé Jean Lebrisseux, undertook to continue the child's education. He was as good as his word, and proved the best and kindest of friends

to François. He lent him books, helped him to read
Virgil, and explained the Psalms to him. More than
this, he encouraged the shy, thoughtful boy to talk freely
upon all subjects. François poured out his heart to him,
and told him how he loved to watch the sea and the
sky, and how full of wonder and mystery the visible
world about him seemed. The good Abbé listened with
kindly interest, but as he heard the child talk and saw
that he was altogether unlike his comrades, he trembled
to think of his future lot, and said with a sigh: "Ah!
my poor child, you have a heart that will give you
trouble. You do not know how much you will have to
suffer."

In after years these words often came back to Millet's
mind, and he owned that Abbé Lebrisseux had been all
too true a prophet. Others shared the good priest's
surprise, when they heard the lad talk of his favourite
books. His great-uncle had left him a few theological
books, and his grandmother had inherited several volumes
of the Fathers and of the Port Royal writers from her
brother, the miller of the Vallée Hochet. François, who
devoured every book that he could lay hands on, became
thoroughly well versed in the *Lives of the Saints*, the
Confessions of St. Augustine, and the writings of Bossuet,
Fénélon, and Pascal. The *Letters of St. Jerome* were
one of his favourite studies, and he knew Virgil and the
Vulgate by heart. The verses of the Bible, he often said,
seemed to him in those days "like gigantic monuments."
One day a professor from Versailles paid a visit to
Gréville, and attracted by François' thoughtful face, ques-
tioned him about his studies. The boy's answers pleased
him so much that he took him for a long walk in the
fields, and encouraged him to open his heart freely on
other subjects. The simple eloquence of François' language
amazed him. "Go on, my boy, go on as you have begun,"

he said, when they parted; and he told his friends that he
had found a Norman peasant-child whose soul was poetry
itself.

But life at Gruchy was hard, and all hands were needed
on the little farm. As the eldest son of a large family,
François was soon called to leave his books and help his
father and mother in their field work. With his own
hands the future artist of the *Travaux des Champs* sowed
and reaped the corn, thrashed and winnowed the grain,
mowed the grass and turned the hay, ploughed the ground
and tended the flocks in the sheep meadows along the
seashore. Another form of labour which Millet has illus-
trated in his drawings, was the gathering of *varech*, the
seaweed with which the Gréville peasants manured their
stony soil. After a violent storm beds of seaweed were
left upon the beach, and the whole village would hasten
to the shore armed with long rakes to collect the *varech*,
and bring it up the cliffs on their mules and ponies.
Some of the Gréville men were in the pay of the smug-
glers, who at that time carried on a profitable trade along
the coast. But the Millets would never have anything
to do with them. " We never tasted that bread. It would
have made my grandmother too miserable."

On winter evenings the men sat round the fire, mend-
ing their tubs or making baskets and chairs, while the
women were busy spinning wool and flax, for clothes
and tools were all made in the village. As they worked,
they sang old songs and told weird tales of ghosts and
hobgoblins that were handed down from one generation
to another. In Millet's home, the old traditions of hos-
pitality were practised in a truly patriarchal fashion.
If a beggar passed that way, he had no need to ask
leave to enter the house. The door was always open,
and François remembered the stately curtsey with
which his grandmother invited the poorest tramp to sit

down by the fire. Often these beggars brought her the latest news of her own family, and came to Gruchy straight from the farm of the Jumelins, where they met with the same hospitable treatment. When François and his brothers grumbled because the beggars took up the largest share of the fire, the old lady told them to remember that they at least were warmly clad, while these poor people were all in rags. When supper was laid, she waited upon her guests first, and talked pleasantly with them, mingling good advice and religious exhortation with her remarks. " Whom the Lord loveth, He chasteneth," she would often say ; " if you have to suffer here, God will not forget you when you appear before Him." In those hard times whole families were often reduced to beggary, and troops of children would come round crying, " Give us bread, of your charity, for the love of God." They were never sent empty away from the Millets' house, and François remembered how his grandmother would send him and his brothers with large baskets, filled with hunches of bread, to feed these hungry wayfarers, " to teach them," she said, " to be charitable."

On Sundays after mass, at which François often officiated as server, or incense-bearer, his father kept open house, and liked to sit down to dinner with all his relations and friends. Afterwards, the village lads often went on ex- peditions to Cherbourg or other places in the neighbour- hood, and then François would shake off his dreamy ways and become the life of the party. His clever talent for mimicry made him popular with his companions, and there was one boy named Antoine, who was his inseparable friend. But, as a rule, he preferred to shut himself up in a bedroom or empty barn on Sunday afternoons, and read some favourite author, or else copy the prints out of the old family Bible. He was still, as his sister Emilie said, " unlike other boys." Not even his love for her

could induce him to pay attention to his personal appearance, or care about fine clothes. In vain she complained that the girls of the village laughed at his shabby jackets ; he only shrugged his shoulders, and said he liked old clothes best. All the same he was a favourite with most of them, and there was a general impression that François would some day become a remarkable man.

So the lad grew up without a thought of leaving home, or a wish to lead any other existence than this to which he was born and bred. To the last he always declared that country life was, in his opinion, the only really enviable one. And no doubt this peasant-life, as it was lived at Gréville in those days, retained a great measure of its primeval charm. The burden of daily toil was lightened by a sense of honest pride and independence, by the pleasures of out-door labour and the strong ties of family affection. The work might be hard and the fare scanty, but there was neither squalor nor vice to be ashamed of, neither dirt nor rags to hide. The simple-minded peasants bore the hardships and monotony of their daily lot without a murmur, and met death as calmly as they went out to work. And the secret of their quiet courage and uncomplaining patience lay in that humble and devout faith, that unshaken trust in a merciful God, and firm belief in a world beyond the grave, which had its roots deep down in the old order. In their patriarchal simplicity and Puritan virtue, these Norman peasants were not unlike the Scottish Presbyterians in their Highland homes; but there was a more picturesque element in their religion, together with a certain freedom and largeness, the result of a long inheritance of Catholic traditions. And, in the natural order of things, out of this life of plain living and high thinking, there sprang the great poem of peasant-life which was this painter's

message to the world. The Sower and the Reapers, the Gleaners and the Angelus, are pages out of the same story. Millet's peasants are men and women of Norman birth, the cut of their clothes, the shape of their tools is that which he had seen and known from his childhood. And the sentiment that inspired these great works, the inborn consciousness of the dignity of labour and its eternal meaning, the ever-present sense of the mysteries of nature and the close relation of man with the infinite, had been learnt by the painter under his father's roof, in the home of his ancestors on the Norman shore. In after years, these scenes of his youth were never long absent from his thoughts. When he lay dying, the vision of his own green fields floated before his eyes, and one of the last pictures which he painted was that of the old grey church at Gréville, with the crosses marking the graves of his fathers under the tall poplar trees, and the pale blue sea beyond.

IV

THE genius of Millet revealed itself in his early years by remarkable powers of memory and observation. The child's passionate love of nature and his thoughtful mind, the seriousness of his impressions and the poetry of his soul were evident to all, but some time passed before the artistic faculty within him took any definite shape. His sister Emilie remembered how once, when François was a child of four or five, his father asked his little ones what professions they would choose when they grew up, upon which the boy replied with decision, " I mean to make pictures of men."

By degrees the vague longings of the boy's heart, his wonder and delight in all living things, began to find expression. The sight of some old engravings in an illustrated Bible first moved him to take up his pencil, and before long he tried his hand at drawing the objects around him. During the noonday rest, while his father slumbered on a couch at his side, François studied the landscape from the window. He sketched the garden and the stakes, the sheep and cattle that were feeding in the pastures and the fields, with their wide horizon of sea and sky. Often Jean Louis, waking from his sleep, would get up and take a peep at the drawing on which the boy was engaged and return softly to his place without disturbing him, well pleased to see this new development of his son's powers.

One clever sketch which François made of three men riding donkeys, who passed through Gréville on market

days, was placed in the window of the blacksmith's shop, where it attracted the notice of these personages, who were all eager to know the name of the artist who had taken their portraits. After this, the boy made several drawings of Bible subjects, one of which, the *Ten Wise and Foolish Virgins*, was especially admired by his family and neighbours.

But no one thought of making him an artist, and he himself never dreamt of leaving home or of following any profession save that of his father's, until one Sunday when he was about eighteen. That day, as he came back from church, the bent figure of an aged peasant who was going slowly home struck his fancy, and taking up a piece of charcoal he drew an exact likeness of the old man upon the wall. The foreshortening of the figure was so good, the movements and attitude were so exactly given, that his parents recognised the portrait at once. Every one laughed, but Jean Louis was deeply moved and pondered seriously over the matter. He had long watched the lad's growing talent, and now he felt that the moment had come when it would be wrong to hinder its progress. A family conclave was held, and the subject was seriously discussed by the elders. François was consulted, and owned that he would like to be a painter. Then his father turned to him with a kindness which the youth never forgot, and said gently,—

"My poor François, I see that this idea has taken hold of you. I should like to have sent you long ago to learn this trade of a painter, which people say is such a fine thing, but it was impossible. You are the eldest of my boys, and I could not do without you; but now that your brothers are growing up, I will no longer hinder you from learning what you are so anxious to know. We will go to Cherbourg and see if you have really enough talent to be able to earn a living."

That simple and touching little speech settled the question. Soon afterwards, the father and son went to Cherbourg, and, by the advice of a neighbour, called upon an artist named Bon Dumoucel, but generally known as Mouchel, who had been a pupil of David, and gave lessons. François took with him as specimens of his work two drawings which he had lately finished. One represented a shepherd playing on the flute at the foot of a tree, while his comrade stood listening to the music on a grassy slope where the sheep were feeding. The shepherds wore the short vest and sabots of the Gréville peasants, and the background was the apple-orchard close to Millet's home. The other drawing was taken from a parable in St. Luke's Gospel, and represented a peasant standing at the door of his house, on a starry night, in the act of giving a loaf of bread to his neighbour, who was taking it eagerly from his hands. Underneath were the words of the text in the Vulgate version,—

"*Etsi non dabit illi surgens eo quod amicus ejus sit, propter improbitatem tamen ejus surget, et dabit illi quotquot habet necessarios.*"

"Though he will not rise and give him, because he is his friend, yet because of his importunity he will rise and give him as many as he needeth."

This is the drawing which Millet kept all his life in his *atelier* at Barbizon and of which he said to Sensier: "You know my first drawing; it is still hanging in my *atelier*. That was done in my old home, without the help of a master, without a model or a guide. I have never worked in any other way; but as far as expression goes, I do not know that I can do better to-day." And Sensier, who had been familiar with this sketch of Millet's youth during thirty years and more, describes it as the work of a man who had already grasped the great issues

of art, its effects and resources—a drawing, in fact, which might have been the work of an old master.

The Cherbourg artist saw at a glance the originality and merit of the country lad's productions.

"You are laughing at me," he said roughly. "You don't mean to tell me that this young man made those drawings by himself!"

"Yes, certainly," replied Jean Louis gravely. "I saw him make them myself."

"I don't believe it," returned Mouchel. "I see that the method is awkward, but as for the composition—I repeat, it is impossible."

Both father and son insisted with so much energy that the drawings were the unaided work of François that in the end the incredulous artist was compelled to believe them. Turning to Jean Louis, he exclaimed:

"Well, then, all I can say is, you will be damned for having kept him so long at the plough, for your boy has the making of a great painter in him."

And he agreed on the spot to take François as his pupil. So at eighteen, the lad of Gréville left his peasant-home to follow this new calling, and, like Giotto of old, the painter of the Sower and the Angelus was taken straight from the sheepfolds.

His first teacher, Mouchel, was a very singular personage. He led the life of a hermit in a cottage outside the town, had a passion for animals, and spent hours with a pet pig whose language he pretended to understand. He painted altar-pieces which he gave to the churches of the villages round, and began large canvases which he never finished. But he had a sincere love of art and was a devoted admirer of Rembrandt and the Dutch masters. The best proof of his wisdom was the advice which he gave his new pupil:

"Draw what you like," he said to young Millet;

" choose anything of mine that you like to copy; follow your own inclination, and above all go to the Museum."

Millet followed this advice exactly. He spent some two months with Mouchel, copying engravings and drawing from casts, and then finding that his eccentric teacher gave him no further hints, set to work to copy pictures in the Museum at Cherbourg. The town gallery contained several good paintings by Dutch and Flemish masters, and during the time of his apprenticeship at Cherbourg Millet copied many of these, including a *Magdalen* by Van der Weyden, an *Entombment* by Van Mol, and the fragment of an *Assumption* by Philippe de Champagne. His own talent began to attract the attention of the leading citizens in Cherbourg. He entered the lists in a drawing competition and carried off the prize given by the Town Council. But when he had spent about a year in Cherbourg the course of his studies was rudely interrupted. He was at work in the picture gallery, when a servant arrived from Gruchy with the news of his father's sudden and dangerous illness. The young painter hurried home to find the parent he loved so well dying of brain fever. Jean Louis was already unconscious, but in his intervals of lucidity he recognised his beloved son, and would take no food or medicine saving from his hand. He repeatedly told him what great hopes he had formed of his future, and how much he wished to live to see him a famous artist. And once, a day or two before the end, he said with a sigh, " Ah ! François, I had hoped that we might one day have seen Rome together ! " He died on the 29th of November, 1835, leaving his whole family in tears, and François worn out with grief and weariness. His youngest child was only a year old at the time.

The care of the family and the management of the farm now devolved upon François. For a while he

D

struggled bravely to take his father's place, but he was
sick at heart and could not feel happy in the changed
and saddened home. And then, too, art had taken hold
of him and would not let him go back to the old life.
He had drunk of the waters of Castaly and could not
forget the taste of that enchanted stream.

His grandmother noticed the lad's restlessness and soon
discovered its cause. She remembered how anxious Jean
Louis had been about his son's future, and resolved that
no hindrance should be put in the boy's way. A message
reached Gruchy to the effect that the notables of Cher-
bourg hoped that he would persevere in his artistic career.
Commissions were promised him if he would return, and
an opening was offered him in the studio of the foremost
painter in the town, Langlois de Chèvreville. This de-
cided the brave old grandmother. The will of her dead
son was sacred, and must be followed.

" My François," she said, " we must bow to the will of
God. Your father, my Jean Louis, said you were to be
a painter. Obey him and go back to Cherbourg."

His mother was of the same mind, and Millet went
back to Cherbourg, to resume his artistic education early
in the spring of 1836. On the recommendation of the
Mayor, he was admitted into Langlois' studio, where he
worked assiduously during the next six months. His
new master had studied in Paris under Gros, and after
some years of travel in Greece and Italy had settled down
at Cherbourg, where he became professor of drawing at
the college, until his death in 1846. Like Mouchel, he
recognised Millet's talent at once, and saw that he could
teach him little. But he gave him drawings of Gros,
and copies of the Louvre pictures to study, and sent him
back to work in the Museum. There the young artist
made a finished drawing of a large *Adoration of the
Magi*, a picture six feet wide and eight feet high. He

also helped Langlois on two large altar-pieces which
he was painting in the Church of the Holy Trinity, and
tried his hand at portraits and designs of his own inven-
tion.

He spent his evenings in reading, and devoured all the
books which he could lay hands upon, from the *Almanach
boiteux* of Strasbourg to Paul de Koch's novels. A young
friend of his, M. Feuardent, who was, like himself, a
native of Gréville, and whose son afterwards married
Millet's eldest daughter, was at this time a clerk in a
library at Cherbourg. Through him Millet obtained
access to the chief libraries of the town and read
Homer and Shakespeare, Walter Scott and Byron,
Milton's Paradise Lost and Goethe's Faust, the ballads of
Schiller and the songs of Béranger. Among modern
French writers, Chateaubriand and Victor Hugo appealed
to him with especial force. In *Atala and René* he found
a regret for the past, a touching recollection of home
and family, and at the same time, a bitter sense of
the miseries of life, which expressed his own feelings,
while Victor Hugo's great poem-pictures of the sea and
sky stirred the depths of his soul. He often said that
these lines were as inspiring as the language of the old
Prophets, and wished that a collection of his poems
on nature could be placed in the hands of every child
in the national schools. Victor Hugo's description of the
awful grandeur of the sea recalled those terrible scenes
which he had witnessed on that All Saints' night at
Gréville, and he was often heard repeating aloud:

> " Oh ! combien de marins perdus dans les nuits noires !
> O flots, que vous savez de lugubres histoires !
> Flots cruels, redoutés des mères à genoux !
> Vous vous les racontez en montant les marées,
> Et c'est ce qui vous fait ces voix désespérées
> Que vous avez le soir, quand vous venez vers nous ! "

Milton was another poet who impressed him deeply, although he could only read his great epics in a French translation, as in later years he was to read Dante. Scott was another of his favourite authors, and of all the Waverley novels the one he read the most often was Redgauntlet. The weird figure of Wandering Willie, " born within the hearing of the roar of Solway, among the eternal sublimity of its rocky sea-shores and stormy waves," had the same fascination for him as it had for John Ruskin, with whom Millet had more than one point in common.

Langlois, meanwhile, watched his pupil's development " with the surprise of a hen who has hatched an eagle." He felt that this village genius deserved a wider sphere and larger opportunities than he could find in the narrow limits of a country town; and fired with the wish to send the young artist to Paris, he addressed the following petition to the Town Council of Cherbourg:

"August 19th, 1836.

" Gentlemen,—

"I have the honour to beg you to examine three drawings which I have placed in your Council Hall. Those drawings are the unassisted work of my pupil, François Millet, of the Commune of Gréville, and are the best proof of his decided taste for art, and rare talent. Many of you, gentlemen, are already acquainted with this young man. It was at your recommendation that he was placed under my charge. During the last six months his progress has been constant and rapid. In a few more days there will be nothing that I can tell him or show him. My pupil deserves a wider sphere than our town, and better schools and models than we can give him. In short, he requires the advantages of Paris, if he is to learn historical painting, to which high vocation he is doubtless called among the number of the *pauci electi*. But, alas! young Millet has no resources, excepting his religious tone of art, high character, and excellent education, together with the esteem in which his family is held.

" The son of a widow, he is the eldest of eight children under age, and his mother's farm barely suffices to maintain this numerous and honourable family, in spite of the most careful economy. This being the case, I beg of you, gentlemen, in the interest of my country, if not to adopt young Millet, at least to give him the present help which he needs, and to recommend him to the General Council of the Department, in order that he may obtain the favour of the Minister of the Interior during his studies in Paris, where I think he ought to be sent before the end of the year.

" Young Millet would require a sum of at least five or six hundred francs to begin his studies at Paris. But, gentlemen, you may be very sure, however little you may be able to do for him, your efforts will not fail to bear fruit, and the success of your *protégé* will eventually prove his claim to the protection of the Government.

" Allow me, gentlemen, for once, to lift the veil of the future, and to promise you a place in the memory of mankind, if you help in this manner to endow our country with another great man.

" Hoping that my petition will meet with a happy result, both for the sake of my pupil and my own, I beg you to believe in our thankfulness, and to remain assured that ingratitude is never found among those whose life is devoted to the study of Beauty and of Truth. I remain, gentlemen, with the highest and most profound consideration,

<div style="text-align:center">" Your devoted servant,</div>

<div style="text-align:center">" LANGLOIS."</div>

<div style="text-align:center">*Historical Painter and sometime Pensioner of l'École des
Beaux Arts in Greece and Italy.*</div>

The language of Langlois' request does credit to his generosity and foresight, although his pupil's fame was not to be won in the field of historic painting, which was in his eyes the only sphere worthy of the young artist's genius.

The Town Councillors of Cherbourg, to do them justice, met his proposal in the same generous spirit, and unanimously voted young Millet a grant of 600 francs. The

Council General of La Manche, to whom he was recom-
mended by the Mayor, was less liberal, and began by
refusing to give any help. This annoyed the Town
Councillors, who pointed out that after all Millet was not
a native of Cherbourg, and threatened to withdraw the
promised subsidy. After protracted discussions, in 1838,
the Council General of the Department agreed to give
the painter an allowance of 600 francs, and the Town
Council voted another 400 francs for his support. But
ten councillors voted against the grant, and the motion
would have been lost if it had not been for the courage
of Millet's constant friend the Mayor, who gave a casting
vote in his favour. The pension, however, was only once
paid in full. The following year it was reduced to 300
francs, and, at the end of two years, altogether withdrawn.

For the present, however, all was well. The first in-
stalment of the sum voted by the Town Council was paid
down in the following January, and Millet went home
to take leave of his friends before he started on his
journey to Paris. That moment was a memorable one
in the young artist's life. The step that he was about
to take seemed a very grave one in the eyes of the
whole village, most of all in those of his mother and
grandmother, who looked on Paris as another Babylon,
and feared to let their beloved child go forth alone to
face the corruptions of the great and wicked world. But
loyal to his dead father's wish, they brought out their
small store of carefully hoarded savings, and, with many
prayers and tears, sent him off on his journey.

"Remember the virtues of your ancestors," were his
grandmother's last words. "Remember how I promised,
at the baptismal font, that you would renounce the devil
and all his works, and know, my dear child, that I had
rather hear that you were dead than that you had been
unfaithful to the laws of God."

Millet's own heart was full, and he left home with strangely mingled feelings. He was sad at bidding farewell to home and friends, and he felt some remorse at leaving these poor women to struggle alone for their living. But he longed to see Paris, which in his eyes seemed the centre of the world, the El Dorado of his dreams. He was eager to learn his trade, and to become great and famous in his turn. Above all, he longed to see the old masters and the noble works of art of which he had heard so much. And with 600 francs in his pocket, he felt as if all the treasures of the *Arabian Nights* were his, and he had nothing to do but to follow in the path that led to fame and fortune.

"I thought all the time of my mother and grandmother, deprived of the help of my youth and strong arm. It gave me a pang to think of them left weak and failing at home, when I might have been the staff of their old age ; but their hearts were too full of motherly love for them to allow me to give up my profession for their sakes. And then youth has not all the sensitiveness of riper years, and a demon within seemed to push me towards Paris. I was ambitious to see and learn all that a painter ought to know. My Cherbourg masters had not spoilt me in this respect during my apprenticeship. Paris seemed to me the centre of knowledge, and a museum of all great works.

"I started with my heart very full, and all that I saw on the road and in Paris itself made me still sadder. The wide straight roads, the long lines of trees, the flat plains, the rich grass-pastures filled with cattle, seemed to me more like stage decorations than actual nature. And then Paris—black, muddy, smoky Paris— made the most painful and discouraging impression upon me. It was on a snowy Saturday evening in January that I arrived there. The light of the street lamps was almost extinguished by the fog. The immense crowd of horses and carriages crossing and pushing each other, the narrow streets, the air and smell of Paris seemed to choke my head and heart, and almost stifled me. I was seized with an uncontrollable fit of sobbing. I tried to get the better of my feelings, but they were too strong for me, and I could only

stop my tears by bathing my face with water at a fountain in the street. The sensation of freshness revived my courage. I stopped before a print-seller's window and looked at his pictures, while I munched my last Gruchy apple. The plates which I saw did not please me : there were groups of half-naked *grisettes*, women bathing and dressing, such as Devéria and Maurin then drew, and, in my eyes, seemed only fit for milliners' and perfumers' advertisements.

"Paris appeared to me dismal and insipid. I went to an *hôtel garni*, where I spent my first night in one continual nightmare. I saw again my native village, and our house, looking very sad and lonely. I saw my grandmother, mother and sister, sitting there spinning, weeping, and thinking of me, and praying that I might escape from the perdition of Paris. Then the old demon appeared again, and showed me a vision of magnificent pictures so beautiful and dazzling that they seemed to glow with heavenly splendour, and finally melt away in a celestial cloud.

"But my awakening was more earthly. My room was a dark and suffocating hole. I got up and rushed out into the air. The light had come back and with it my calmness and force of will. But the sadness remained, and the words of Job rose to my lips : '*Let the day perish wherein I was born and the night in which it was said, There is a man-child conceived.*'"

PART II

PARIS

" L'Art n'est pas une partie de plaisir. C'est un combat, un engrenage qui broie. . . . Je ne suis pas un philosophe, je ne veux pas supprimer la douleur, ni trouver une formule qui me rende stoïque et indifférent. La douleur est, peut-être, ce qui fait le plus fortement exprimer les artistes."

—J. F. MILLET.

I

THERE is an interesting portrait of Millet at this period of his life which gives us a good idea of the young painter when, at the age of twenty-two, he came to Paris, on the 31st of January, 1837. The young artist is represented in a white blouse, holding a small pipe in his hand. His long black locks fall in thick waves about his temples and on his neck. The large brown eyes are full of poetry and tenderness. The features are delicate and refined; the expression grave and thoughtful; but the broad forehead and square jaw already give signs of a power which time was to develop more fully. It is impossible to look at this portrait without recalling the words of the good priest of Gréville : " Ah ! my poor child, you do not know how much you will have to suffer ! " Certainly this gentle and dreamy youth was little fitted to make his way alone in the world, in a great and crowded city, where he was a complete stranger. The very sight of the crowded streets and hurrying throng of men, the noise and bustle, bewildered him, while the dirt and misery he saw oppressed his soul with melancholy. No wonder his heart sank within him, and he pined for the pure air and green fields of his home, for the familiar faces and kindly words which used to meet him at every step ! He was the most unpractical of men, unable to cast up the simplest sum, and altogether ignorant of the ways of the world. And to make matters worse, he was proud and sensitive to a fault.

He shrank from intercourse with strangers, had a horror
of being patronised, and was so shy and awkward that
he did not dare to ask his way in the streets for fear of
being laughed at. His first impression of Paris had been
a disagreeable one, but his dislike of his new surround-
ings had been tempered by wonder and curiosity.

"So I greeted Paris," he writes, "not with curses, but with a
terror that arose from my incapacity to understand its material or
spiritual life, and at the same time with a great wish and longing
to see the pictures of those famous masters, of whom I had heard
so much and seen, as yet, so little."

But as he became familiar with Paris life, its atmo-
sphere grew more and more distasteful to him. This
serious and earnest young thinker, brought up by God-
fearing parents in his country home, accustomed to soli-
tary communings with nature under the starlit sky and
by the wild seashore, and fed upon the Bible and writers
of Port Royal, looked with instinctive horror at the
licence and affectation of Parisian art. This reader of
Virgil and Milton, whose whole soul worshipped truth,
and whose natural taste led him to all that was sublime
and heroic, recoiled from the brilliant emptiness and
theatrical display of the romantic painters. He turned
away with sickening disgust alike from the trivialities
of contemporary art, and from the painted faces which
he met in the streets. As ill-luck would have it, his first
experience of lodgings and landladies proved singularly
unfortunate. Yet his Cherbourg friends had done their
best to help their young countryman, and had supplied
him with letters of introduction which ought to have
been of use. But by his own account, it must be con-
fessed, he threw away more than one opportunity.

First of all, he presented himself at the door of a
maker of fans, who offered to take him *en pension*, but

the conditions which he made did not meet with Millet's views, and he declined his proposals rather than submit to any restriction on his freedom. Monsieur L——, to whom he next addressed himself, seemed to him a grave and sensible man; and since he made no tiresome conditions, Millet entered his house as a lodger, and was given a clean little room on the fifth floor, looking out on the roofs and chimneys of an inner court. But Monsieur L—— had a wife—a contingency for which Millet had not bargained—who certainly managed to make things very disagreeable for her lodger. The following graphic account of his experiences in her household was dictated by him to his biographer:

"When I found myself in this little attic, with its marble chimney-piece and narrow window, I began to realize the cramped and dreary life of Paris, and I went to bed full of regret for my country home, where air and light and space were given without measure. Yet I managed to sleep. The next morning the maid told me *déjeuner* was served. I went down, and in a room covered with oil-cloth squares, as smooth and polished as ice, I found a table also covered with oil-cloth, on which my breakfast was laid. This consisted of a portion of *fromage de Brie*, a roll, a few walnuts, and quarter of a bottle of wine. It seemed to me a meal hardly fit for a child. I was hungry enough to eat it all, but I thought to myself, 'If I leave nothing on my plate, I shall be looked upon as an ill-bred glutton; but if I am content with half rations, I shall die of hunger.' But in the end regard for my reputation prevailed over my good appetite, and I went out famished. As this Carthusian meal was repeated every morning, I was always famished, and could only appease the pangs of hunger by going to dine in the streets with a cab-driver who had recognised me as a fellow-countryman, and had taken me with him into a wine-shop.

"I soon found that life at Monsieur L——'s was very difficult. Madame L—— was an ill-tempered woman, who was never tired of trying to induce me to go with her to see the fine sights of Paris, the gay ballet-dancers and students' balls. She reproached

me constantly for my clumsy manners and shyness; this made me uncomfortable in the house, and I was only happy on the quays. One day I went to the Chaumière, but the dances of that rollicking company disgusted me. Of the two, I certainly preferred the boisterous joy of our country-folk, and of the tipsy fellows at home.

"In the evening I returned to my cold and bare garret, and the next morning I went back to the Louvre. On arriving from Cherbourg, I had given Madame L—— charge of the box that held my clothes, together with my few hundreds of francs. At the end of a month, I found that I had spent about fifty francs in dinners and prints; so one morning I asked Madame L—— to let me have five francs. She replied by making a terrible scene, and told me that if our accounts were made up I should certainly be in her debt, and that the services which she and her husband had rendered me greatly exceeded the sum which I had placed in her hands. 'I am well aware that I owe *Monsieur L*—— a great deal,' was the reply which I ventured to make, 'but a debt of that kind is not paid in money.' And I then threw down the five francs which she had brought me on the table, saying, 'At least now we are quits, madame.' That day I left the house with nothing but the clothes which I wore on my back, and thirty sous in my pocket. For the next three days I took shelter in a working man's lodging, where they gave me credit, but I had to take care that my meals did not exceed my unfortunate thirty sous. I expected Monsieur L—— to come and give me an explanation. He did send me a letter, in which he said that he much regretted to hear what had happened, but that after this, I must understand that he could not ask me to return; he would not, however, cease to regard me with esteem, and hoped to see me still and to indemnify me for the loss which I had suffered owing to his wife's injustice. At his request I went to see him at his office. He renewed his protestations, but gave me nothing; his wife was the mistress, and he himself was powerless. But three months afterwards, he did pay my lodging —a sum of about fifty francs. After this Madame L——, hearing that I went to see her husband, desired him to have nothing more to do with me. He obeyed very reluctantly, and begged me to give up my visits in order not to displease his wife. That was all the help and protection I got from Monsieur L——; but some time afterwards he was seized with remorse. A year later I fell ill, and was

at death's door. A violent fever deprived me of consciousness, and I lay in a profound lethargy for twenty-one days. When I woke, I found myself lying in bed in the country, under the trees, and surrounded by strangers. By degrees my senses returned, and I slowly recovered strength. I found that I was staying with a friend of Monsieur L——, who had removed me to Herblay, near Montmorency. I was well nursed there. It was in June, at haymaking time, and the first day that I took a walk in the garden I tried to mow the grass, but fell down in a fainting fit. This weakness troubled me greatly. I felt that I was no longer fit to be a country labourer, and the thought was very humiliating. I hurried indoors, overcome with grief, but in a few weeks I became quite well. It was Monsieur L—— who did me this service. How and wherefore, I do not know to this day, for I never saw him again.

"I often tried to account for Madame L——'s strange conduct and her violent passion, but I never could succeed. At length, one day, I met her servant, and this is what he said to me : ' Ah ! monsieur, you were too innocent ! You did not see what was happening. Madame is always reading bad books. Her occupations are strange, indeed, for a lady. I used to find *Faublas* and other novels by her bedside. And,' he added with a laugh, ' perhaps you disturbed her readings ! ' "

The man's remark opened Millet's eyes. He understood that, " like Joseph, he had met with Potiphar's wife at the opening of his career."

One of his Cherbourg friends, probably his master, Langlois, had given him a recommendation to M. George, an official of the Luxembourg Gallery. Millet called at his house the first week that he was in Paris and delivered the letter. M. George received him kindly, and asked what he could do for him, upon which Millet unrolled the large cartoon which he had copied from Jordaens' picture at Cherbourg. George showed it with an expression of surprise to some other artists who were with him, and one of them exclaimed : " We did not know there was any one in the provinces who could draw as well ! " M. George proceeded to offer to introduce Millet

to other artists, and said he would show him the picture galleries, and help him to enter the École des Beaux Arts.

" You must go in for the competitions," he said kindly, " and at this pace you will soon succeed."

Millet thanked him and wished him good-morning, leaving his drawing in M. George's hands. He intended to return and avail himself of the professor's kind offers. But then he remembered what he had heard of the École des Beaux Arts, of the competitions there, and of the regular course required of students who entered the school. The prospect alarmed him not a little. He shrank from the prospect of the constraint which would be imposed upon him, and from the thought of entering the lists with strangers who were far cleverer and quicker than himself. M. George's very kindness frightened him. He felt afraid of incurring obligations which he could not discharge, and made up his mind that he would not call upon him again. He did not even attempt to recover his cartoon, which, however, was returned to him some weeks later.

Langlois had advised his pupil to enter the *atelier* of Paul Delaroche, at that time the foremost of the Romantic school of painters, and, as Millet found, the most popular master in Paris. But what he saw and heard of Delaroche's art did not encourage him to approach him, and some weeks passed before he could bring himself to take the final step. Meanwhile, he had already found his way to the Louvre, and thus describes his first visit to the old masters which he had longed to see :

" During the first days after my arrival in Paris, my fixed idea was to find out the gallery of old masters. I started early one morning with this intention, but as I did not dare ask my way, for fear of being laughed at, I wandered at random through the streets, hoping, I suppose, that the Musée would come to meet me ! I lost myself

several days running in this fruitless search. During my wanderings one day I came across Nôtre Dame for the first time. It seemed to me less fine than the Cathedral of Coutances. I thought the Luxembourg a fine palace, but too regularly beautiful—the work, as it were, of a coquettish and mediocre builder. At length, I hardly know how, I found myself on the Pont Neuf, where I saw a magnificent pile, which, from the descriptions which had been given me, I supposed must be the Louvre. Without delay I turned my steps there and climbed the great staircase with a beating heart and the hurried steps of a man who feels that the one great wish of his life is about to be fulfilled. My hopes were not disappointed. I seemed to find myself in a world of friends, in the midst of my own kinsfolk. My dreams were at length realized. For the next month the old masters were my only occupation in the day-time. I devoured them all: I studied them, analysed them, and came back to them continually. The Primitives attracted me by their admirable expression of sweetness, holiness, and fervour. The great Italians fascinated me by their mastery and charm of composition. There were moments when the arrows of *St. Sebastian* seemed to pierce me, as I looked at the martyr of Mantegna. The masters of that age have an incomparable power. They make you feel in turn the joys and the pains which thrill their souls. But when I saw that drawing of Michelangelo's representing a man in a swoon, I felt *that* was a different thing. The expression of the relaxed muscles, the planes, and the modelling of that form exhausted by physical suffering gave me a whole series of impressions. I felt as if tormented by the same pains. I had compassion upon him. I suffered in his body, with his limbs. I saw that the man who had done this was able, in a single figure, to represent all the good and evil of humanity. It was Michelangelo! That explains all. I had already seen some bad engravings of his work at Cherbourg; but here I touched the heart and heard the voice of him who has haunted me with such power during my whole life."

The words of the young French artist are curiously similar to those in which Mr. Ruskin speaks of Michelangelo on his first visit to Florence, in 1840: "I saw at once in him that there was emotion and human life more than in the Greeks, and a severity and meaning which were not in Rubens."

E

"After that," Millet continues, "I went to the Luxembourg, but, with the exception of Delacroix's pictures, which struck me as great, alike in gesture, in invention and richness of colour, I saw nothing remarkable. The figures were like waxwork, the costumes conventional, and both invention and expression dreary in the extreme.

"There I saw the *Elizabeth* and *Les Enfants d'Edouard* of Delaroche. I had been advised to go to Delaroche's studio; but none of those pictures gave me the least wish to become his pupil. I could see nothing in them but cheap illustrations on a large scale, and theatrical effects. There was no genuine emotion; nothing but posing and stage-scenes. The Luxembourg first gave me a strong dislike to the theatre; and, although I was not insensible to the famous dramas which were to be seen in Paris, I must say that I have always retained an invincible feeling of repulsion for the exaggerations, falseness and grimaces of actors and actresses. Since those days, I have seen something of people of this sort in private life, and I am convinced that by constantly trying to put themselves into the place of others they lose the sense of their own personality, and can only speak in the character of the parts they play. So in the end they become deprived of truth and common sense, and lose the simple sentiment of plastic art. It seems to me, that if your art is to be true and natural, you must avoid the theatre.

"There were moments when I had a great wish to leave Paris and to return to my own village, so tired was I of the lonely life that I led. I saw no one; I did not speak to a soul, and I hardly dared ask a question of any one, so great was my fear of ridicule, and yet people never troubled themselves about me. I had the awkwardness which I have never lost, and which still distresses me when I am obliged to speak to a stranger, or make the simplest inquiry. I had a great mind to walk my ninety leagues at a stretch, like my Uncle Jumelin, and say to my family, 'I have come home, and have given up painting.' But the Louvre had taken hold of me. I went back there and felt comforted. Fra Angelico filled my soul with heavenly visions, and when I was alone in my garret I thought of nothing but those gentle masters who painted human beings so full of fervour that they become beautiful, and so nobly beautiful that we feel they must be good. People have said that I was very fond of the eighteenth century masters because at one time I painted *pastiches* à la Boucher, or Watteau. It is a mistake. My taste in this respect has never changed. I have always had a

very strong dislike to Boucher. I saw all his skill and talent, but I could not understand his choice of subjects, or look at his miserable women without feeling what a poor kind of nature he chose to represent. Boucher did not paint naked women, but little undressed creatures. It was not the lavish display of Titian's women, proud of their beauty and revealing their charms in the confidence of their power. There is nothing to say against that kind of art. It is not chaste, but it is strong and great by virtue of its womanly power of attraction. That is great and good art. But these poor ladies of Boucher, with their slim legs, their feet crushed in high-heeled shoes, their tight-laced waists, their useless hands and bloodless necks, repelled me. When I stood before Boucher's *Diane*, which was always being copied in the Louvre, I recalled the *marquises* of his day, whom he painted from no very worthy motive, and whom he undressed and placed in graceful poses in the studio, which he afterwards transformed into a landscape. From this *Diane* I turned back to the *Diane Chasseresse* of the Greeks, so beautiful and noble in her perfect form. Boucher, after all, was merely a seducer.

"Nor was Watteau the man for me. He was not an artist of Boucher's stamp, but his theatrical little world distressed me. Of course, I saw all the charm of his palette, and the delicacy of his expression, even the melancholy of these little actors who are condemned to smile. But the idea of *marionettes* always came back to my mind when I looked at his pictures, and I used to say to myself that all this little troupe would go back to their box when the spectacle was over, and lament their cruel destiny.

"I preferred Lesueur, Lebrun and Jouvenet, because they seemed to me very powerful. Lesueur made a deep impression upon me, and I think he is one of the great souls of our School, as Poussin is its prophet, sage, and philosopher, and at the same time the most eloquent exponent. I could spend my life before Poussin's works, without ever getting tired of him.

"So I lived in the Louvre, in the Spanish Museum, the Musée Standish, or among the drawings, and my attention was always fixed upon those canvases, where thought was expressed truthfully and forcibly. I liked Murillo's portraits, Ribera's *Saint Barthélemy* and *Centaurs*; I liked everything that was strong, and would have given all Boucher's works for one nude figure by Rubens. Rembrandt I only learned to know later. He did not repel me, but he blinded me. It seemed to me that it would be necessary to go

through a course of serious study before you could enter thoroughly into the genius of this man. I only knew Velasquez, who is held in such high repute to-day, through his *Infanta* in the Louvre. He is certainly a painter of high degree and of the purest race, but his compositions seem to me poor. *Apollo and Vulcan* is weak in point of invention, his *Winders* are not winding anything; but as a painter he is no doubt strong.

" I never tried to copy any of these masters. It seemed to me that any copy of them would be a failure, and must want the spontaneous charm and fire of the original. But, on one occasion, I spent the whole day before Giorgione's *Concert Champêtre*—I was never tired of that. It was already past three o'clock when I took up a small canvas belonging to a comrade, and began to make a sketch of the picture. Four o'clock struck, and the terrible *on ferme* of the keepers turned me out; but I had succeeded in making a sketch sufficiently good to please me as much as a run into the country. Giorgione's landscape had given me the key of the fields, and I had found consolation in his company. After that I never tried to make copies, even of my own pictures. The fact is, I am incapable of doing that kind of thing.

" Next to Michelangelo and Poussin, I have always loved the early masters best, and have kept my first admiration for those subjects as simple as childhood, for those unconscious expressions, for those beings who say nothing, but feel themselves overburdened with life, who suffer patiently without a cry or complaint, who endure the laws of humanity, and without even a thought of asking what it all means. These men never tried to set up a revolutionary art, as they do in our days."

These reflections reveal the character of the man, and help us to understand his dislike of Paris, a feeling which lasted to the end of his life. His own passionate sincerity, and habit of seeking after essential truth, made him hate all artificial conventions, and look with positive aversion on every form of theatrical display. But all great and serious art had for him an indescribable fascination. In the old Florentines he discovered at once kindred spirits, men of his own flesh and blood. These radiant saints with parted lips and upturned eyes, these visions of the flowery

meadows of Paradise, spoke to him in the language which he had learnt at his grandmother's knee; they were inspired by the same simple and ardent faith, the same lofty hopes. From the elegant trivialities of the eighteenth century he turned with relief to the perfect forms and noble purity of classic art, to the Diana of the Louvre and the Venus of Milo, and to the Achilles, which seemed to him the ideal of manly grace and beauty. Among French artists, Poussin and, curiously enough, Lesueur, whose long series of monotonous works have little interest for most of us, were his favourites. For Poussin's work especially he had the deepest admiration, and was never tired of dwelling on his lofty intention and grandeur of composition. Even Titian and Rubens appealed to him more than Watteau and Boucher. Among contemporary painters Delacroix alone impressed him. Rembrandt, he owned, took him by storm. He bowed to his greatness, although as yet he could hardly grasp all his meaning. But Giorgione charmed him with the poetry of his invention, with his green pastures and running waters; and in Michelangelo he found a consummate rendering of profound emotion and deep meaning beyond all that he had ever dreamt. In him he recognised at once the guide and master whom he sought, whose presence was to follow him to the end of his days—" *Celui qui me hanta toute ma vie.*"

He no longer tried to copy these masters, he lived with them. He spent his days in the Louvre, and his evenings reading Vasari in the library of Sainte Géneviève. He studied the drawings of Lionardo and Albert Dürer, the designs of Jean Cousin and Nicolas Poussin. Above all, he learnt all that he could discover about Michelangelo, and was never tired of studying the life of the great Florentine, whose work remained for him the highest expression of art.

II

THE choice of a master now became a necessity if the young student was to learn his trade. For some time Millet wavered. The names of the leading Paris masters were unknown to him. He had not even seen a single work by Ingres. Delaroche was the only master whom he knew by reputation, and his pictures did not by any means attract him. At length, however, after spending some weeks in daily visits to the Louvre, and in reading Vasari in the library of Sainte Géneviève, he determined to take the final plunge.

" I had," he writes, "a great fear of this unknown teacher, and I put off the evil day as long as possible. But one morning I rose with my mind made up and determined to venture all. To put it briefly, I obtained admission to the *atelier* of Paul Delaroche, the painter who was generally recognised as foremost among living artists. I entered his studio with a shiver—this world was so new to me; but by degrees I became used to it, and in the end I was not altogether unhappy there. I found some kindly souls, but a style of wit and manner of speech which in my ears sounded a tedious and incomprehensible jargon. The famous puns of Delaroche's *atelier* were the rage of the student-world. Everything was discussed there—even politics ; and I could not endure to hear them chatter about the ' phalanstery ' ! But at last I began to take root, and to feel a little less home-sick."

If the young men of Delaroche's studio astonished Millet, he on his part puzzled his new comrades not a little. They knew not what to make of this strange,

silent, country lad, with his Herculean frame and his
solemn face. They nicknamed him "Jupiter in *Sabots*,"
and "The Wild Man of the Woods." But he spoke seldom,
and seemed to heed their gibes as little as he did his
teacher's praise. Once, when the mockers went too far
in their rough pleasantry, Millet clenched his fists—a
threat which had the effect of quickly silencing the
offenders, and after that he was left in peace. One or
two of his comrades made friends with him, but for the
most part they looked upon him as an eccentric indi-
vidual, who dared to set up his opinion against the laws
of academic art, and refused to join in the universal
worship of their master's style.

Meanwhile, the originality of his studies, and his
vigorous drawing, had already attracted Delaroche's notice.
He looked for a long time at Millet's first drawing—a
sketch of the statue of Germanicus, which was regularly
copied once a fortnight by the students—and said:

"You are a new comer? Well, all I can say is, you
know too much already, and yet not enough."

Another master, Couture, who directed studies from
the undraped model, paused with a look of surprise before
Millet's first drawing, and said:

"*Holà, nouveau!* Do you know that your figure is
very good?"

He had hardly touched a brush; but the first day that
he painted a figure from a model Delaroche said to him:

"I can see that you have painted a good deal."

"And yet," Millet observes, "I had only tried to ex-
press as strongly as possible the joints and the muscles,
without troubling myself with the new medium of colour
to which I was so little accustomed."

After that he was treated with more respect by his
fellow-students, although there were still some among
them who declared that Millet's figures were insolently

true to nature; and one gay youth, who prided himself
on being a pet of the master, was never tired of teasing
him about his country origin. "Are you going to give
us some more of your famous figures—some more men
and women after your fashion?" he would say. "You
know the patron does not care for your dishes à la
mode de Caen?"

To which Millet replied, "What do I care for that?
I did not come here to please any one; I came here to
learn drawing from antiques and models, and for no
other purpose. Do I trouble my head about your butter-
and-honey dolls?"

Delaroche himself could not understand this strange
pupil. Millet puzzled him, as he had puzzled both his
earlier teachers. He would have liked to employ him
as his assistant in the great works upon which he was
engaged, but Millet was of too independent a nature to
allow himself to be dragged at the chariot-wheels of a
painter whom he despised. Sometimes the master held
up his work as an example to the whole *atelier*; at other
times he criticised it severely. One day he said that he
needed a rod of iron to train him in the right methods;
another, he turned to him with the words: "Well, go
your own way; you are so new that I have nothing to
say to you."

On one occasion "Prometheus Chained to the Rock"
was the subject given for composition. Millet represented
him as the victim of the wrath of Jupiter, hanging on
the edge of an abyss, and uttering a cry of revolt against
the heavenly powers. "I should like to make others
feel that his sufferings are eternal," he said, as the
students pressed around to gaze at this figure which took
their breath away. "Æolus Letting the Winds Loose"
was the subject of another striking composition. "There
goes Millet, as usual," cried a jeering comrade, "doing

what he thinks *chic*, and inventing muscles out of his own head!"

But Delaroche, who entered the *atelier* at that moment, interrupted him. "He is right," he said, pointing to Millet. "He paints from memory, and makes good use of his recollections. Do as he does, if you can."

Besides his studies at Delaroche's *atelier*, Millet worked hard in the wretched garret where he lodged, on the Quai Malaquais. He painted portraits of his neighbours for a few francs each. Porters and maidservants, coal-carriers, and on one occasion a daughter of his old friend the *concierge* at Monsieur L——, all sat to him in turn. But he was often at his wits' end for money, and at one time he had to give up going to Delaroche's *atelier* for want of means to pay the yearly fee of 100 francs. The master missed him from his accustomed place, and sent him word to come and see him. Millet obeyed the summons, and found Delaroche at work on his great fresco of the *Hémicycle*, in the hall of l'École des Beaux Arts.

"Why do you never come to the *atelier* now?" the painter asked in a friendly tone, offering him a cigarette as he spoke.

"Because, sir, I am unable to pay the fees," replied Millet.

"Never mind that!" replied Delaroche. "I do not wish you to leave. Come all the same, and I will speak to Poisson (the porter of the studio). Only say nothing about it to the other fellows, and draw just what you like—big subjects, figures, studies, whatever you fancy. I like to see your work; you are not like the rest of them; and then I wish to speak to you about some work in which you can be of use to me."

Millet was touched by this unexpected kindness on the painter's part, and went back to the *atelier*. But the historical compositions in academic style that were then

in fashion seemed to him every day more wearisome.
An artist of his power could not fail to produce striking
work; but in the conventional figures and heavy, sombre
colouring of Millet's compositions at that period, it was
difficult to discern the germ of his future greatness.
Still he persevered, and in the summer of 1838, he entered
the lists for the Prix de Rome. The originality of his
composition attracted Delaroche's notice, and pricked the
master's conscience, for he had already promised to use
his interest on behalf of one of his favourite pupils—a
student named Roux; so he sent for Millet, and said to
him:

"You wish to win the Prix de Rome?"

"Certainly," replied Millet, "or I should not have
entered my name."

"Your composition is very good," said Delaroche;
"but I must tell you that I am anxious to see Roux
nominated this time. Next year I will promise to use
all my influence on your behalf."

This frank declaration was enough for Millet. He left
Delaroche's *atelier* for good, and determined never again
to look to others for help or advancement, but to rely
solely upon his own efforts.

He always declared afterwards that he had learnt
little or nothing from Delaroche. No doubt the instruc-
tion which he received there, and the tendencies of the
place, were alike contrary to the natural bent of his
genius.

"I came to Paris," he said in later years, "with my
ideas upon art already formed, and I found nothing there
to make me change my mind. I have been more or less
attracted by different masters and methods, but I have
never altered my idea of the fundamental principles of
art as I learnt them first in my old home, without teacher
or models."

None the less, he had found in Paris exactly the training which he required. Genius has a marvellous power of assimilation, and discovers the food needed for its development in waste places and barren ground. Even the months that Millet spent in Delaroche's *atelier*, working on the academic designs which his soul abhorred, were not thrown away. He learnt that thorough mastery of means which was to stand him in good stead hereafter, and acquired that knowledge of the human frame which practice alone can give. He learnt, too, how to reject the evil and to choose the good, and went on his way with his hatred of convention and artifice and passionate love of sincerity more deeply rooted than ever.

During the next two years he still worked diligently at the academies of models kept by Suisse and Boudin, and drew both from the antique and from living models. He had made friends with one of the students in Delaroche's *atelier*, named Louis Marolle, the son of a polish manufacturer, whose parents were in easy circumstances, and who did not depend entirely upon painting for his bread. Marolle, himself a clever and cultivated youth, was early struck by Millet's powers of brain and independence of character. "It seems to me that with a little practice," Millet said to him one day, "you and I would soon know as much as any of our teachers."

So they settled together in a little *atelier* of their own, No. 13, Rue de l'Est, at the corner of the Rue d'Enfer and the Rue Val-de-Grâce. There they painted portraits, and quarrelled over the books they read, and led a free Bohemian life, and were neither dull nor yet unhappy. Millet's new friend was in many respects curiously unlike himself. Marolle was a thorough Parisian, who admired the Romantic schools in poetry as well as in painting, declaimed Alfred de Musset's verses at all hours of the day, and tried to write poems of his own

in the same style. Millet, on the contrary, had little
sympathy with Musset, and criticised the tendencies of
his art severely. "He puts you into a fever, it is true,"
he said to Marolle; "but he can do nothing more for
you. He has undoubted charms, but his taste is capri-
cious and poisoned. All he can do is to disenchant and
corrupt you, and at the end leave you in despair. The
fever passes, and you are left without strength––like a
convalescent who is in need of fresh air, of the sunshine,
and of the stars." And he bade his friend go back to
nature and to reason—to those great poets of old, who
had fathomed the deep things of life—to Homer and
Virgil; above all, to the Bible which still remained in
his eyes the book of all books, where the artist will find
the most pathetic of pictures, painted in the noblest
words.

Marolle listened with a smile, and shrugged his shoul-
ders. And yet at times a conviction would cross his mind
that his peasant-friend might be right, and that this,
after all, might be the more excellent way. He himself
tried his hand in turn at water-colours and oils; he en-
graved plates, and wrote verses, but seldom achieved
any serious work ; and there were moments when he
was half inclined to envy his companion, and would say
to Millet:

"You think that I am a lucky man because I need
not earn my bread; but it is you who are really the
fortunate one! You have kept your first impressions of
nature, and the deep emotions of youth. I have never
felt anything, or cared for anything, except the Faubourg
Saint-Marceau!"

At the same time, Marolle's practical turn of mind
made him of great use to Millet. He accompanied him
on his nightly visits to the library of Sainte Géneviève;
he asked for the books which Millet wanted, helped him

in his researches, and became, in fact, the link between
the shy, reserved student and the outer world. Through
Marolle, Millet learnt to know other artists, to look more
kindly upon the world in general, and to take a more
cheerful and hopeful view of the future. Without the
help of this true and loyal friend his courage might
have failed him in the hard battle which he had to fight
during these long and lonely years.

In 1839, his Cherbourg pension had been withdrawn,
and his mother and grandmother could ill afford to help
him. Under these circumstances he consulted Marolle as
to the best means of earning a livelihood, and proposed
to paint a series of peasant-subjects.

"Supposing I were to draw figures of men at work
in the fields?" he said—"a man mowing or making
hay, for instance? The action is fine."

"Yes," replied Marolle, "but you will never sell
them."

"What do you say to pictures of fauns and nymphs
—woodland scenes?" said Millet.

"Who do you think has ever heard of a faun in
Paris?" returned Marolle.

"Well, then," said Millet gloomily, "what would you
have me do? Tell me, for I am at my wits' end."

"Boucher and Watteau are popular," said Marolle;
"coloured illustrations of nude women, for instance. Do
some *pastiches* in that style."

Millet shook his head. Such subjects were little to his
taste. As a last resource he painted a little picture of
Charity Feeding her Children, and took it himself to the
dealers. It was in vain. No one would offer him a single
franc for his picture. He brought it home sadly, and
said to Marolle:

"You were right. Tell me what subjects to choose,
and I will paint them."

And so the future painter of the *Sower* was driven by sheer necessity to compose little pastels in the style of Watteau and Boucher, to which Marolle gave names of his own invention, such as *A Music Lesson, The Old Man's Calendar, A Girl reading a Novel, A Soldier making Love to a Nurserymaid, A Day at Trianon.* Now and then Millet would attempt a Bible subject—*Ruth and Boaz in the Harvest Field,* or *Jacob in Laban's Tents*—but they seldom met with success. Marolle would himself take his friend's pastels to the shops, and do his best to sell them. When everything else failed, Millet painted portraits for five or ten francs, and as soon as the money was paid down hastened to get a meal at the nearest restaurant. In those days he breakfasted on a roll and a glass of water, and as often as not had to go without his dinner; but he never complained, and never begged. And on the rare days when fortune smiled upon him, and he sold a pastel for 20 francs, he threw up his cap, and rejoiced to think the day was coming when he would be free to go back to the impressions of his youth, and to paint pictures of Gréville and of peasant life.

III

ART was at a low ebb when Millet came to Paris some fifty years ago. The jury of the Salons was not elected by the artists themselves, but was an official body which held tyrannical sway over the progress of painters, and closed the doors upon all who ventured to depart from the most rigid academic rules. " In the École des Beaux Arts," wrote Thackeray in 1838, " all is classical: Orestes pursued by every variety of Furies; numbers of wolf-sucking Romuluses; Hectors and Andromaches in a complication of parting embraces." The gallant effort made by the men of 1830, with Rousseau, " the apostle of truth in landscape," at their head, had been apparently crushed. In 1835 the works of Delacroix, of Decamps and Corot, as well as two of Rousseau's finest paintings, were all rejected. For the next thirteen years the doors of the Salon were closed upon the last-named painter, and the systematic exclusion of his landscapes won for him the name of " le Grand Refusé." In the words of a well-known critic, M. Edmond About, " His incontestable talent was contested by every body."

The moment was an unfortunate one for an unknown artist to make his appearance, but Millet ventured to send two portraits to the Salon of 1840. One, a likeness of his friend Marolle, was rejected. The other, a portrait of a Cherbourg friend, Monsieur L. F——, in the artist's own opinion the poorer of the two, was accepted. With this portrait, painted in the dull and heavy tones which the

young artist had acquired in Delaroche's studio, Jean
François Millet made his first appearance in public. It
was a proud day for the painter of five-and-twenty, and
when he went home that summer, his mother and grand-
mother told him how they had read his name in the Cher-
bourg papers, and looked upon him as a hero. Ever since
he had left home three years before, they had followed his
steps anxiously, and watched eagerly for each post which
brought news of their absent boy. His young brother,
Pierre, remembers still the grief with which the whole
family heard of François' illness, and the impatience with
which each post was awaited. And now he was with them
again, unchanged and unspoilt, the same François that he
had been of old, wearing his old blouse and sabots, and
with his long wavy hair falling on his shoulders. His
mother, to tell the truth, would have liked to see him
dressed "like a gentleman," in his Paris clothes, and com-
plained of his rustic appearance, but nothing gave him
greater pleasure than to feel himself a peasant again. He
liked to join the labourers at work, to reap the corn and
bind the sheaves and share their brown bread and cider.
He helped in building a wall, and said, as he handled the
mortar and plaster, that if he had not become an artist
he should certainly have been a mason. Above all, he
loved to sit by the open hearth watching the wood fire
crackle and blaze in the great chimney corner, and seeing
its flames reflected in the brass jugs and pails on the shelves
around the room, and the flower-painted china which was
his mother's pride.

The sight of these familiar scenes and the joy of set-
ting his foot once more on his native heath made Millet
seriously think of settling in the neighbourhood, and, if
possible, obtain work at Cherbourg. He spent several
weeks at Gruchy, painting portraits of his friends and
relatives, amongst others, of Monsieur and Madame Feu-

ardent and their brothers, of a Doctor Simon, at Vauville, and of an old maidservant who lived in the family of an Eculleville doctor called Asselin. The portrait of this old countrywoman, *La Vieille Fanchon*, excited great admiration, and was the first revelation of Millet's power in bringing out the character and habits of the peasant race which he understood so well. But he bestowed even greater pains and thought on another portrait, that of his grandmother, which he painted about this time. " I want to show her soul," he said. This portrait is still in the possession of his younger brother, Jean Louis, who owns a farm near Gréville. Another life-size drawing of his grandmother, the one which Sensier describes as showing her strong character and austere religious spirit, has passed into the hands of a branch of the family residing at Les Prieux, a village in the neighbourhood of Gréville. At his mother's suggestion he also painted portraits, on oiled paper, of his seven brothers and sisters, which have unfortunately perished. Early in 1841, Millet took up his abode at Cherbourg, where he spent several months studying in the Museum and painting portraits of his friends. The most remarkable work which he executed at this time was a *Martyrdom of Sainte Barbe*, a picture strongly marked by his reminiscences of the Primitives in the Louvre, and representing the corpse of the saint borne away by angels into heaven. This was purchased by Doctor Asselin, the old friend of Millet's family, for 300 francs. He also painted several small subjects which were suggested by the sight of the Cherbourg fishermen, such as a young fisherman rescuing his comrade from drowning, sailors mending their sails, fishermen at their boats. But these pictures did not sell, and Millet found himself reduced to paint sign-boards for shops, and he executed a life-size figure of a milkmaid for a milliner's shop, a horse for a veterinary surgeon, a sailor for a sail-

maker, and, finally, a battle-piece for the manager of a travelling circus, who paid him thirty francs in coppers.

His old patrons, the Town Councillors of Cherbourg, commissioned him to paint a portrait of a former Mayor, M. Javain, and offered him the sum of 300 francs. But since Millet had never seen the Mayor, and had only a miniature of M. Javain as a young man to work from, the task was by no means easy. To add to his difficulties, he had to work in a public hall and to listen to all the advice and criticisms offered by the late Mayor's family and friends, who took great offence at his employing a former servant of M. Javain to sit to him as a model for the hands of the city magnate. When the portrait was finished, the Town Council declared that it was a very bad likeness of the late Mayor, that the face wore an expression of severity which by no means resembled him, and declined to pay the sum which had been agreed upon. After much wrangling and many weeks of vexatious delays, the Council finally offered the painter the sum of 100 francs, a proposal which he rejected with scorn, telling them that since they had withdrawn their original offer, he would make them a present of the portrait.

The portrait of the ex-Mayor was accordingly hung in the Town Hall of Cherbourg, and Millet was left without a penny for his pains and with his reputation seriously impaired. Even his old teacher, Langlois, is said to have turned against him and to have pronounced the pupil, whom he had once thought so full of promise, to be no better than a barbarian. It was now plain that there was no opening for him in his native Normandy. A prophet, he was convinced, is without honour in his own country, and much as it grieved him to leave the mother and grandmother who clung to him so fondly, he determined to return to Paris and once more seek his fortune in the great city. But this time he felt he could not go alone.

Among the portraits which he painted that summer at Cherbourg was one of a pretty young dressmaker, Mademoiselle Pauline Virginie Ono, with whose parents he lodged. Millet himself was a tall, handsome young man of six-and-twenty, with a mass of dark wavy locks and deep blue eyes. He had made himself a name, and what was more in a woman's eyes, he was unfortunate and had been badly treated by the Cherbourg authorities. Mademoiselle Pauline listened to his story and pitied him with all her heart. In November they were married at Cherbourg, and Millet took his young wife with him to Gréville. Pierre Millet describes her as a charming little woman, gentle and affectionate, but very delicate. His mother and grandmother gave the young couple a warm welcome. They made a wedding feast, in true patriarchal fashion, and invited all their friends and relations in Gréville and Cherbourg to do honour to the nuptials of the eldest son of the house. And as they sat at the festive board, the old grandmother made this little speech: " Remember, my François, that you are a Christian before you are a painter, and never devote so fine a calling to the service of the enemies of religion. Never sacrifice on the altar of Baal. Remember the great saints who painted beautiful pictures, and follow their example!"

The subjects of some of Millet's pictures were probably not altogether to the taste of the good old woman, who would have liked to see him paint nothing but pictures from sacred story and the lives of the saints. But her grandson hastened to calm her fears and assured her that, come what might, he would never sacrifice his conscience to his art.

" Even if they cover the canvas with gold and ask me to paint a ' St. Francis possessed by the Devil,'" he added, with a smile, "I will promise you never to consent!"

His grandmother laughed in her turn, and his fond

mother whispered, in her Norman dialect: "*Fè don notre gas, François, comme y préchit bié!*"—"Listen to our boy François, how well he talks!"

Early in 1842 the young couple returned to Paris. Before his departure Millet left his own portrait and that of his bride, and several other pictures which he had lately painted, in the hands of his wife's family. Unfortunately, these new relations were not congenial to him. From the first, they seem to have treated him badly, and he never spoke of his Cherbourg connections without evident pain. A pastel of his young wife which belongs to this period is now in England, and is one of the earliest works that he executed in this method. She is represented seated at a table reading. A black shawl is thrown over her shoulders, and a handkerchief tied round her head, as, resting her cheek upon one hand, she looks down on the open book. Her whole appearance is graceful and refined, but frail and delicate. The poor young woman was, it is plain, little fitted to share the hardships of a struggling artist's life. She had never been strong, and from the time she moved to Paris, her health and spirits drooped, and she faded slowly away.

The next two years were full of suffering for Millet, who had the bitter grief of seeing his wife's failing health, and of being unable to procure the comforts which she needed. They lived in a little lodging in the Rue Princesse, No. 5, and had no friends excepting the faithful Marolle, who paid them constant visits and did his best to help them. Fortune seemed to have turned her back upon Millet. The pictures which he sent to the Salon of 1842 were rejected, and the following year he did not try to exhibit. In his dire need he accepted whatever orders he could get, and painted signs and portraits for the smallest sums. Even then he had great difficulty to get paid, and often met with harsh and cruel treatment. Life, he said himself to Sensier, was

one daily fight for bread. As his poor young wife grew worse his position became more painful. In that dark little room of the Rue Princesse he went through days and nights of untold anguish.

In after years he often experienced hard times, but he never again suffered the misery and desolation which he had known in those days. The years 1843 and 1844, he always said, were the hardest in his life, and he never spoke of them without a kind of horror, as if the recollection of this terrible time was too bitter to be endured. Yet he was never heard to utter a complaint or to speak angrily of the men who had treated him the worst. "There are bad people in the world," he would say, when he recalled these incidents, "but there are good ones too, and one good man consoles you for many who are bad. Here and there I found a helping hand and I have no right to complain." But all the while he worked at his art with untiring zeal. He made studies, and painted pictures, and when he found himself short of material, destroyed the work which he had done, and began another subject on the same canvas. And he paid frequent visits to the Louvre, and consoled himself with Fra Angelico's celestial visions and Michelangelo's sublime forms. Correggio was another master who attracted him at this period of his career. He studied his flesh-tints and modelling with great interest, and learnt new secrets of light and colour which were to prove of lasting value.

The first of these studies appeared in the pastels which he finished in the winter of 1843–1844, and exhibited in the following Salon. One was a Normandy peasant-girl carrying a pitcher, which Marolle insisted on calling *The Milkmaid*. The other was a group of children playing at horseback on the floor, called *The Riding Lesson*. The animation and luminous colouring of this little picture attracted considerable attention in the Salon. The critic

Thoré spoke of it with high praise, and the painter Diaz
was filled with admiration for the work of this unknown
artist, and declared it to be a work of undoubted genius.
"At last we have a new master," he exclaimed, " who
has a talent and a knowledge which I for one covet, and
can give life and expression to his creations. That man
is a true painter!"

Both Diaz and his friend, Eugène Tourneux, were bent
on finding out this new genius. They made repeated in-
quiries after Millet, and at length, one morning in
May, they knocked at the door of the humble lodging
in the Rue Princesse and asked for the artist. The story
they heard was a sad one: "There were two persons
living here in a small lodging. The wife is dead; and the
husband is gone away, no one knows whither." That
brilliant pastel, which delighted both critics and artists by
its life and gaiety, had been painted during the sad hours
that Millet had spent in watching at the bedside of his
dying wife. The poor young woman had breathed her
last on the 21st of April, and her husband was gone to
hide his tears in his old home.

There he remained for the next eighteen months, finding
consolation in the presence of familiar faces and in the
sight of his native fields. By degrees courage and hope
revived, and he began to paint with fresh ardour. News of
the success of his pastels in the Salon reached Cherbourg,
and the despised artist received a cordial welcome from
his old friends. During the following year he painted a
variety of pictures and pastels in the bright and graceful
style which he had lately adopted. His portrait of his
friend's child, Mademoiselle Antoinette Feuardent — a
curly-haired little girl with a pink silk scarf on her head,
laughing at the sight of her own face in the glass—was
greatly admired. A Head of Christ wearing the Crown of
Thorns, in chalks heightened with white, was also among

the works which he drew at Gréville, and was, no doubt, more to his grandmother's taste. Fresh orders reached him, and the prefect of Cherbourg offered Millet the post of Professor of Drawing at the town college. The proposal was a flattering one, and Millet's attachment to his native soil tempted him to accept it. But he valued his independence still more, and in spite of all that he had suffered in Paris, he felt that he must go back there and once more try his fate in the great world of art. So he declined the post, and fearing that his decision would distress his mother and grandmother, did not even tell his family of the offer which had been made him.

Millet's first marriage had proved unfortunate, and had left him a childless widower before he was thirty. The iron had entered into his soul; but he was not the man to live alone. His serious air and romantic face captivated the affections of a good and gentle peasant maiden—originally a native of Lorient, on the coast of Brittany—Catherine Lemaire by name. She listened pityingly to the tale of his sorrows, and shared his dreams of future work: he took pleasure in her company, and she looked up to him as one far above her. Pity and admiration soon deepened into love. Before long Millet learnt her secret, and the village maid became his wife. She was barely eighteen and had never left her village home; but she had a heart of gold and a courage beyond her years, and she gladly devoted her whole life to the man whom she loved. During the next thirty years this brave and loyal wife was Millet's faithful companion and helpmeet. She was intelligent enough to appreciate his genius and to share his deepest thoughts, and her devotion was his best comfort in the trials of his future life. Few but his most intimate friends knew how much he depended upon her sympathy and support, and the world is perhaps hardly yet aware how much it owes to Catherine Millet.

Her husband often made her sit to him as a model for his peasant-women, and has left us more than one excellent likeness of her. Perhaps the most familiar is the portrait of the head and bust engraved in Sensier's life, and at that time in the collection of M. George Petit. This drawing belongs to the early years of her married life, and, in its perfect simplicity and truthfulness, helps us to realize the charm of her goodness and the strength of her character. In the drawing of a *Young Woman Sewing*, which he made at Barbizon in 1853, we see another portrait of his wife, taken when she was about five-and-twenty. Here Madame Millet is represented sitting in her chair, wearing the white cap of the Normandy peasant, engaged in mending her husband's coat, which lies across her knees. Her head is bent over her work with an intent expression, and the light falls on her white linen collar and on the thread which she is in the act of drawing through her fingers. Nothing could be more true to life or more delicately rendered than this little study, which has at once so rare a charm and so pathetic an interest. It bears the date 1853, together with an inscription from the pen of his friend Campredon—to whom it belonged at one time—stating this to be a portrait of the painter's wife.

The marriage took place at Gréville, late in the summer of 1845. In November, the newly-wedded pair set out for Paris; but on the way they made a stay of several weeks at Havre. Millet's reputation had already preceded him here, and a Gréville friend who was residing in the town introduced him to many of the chief residents. Sea-captains and sailors, harbour officials and consuls, all sat to him in turn for their portraits; and a picture of a Spanish lady whom he painted, robed in gay draperies of blue and pink silk, and reclining on a couch, created quite a sensation in the town. Before he left Havre, a public exhibition of his works was held in the Town Hall. Here,

besides these portraits, several of the pictures and pastels of pastoral and mythological subjects which he had lately painted at Gréville and Cherbourg, were exhibited, and pleased the popular fancy by their graceful forms and harmonious colouring.

Chief among these were two pictures, *Daphnis and Chloe* sporting on the banks of a running stream in a woodland landscape, and the *Offering to Pan*, a young girl placing a crown of flowers on a marble term, in the heart of the woods, which is now in the Museum of Montpellier, together with a number of smaller *genre* pictures, such as, *A Child Bird-nesting*, *The Flute Lesson*, *A Girl Brushing away the Flies from the Face of her Sleeping Lover*, *A Workwoman Asleep*, *The Bacchantes*, *A Sacrifice to Priapus*, *The Temptation of St. Anthony*. Many of these subjects were sketchily treated, and bore evident signs of haste; but the grace of the grouping, the transparency of the warm atmosphere, were undeniably attractive. The influence of Correggio was strongly marked, while the drawing and modelling of the figures revealed a thorough mastery of form.

Millet's visit to Havre is described by Sensier as a bright and joyous moment in his life, which was soon to be eclipsed in gloom. Many years were to go by before he enjoyed another interval of comparative freedom from care, or tasted the sweets of popular applause even in this passing form. The next four years of his life were spent in Paris, and were one long tale of poverty and neglect. The growing cares of a young family made the struggle harder, and compelled him to sacrifice his natural inclinations and paint for bread. At home his mother and grandmother waited anxiously for his letters, which came but rarely now, and treasured up the brief notices which were occasionally to be seen of his pictures in the newspapers. They urged him to come and see them, and he too longed

passionately for one sight of the old home. "I felt," he said to Sensier, "that I was nailed to a rock, and condemned to hard labour for the rest of my natural life. And yet I could have forgotten all, if only I might, now and then, have been able to see my native village again!"

But with a wife and increasing family, the journey was impossible, and seven long years passed away before Millet set foot again on Norman soil. When at length he came back to his native place, it was to find the hearth empty, and the faces that he had loved best there missing. He might well say, as he gazed "with breaking heart" on that "poor roof" where he was born and where his parents had died, "In Art you have to give everything—body and soul."

IV

MILLET and his wife reached Paris in the last days of December, 1845. They took a lodging, consisting of three small rooms, at No. 42, Rue Rochechouart, and Millet made himself a modest *atelier*, furnished with three chairs and an easel. Here he set to work at once on a *Temptation of St. Jerome*, which he destined for the next Salon. He had 900 francs in his pocket—the fruit of his success at Havre—and was in good spirits, full of hope and courage. His young wife made his home peaceful and happy. His old friends, Marolle, and Charles Jacque, the engraver, who lived opposite, gave him a cordial welcome, and before long other visitors arrived. Eugène Tourneux, true to his word, found Millet out soon after his return, and expressed his admiration for his work in glowing terms. Diaz was equally encouraging, and, finding that Millet was in want of employment, exerted himself strenuously on his behalf. This warm-hearted Spaniard, who, more fortunate than his brother-artists, knew, as he once said, " how to keep success tied to the leg of his easel with a pink ribbon," tried hard to give Millet a share of his prosperity. He went from shop to shop seeking orders for his friend, and told dealers and amateurs alike that they must be blind to shut their eyes to the man's talent, and that they would assuredly live to repent of their folly.

Meanwhile François was not forgotten at Gréville, and while he was at work on his *St. Jerome* he received the following characteristic letter from his grandmother:

" MY DEAR CHILD,—

"You tell us that you are going to work for the Exhibition. You have not told us if you received any benefit from the quantity of pictures which you exhibited at Havre. We cannot understand why you refused the post at the College of Cherbourg. Do you really see greater advantages in life at Paris than here in the midst of your friends and relations? You tell us that you are about to paint a picture of St. Jerome groaning over the dangers to which he found himself exposed in his youth. Ah, my dear child! follow his example. Make the same reflections, to your eternal profit! Remember the words of that man of your profession who said, 'I paint for eternity.' Whatever may happen, never allow yourself to do bad works; above all, never lose sight of the presence of God. With St. Jerome, think continually that you hear the sound of the trumpet which will call us to judgment. . . .

"Your mother is very ailing, and spends much of her time in bed. As for me, I become worse and worse, and find myself almost unable to walk at all. . . .

" We wish you a good and happy new year, and the most abundant blessings from heaven. Do not delay to give us your news. We are very anxious to know what your present position may be. We trust it is a prosperous one, and we all embrace you with the tenderest affection.

" Your Grandmother,

"Gréville, 10th January, 1846. " LOUISE JUMELIN."

This picture of *St. Jerome*, in which Millet's grandmother took so deep an interest, was unfortunately rejected by the jury of the Salon. Couture, Millet's old teacher in Delaroche's *atelier*, admired it extremely, and both execution and conception are said to have been very striking. But in the following year Millet finding himself short of canvas painted a new subject—*Œdipus Taken from the Tree*—on the same picture, and nothing was left of his *St. Jerome*. There was little of Greek feeling in Millet's rendering of this classical subject. The infant Œdipus is seen released from the tree, to which he is bound, by a shepherd, while a young

woman standing below receives him in her arms, and a black dog is seen barking at her side. The picture was merely, as the artist himself said, an excuse for practising the flesh-painting and modelling in which he excelled. But it is at least a noble study of form and colour, and bears witness to the profound impression which Michelangelo's work had made upon the painter. It attracted considerable attention when it was exhibited in the Salon of 1847, and was noticed by two leading critics, Théophile Gautier and Thoré, as a striking and original work by a painter who could not fail to make himself a name ere long. And in the old home at Gréville, the blacksmith, who had long ago admired the boy's drawing of the three men on donkeys, read a flattering notice of the picture in a newspaper that was sent him from Paris, and ran to take the good news to Millet's house. His mother and grandmother wept tears of joy at this mention of their absent son, and there was great rejoicing among his family and friends.

At this period of his career Millet was chiefly famous for his undraped nymphs and fauns: his brother-artists called him *le maître du nu*. Women bathing or resting under the trees, children at play in flowery meadows, groups of youths and maidens dancing on the grass, a young girl with a lamb in her arms—these were the subjects of the drawings or pastels which he made for Deforge or Durand-Ruel, and the other dealers who bought his works. One little picture of a nude girl asleep on a grassy bank, while a faun watches her slumbers through the boughs, so delighted Diaz that he bought it on the spot. But the finest example of his talent in this direction is that famous little picture of four children dragging a half-draped nymph through a forest glade, to which he gave the name of *L'Amour Vainqueur*. The action of the laughing children and the form of the

golden-haired nymph are rendered with masterly art, while the beauty of the colouring, the fine effect of the blue drapery against the warm flesh-tints, and the rich glow on the woodland background, recall the art of Titian and Giorgione. The original version of this truly classical picture has been exhibited of late years both at Edinburgh and in London, and is the property of Mr. J. S. Forbes. A replica may be seen in Mr. Quilter's collection, and a study for the upper part of the nymph's figure is reproduced by Sensier in his book, and was at the time in the writer's possession. These little idylls, painted in what critics have called the artist's flowery manner, are curiously unlike the work that we have learnt to associate with Millet's name ; but their power and charm are indisputable. Their subjects may not appeal to us, the sentiment may strike us as forced and artificial ; but there can be no doubt as to the mastery of form and of chiaroscuro which they reveal. A new stage, we feel, has been reached in the history of the Norman peasant-lad who came up to Paris to seek his fortune and learn his trade ten years before. The days of his apprenticeship are over. He stands before us a finished artist, complete in every sense of the word, who has mastered the secrets of his craft, and is able to tell the world all that he has to say.

It was at this moment of Millet's career, early in 1847, that Alfred Sensier, his future biographer, first made his acquaintance. That year Sensier saw a life-size crayon portrait of the painter which he himself had drawn and given to his friend Charlier. The sight of this noble head, "as melancholy as that of Albert Dürer, with its deep, earnest gaze, full of intellect and goodness," made a profound impression upon the young lawyer whose recent appointment to a post in the Musée du Louvre brought him into contact with many rising

painters. He sought eagerly for an opportunity of be-
coming personally acquainted with this man whose face
haunted him day and night. At length, one day, the
landscape-painter, Constant Troyon, who knew Millet
through their mutual friend Diaz, took him to see the
artist in his lodging of the Rue Rochechouart.

"Millet," writes Sensier, "at that time wore a curious garb. A
brown overcoat, in colour like a stone wall, a thick beard and long
locks, covered with a woollen cape like that of a coachman, gave
him a singular appearance. The first time I saw him he reminded
me of the painters of the Middle Ages. His reception was cordial,
but almost silent. He took me for a philosopher, a philanthropist,
or a politician—neither of whom he cared much to see. But I
talked of art to him, and seeing his *Daphnis and Chloë* hanging on
the wall, I told him what I thought of it. He looked hard at me,
but still with a kind of shyness, and only said a few words in a reply.
Then I caught sight of a sketch of a sower. 'That would be a fine
thing,' I remarked, 'if you had a country model.' 'Then do you
not belong to Paris?' he asked. 'Yes; but I was brought up in the
country.' 'Ah! that is a different story,' he said in his Norman
patois; 'we must have a little talk.' Troyon left us alone, and
Millet, looking at me some moments in silence, said: 'You will
not care for my pictures.' 'You are wrong there,' I replied warmly;
'it is because I like them that I have come to see you.'

"From that moment Millet conversed freely with me, and his
remarks on art were as manly as they were generous and large-
hearted.

"'Every subject is good,' he said. 'All we have to do is to —
render it with force and clearness. In art we should have one
leading thought, and see that we express it in eloquent language,
that we keep it alive in ourselves, and impart it to others as clearly
as we stamp a medal. Art is not a pleasure-trip; it is a battle, a
mill that grinds. I am no philosopher. I do not pretend to do
away with pain, or to find a formula which will make me a Stoic,
and indifferent to evil. Suffering is, perhaps, the one thing that
gives an artist power to express himself clearly.'

"He spoke in this manner for some time and then stopped,
as if afraid of his own words. But we parted, feeling that we

understood each other, and had laid the foundations of a lasting friendship."

From that day the young official of the Musée du Louvre saw Millet frequently, and became one of the most frequent visitors to the humble dwelling of the Rue Rochechouart. He liked to watch the painter at his work, wholly absorbed in the task before him, executing with rare dexterity those graceful little compositions of mothers and children, of sleeping nymphs or sportive cherubs, which he endowed with all the magic of his art.

" It was always a joy," writes Sensier, " to see Millet paint. He seemed to express his ideas and fancies in paint as naturally as the bird sings, or the flower opens in the sunshine. I never looked at his work as a critic, but merely enjoyed the pure and life-giving air which I breathed in his companionship. When life's cares oppressed me, I went to see Millet paint, and came away refreshed and consoled."

Another link which drew the two men together was their mutual taste for country life. Sensier cherished happy recollections of the woods and meadows where his early days had been spent, and which all the years that he had lived in Paris could not make him forget. As he watched Millet work these old memories revived. The two friends talked of harvest and hay-making, of sowing and reaping, until, moved by the sense of mutual sympathy which knit them together, he would declare that in some former stage of existence they must surely have already been twin souls, sharing the same thoughts and living the same life.

" Why not? " Millet would reply in his half-serious, half-jesting manner. " Who knows if we were not shepherds, keeping flocks together in the age of Saturn ! "

Millet's friend and neighbour, the clever engraver and

painter, Charles Jacque, shared his friendship for Sensier, and took part in their discussions. Often, after dark, the three would meet together at Millet's lodging, and with Diaz or Campredon, and a few other intimate friends, they would sit up talking over a pot of beer till the small hours. Then ancient and modern art, the early Florentines in the Louvre, and the Romanticists of the present day, together with a hundred other subjects relating to painting, to poetry, or to philosophy, would be brought up and discussed in turn. Millet, as a rule, seldom took any leading part in these interminable conversations. He listened silently to each speaker, and contented himself with an occasional remark; but when he did intervene, it was with crushing force. His sentences were always brief and to the point, his arguments well thought out and lucidly expressed. Once thoroughly roused, he entered the fray with Herculean vigour, and dashed his opponents to pieces. On these rare occasions he would speak almost fiercely of the state of society. Politicians, romance-writers, dogmatists in art and letters were alike hateful to him. The whole atmosphere of Paris oppressed him, and the chatter of the great city, its literature and ambitions, its fashions and morals, remained for him to the end an incomprehensible world. The poorer class of the labouring population were the only people who really interested him, and the sight of their squalor and misery gave him a sickening sensation. He painted the stone-masons at work in the quarries of Charenton, and the navvies employed on the fortifications of Montmartre; he drew a mother and child begging in the street, and a working-man spending his Monday's rest in a drunken bout. Then in disgust at these repulsive subjects of city life, he turned back with fresh delight to his memories of Gréville, and set to work on a large-sized figure of a peasant winnowing grain on the floor of a Norman barn.

G

Meanwhile his own prospects did not improve, and it was often hard to keep the wolf from the door. His eldest child, a girl named Marie, was born on the 27th of July, 1846. Two others, a second girl and a boy, followed before the end of 1848. Millet himself was often to be seen rocking his babies in his arms, and singing them to sleep to the tune of old Norman songs. Then, when they were safely asleep in their cradle, he would take up his brush and go back to work. His wife was the tenderest and best of mothers, and never complained of want and hardship herself as long as she had food for the children. Whatever happened, she met her husband's friends with a cheerful face, and did her best to hide the poverty of her small household. But do what she would, there were days when it became impossible to conceal the truth, and it was plain to Millet's friends that the whole family were reduced to the verge of starvation.

The troubles of the year 1848 brought things to a crisis. Early in the spring Millet fell ill of rheumatic fever, which brought him to the point of death. For several weeks he lost consciousness, and was a prey to the wildest delirium. The doctors gave up all hope of recovery, and only awaited the moment of his death. But to their surprise Millet's vigorous constitution triumphed, and he recovered. The generous help of his friends supplied him with funds during his convalescence, for his long illness had left him too weak to work. One day, however, he sat up, shook himself, as he says, " like a wet dog," and painted a pastel of a *Little Girl* sitting on a bank, with bare feet, and sorrowful eyes lifted heavenwards. A friend bought this pathetic little picture for thirty francs, and paid him the same sum for a similar pastel of a *Little Traveller*. But the Revolution had effectually stopped all demand for work of this kind, and, in common with other artists, Millet found himself reduced to sore straits.

The Salon of 1848 was a memorable one. The Revolution in February was followed by a revolt of the artists, who rose in a body against the tyranny of the Institute, and a free exhibition was held in the Louvre. Rousseau and Dupré were on the hanging committee; Delacroix sent as many as ten canvases. When the doors of the new Salon opened on the 15th of March, two of Millet's works were seen on the line. One, his fine figure of *The Winnower*, occupied a prominent place in the Salon Carré; and the other, representing *The Captivity of the Jews in Babylon*, hung in the Great Gallery. The last-named picture was a classical composition in the style of Poussin; but in this scene of the Jewish women refusing to play their harps in their captivity the painter has given utterance to his own sorrow, and to the yearning of his heart after his own land: "By the waters of Babylon we sat down and wept, when we remembered thee, O Zion. As for our harps, we hanged them up upon the trees that are therein. For they that led us away captive required of us then a song and melody in our heaviness: Sing us one of the songs of Zion. How shall we sing the Lord's song in a strange land?"

Unfortunately this picture, which Sensier describes as singularly impressive, was destroyed by the painter himself, who, many years afterwards, painted his *Woman Shearing Sheep* on the same canvas.

Both works attracted considerable notice at the time. *The Winnower*, that fine figure of the peasant, in his blue shirt and red handkerchief, winnowing grain in the barn, surrounded by a cloud of golden dust, commanded general admiration. The noble action of the figure and the rich tones of the colouring were widely recognised in artistic circles. Before the close of the Salon it was bought by M. Ledru Rollin. Since then it has often changed hands, and was at one time in the Sécrétan collection, while a

smaller and later version belonged to the Laurent-Richard
collection, and was afterwards bought by M. Bellino. But
while all Paris was talking of his pictures, the painter
and his wife were actually without food or firewood in
their lonely garret. They had not uttered a word of com-
plaint, they did not beg now ; but a neighbour discovered
their pitiable plight, and sent word to some of their friends.
One kind-hearted artist hastened to the office of M. Ledru
Rollin, who, as Minister of the Interior, was at the head
of the Administration of Fine Arts, and obtained a grant
of 100 francs, which he took at once to Millet's lodging.
It was a cold evening towards the end of March. The
painter was sitting on a box in his studio, shivering with
cold ; there was no fire in the room and no bread in the
house. He said, "Good-day," but did not move. When
the money was put into his hand, he replied:

" Thank you ! It has come in time. We have not eaten
anything for two days. But the great thing is that the
children should not suffer; they at least have had food
until now."

Then he called his wife, and handing her part of the
money, he said: "Take this, and I will go out and buy
some wood ; I am very cold."

He said no more, and never again alluded to the incident.
But the cold and hunger of those days told upon his en-
feebled frame, and were no doubt one cause of the terrible
headaches from which he suffered in after years.

A few days afterwards M. Ledru Rollin himself came to
see Millet, and told him that he had bought *The Winnower*
for 500 francs. At the same time he promised him an
order for another picture from the State. This was a joy-
ful day for Millet and his wife, and on the strength of this
good fortune they moved into a new lodging at No. 8, Rue
du Delta. A prize was offered by the State for a figure of the
" Republic," and Millet painted a classical figure crowned

with ears of corn, and seated by a hive of bees, holding in one hand a palette and brushes and in the other cakes of honey. Liberty, as he conceived her, was to encourage agriculture and the fine arts, and flourish on their produce. But these ideas were too peaceable for the times, and he was told that he had committed one unpardonable fault—his goddess did not even wear the *bonnet rouge*! Consequently, this *Republic* was returned on his hands, and did not even receive honourable mention from the judges who awarded the prizes to the successful competitors.

In June the insurrection broke out, and Millet, like every one else, was compelled to shoulder a musket and take part in protecting the National Assembly. He was present at the taking of the barricades in the Quartier Rochechouart, and saw the leader of the insurgents shot. These scenes of riot and bloodshed sickened his very soul. He turned away horror-stricken from the sight, and sought to recover calm by long wanderings at nightfall on the plains of Montmartre or Saint Ouen. Then in the morning he sat down to paint the impressions of his evening walk and produced a series of charming little pastels—*Swimmers at Sunset, Horses Drinking at the Fountain of Montmartre, Cattle Led to the Slaughterhouse, Sleeping Labourers,* etc. More than one artist who saw these rapidly-executed impressions was struck by the genius of the artist, and prophesied that a great future was in store for him. Guichard, especially, a pupil of Ingres, who had attained some distinction, used to tell his old master that Millet was the finest draughtsman and had the most poetic feeling among all the artists of the new school.

But in Paris, during that fatal year of revolutions, there was no sale for works of art, and the end of the summer found Millet once more penniless and hopeless. When the insurrection of June broke out he was in the act

of painting a sign for a midwife. He finished the panel
to the sound of firing guns, and the thirty francs which
the honest woman paid him on the spot stood him in
good stead during those troublous days.

"Those thirty francs saved me," he told Sensier; "for
they kept us alive a whole fortnight, until the insurrec-
tion was over. How often I blessed that unexpected
help!"

When the streets were quiet again, he painted a Mer-
cury carrying off the flocks of Argus and a gaily-coloured
little pastel of Delilah cutting off Samson's locks. Un-
fortunately, like most of Millet's works of this period,
these pictures, to which he attached no value, were after-
wards destroyed by the artist himself, who painted others
on the same canvas. Two pastels of Liberty—the one
armed with a sword and dragging her victims along the
ground, the other seated on her throne, surrounded by
the dead corpses of kings—were rescued from destruc-
tion by Sensier, who bought them because no dealer
would take them as a gift.

In his destitution he accepted an order from a music-shop,
and actually executed two engravings for the title-page
of songs. One of these was a portrait of Châteaubriand,
which has disappeared, the other was destined for a musical
romance càlled, "*Où donc est-il?*" composed by the pub-
lisher, Frédéric Lebel. In Millet's vignette, a lady dressed
in black is seen clasping two children in her arms and
leaning against a balustrade, as she looks out anxiously
into the night and repeats the words, "Where is he?"
The group was graceful, its meaning apparent to the
meanest capacity. But when Millet presented himself at
the door of the music-shop with his plate, and claimed
the thirty francs which had been agreed upon as the
price, the publisher declared his engraving to be useless,
and insolently refused payment. Millet's remonstrances

were of no avail; the music-seller turned him out of the
house, and slammed the door so violently that his right
hand was badly crushed, and for some weeks afterwards
he was unable to use his pencil. The luckless plate was
destroyed at the time, and the only impression now in
existence was discovered in Paris, eight years ago, by
an American collector, Mr. Keppel, who bought it for a
high price, and preserves it as a precious memorial of
the great master's struggling days.

V

IN the midst of the disasters which overtook Millet
during 1848, he met with one stroke of good fortune.
The Minister of the Interior, M. Ledru Rollin, urged
by Jeanron, the new Director of the Louvre, and con-
stant champion of struggling artists, had as we have seen
promised Millet an order from the State. He proved as
good as his word, and when the troubles of the summer
were over, Millet received a commission from the Repub-
lic for a picture, to be painted at his leisure. The choice
of the subject was left to the painter, and 700 out of
the promised sum of 1,800 francs were paid in advance.
The terms were liberal, and Millet, in his joy at his
good fortune, set to work on a large canvas of a size
proportionate with the price, he said. His artist friends
reproached him with his folly for beginning work on so
large a scale, and told him that a small picture would
meet the requirements of the case equally well. But
Millet persisted in his resolution, and began a large sub-
ject of Hagar and Ishmael in the Desert—an allusion to
his own fate, his biographer remarks, in the Sahara of the
great city. The figures were larger than life : Hagar was
seen lying on the ground, her bare limbs bronzed by long
exposure to the sun, clasping her fainting child in her
arms, and gazing at his face in a passion of love and
grief. Millet had lavished all his skill on the modelling
of Hagar's form, and intended the whole to be a striking
study of the nude. Suddenly, when the picture was al-
most finished, he changed his mind and stopped short.

For one evening, as he stood before the lighted window of Deforge's shop, he happened to see two young men looking at one of his own pastels—a drawing of women bathing, which he had lately sold. One youth asked the other who had painted this picture. His companion replied: "A man named Millet who never paints anything but naked women."

The words were a shock to Millet. His friends had often admired his nude figures, and praised his skill in flesh-painting. But never until that moment had he realized that his reputation as an artist depended on this kind of work. His whole soul rose up in protest against the injustice of the accusation. He thought of his old aspirations, of his grandmother at home, of the fields where he had ploughed and sowed with his dead father, and vowed that, come what might, he would paint no more naked figures. The reproof he felt had not been undeserved. But whether for profit or for renown, he would do no more of the devil's work, and it should never again be said of him that he was a master of the nude. He went home that evening and said to his wife:

"If you consent, I will paint no more of those pictures. Life will be harder than ever, and you will suffer; but I shall be free and able to do what I have long dreamt of."

The brave woman replied: "I am ready. Do as you will."

It was an answer worthy of Millet's grandmother herself.

So the great decision was made. From that moment he turned his back resolutely on the past and entered on a new course.

His *Hagar and Ishmael* was abandoned, and then and there, on the same canvas, he began to paint his picture of *Haymakers Resting in the Shadow of a Hay-stack*, on

an open Plain. It was a memory of Gréville and of the hay-stacks on his father's farm. But the task was not easy, and many months passed before the new picture was finished. He could not find the right models in Paris, and sought in vain along the banks of the Seine and at Saint-Ouen for a country-woman who would satisfy his ideas.

"It is of no use," he said; "I can only find women of the suburbs. What I want is a real country peasant."

The revulsion of feeling which he had lately undergone had revived his old longings for the country with increased force. Paris seemed to him more intolerable than ever, and his desire to escape from an atmosphere which weighed every day more heavily upon his soul became a settled resolve. But his artist-friends were unanimous in begging him to remain where he was; Diaz, above all, urged him to consider seriously the inevitable results of a step which, in the present state of affairs, seemed to him little short of madness.

"What!" he cried; "do you mean to tell me that you prefer to live with brutes, and to sleep on weeds and thistles—which will certainly be your lot, if you choose to bury yourself among peasants in the country—when, by remaining in Paris and persevering in your immortal flesh-painting, you are sure to be clothed in silks and satins!"

But Millet's mind was made up, and no argument could shake his resolution.

"I know that," he replied quietly. "But all the same I am more familiar with country life than with town life, and when I set my foot on the grass, I shall be free." And he went back to work at his *Haymakers.*

The troubled state of Paris, and the feeling of uncertainty that prevailed in all classes of society, made that winter a hard one. At Christmas Madame Millet

gave birth to a third child, a son, who received his father's name, Jean François. The burden of domestic cares seemed to grow heavier every year. In his distress Millet was forced to part with his drawings for clothes and other necessaries: a picture went for a bed, six drawings were exchanged for a pair of boots. Some of those precious crayon-sketches which are bought for hundreds of pounds to-day were sold for prices varying from one to five francs; and four superb portraits of the painter Diaz, of Victor Dupré, of the sculptor Vechte and the artist Barye were bought by a dealer for the sum of twenty francs. Three out of the four—the portraits of Diaz, Dupré, and Barye—together with another of the critic Desbrosses and a magnificent head of Théodore Rousseau in the same style, are now the property of Mr. J. S. Forbes, and were recently exhibited at the Grafton Gallery. All five are life-size, half-length portraits in crayons, and in shape and execution exactly match the well-known portrait of Millet himself, which, given by him to his friend Charlier at the time it was painted in 1847, afterwards became the property of Sensier. They give us a high idea of Millet's powers as a portrait-painter, and make us regret that so little remains of his work in this direction. The personality of each of his sitters is admirably rendered: the thoughtful expression of Desbrosses' head and down-dropped eyes contrasts finely with Dupré's keen and alert air, and with the fiery gaze of the Spanish master, whose piercing eyes flash from under the thick tuft of black hair falling over his forehead. Barye's delicate features bear the stamp of his refined intellect and artistic feeling, while the majestic portrait of Rousseau leaning his brow on his hand recalls the masterpieces of Italian art, and might have supplied Lionardo with a model for his *St. Peter*.

We realize the straits to which Millet must have been reduced when such fine work as this was allowed to go for so paltry a sum. One day, about the same time, his friend Jacque collected a number of stray notes and sketches which were about to be used to light the fire, and ill as he himself could spare the money, insisted on paying Millet what he considered to be their value.

In spite of the daily pressure of grinding poverty that weighed so heavily on Millet's spirit he worked on steadily, and by dint of unremitting toil succeeded in finishing a figure of a peasant woman sitting down, in time for the Salon of 1849. A few weeks afterwards he completed his picture of *Les Faneurs*—haymakers at rest—and having at length ended this important work, addressed the following letter to the Minister of State:

<div style="text-align:right">

"Paris, April 30, 1849.[1]
</div>

" Sir,—

"I have completed the picture which you were kind enough to order, and have executed it with all possible care and conscientiousness. I ought to send it to the Exhibition, where it could be properly seen and judged. I pray you to be good enough to pay me the balance of 1,100 francs which is still due on this commission. My great need of money obliges me to ask you to let me have it as soon as possible. Accept, sir, the assurance of my profound respect.

<div style="text-align:right">

"J. F. MILLET.
</div>

"8, Rue du Delta."

A month afterwards Millet received the promised sum. During the interval, the cholera had broken out in Paris; it raged violently in the quarter where Millet lived, and hundreds of children fell victims to its

[1] N.B.—This letter was first published in *Scribner's Magazine* (May, 1890) by Mr. T. H. Bartlett, to whom, as stated in the Preface, we owe many interesting details of Millet's private life at this period.

ravages. Both Millet and his friend Jacque, who had a large family, were in mortal fear lest their children should be attacked by this terrible disease. Jacque himself fell ill and had hardly recovered when Millet came to him with joyful news: he had that morning received the eleven hundred francs that were due to him from the Government, and was longing to share his good fortune with his friend.

"Here is a thousand francs," he cried; "I will lend you half. Let us go together into the country, I do not care where; if you can tell me of some place, all the better; anyhow, we will leave Paris."

Jacque accepted this proposal gladly, and told Millet that he knew of a little place on the edge of the Forest of Fontainebleau, which he thought would exactly suit their requirements. He could not remember the name of the village, but knew that it ended in *zon*, and felt sure that they would be able to discover the rest of the word when they reached Fontainebleau.

And so, one fine summer's day, just before the Revolution of the 13th of June, 1849, the two families set off in the diligence for Fontainebleau. They were in high spirits and talked and laughed so gaily on the road that they forgot to ask for Barbizon, although they actually passed within sight of its roofs as they drove through the forest. When they reached Fontainebleau, they took rooms at the Blue Dial, an old inn still standing in the principal street, and rested there for a few days enjoying the country air and the beauty of the forest, then in all the freshness of early summer. But Madame Millet's frugal mind soon took fright. "*Mon ami*," she said to her husband, "this hotel is beyond our means. Had you not better find out some cottage where we can take shelter?" And so the two artists set out together in search of the village with the name that ended in

zon. After a long walk through the forest they found
a wood-cutter who showed them the path which led to
Barbizon, and they entered the village by the cowherd's
gate. Millet was charmed with the beauty and primi-
tive air of the place, and the next day he brought his
family by diligence to the corner where the path to
Barbizon branches off from the high-road to Chailly;
here they left the coach and walked through the forest
towards the village. Millet led the way bearing his
two little girls of three and two years old on his
shoulders; his wife followed with the baby-boy in her
arms and accompanied by the maid-servant carrying a
big basket of provisions. A storm of rain came on
just as they started, and Madame Millet threw the
skirt of her gown over her head to protect her babe.
As they entered the village Millet heard an old woman
call out: "Look! there goes a company of strolling
actors." They reached Père Ganne's inn at dinner-
time, and found a party of artists with their families
sitting down to table. Diaz, who was present on this
occasion, introduced the strangers, and invited them,
after the custom of Barbizon, to smoke the pipe of
peace. A discussion followed as to whether Millet
was to belong to the Classicists or Colourists, the two
groups into which the Barbizon artists were divided.
"If you are in doubt about that," said Millet, "put me
in a place by' myself," upon which one of the company
remarked that the new-comer looked powerful enough
to found a school which should bury them all. He little
dreamt how true his words were to prove.

After spending a fortnight at the inn, Millet and
Jacque both decided to settle at Barbizon for the present.
Millet took a bedroom in a one-storied cottage, at the
western end of the village, belonging to a man known
as Petit Jean, who bought and sold rabbit-skins. This

singular individual, whose eccentric habits afforded Millet great amusement, was seldom at home himself, and, besides giving his lodgers the use of one of his rooms, allowed them to cook their food at the only fireplace in the house. Here they remained for several weeks, and Millet rented a little upper room across the street, which he used as his *atelier* until he found a house of his own. His relief at feeling that he had left Paris behind him was great, and in the first flush of joy in the sense of newly-recovered freedom, he sat down and wrote the following letter to Sensier:

"Barbizon, 28th June, 1849.

"MY DEAR SENSIER,—

"I shall be greatly obliged if after reading and sealing the enclosed letter, you will take it to Rue du Delta, No. 8. You will find my landlord, the father-in-law of the painter Salmon, at home, as a rule, as late as nine or half-past nine in the morning, or again by six o'clock of an evening.

"Jacque and I have settled to stay here for some time, and have accordingly each of us taken rooms. The prices are excessively low compared to those in Paris; and as it is easy to get to town if necessary, and the country is superbly beautiful, we hope to work more quietly here, and perhaps do better things. In fact, we intend to spend some time here.

"You will therefore oblige me by giving the enclosed letter to the landlord before the 1st of next month, and make him understand (what is only too true) that I shall have great difficulty in paying him my arrears, if I am ever able to manage it. I wish you good-bye, with many hearty embraces. Jacque sends you warm remembrances, and will answer your letter to-morrow.

"J. F. MILLET."

This little holiday at Barbizon was to last twenty-five years, and before the summer was over, Millet had taken the cottage which was to be his home until the end of his life.

PART III

BARBIZON

1849—1875

"C'est le côté humain qui me touche le plus en art, et si je pouvais faire ce que je voudrais, ou tout au moins le tenter, je ne ferais rien qui ne fût le résultat d'une impression reçue par l'aspect de la nature, soit en paysages, soit en figures. ' Tu mangeras ton pain à la sueur de ton front.' Est-ce là ce travail gai, folâtre, auquel certaines gens voudraient nous faire croire ? C'est cependant là que se trouve pour moi la vraie humanité, la grande poésie."

<div align="right">—J. F. MILLET.</div>

I

WHEN Millet finally left Paris to pitch his tent at Barbizon the hardest part of his life was over. Suffering and trouble enough were still in store for him, but he had taken the great step, and broken for ever with the slavery of conventional art. Henceforth he was free to choose his own subjects and paint in his own way. He had found his true vocation, and fought his way through stress and storm into the light. The clouds of doubt and perplexity which darkened his steps in the past had all vanished, and the path lay clear before him. Whatever difficulties he might have to encounter, however bitterly hostile the outside world might prove, he was sure of himself. And from that moment he never wavered in his choice, never once looked back, or returned even in thought to the style of art which he had deliberately put away from him.

But those dreary twelve years of struggle and effort which he had spent in Paris had not been all in vain. The artist had served his apprenticeship and learnt his lesson well. He had mastered the technical side of painting, and had laid a firm hold on the great and abiding principles which are the foundation of all true art. And now he was to apply these principles to those types of human life which had been present to his mind from his early youth. The lessons which he had learnt at his grandmother's knee, when the little birds sang in the old elm trees, and the scenes which had

sunk into his mind as he followed the plough at his father's side, were henceforth to be his theme and the inspiration of his art.

Barbizon, the village which the names of Millet and Rousseau have rendered immortal, is a hamlet of the Commune of Chailly, in the department of Seine-et-Marne, thirty-four miles from Paris, and six from the town and palace of Fontainebleau. It consisted in those days of a winding street of low stone houses and barns, running between the western part of the Forest of Fontainebleau and the plain of La Bière. The nearest shops, the church, and posting office were at Chailly, a sleepy little village on the high-road between Paris and Fontainebleau, about a mile and a half distant. Here the people of Barbizon went to be married, and took their children to be christened; here they were buried in the shadow of the old church where so many generations of their forefathers had worshipped. The first artists who discovered Barbizon are said to have been Aligny and Le Dieu, who, coming down to visit a friend in 1824, were fascinated by the beauty of the spot, and spread the fame of its charms among their comrades in Paris. Corot and Rousseau, Diaz and Barye and François, and many others, came there during the next few years, and took up their quarters at the White Horse at Chailly, which afforded better accommodation than could be found in Barbizon, until in 1830 a tailor named François Ganne, who had married a German wife, took a barn at the western end of the street of Barbizon, and fitted it up as an inn. Père Ganne's hotel, as it was called, soon became the favourite resort of French painters and art students; and the landlord boasts that he had entertained more artists under his roof than any other innkeeper in the world.

During the next forty years, men of all nationalities and of every degree of reputation, from the fore-

most painters of the day down to the youngest student from London or Edinburgh, from New York or Boston, flocked to Barbizon each summer, attracted by the picturesque beauty of the forest and the free Bohemian life of the place. Some of them spent their days sketching in the forest or on the plain, others gave themselves up to fun and idleness. They smoked their pipes over their beer, and danced and acted, and covered the walls of Père Ganne's hostelry with comic verses and drawings. Père Ganne and his wife made them all welcome; the neighbouring barns and outhouses were fitted up as temporary lodgings, and often on summer days as many as fifty guests sat down to table. But when Millet came to Barbizon in 1849, the place was still comparatively little known, and was chiefly visited by the men who are known to-day as the masters of the School of Barbizon. Rousseau, with whom Millet was about to form the closest friendship of his life, was already living there, and Diaz, Corot, and Barye were among the most frequent of the summer visitors. In the eyes of Millet, weary as he was of Paris streets and hoardings, of riots and barricades, this quiet spot seemed another Arcady. The first sight of the forest made an indescribable impression upon his mind: the majesty of its giant trees, the solemn stillness of their shades, filled him with awe and wonder; the wild parts of the forest, its picturesque gorges and rugged crags, revived the old dreams of his childhood. He rushed to and fro in a frenzy of delight, climbed the granite boulders of the rocky wilderness, and lay on the heather gazing up at the blue sky and crying: "My God! how good it is to be here!" and he told Sensier, who came down to see him and looked on in amazement at these transports of joy, that he knew no bliss so exquisite as that of lying at full length on the heather, watching the clouds sail by.

When his first rapture of delight was over, he began to draw, not only the rich and varied forest scenery around, but the human beings and animal life which he found there—the wood-cutters and charcoal-burners; the cow-herds leading their cattle to pasture; the poachers lying in wait for game; the old women tying up faggots and bearing their load home upon their backs; the stone-breakers at work in the quarries; and the rabbits starting out of their burrows. Yet more to his taste were the subjects which he found on the great plain that lies to the north-west of Barbizon, and stretches as far as the eye can reach. On this wide, Campagna-like expanse of country peasants were to be seen at work all the year round; here, within a day's walk of Paris, some rem-nants of the beauty and poetry of pastoral life still lingered. Shepherds might still be seen abiding in the fields by night, keeping watch over their flocks; the sower still went forth to sow, and the gleaners followed in the steps of the reapers, as Ruth of old in the field of Boaz. Here, as Millet saw the labourers digging and ploughing the soil, and the women weeding and pulling up potatoes, as he watched the shepherd calling his sheep by name, and the young girl spinning or knitting while she led her flock back to the fold, he felt himself once more at home. He put on sabots, an old straw hat, brought out a red sailor's shirt which he used to wear at Gruchy, and became a peasant again. Then he looked about him for a little home of his own, where he and his family could take up their abode and lead a peaceful and sheltered life, free from the endless worry of lodging-houses and land-lords.

He soon found a cottage that suited him at the eastern end of the street, near the entrance of the forest, and next door to the house which his friend Jacque had taken. It was a low, one-storied stone building, with a tiled roof,

seventeen feet high and sixty-one feet long by sixteen
wide, with its gabled end fronting the street. Like all
the Barbizon houses, it stood in a courtyard enclosed by
a high wall, with a well and shed in one corner, where
the cows came to be milked, or the sheep to be shorn.
Beyond was a garden and small orchard, stretching to-
wards the forest, and a gate leading out into the meadows
at the back. The house itself consisted of two small
rooms, with plaster walls and raftered ceiling, each eight
feet high and about twelve feet square. There was an
outhouse which was used as a kitchen, and an old barn,
the floor of which was several steps below the level of
the street. This damp, cold room, without a fireplace,
and lighted only by one little window in the corner, be-
came Millet's *atelier*, where, during the next five years,
all his great pictures were painted. The house itself was
afterwards improved, and a new *atelier* was built by
his landlord, a peasant named Brézar, and popularly
known as the Wolf. But for the present these three
rooms were the whole accommodation in the cottage,
which Millet rented, just as he found it, for the modest
sum of 160 francs, or rather more than six pounds a year.

Such as it was, the painter and his wife lived there in
perfect contentment; the freedom and tranquillity of
his new life exactly suited him. The early mornings
were spent in digging his garden and planting vegetables
for home use, and it was with genuine delight that he
once more handled spade and hoe. Often in his walks
on the plain he would take the spade out of some
labourer's hand and, much to the man's surprise, show
him how well he could dig. After breakfast he went
into his studio and worked till sunset, when he would,
if possible, break off in time to take a run in the forest,
or, at least, watch the sun go down from the fields at
the back of his house. It was a healthy and peaceful

existence, favourable to actual work and to the gradual development of the ideas that were teeming in his brain. The first subject on which he set to work was a study of Ruth in the harvest-field of Boaz, which he sketched rapidly in charcoal on the walls of his *atelier*. The field and the labourers and gleaners were alike studies from Barbizon life, and the picture was afterwards exhibited in 1852 under the title of *Les Moissonneurs*. But he did not proceed further with this subject that autumn, and spent his time in recording the thousand impressions which he received daily from his new surroundings, and in completing half-finished pictures for Paris dealers. He was still heavily in debt to his landlord of the Rue du Delta, and knew that it would be long before he could feel himself a free man.

The following letter bears no date, but seems to have been addressed to Sensier during the first winter at Barbizon :

"Barbizon, Saturday.

" MY DEAR SENSIER,—

"When does the sale of pictures, which you mentioned, take place ? Let me know in good time, and I will bring the pictures which are ready with me, and will finish the others in Paris. In any case, I must probably come to Paris in another fortnight. I think I shall have done well if I can finish five pictures. I have also three in progress, and I have done a good deal to the *Washerwomen* for M. de Saint Pierre. I work like a slave, and the days seem to be gone in five minutes ! My wish to make a winter landscape has passed into the stage of a fixed resolve. I have also a plan for a picture of sheep, and all manner of other ideas in my head.

"If you could but see how beautiful the forest is ! I run there whenever I can, at the end of the day when my work is done, and each time I come back crushed. The calm and grandeur are tremendous, so much so, that at times I find myself really frightened. I do not know what the trees are saying to each other. It is something that we cannot understand, because we do

not speak their language, that is all; but I am quite sure of this—they do not make puns!

"To-morrow, Sunday, is the Fête of Barbizon. All the ovens, stoves, and chimneys, all the pots and saucepans, are so busy that you might believe it was the eve of Gamache's wedding. There is not an old gridiron in the place which has not been brought into use; all the turkeys, geese, chicken, and ducks that you saw in such good condition, are roasting or boiling on the fire, and pies as big as cart-wheels are being cooked! Barbizon, in fact, is turned into one big kitchen, and the fumes must fill the air for miles round!

"Tell me about the sale, and if you advise me to send any-thing. Be so kind as to give your gilder the enclosed order, and try and see that his frames are not too frightful. The gilding I care less about, but it is the shape that matters. However, he must do his best. And please send me these colours as soon as possible: three burnt Sienna, two raw Sienna, three Naples yellow, one Venetian red, two yellow ochre, two burnt amber, and one bottle of oil. That is all. Remember me to Diaz. A hearty embrace to yourself.

<div style="text-align:right">"J. F. MILLET."</div>

In his next letter he informed Sensier of his firm re-solve to keep henceforth to peasant-subjects, and pro-claims himself *le Grand Rustique* of the years to come.

"MY DEAR SENSIER,—

"Yesterday, Friday, I received the colours, the oil, canvas, etc., which you sent me, and the accompanying sketch of the picture. These are the titles of the three pictures destined for the sale in question:

"(1) *A Woman Crushing Flax*;

"(2) *A Peasant and his Wife going to Work in the Fields*;

"(3) *Gatherers of Wood in the Forest.*

"I do not know if the word *Ramasseurs* can appear in print. If not, you can call the picture, *Peasants Gathering Wood*, or anything else you choose. The picture consists of a man binding sticks in a faggot, and of two women, one cutting off a branch, the other carrying a load of wood. That is all.

"As you will see by the titles of the pictures, there are neither

nude women nor mythological subjects among them. I mean to
devote myself to other subjects; not that I hold that sort of thing
to be forbidden, but that I do not wish to feel myself compelled
to paint them.

"But, to tell the truth, peasant-subjects suit my nature best,
for I must confess, at the risk of your taking me to be a Socialist,
that the human side is what touches me most in art, and that if I
could only do what I like, or at least attempt to do it, I would
paint nothing that was not the result of an impression directly
received from Nature, whether in landscape or in figures. The
joyous side never shows itself to me ; I know not if it exists, but
I have never seen it. The gayest thing I know is the calm, the
silence, which are so delicious, both in the forest and in the cul-
tivated fields, whether the soil is good for culture or not. You
will confess that it always gives you a very dreamy sensation, and
that the dream is a sad one, although often very delicious.

"You are sitting under a tree, enjoying all the comfort and quiet
which it is possible to find in this life, when suddenly you see a
poor creature loaded with a heavy faggot coming up the narrow
path opposite. The unexpected and always striking way in which
this figure appears before your eyes reminds you instantly of the
sad fate of humanity—weariness. The impression is similar to
that which La Fontaine expresses in his fable of the Wood-cutter :

> " 'Quel plaisir a-t-il eu depuis qu'il est au monde ?
> En est-il un plus pauvre en la machine ronde ? '

"In cultivated land sometimes—as in places where the ground
is barren—you see figures digging and hoeing. From time to time,
one raises himself and straightens his back, as they call it, wiping
his forehead with the back of his hand—'Thou shalt eat bread
in the sweat of thy brow.'

"Is this the gay and playful kind of work that some people
would have us believe? Nevertheless, for me it is true humanity
and great poetry.

"I must stop, or I shall end by tiring you. You must forgive
me. I am all alone, and have no one with whom I can share
my impressions. I have let myself go, without thinking what I
was saying. I will not start this subject again.

"Ah, while I think of it, send me from time to time some of
your fine letters, with the Minister's seal in red wax, and all

possible decorations! If you knew the respect with which the postman hands me these letters, hat in hand, (a very unusual thing here!) saying with the most deferential air, 'This is from the Minister'! It gives me a distinct position, it raises my credit, I can assure you; for, in their eyes, a letter with the Minister's seal comes, of course, from the Minister himself. Such an envelope is a great possession! . . . Tell me if there is any chance of an order. And do you know how Jacque's affairs are getting on? Good-bye.

"J. F. MILLET.

"Are Rousseau's pictures producing any great effect? Are they much of a success?"

This interesting letter, in which Millet opens his heart to his friend, bears no date; but from the allusion which it contains to Rousseau's pictures, which were exhibited in Paris before their sale on the 2nd of March, 1850, it must have been written in the February of that year. The jesting manner in which he ends his letter, half-ashamed, as it were, of the confidences which he has been making, is highly characteristic. But Sensier was right in attaching especial importance to these words, in which the grave and silent man revealed his thoughts. They contain his whole philosophy of art, and were the formal manifesto in which he laid down the lines of his future work.

II

1850–1852

THIS then was Millet's discovery, this the new gospel which he had to proclaim in the ears of the modern world. Before his time the peasant had never been held a fit subject for art in France. Kings and queens, lords and ladies might play at pastorals if they chose; *le Grand Monarque* might set the fashion by appearing in the character of Apollo — *le plus beau des bergers*, leading his flocks along the slopes of Parnassus; Marie Antoinette might put on peasant-maid's skirts, and milk her cows under the trees of her elegant dairy; but the *bergeries* of Trianon and the *paysans enrubanés* of Watteau's *Arcadia* were as far removed from reality as possible. The polite world remained convinced of the truth of Madame de Staël's saying, and agreed with her that *l'agriculture sent le fumier*. A group of peasants drinking or quarrelling, a picturesque beggar, or even a pair of humble lovers at a cottage door might be tolerated; but no one was so audacious as to attempt the prosaic theme of a labourer at his work.

This Millet was the first to do. Born himself of a long race of yeomen, and familiar with every detail of rustic toil, he was admirably fitted both by nature and education for the task. He saw the dignity of labour, and knew by bitter experience the secrets of the poor. And the pathetic side of human life had for him an especial attraction. "The gay side of life," he had said in his letter to Sensier,

"never shows itself to me; I know not if it exists, but I have never seen it." Like the great Roman poet whom he loved from his boyhood, he was profoundly conscious of the pathos of human life and the unsatisfied yearnings of the human heart. The sight of the struggling masses of toiling humanity filled him with sympathy; the hardship and monotony of the labourer's daily lot, the patient endurance that comes of long habit, touched his inmost soul. In his eyes this was true humanity and great poetry.

And more than this, he looked on the peasant with the eye not only of the poet but of the artist. He realized from the first the close relation that exists between the familiar sights of every-day life and the noblest works of art; saw that there might be action as heroic, and beauty as true, in the attitude and gesture of a peasant sowing or a woman gleaning as in the immortal forms of Greek sculpture. That natural instinct for beauty of line, that keen appreciation of form which revealed itself in the boy's charcoal-drawing of the old man bent double with age, led him to note every gesture and movement in the people about him, just as it made him find such keen delight in the drawings of Michelangelo. When, in his struggling Paris days, he proposed to make drawings of reapers at work, "in fine attitudes," his friend shrugged his shoulders and shook his head at this strange suggestion. But in the end this was exactly what Millet did, and the world to-day no longer laughs at his *Sower*, or *Gleaners*. He knew, as few masters have ever known, how to put a whole world of thought into an individual action, how to express the lives and character of bygone generations in a single gesture; and with true poetic insight he makes us realize the deeper meaning that lies hidden below the eternal destiny of the human race, the age-long struggle of man with Nature, which will endure

while seed-time and harvest, summer and winter, follow each other upon the face of the earth.

The first page in Millet's great epic of labour, the first celebrated picture which he painted at Barbizon, was the *Sower*. Long ago, in the days of his youth at Gréville, he had sketched the figure of a peasant scattering grain in the furrows as he walks along. That little pen-and-ink drawing, in its few strokes, contains the germ of the future work. The pose and movement of the figure, the measured step, and outstretched arm are there already; the rusty felt hat sunk over the young labourer's brows, the very shape and cut of his clothes, the sack of grain at his side, even the oxen ploughing in the background, are all indicated.

From this slight sketch the artist, after his wont, slowly and painfully evolved his noble work. He has left us several drawings which enable us, step by step, to follow the development of his idea through its successive stages. We see how the figure gradually gained in breadth and vigour, and by degrees acquired that solemn majesty and rhythm, until the homely theme became a grand and sublime poem. All through the winter and spring-time at Barbizon, surrounded as he was by country sights and sounds recalling the old life, he brooded silently over that first impression of his early days. He thought of the serious meaning of the sower's task, of the great issues that hang upon the seed-time, and of the new life that germinates in the grain that he casts abroad to supply the bread of the coming years. He remembered the old custom, still practised in his boyhood, of uttering a few words of prayer, and sowing the first seed in the ground in the form of a cross. And as he meditated over these old memories, the great picture grew into being, and he painted that wonderful form of the Sower, striding with majestic tread across the newly-ploughed field, flinging the precious seed broadcast. Night is falling, the shadows

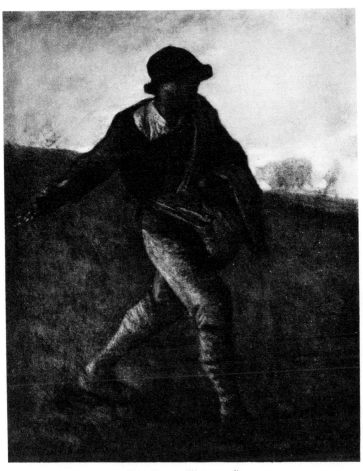

Le Semeur (The Sower)

are lengthening over the wind-swept fields, and scarce a
gleam in the western sky lights up the winter landscape ;
but still he goes on his way, careless alike of the coming
darkness or of the flocks of hungry crows that follow in
his track. In that solitary figure, with his measured
tread and superb action, the whole spirit of the peasant's
calling is summed up with a power and concentration of
thought worthy of Michelangelo.

The first version of *The Sower*, Sensier tells us, was
executed at fiery speed, in the white heat of the painter's
glowing imagination. But when he had almost finished
the picture, he found to his dismay that the canvas was
too short, and would not allow sufficient room for the
ground on which the sower's front leg rests. Accordingly
he traced the lines of his figure on a larger canvas, and
produced an exact replica of the original, which was
finished in time to appear at the Salon held in the Palais
Royal at the close of 1850. The impression which it made
was twofold : on the one hand, the older and more con-
ventional critics declared *The Sower* to be a revolutionary
work, plainly conceived on Socialist lines by a painter
who wished to protest against the cruel tyranny of the
upper classes and the misery of the poor. Some ingenious
persons went so far as to see in this " severe and threaten-
ing figure " a Communist, who is flinging handfuls of shot
at the sky in open defiance of God and man ! On the other
hand, it attracted the admiration of all the younger school
of artists, and was greatly praised by at least one critic,
Théophile Gautier, who recognised its rare merit, and
described it in eloquent language as the finest picture of
the year.

This *Sower*, exhibited in the Salon of 1850, soon found
its way to America, and has for many years been the
chief ornament of the Vanderbilt collection. The first
and smaller picture is also in the New World and is

now the property of Mr. Quincy Shaw, of Boston. In later years Millet made several drawings and pastels of the same subject, which had already acquired a wide popularity. But this time his model was a Barbizon peasant. Instead of the white oxen, two horses were harnessed to the plough, the plain of La Bière took the place of the Norman moorland, and the ruined tower near Chailly was introduced, with a clump of trees in the background.

Together with *The Sower*, Millet sent another picture, *The Hay-binders*, to the Salon at the Palais Royal. This was a group of labourers binding newly-cut hay in trusses at the foot of a haystack, while a young girl at their side collects the last rakings of the meadow. Here again the vigorous action of the men, and the blazing heat of the June day, were given with remarkable truth; but the colour was heavy in tone, and the picture passed comparatively unnoticed by the side of *The Sower*.

Gautier's criticism of these two works pleased Millet, and he frankly owns the justice of a remark which that writer had made on the meanness of his colouring in *Les Botteleurs*—the hay-binders.

"Gautier's article," he writes on the 23rd of March, 1851, "is very good. I begin to feel a little more contented. His remarks about my thick colours are also very just. The critics who see and judge my pictures are not forced to know that in painting them I am not guided by a definite intention, although I do my utmost to try and attain the aim which I have in sight, independently of methods. People are not even obliged to know why it is that I work in this way, with all its faults."

Millet was probably alluding to the journalists who tried to discover political theories and Socialist tendencies in his peasant - pictures—a form of criticism which he naturally resented as unjust and absurd. The same

letter to Sensier contains a touching expression of Millet's grief at the sudden death of a mutual friend, Longuet:

"I am still stupefied and astounded at the news of the death of poor Longuet. I am very much pained, not only because of the suddenness of his death—only very lately he came to see me at Laveille's, and appeared in as good health as he had ever been—but because I have always held him to be a very worthy man. What a frail machine this body of ours is! I believe he was married, but I did not know his wife. Did he leave any children? I heard from Jacque a few days ago. The commission, he says, has fallen through; but they will get up a subscription of 2,000 francs, which is something, and even a very agreeable gift, if only half the sum which he expected to have."

The next day Millet opened his letter again, in great distress at the sudden illness of his little daughter, Marie, a child of five. He had a profound distrust of the country doctor and of his drugs, and anxiously begs Sensier to send him a bottle of medicine from Paris.

"Monday Morning.

"Yesterday evening, Sunday, when I was writing to you, and had got as far as you see above, I was forced to interrupt my letter to attend to my eldest girl, who had been suddenly attacked by a violent fever. She played during the day as usual, but asked to be put to bed while she was eating her dinner, and complained of being cold. I passed the night with her, applying, according to Raspail's method, bandages soaked in sedatives; but it did no good, and the fever developed to a formidable degree. I am suffering the greatest anxiety. Generally speaking, I have very little confidence in physicians, and much less in the one at Chailly than in any other. How and what is to be done? I have just bathed her again. . . . Poor little girl! so gay all day and in a moment stricken by this sudden fever. Whether I send or not for the horrid doctor at Chailly, oblige me by buying and sending by the coach a bottle of camphorated ammonia as soon as you get this note. Perhaps you will not read my letter before to-morrow evening; but if by any chance you happen to be at home during the day, buy the bottle, and send it by the coach that leaves at

I

four o'clock. In any case do this on Wednesday, and I will go to Chailly to see if it arrives. I hope I may have no need of it when it reaches me, but it may be required at any moment. Good-bye. The fever does not diminish.

"J. F. MILLET."

This letter reveals all the man's tenderness of heart, and gives a faithful picture of his life at Barbizon, divided as it was between the practice of his art and family cares. Fortunately, the child recovered and the anxious father was able to return to his work.

It was his habit at this period of his life to take up his pictures to Paris, and finish them either in the *atelier* of his friend Diaz or at the shop of Laveille, the dealer who bought most of his early drawings and whose name is constantly mentioned in his letters. Here he met other artists and became acquainted with collectors who gave him new commissions.

Of the three smaller works painted in 1850, which Millet sent to the sale mentioned in his former letter, the most important was *Allant Travailler*—a peasant and his wife going out to work. This well-known picture was one of the painter's first Barbizon impressions, and proved so popular that he afterwards reproduced the same theme in a variety of drawings and pastels. In this young couple starting for the fields together, there is a spirit of frank and cheerful enjoyment, seldom found in Millet's works. The young labourer, in his straw hat and blouse, steps blithely along, with his hand in his pocket and his fork upon his shoulder, his wife walks at his side, in her short petticoats and sabots, carrying a stone pitcher in her hand and wearing her basket on her head, to protect her from the heat of the sun. Their bright faces and brisk steps are in tune with the pleasant fresh-ness of the early morning and the happy spring-time of life, when toil is easy and action full of delight. Every

detail in the landscape—the tufts of grass at their feet, and the plain behind them—is reproduced with loving care, and in the distance are the roofs and houses of Barbizon.

This charming little work was promptly bought by a Paris tradesman, named Collet, who was so pleased with his purchase that he ordered a figure of the Virgin as a signboard for his draper's shop in the Rue Notre Dame de Lorette. Accordingly Millet painted a blue-robed Virgin, clasping the Child Christ in her arms, and resting her feet on the crescent of the moon. He executed the work in the courtyard of a neighbour in open daylight, and fixed his canvas on the top of a ladder on a level with the roof, that he might better judge of the effect which it produced at this height. He writes to Sensier on the 18th of December, 1851 : " If you see Collet, tell him that he shall soon have his signboard, only I must have a few days of dull weather before I can finish it." During many years this blue-robed Virgin hung outside M. Collet's shop at the corner of the Rue Notre Dame de Lorette and Saint Lazare, a familiar object to passers - by. Constant exposure to weather made repeated restorations necessary, and when, after often changing hands, it came into the possession of its present owner, M. Morel, several coatings of paint were removed, and the surface was carefully cleaned. In spite of its damaged condition, this picture was exhibited in London some years ago, and attracted considerable attention. The Virgin is of distinctly peasant type, but has a nobleness of character and simple dignity not unworthy of Millet. Her eyes are turned heavenwards with a calm and trustful gaze, and the tiny babe on her arm, in its weakness and helplessness, recalls the child of Holbein's Darmstadt Madonna.

Another picture which belonged to these first years at

Barbizon, was the small canvas of *Les Couseuses*, or young women sewing at home. " They are not professional needlewomen," Millet was always careful to insist, " but women engaged in mending the household linen in their own homes." The artist had an example of domestic industry constantly before his eyes in his own wife, who sat to him about this time as a model of his drawing of *Young Women Sewing*, which was bought by his friend Campredon. The picture of *Les Couseuses* had one good result—it brought the painter an order from the State.

M. Romieu was at that time Director of the Fine Arts, but although a cultivated man, he took little interest in art, and owned frankly that he knew nothing about painting. When Sensier addressed a request to him through his secretary on Millet's behalf, he was told that inquiries must first be made as to the artist's political views and moral character. There were influential persons, it appears, who had an idea that the painter of *The Sower* must be a demagogue and agitator. Accordingly, inquiries on the subject were addressed to the Prefect of the department of Seine-et-Marne, who replied that Millet was a very quiet and well-conducted citizen, who was rarely seen and seldom heard of at Barbizon, and that he spent his whole life in painting at home or in taking walks by himself in the neighbourhood, watching the sky and the trees. These accounts of his character were so far reassuring. Unfortunately, the artists whom M. Romieu consulted as to Millet's capabilities, described him as a pretentious and eccentric personage, who went his own way and rejected the great traditions of the past. This was sufficient to excite suspicion in the Director's mind, and, to Sensier's disappointment, his appeal met with no response. As a last resource, he took Millet's picture of *Les Couseuses*,

and, carefully concealing the painter's signature, he asked his friend the secretary to hang it in M. Romieu's rooms, and see what impression it produced upon the Minister and his friends. This simple and graceful little canvas certainly bore no trace of the dangerous opinions that Millet was supposed to hold. Before long its quiet charm attracted the notice of more than one visitor. One day it caught the eye of Paul Delaroche, who stood still before it during several minutes, and asked the Director to tell him the name of the painter. "It must be the work of some new man," he remarked; "I have seen nothing like it before."

In reply, he was told that the little picture had been painted by an artist named François Millet, who was said to be a mere peasant. Delaroche recognised the name at once. "Millet!" he exclaimed, "why, he was my own pupil. I am not at all surprised; he was full of imagination, and had a vigorous method of his own."

After that, Sensier had no difficulty in attaining his object. The order from the State was signed at once. Millet received 600 francs in advance, and was desired to paint any subject which he liked to choose, and to deliver the work at his own convenience. The commission reached him in 1852, at a time when he was in great want of money and hard pressed by his creditors. He was still hampered by his old debts, and found, to his surprise, that at Barbizon he could not live upon credit, as he had done in Paris. The small Chailly tradesmen naturally asked for ready money, and were little disposed to trust a struggling artist with a large and yearly-increasing family. Before long, Millet found himself surrounded by a whole tribe of angry shopkeepers who clamoured for payment of their weekly bills, and threatened to stop supplies. The baker refused to let him have any more bread, the grocer sent

him a lawyer's letter, and one day a tailor put an exe-
cution into his house, and sent bailiffs to sell his furni-
ture, refusing to allow him a single day's grace. In
these straits, Millet wrote urgent letters to Sensier,
entreating him to sell his pictures

"Try, my dear Sensier," he wrote, "to make money with my
pictures ; sell them for whatever price you can get, and send me
100 francs, or even 50 or 30, for the time is rapidly coming when I
must have the money or starve."

These appeals were especially frequent at the end of
the month, or quarter, when impatient creditors refused
to be put off with promises any longer. And Millet,
it must be owned, was a thoroughly bad man of business,
incapable of managing his own affairs, and an easy
prey to the neighbours or false friends who tried to
impose upon his credulity.

His health was another cause of trouble. He suffered
from constant headaches, partly caused by the un-
healthy atmosphere of the damp, close barn in which
he worked, and was often unable to paint for weeks
together. At such times his courage sank, and his
anxieties assumed alarming proportions which prompted
the despairing utterances that we read in his letters to
Sensier. But a single ray of hope—the sale of a picture
or a fresh order—quickly produced a revulsion of feeling.
His headaches were cured, the sun shone once more in
the heavens overhead, and he went back to work with
new ardour and hope. His love for his art and his faith
in himself never failed. If he could but struggle on
for a few years, he firmly believed that a better day
would come, his pictures would begin to sell, and the
world would acknowledge the truth of the principles
which he maintained. For the present he must wait
and work on in patience. "In Art," he often said, "you
have to give your skin."

III

1851–1854

WHILE Millet was painting immortal pictures and wrangling with his creditors at Barbizon, sad news came from his old Norman home. His mother and grandmother had their troubles, and found it hard to get a living for their large family out of the few acres of their Gruchy farm. Wheat was dear, and poverty widespread; the roads swarmed with beggars, and the poor women could no longer feed the needy travellers who knocked at their doors. They heard with dismay of the disturbances in Paris, and lay awake thinking of the dangers to which François was exposed. At last they learnt with relief that he was at Barbizon, out of reach of riots and barricades. Then in 1850 came the news of the success of his *Sower*, and the good old grandmother thanked God for her boy. But her own strength was failing fast; she was partially paralysed, and could hardly move, but still managed to write pious exhortations to her beloved François. Her mind remained clear and vigorous to the last, and she met death with the serenity of some aged saint. She died early in 1851, talking of François, the Benjamin of her heart, with her last breath, and sending him her love and blessing.

The news of his grandmother's death was a great shock to Millet. For days he hardly spoke, and refused to see any one but his wife and children. With them he recalled every detail of her beautiful life, and spoke

of her care of him as a child, of the unselfishness of her affection, her deep piety and firm principles. "And to think I should never have seen her again!" he repeated again and again in the bitterness of his grief. His thoughts now turned with fresh yearning towards his mother, who was ill and suffering, and filled with anxiety for the future. Her daughters had married, her sons were leaving the country; the farm could no longer suffice for their support, and the poor mother thought with a sigh that at her death the home would be broken up, and the land, which the Millets had owned for hundreds of years, divided among strangers. And amid these sad forebodings she poured out the sorrow and longing of her soul in a tender letter to her eldest son:

"My dear child," she wrote; "you tell us that you are very anxious to see us, and are soon coming here to pay us a long visit. I am very anxious to see you too, but it seems that you have not the means to come. How do you manage to live? My poor child! when I think of this, I am very unhappy. Oh! I hope you will come and take us by surprise when we least expect you. As for me, I cannot either live or die content, so great is my longing to see you. Here times are hard and life is sad for us all. The wind has parched up the ground, and we know not what to do with the animals. They are dying of hunger. The corn is bad and the price of wheat seven francs a bushel. And the taxes must be paid and all the household expenses.

"I have been very neglectful in not writing for so long, because I thought you would come before the summer was over. But now it is almost gone. Yet we are very anxious to see you.

"I have lost everything, and nothing is left me but to suffer and die. My poor child, if you could but come before the winter! I have a great desire to see you once more before I die. I think of you oftener than you imagine. I am so weary of suffering both in body and mind, and when I think what is to happen to you all in the future without any fortunes, I can neither sleep nor rest.

"Tell me how you are getting on, if you have work, and are well paid, and if you can sell your pictures. It is strange that you have not told us a word about all these revolutions in Paris. Is it true that all these things are happening there? Tell us something about them. I am always so afraid that you will be dragged into them. Will you come here soon? If I had but wings, how I would fly to you! As soon as you receive this letter, write back to me. I end by embracing you with all my heart, and remain, with all possible love, your mother,

"VEUVE MILLET."

This pathetic appeal went to Millet's heart. He longed to leave everything and hasten to his mother's side. But he had neither time nor money for the journey. The birth of a fourth child in 1851 made it impossible for him to leave his wife that autumn, and all the next year he was busy painting new pictures for the Salon and bargaining with dealers, who bought his drawings for trifling sums, in order, if possible, to free himself from the load of debt which oppressed him. The journey to Gréville was put off, month after month, and he could only write affectionate letters to his mother, promising that he would come to her as soon as possible. So the faithful soul waited and sat in the old home on the cliffs by the sea, listening for the step of her boy, and hoping every day to see him open the door and walk in. But the weeks became months and the months became years and François never came. His mother's asthma grew worse; she became rapidly weaker, and could write no more. But she still watched and waited and believed to the last that he would come. At length, one day early in April, 1853, she died with François' name upon her lips.

Millet's grief was inconsolable. He shut himself up in his studio, and abandoned himself to his despair. A few days afterwards he sent Sensier the following note:

 "Monday evening, 26 April, 1853.

"My dear Sensier,—

 "I write to tell that my poor mother has just died. I am in a state of misery which no words can describe. I try to work, but it is impossible to forget my pain. It is a terrible blow for me and for those of my sisters who are still at home. I cannot understand how they will manage to live. I am in the most frightful condition of grief and anxiety. I clasp your hand.

 "J. F. Millet."

It was then in his bitter grief, as he thought of his poor mother's last words, of her longing to see him and of her patient years of waiting, that the idea of his picture, *L'Attente*, first came into his mind. He took out his old Bible and read the familiar tale of Tobit and his wife, and remembered how they too had waited and looked for their son's return. And then and there he made a sketch of two aged parents, sitting at the door of their cottage in the forest, straining their eyes towards the distant horizon, where the sun is setting, in the vain hope of seeing the wanderer return. Even so in the old home, his mother and grandmother had waited for the son who never came, and for the footstep which they were to hear no more. The picture, which he painted some years later and exhibited in the Salon of 1861, is one of the most pathetic poems with which he was ever inspired. It was bought soon afterwards by an American collector, and, like so many of Millet's finest works, is still in the New World.

The death of Millet's mother made a visit to Gréville necessary. His brothers wrote that without him it was impossible to divide the property or make any definite arrangements. Fortunately, he had succeeded in selling a few pictures and had finished three important works for the Salon of 1853. So he decided to start at once, and set out for Normandy on the 5th of May, after sending Sensier the following note:

"Tuesday, 3rd May, 1853.

"MY DEAR SENSIER,—

"My brothers and sisters write that my presence is indispensable and that I must go and help them arrange their affairs. Little as I understand business, they say I must be there. I start on Thursday. I do not know if I shall be able to see you before I set out on my journey. Anyhow, this is to say good-bye and to wish you good health. I shall probably be away a month.

"J. F. MILLET."

That week the eight children of Jean Louis Millet met at Gruchy and divided their modest inheritance. François gave up his share in the house and land to his brother Auguste, who was to remain at Gruchy, and only asked for his great-uncle Abbé Charles's books, and the great oak cupboard which had been handed down for many generations in the family, and had stood in the house for hundreds of years. And he begged that the ivy which trailed round the lattice casement of the kitchen and over the old stone well should be left untouched, a condition which has been faithfully observed by his brother, and after him by the widowed sister-in-law, who now lives in that portion of the house.

The sight of the old cliffs, the view of the sea, which he had loved from his childhood, stirred the painter's heart to its depths. He found time to take sketches by the seashore, and his youngest brother Pierre, now a lad of nineteen, was proud to carry his easel and canvas and to watch him at his work. He made drawings of the big hearth, where the whole family used to assemble at evening, and of the brass *cannes* and kettles on the kitchen shelves. He even insisted on carrying off one of his mother's large brass water-pots, which he kept as a precious relic in his house at Barbizon. These familiar scenes naturally revived many of his saddest

memories. He missed his mother and grandmother at
every turn, and felt so wretched away from his wife
and children that he shortened his stay and hurried
back to Barbizon. But his love for his native soil was
as strong as ever, and he left Gréville with the fixed
intention of bringing his family there, as soon as pos-
sible, for a longer visit.

Fortune now began to turn a kinder face upon him.
His pictures in the Salon of 1853 had been favourably
received by the critics, and were all three sold before the
end of the summer. The largest and finest of the three
was his *Ruth and Boaz*, or, as it was called in the
catalogue of the Salon, *Le Repas des Moissonneurs.* This
composition, which had engaged his attention ever since
his arrival at Barbizon in 1849, represented a group of
reapers taking their mid-day rest in the shade of a
wheat-rick. In the fore-front a farmer is seen laying
his hand on the shoulder of a young girl who has been
gleaning the ears of corn, apparently without his leave.
The Biblical character of the composition was plainly
felt. This peasant, wrote a journalist, might easily pass
for Boaz, and this startled gleaner might be Ruth her-
self. The artist himself had taken infinite pains with
his subject, but had not been satisfied with the result.
" I feel," he said disconsolately, " like a man who sings
in tune, but with a voice so weak that he can hardly
make himself heard." Yet the best critics recognised
the excellence of his intention and the vigour and
originality of his execution.

"M. Millet's Reapers are certainly not handsome," wrote
Théophile Gautier ; "he has not copied them from the Belvedere
Apollo. Their noses are flat, their lips thick, their cheek-bones
prominent, their clothes coarse and ragged. But in all this we
see a secret force, a singular vigour, a rare knowledge of line
and action, an intelligent sacrifice of detail, a simplicity of colour

which give these rustics a proud and imposing air, and at times recall the statues of Michelangelo. In spite of their poverty and ugliness, they have the majesty of toilers who are in direct contact with Nature."

Another able critic, who in that Salon first recognised Millet as the interpreter of a new idea, and pronounced him to be at once the strongest and most poetic artist of the day, was Théodore Pelloquet. This discerning writer was not personally acquainted with Millet, and did not even know the painter by sight. But he was one of the first to recognise the presence of a new and powerful element in art, and to the end of his life he never ceased to speak of Millet as a great man, whose genius would one day be recognised as the glory of his age.

Millet obtained a second-class medal at the close of the Salon. His *Reapers* was bought by an American, Mr. Martin Brimmer, who has a fine collection of the master's pictures and drawings in his house at Boston; and his two smaller pictures—*A Shepherd of Barbizon*, and *A Young Woman Shearing a Sheep*, the first idea of his *Grande Tondeuse*—were both bought by another citizen of the United States, who had lately settled at Barbizon, the artist William Morris Hunt.

At the same time a distinguished connoisseur, M. Atger, bought several of his drawings, and he received an order for a picture from a Dutchman who had seen his works in the Salon. He writes to Sensier respecting this last-named patron on the 15th of November, 1853.

"MY DEAR SENSIER,—

". . . *À propos* of the man from Holland, here are some considerations. The sum of 500 francs is not to be despised—far from it ; but I should like, if such a thing were possible, to raise my

prices. You will tell me, and I am ready to accept your decision, whether it is best at this time to say Yes or No. At the same time, if it is not too much trouble, ask for 600 francs, and make it appear that I will not paint the two pictures for less. But if it is already understood that he will not give more than 500, take it upon yourself to settle the matter at that price. All this is very perplexing, but I am afraid, on the one hand, of raising my prices unreasonably ; on the other, of working too long for low prices. *Sacré nom de Dieu!* all this seems foolish, and perhaps after all it will be better simply to say that I cannot do the work for less than 600 francs. Really this irresolution is foolish ! Once for all, I will not take less than 600. It is not so much a case of bargaining for 100 francs more or less—although that is the sum which I insist upon—but 300 francs sounds to me a much larger sum than 250 ! It seems to me half as much again.

"As for the Feydeau order, that pleases me perfectly. Bring the canvases and panels of the proper sizes, and we will talk over the subjects which are to be painted on them."

This letter, which is one of those not included in Sensier's book which has been lately published by Mr. Bartlett, is interesting as showing a resolute effort on Millet's part to obtain a fair price for his pictures. It may also be taken as a proof that at this time he was in no want of work. He was engaged in finishing this commission for the "man from Holland," when one day in January he received a visit from a stranger, who had been privately directed to his *atelier* by his good friend Rousseau, and who immediately bought a picture. He hastened to inform Sensier of the good news, and at the same time to make his usual request for a loan of ready money.

"Barbizon, Thursday, 19 January, 1854.
"My dear Sensier,—
"On Saturday last I received a letter from a M. Letrône, whom I do not know, asking if he might come and see me at

Barbizon, and when he would find me at home. I replied that he might come when he liked. He came yesterday, and bought my *Women Putting Bread in the Oven* for 800 francs, and another little picture which I am to make from a sketch which he has seen for 400 francs. This gentleman has a son who has been, and, for all I know, may be still, a pupil of Rousseau.

"I am working, in spite of frequent interruptions, at my picture of *A Woman Sewing by the Light of a Lamp* for the Dutchman. It is already in a forward state, but trivial matters disturb me too often.

"This is what I have to ask of you. Do me the kindness, if you can, to send me a sum of fifty francs, and any more you can spare. I will pay you back directly I get an instalment of the money due to me, either from M. Atger, or from the Dutchman, or one of fifty others. Since my funds were running low, I meant to devote a day to make a drawing or two for Atger, but my work has been hindered by violent headaches, and I have reached the bottom of my purse. If you can let me have the money, please send it at once—*at once* I repeat, for I have literally only two francs left. You will tell me that I ought not to have put off writing to you so long, but even the day before yesterday I was lying down like a calf all day, and yesterday this visit took up my time.

"J. F. Millet."

Happily for Millet M. Letrône's orders did not end here. He came back again a few weeks later and ordered two more pictures. One of these was that fine composition of a *Woman Feeding Hens on the Steps of her House*, for which the painter received 2,000 francs —an enormous sum in his eyes.

For the first time in his life Millet felt himself a rich man. He repaid Sensier's loan, satisfied his most pressing creditors, and set off in June with his whole family for Gréville.

On Sunday, the 18th of June, 1854, he wrote to Sensier in high spirits:

"I start for my Normandy to-morrow, Monday. In the words

of the old song, '*Je vais revoir ma Normandie.*' At least we go to Paris to-morrow, and start on Tuesday, so that the children may not be too tired when they begin their journey in the diligence, of which they will have had enough by the time we reach Cherbourg! I know not if I shall find you; it will not be my fault if I do not. I wish you good health, and say, *Au revoir !* I hope to return in a month's time. All good wishes!

<div style="text-align:right">"J. F. MILLET."</div>

His visit to Gréville was to last a month, but Millet put off his return day after day, and in the end he remained there four months. It was a period of great interest and importance in the artist's career. At first the sight of the altered home brought tears to his eyes. The old house had been divided, and the inmates were scattered far and wide. Some were dead, others were gone. Of all the brothers and sisters who had grown up under the same roof, but two were left. One was Auguste, who still inhabited his father's house, under whose roof Millet and his family took up their abode; the other was his beloved sister Emilie, who had married a Gréville farmer named Lefèvre, and who welcomed François and his family with the warmest affection. By degrees the first painful impression passed away, and he felt himself at home again. He put on blouse and sabots, joined his old comrades in the harvest-field, and shared in their labours as he had done in old days. His brother Pierre, who was also bent upon making art his profession, and was now studying sculpture in Cherbourg, came to spend Sundays at Gruchy, and declared that he had never seen François in such fine spirits before. He forgot his own cares and the troubles of the political world, and never even read a newspaper. "The poetry of the fields," writes Pierre, "filled his soul completely." His old delight in the rocks and in the

sea, in the wild moorland and in the green pastures and orchards returned. He revisited the favourite haunts of his childhood with his wife, and sketched every corner of the ancestral domain with religious care. The house and garden, the barns and stables, the orchard and meadows, even the cider-press and the yard, were all faithfully recorded in his sketch-book, and supplied him with subjects for many a picture in years to come. The old elm-tree under the window, " gnawed by the teeth of the wind, and bathed in aerial space," which had played so great a part in his young dreams, the laurel bush fit for Apollo, the cattle feeding on the short grass on the top of the cliffs at the edge of the sea, were all painted in turn. He made excursions with his wife to the ancient farmhouses and decayed mansions, which he used to visit with his old great-uncle. He went to the Hameau Cousin, and the Priory of Vauville, and took hasty pencil sketches of all these places, which he afterwards outlined carefully in pen and ink, or washed over with colour. During the four months which he spent at Gréville, he painted as many as fourteen pictures, and finished upwards of twenty drawings, besides filling two complete albums with studies. The impressions of his youth were revived and strengthened, and he returned to Barbizon with an inexhaustible store of material for future use.

Once evening, on his way back from some distant walk, he paused at the door of the little church of Eculleville. The Angelus was ringing, and he went inside. There the figure of an old man kneeling before the altar caught his eye. He waited, and presently the old priest rose from his knees and touched him gently on the shoulder, saying in a low voice, "François!" It was his first teacher, the Abbé Jean Lebrisseux.

" Ah! it is you, my dear child, little François!" the

K

good old man cried ; and they embraced each other with tears in their eyes.

"And your Bible, François, have you forgotten it?" asked the Curé presently. "The Psalms you were so fond of—do you ever read them now?"

"They are my breviary," replied Millet. "It is there I find all that I paint."

"I seldom hear such words nowadays," said the old Abbé, with a sigh of thankfulness. "But you will have your reward. And Virgil—you were very fond of him in old days."

"I love him still," replied Millet.

"That is well. I am content, my son," said the old man. "Where I sowed, the blade has sprung up. It is you who will one day reap the harvest, my child."

And so they parted.

The summer months slipped by, Millet went back to Paris, and the good old priest, who had loved him as a father, never saw his face again. But his prayers had been answered, and he could die happy.

IV

1854–1855

WHILE Millet was absent at Gréville that summer
his cottage home at Barbizon had been con-
siderably improved. The three-roomed house was too
small for his increasing family and frequent visitors;
and his landlord, the Wolf, as he was called in the
village, seeing that he had in Millet a permanent tenant,
agreed to make certain improvements in the house.
The old barn in the corner of the garden, alongside of
the street, was fitted up as a studio : the roof was
ceiled, a wooden floor—a luxury seldom known in Bar-
bizon—was laid down, a large, clumsy window was built
at one end, and opened in the north wall, looking on
to the street. This old grange, which had served as a
shelter for cows and horses, or a storehouse for grain
and hay, now became the painter's permanent studio.
Here, during the next twenty years, all his great
pictures and all his famous drawings saw the light.
Here the foremost artists of the day—Rousseau and
Corot, Diaz and Barye—watched him at work and sat
for many an hour in the big arm-chair in the corner.
Here, long after he was dead, his admirers from all
parts of the world came in a ceaseless stream to visit
the spot which was so closely associated with his
memory. To-day the studio is still standing, but the
interior has been completely altered, and the whole
place wears a new and modern look. In Millet's time
the walls were neither papered nor stained ; three or

four easels, a couch covered with chintz, and a table heaped up with a disorderly collection of brushes, chalks, books and papers, were the only furniture. A green curtain was drawn over the lower part of the window, and an iron stove stood near the easel at which Millet usually worked. A few casts of the Elgin marbles and the Column of Trajan, a bust of Clytie and a head of Achilles stood on shelves along the wall; while in one corner of the room lay a whole heap of blouses and aprons of every shade of blue—some of the deepest indigo, others bleached almost white from constant exposure to sun and air. Here, too, were handkerchiefs for the head—*marmottes* as they were called in Millet's old home—cloaks and skirts of faded hues, more beautiful in his eyes than the richest stuffs. Blue, he told one of his American friends, was always his favourite colour; and it certainly holds a prominent place in his pictures. On the floor, heaped together in careless confusion, lay piles of canvases in various states of progress—some only lately begun, others which had not been touched for years.

When this new studio was fitted up, the old *atelier* was converted into a dining-room, communicating with the rest of the house, and the hen-house was replaced by a small kitchen. Millet himself, after his return from Normandy, built a hen-house of rough stones which he brought from the forest, and thatched it with his own hands. He still cultivated the garden himself, and besides growing vegetables for his own use, he planted vines and fruit-trees on the walls and filled the little courtyard with fragrant flowers. During his absence at Gréville the vines and creepers had climbed up the walls of house and studio, and on his return he found nasturtiums, morning-glories and briar-roses growing together in a tangled thicket. This wild beauty charmed

him, and he wrote to Pierre that his garden was turned into a perfect fairy-land. After the property was bought by Sensier some years later, further improvements were made, and by degrees the little place became a pleasant and comfortable home. At one time Millet thought of building a house and making himself what he called a nest of his own. But the dread of becoming involved in fresh liabilities made him give up his plan ; and he remained to the end—what he always declared his grandmother had taught him to detest—the tenant of another man's house.

His friend Jacque, who had originally taken the neighbouring cottage, soon quarrelled with the Barbizon peasants, and before long made himself hated in the village. The boys chalked impertinent names upon his doors, and teased him in every possible way ; and the indignant artist was often to be seen standing in the street holding a furious dialogue with a crowd of women and children, who often proved more than a match for him. Before many years were over these annoyances increased to such a pitch, that he sold his property to Sensier and left Barbizon.

Millet never stooped to these quarrels and often annoyed Jacque by his endeavours to bring him to reason. He led a quiet and reserved life, attending to his own business and seldom mixing with his neighbours. He was never to be seen at the inn, excepting on the occasion of some rare festivity, when it would have seemed unfriendly to hold aloof. At the marriage of Père Ganne's daughter to the Arras painter, Eugène Cuvelier, he and Rousseau decorated the barn with ivy, and Coret opened the ball and led the bottle-dance to the tune of rustic violins. Empty bottles were placed in rows along the floor, and the man or girl who knocked one over was out of the dance. They began slowly and

danced ever faster and faster, until they ended in a furious gallop, and the last remaining dancer received a flower from the bride as his reward. Millet with his wife and friends were all present on that occasion, but as a rule they had little to do with the artists who thronged to Père Ganne's or Siron's hostelries during the summer months, or with the peasants of Barbizon.

The only persons with whom Millet associated were a few intimate friends, who, like Rousseau and Barye, made Barbizon their home, or who, like Sensier and Campredon, or Diaz, came down there on occasional visits. Foremost among the residents at Barbizon during the first years that Millet spent there, was the American artist, William Morris Hunt. He was a pupil of Couture, who had known Millet in Paris, and who, moved with enthusiastic admiration for the man and his works, had followed him to Barbizon. Here he lived in almost daily intercourse with the painter during the next five years, sharing his closest intimacy and entering with warm sympathy into his trials. More than once this genial and kindly soul came to Millet's rescue in his hour of sorest need, and helped him in the most generous and thoughtful way. He it was who bought both of the small pictures which Millet exhibited in the Salon of 1853—*The Young Shepherd* and *The Woman Shearing Sheep*—and who first introduced his works to the notice of American connoisseurs. In 1855 Hunt, who was himself a frequent exhibitor in the Salons, left France to return to the United States, and settled in Boston, where he attained considerable reputation as a landscape painter, and spread the fame of the Barbizon master far and wide among his countrymen on the other side of the Atlantic. When first he became acquainted with Millet, he must have been quite a lad, and he was not yet thirty when he returned to Boston.

Sensier scarcely mentions him, but he played an important part in Millet's life at this period; and although his name does not often appear in his letters to Sensier, he once told another of his American admirers, Edward Wheelwright, that William Hunt had been the best and most intimate friend that he had ever had.

The presence of Hunt brought other citizens of the New World to Barbizon, and a little colony of American artists soon grew up round Millet's home. William Babcock, of Boston, who had taken lessons of Millet in Paris, in 1848, was a permanent resident at Barbizon, a loyal friend of Millet, and an enthusiastic admirer of his art. Two others, Edward Wheelwright and Wyatt Eaton, who also paid long visits to Barbizon, have both of them left us interesting recollections of the painter at different periods of his life. Another American, William Low, and the Irish artist Richard Hearn, who, like Hunt, was a pupil of Couture, and frequent exhibitor at the Paris Salon, belonged to the same circle and were among the privileged friends and guests who met at Millet's table.

But of all the Barbizon artists whom Millet knew and loved, the greatest and the most unfortunate was Théodore Rousseau. He had first been attracted, like Diaz, by the beauty and originality of Millet's pastels in the Salon of 1844, and from that time had earnestly sought for an opportunity of making the painter's acquaintance. On Millet's return to Paris after his second marriage in 1845, Rousseau had at length accomplished his purpose, and had succeeded in forming a personal acquaintance with the shy Norman artist. But both men were reserved and silent; Rousseau was naturally suspicious of strangers, and Millet was repelled, as he afterwards confessed, by the luxurious surroundings of Rousseau's studio. Even after he settled at Barbizon, with Rousseau as a neighbour during the whole of the summer and a

great part of the winter months, it took some years
before the two artists became friends. Yet they had
many things in common. Both were equally single-
minded in their ideas of art, both had the same passionate
love of Nature and delight in the beauty of sky and field.
Both had a hard and uphill battle to fight, before they
could gain a hearing from the world, and Rousseau
up to this time had been at least as unfortunate as
Millet. He had to endure a long struggle with poverty,
and until the latter years of his life was constantly bur-
dened with financial difficulties. Worse than this, he
was linked to an unhappy woman, who suffered from fits
of mental derangement, and whose presence made his
life an incessant torture, while his love for her was so
true that he could not find it in his heart to part from
her.

By degrees, however, the two men began to know each
other and the ice was broken. Millet talked half in jest,
and half in earnest, of his difficulties and aspirations,
and Rousseau, ere long, opened his heart to him in return.
They took long walks in the forest together on Sunday
afternoons, and stood at the same gate to watch the sun
go down over the plain. They shared their impressions
of man and Nature, and soon became fast friends.
Rousseau, who would never take advice from any other
artist, began to consult Millet about his pictures. Millet
gave him his opinion with a frankness which no one
else would have dared to use. But Rousseau had from
the first the highest admiration for his friend's genius,
and trusted him implicitly. And Millet on his part
always declared Rousseau to be the first living master
of landscape, and looked forward confidently to a day
when his greatness would be publicly recognised. As
early as December, 1851, we find Millet writing in
affectionate terms of his brother-artist to Sensier:

"Will Rousseau come here, I wonder? If he does not come, I shall spend the winter here alone. In one way, I shall not be sorry. There will be moments when I shall feel my solitude, but I shall not find it really tedious. I love my 'toad's hole' too well for that, and the impressions which I receive daily from the natural world around me will prevent me from feeling this loneliness oppressive."

And again, in the early spring of 1853, when he himself was busy preparing his *Reapers* for the Salon, he writes to Rousseau, who was then in Paris, urging him to complete his forest landscape in time, and gives him practical advice as to the composition of the picture.

"MY DEAR ROUSSEAU,—

"I do not know if the two sketches which I enclose will be of any use to you. I merely wish to show you where I would place the figures in your picture, that is all. You know better than I do what is best, and what you wish to do.

"These last few days we have had some effects of hoar-frost, which I am not going to try and describe, feeling how useless this would be! I will content myself with saying that God alone can ever have seen such marvellously fairy-like scenes. I only wish that you could have been here to see them. Have you finished your pictures? because you have only a month more in which to finish your *Forest*, and it is very important indeed that this picture should be in the Salon. In fact, it must absolutely be there.

"I am trying to be ready in time myself. I think that by working steadily I shall manage it. My picture begins to look well as a whole, but I live in dread of hindrances. The only thing one can do is to work like a slave! Good-bye, my dear Rousseau, and accept a whole pile of cordial good wishes."

In the following year, 1854, Rousseau, finding himself unexpectedly in funds, owing to the sale of several pictures, purchased Millet's fine winter landscape, *A Peasant Spreading Manure on the Land*, originally one of a set of drawings of *The Four Seasons*, which he executed about this time for Laveille. Twelve months later he gave a

still more decisive proof of his generous admiration for his friend's work.

The year 1855 is remarkable in the history of French painting as the date of the first International Exhibition of Art that was ever held in Paris. The Emperor Napoleon III. determined to celebrate the opening years of his reign by a series of brilliant festivities, and to bring all the crowned heads of Europe, if possible, to meet at his Court. With this end in view, he decided to merge the Salons of 1854 and 1855 into one grand exhibition of the art of all nations, which he opened in person with great state and show. All the leading men of 1830, whose works had been excluded under the old *régime*, appeared in great force on this occasion. Rousseau's pictures excited the greatest admiration among the English, American, and Russian visitors, and a number of his works were sold before the close of the Exhibition. Only one canvas by Millet's hand figured in that memorable show, but it was an admirable example of his most characteristic style. A line of his favourite poet had inspired him with the subject:

"Insere, Daphne, piros: carpent tua poma nepotes."

A young peasant is represented in the act of grafting a tree in an orchard in front of his house, while his wife looks on with her baby in her arms. The earnest faces of the young parents, the presence of the wife and child, and of the thatched cottage in the background, made this little picture a complete parable of that honest thrift and industry which, combined with love of home, is so marked a feature among the better class of the French peasantry.

"M. Millet, it is plain," wrote Théophile Gautier, "understands the true poetry of the fields. He loves the peasants whom he represents. In his grave and serious types we read the sympathy which he feels with their lives. In his pictures sowing, reaping,

and grafting are all of them sacred actions, which have a beauty and grandeur of their own, together with a touch of Virgilian melancholy."

Rousseau had watched the progress of Millet's picture with the keenest interest, and was deeply moved by his patient and poetic rendering of the subject. In his eyes it was a type of the artist's own life.

"Yes," he said to Sensier one day, when he was more than usually communicative, "Millet works for his family; he wears himself out like a tree which bears too many flowers and fruits, and toils night and day for the sake of his children. He grafts buds of a higher philosophy on the robust stem of a wild stock, and under the garb of a peasant he hides thoughts worthy of Virgil."

A few minutes later he added: "This time I mean to find him a buyer."

A week or two later he wrote to Sensier:

"Well, I have kept my word, and have sold Millet's picture. I have actually found an American who will give 4,000 francs for his *Grafter*!"

The sum named by Rousseau sounded incredible in the ears of Sensier, who had tramped the streets of Paris in vain to try and find buyers to give as much as a thousand francs for Millet's other works. He smiled at the notion, and frankly owns that he held Rousseau's American to be a myth, until one morning the painter paid down the 4,000 francs in gold. Upon this Sensier begged eagerly to be allowed to see this nabob, who was so enlightened a patron of art. After some hesitation Rousseau consented to gratify his curiosity, and invited him to come and meet the American at his house the next day. Sensier presented himself at the appointed time, and was met at the door by Rousseau.

"Come in," he said; "he is here awaiting you."

Sensier followed his friend inside the house, and looked around in vain for the expected visitor. Rousseau remained silent for a few moments, enjoying the sight of his perplexity. Then he said:

"Well, if you must know it, I am that American. But swear that you will tell no one else my secret. Millet must believe in the existence of the American. It will cheer him up, and help me to buy some more of his pictures at a reasonable price."

A whole year elapsed before Millet discovered his friend's plot. Meanwhile *The Grafter* became Rousseau's property, and after his death passed into the Hartmann collection. It was eventually bought by a genuine American, and now belongs to Mr. Rockafeller, of New York.

V

1855–1856

THE year 1855 is admitted by Sensier to have been a prosperous one for Millet. He sold several pictures and paid off many of his old debts. This enabled him to devote his time and thoughts to new conceptions, and to work out his ideas in peace. His Gréville sketches became the subjects of new compositions, and many of his finest works were begun at this time. One of these was the famous *Water-carrier* which excited so much interest when it was exhibited in 1860. Another, the noble picture of *L'Attente*, or Tobit and his wife expecting the return of their son, was begun early in 1853, and at the end of a few weeks put aside, and banished to the usual place on the shelf. It was Millet's habit to have several pictures in hand at once, and to begin more than he ever had time to finish. At the beginning of 1860, he had, we learn, as many as twenty-five pictures in his *atelier* in various stages of progress. Often he would set to work with ardour on a new subject, and then, just when in the eyes of others it seemed to be approaching completion, he would put it aside for no apparent reason, and take up some altogether new idea. In this way many half-finished pictures remained in his *atelier*, sometimes for as many as twenty years. The *Hameau Cousin*, for instance, a view of an old farm near his home, which he commenced soon after his return from Gréville, late in the autumn of 1854, was only finished during the last year of his life.

He had already come to the conclusion that he should never live long enough to paint all the pictures which he had in his mind, and that he must find some simpler means of expression if he was ever to tell the world all that he had to say. With this object he endeavoured to learn the art of etching, and during the winter of 1855–1856, he paid frequent visits to Paris, and spent much of his time in trying to master the process. M. Mantz gives a list of twenty-one etchings by his hand, most of which were executed at this period. The first of the series was a boat at sea under a stormy sky, evidently a reminiscence of the Norman coast. Another, the sea-weed gatherers—*Ramasseurs de Varech*—at the foot of the cliffs of Gréville recalled another impression of his childhood. *La Couseuse*, a young woman in a white cap sitting in a chair near a diamond-paned casement, at work on her husband's coat, is evidently taken from the drawing which the artist made of his wife in 1853. Two others, *La Baratteuse*, a woman churning, a subject which he afterwards repeated both in oils and water-colours, and a peasant pushing a wheel-barrow loaded with manure, also bear the date of 1855. *La Veillée*, two women sewing by the light of a lamp hanging on a pole by the side of a curtained bed, was executed early in 1856. Other plates which bear no date, but apparently form part of the same series, are: a woman carding wool, a child driving a flock of geese into the pond, a peasant-woman leading two cows to pasture, a woman laying out clothes to dry, a man leaning on his spade, and a woman knitting.

Four of the series are reproductions from well-known pictures. Two of these, *Allant Travailler* and *Les Bêcheurs*, belong to this period; the two others, the finest of all Millet's etchings, *Les Glaneuses* and *La Grande Bergère*, were executed several years later. One very

rare plate, a young woman blowing on a spoonful of broth which she is about to give to the child in her arms, bears the date 1861; while another, the earliest ever attempted by Millet, representing a shepherd leaning on his staff between two sheep, is dated 1849, and signed with the name of Charles Jacque. This signature was mischievously added, Sensier tells us, by Jacque himself one evening when Millet made this first attempt at etching under his direction on the corner of a table at the house of their mutual friend, the printer Delâtre. Ten of these etchings, together with the interesting series published by Laveille, under the title of *Les Travaux des Champs*, appeared, a few years ago, in an English edition with a brilliant introduction from the pen of Mr. W. E. Henley.

On the whole, however, Millet's experiments in this branch of art cannot be said to have been successful. He ruined many plates and wasted a great deal of precious time. Sometimes he left the plates by accident for a whole night in water, and at other times a portion of the etching was found to be effaced or imperfectly bitten. Then Millet would destroy the stone and only a few rare impressions would remain in existence. Before long he came to the conviction that pastel and charcoal were better suited to the expression of his dreams, and gave up etching altogether. The process of biting, he told his friends playfully, was evidently not one for which Nature had intended him. But he still occasionally tried his hand at a plate, and often employed his brother Pierre to etch his designs.

After his mother's death, and the breaking up of the old home, two of his brothers had adopted art as their profession, and had come to seek their fortune in Paris. As a natural result they sought shelter at Barbizon, and François was for many years their teacher. The elder

of the two, Jean Baptiste, became a painter of some
merit, and exhibited many water-colours, chiefly land-
scapes and peasant-subjects, at the Salon between 1870
and 1880. The reputation of his brother naturally helped
him in his career, and dealers repeatedly offered him
large sums for his works if he would consent to drop
his second name, or even write the letter B less distinctly.
But Jean Baptiste had inherited the straightforward
honesty of his race, and steadily declined to confuse the
public as to his identity. The younger brother Pierre—
who has left us many precious recollections of Millet—
came to Paris early in 1855, to follow his profession as
a sculptor, upon which François immediately wrote to
him: "Since you have decided to come to Paris, I wish
you would come and stay with me for some time and
learn drawing." The young man gratefully accepted his
brother's invitation and spent the three following years
—1855–1858—under Millet's roof. His arrival is men-
tioned in a letter written by Millet in the year 1855,
although Sensier places it some time later. But Hunt,
who is also mentioned in the same letter, left Barbizon
for good before the end of the year. The painter had
just recovered from one of the headaches which so often
interrupted his work, and in his relief at freedom from
pain wrote cheerfully:

"I am certainly much better, and have begun to work again.
My plan of buying a house is put off for the present. I am afraid
of embarking on a venture of this extent, all the more since I find
nothing at present which suits my taste well enough. But I must
wait. Pierre, my youngest brother, has just arrived at Barbizon.
Hunt has been here for a few days. When is Rousseau coming?
 "J. F. MILLET."

This plan of buying a house also belongs, it is clear, to
the earlier date. For, in 1855, the painter's affairs, as we

have already remarked, were in a fairly prosperous condition, while in the following year the clouds again closed over his head, and between 1856 and 1860 he went through another period of financial anxiety. On New Year's Day, 1856, he sent Sensier one of his most despairing letters. A whole host of creditors in the shape of Chailly tradesmen seem to have invaded his house, and the painter found himself as usual utterly helpless in their hands.

"Barbizon, 1st January, 1856.

" My dear Sensier,—

"This time I am indeed in a fine mess! I have just found a summons to pay the sum of 607 francs 60 centimes to M. X—— (tailor), within the next twenty-four hours. This man acts like a vampire. He had promised to take a note until the month of March. At the same time, G—— (the baker) has refused to supply bread, and has been abominably rude. It has come to this— a whole procession of bailiffs and creditors will march through the house! A very gay prospect, truly!

" I have just seen the bailiff, and have told him, in my ignorance, that credit was an accepted and understood thing. Does not the law then admit of such arrangements? According to this plan, a tradesman can set a trap for you by offering to give you credit for a year, and at the end of six months, bringing you his bill and compelling you to pay! The law, it appears, recognises none of these matters. If you owe money, you must pay! This has, in a great measure, satisfied me as to my inability to understand business, since, as far as I can see, you must put aside all honest reasoning and good sense if you are to fathom the trickery of lawyers, which, as far as I can see, is merely another name for cheating! Since the law has the right to take me by the neck in this fashion, what will happen next? Pray tell me at once, for I cannot admit the right of the law to use violence, unless I refuse payment. I thought the object of the law was to effect conciliations. Tell me—for I have a dull brain—how far people can go, who mean *to proceed with the utmost rigour and whose conscience is never troubled by their actions.* You may, of course, be shocked to think of what the law *can* do, and say, ' That would be wrong, odious indeed,' etc. But

L

I want you to tell me, not what is right or wrong, but what can be done in the name of the law. Rousseau, to whom I repeated what the bailiff said, is furious! Answer immediately.

<div style="text-align: right">" J. F. MILLET."</div>

This letter reveals at once the simplicity of Millet's character, and his absolute ignorance of the most ordinary business. He had grown up in a home where food and clothes alike were the produce of the farm, and money seldom passed between the peasant-owners. His Paris experiences, it might have been supposed, would have brought him wisdom; but he had failed to learn the lesson, and to the end he remained as ignorant of money matters as a child. Sensier assures us that these crises in Millet's affairs recurred perpetually in the course of the next few years, and that his letters were one prolonged cry of misery and despair. And in support of this statement he quotes the following fragments of his letters:

"Ah! the end of the month is come—where shall I turn for money? The children must have food before anything else! . . ."

"My heart is all black. . . .

"If you knew how dark the future looks, even the next few weeks! But at least let us work unto the end. . . ."

"I have a series of sick headaches, which interrupt my work at every other moment. I am sadly behindhand. What if I cannot get done by the end of the month? . . ."

Or else in his misery he sends this one word, " Come."

These sentences, read continuously, certainly produce a melancholy impression. But if we take them for what they really were, isolated exclamations scattered up and down the letters of many years, it must be confessed they lose much of their harrowing effect. That Millet felt deeply and suffered keenly is evident to all. This, as

the good priest of Gréville had long ago foreseen, was the inevitable consequence of his poet's nature; and like all who have the gift of utterance, he gave voice to his complaints and did not always suffer in silence. But when Sensier gravely tells us that his correspondence reads like the story of men starving in the wilderness, it is impossible not to feel that he exaggerates the situation. He seems indeed to take pleasure in dwelling on the dark side of the picture, and insists so much on the misery and poverty which Millet endured, that he fails to give a really accurate account of his friend's life.

Since Sensier wrote, other friends, we must remember, have given us their impressions of Millet at this period of his life—men who were, like him, intimately acquainted with the artist, who lived in daily intercourse with him at Barbizon, and whose description of his life and surroundings is of a far less gloomy character. It is necessary to read what they have written and to look facts fairly in the face if we wish to form a just conclusion. That Millet was oppressed with the burden of a large family, that he was often heavily in debt and compelled to part with his pictures and drawings for sums far below their value, is undoubtedly true. The facts are pitiful enough in themselves. But when Sensier represents him as harassed by perpetual "inquietude and mortal anxieties," that left him no peace day or night, and describes his correspondence "as a monthly, weekly, and sometimes daily inventory of his tortures," it is impossible not to feel that he makes use of exaggerated expressions.

Sensier, it must be remembered, was Millet's confidential agent in all business matters. The painter trusted him implicitly and placed the most absolute confidence in his friend's wisdom and knowledge of the

world. He employed him, as we have already seen, to
order his materials, obtain commissions and receive pay-
ments on his behalf. Whatever the difficulty, he does
not hesitate to apply to him for help, whether he asks
him to lend him 100 francs on the spot, or to send a
bottle of medicine for his sick child by the next post.
In later years, when Sensier had become an official of
high position, Millet often applied to him on behalf of
needy and suffering cases which had come to his know-
ledge with the same perfect confidence. And Sensier,
who had considerable private means and became an
extensive purchaser of land at Barbizon as early as
1852, frequently supplied him with temporary advances of
ready money, and, according to his own account, exerted
himself strenuously on his friend's behalf. He tells us
how he tramped the streets of Paris, offering his pictures
for sale to dealers and amateurs, how he knocked at
the doors of artists' studios and entreated them to buy
the works of their illustrious comrade. His own belief
in Millet's greatness never failed. Sooner or later, he
was persuaded, the day of triumph would come, and he
would be owned as a painter of the highest rank. But
it was not easy to make others share his certainty.
Some laughed, others called him a fool for his pains, a
few bought the pictures or drawings for a trifling sum.
Sometimes even these buyers would repent when the
bargain was concluded, and return the work in question.
In this way Sensier acquired a large number of Millet's
works, which increased in value to an enormous extent
during the next twenty years, and were ultimately sold
in years to come, greatly to the advantage of their owner
and his heirs. Under these circumstances, Millet's cor-
respondence with Sensier naturally turns largely on
business matters, and his financial difficulties always
occupy a prominent place. But a recent writer, Mr.

T. H. Bartlett, who has had access to the correspondence, consisting in all of 600 letters, of which only 100 are given in Sensier's Life, informs us that it also deals largely with professional interests, with Sensier's private affairs and a variety of other subjects. And one especial characteristic of Millet's letters, he remarks, is the large amount of details which the writer gives concerning his own family and that of Sensier. They show all the charm of the man's character, the sweetness and sympathy of his nature, his goodness and unselfishness. Sensier himself does ample justice to Millet's noble character, to his touching resignation and simple faith in God.

"I was attached to Millet," he writes, "as to an elder brother, who revealed the true beauties and charms of life to me. In him I saw a wise man whose character never altered, whose welcome was always full of kindness, and who taught me by his example to do without the superfluities of life, and led me to higher and better things."

Finally it must always be remembered, in justice to Sensier, that he himself died before he had finished his Life of Millet, and left it to be completed by another pen. If he had lived, he might, on further consideration, have doubted the fairness of publishing many of these private letters during the lifetime of Millet's widow and children. Their publication, only six years after the painter's death, naturally gave his family pain, and Madame Millet complained with good reason that the picture had been painted in colours of too gloomy a hue, and that Sensier had failed to do justice to the brightness and serenity of her husband's temper, and had, in many respects, given a false impression of his life and character. Millet had, there can be no doubt, a hard battle to fight, and an uphill road to climb, and he died before his time, worn

out by the long struggle. But in his darkest hours he
had two sources of consolation which never failed him—
on the one hand his love for his wife and children, on the
other, his supreme devotion to his art. With these to
cheer him in the battle of life a man can never be called
miserable.

VI

1855–1856

THE year 1856 is described by Sensier as the beginning of a long period of famine and suffering in the life of Millet. But just at this moment, during this " infernal year " in fact, we have an account of the painter in his home life, from another source, which helps us to modify the biographer's statement. Early in October, 1855, a young American artist, Edward Wheelwright, came to Barbizon with a letter of introduction to Millet from his intimate friend, William Hunt, who had lately left France to settle at Boston. Fired by Hunt's enthusiasm for the talent and character of the Barbizon master, the young man lost no time in presenting himself at Millet's door. In a letter written at the time, he thus describes this first interview:

" Presently I found myself in Millet's *atelier* and in the presence of the great man. I had been told that he was a rough peasant; but peasant or no peasant, Millet is one of Nature's noblemen. He is a large, strong, deep-chested man, with a full black beard, a grey eye that looks through and through you, and so far as I could judge during the moment when he took off a broad-brimmed, steeple-crowned straw hat, a high rather than a broad forehead. He made me think at once of Michelangelo and of Richard Cœur de Lion."

After a few minutes' conversation about Hunt the young American explained the object of his visit and

asked Millet if he would give him a course of lessons, or at least let him have the benefit of his advice. Millet examined some drawings which he had brought with him and criticised them kindly but freely ; but some other visitors having been introduced, Wheelwright took his leave, saying that he would return the next day. When he came back Millet told him at once that he could not take him as a pupil, but that if he liked to engage a room in a neighbouring house, and bring him his drawings, he would give him the best advice that he had to offer. At the same time he told the young artist frankly that if he wished to study the human figure, he had much better go to Paris and study in some *atelier* where he would find models. Wheelwright left the studio under the impression that Millet was by no means inclined to give him any instruction, and went back to Paris that evening, much disappointed. But the strong personality of the painter, " his handsome, intelligent, honest face, the grand dignity of his manner, the serious charm of his conversation," had impressed him deeply, and a week or two afterwards he returned to Barbizon and paid Millet a second visit. This time the painter agreed to superintend his studies, but observed he should have to charge a very high price, as his time was precious, and named what seemed to him the formidable sum of 100 francs a month. To his surprise Wheelwright agreed readily, and went off at once with Madame Millet's maid-servant in search of a lodging. Within a week he had taken a room in a neighbouring cottage and was settled in his new quarters, where he remained from the 29th of October, 1855, to the 23rd of June, 1856. During that time he lived in daily intercourse with Millet, and has left us not only a minute account of his home and way of living, but many interesting fragments of his conversations. He tells us how he found the painter digging in his garden, and

how in their walks together on the plain, he would often take the spade out of the astonished labourer's hands and show him how well he could handle it. Millet, he says, was never tired of watching the peasants at work on the plain—the women pulling potatoes and carrying them home in sacks on those autumn days, the men ploughing and carting manure, or hoeing and digging the ground. The rise and fall of the line, the regular movement of the spade had for him a curious fascination. He liked to watch the unconscious grace of the digger's action, and would make his companion notice how a good labourer never wastes his strength, and expends neither more nor less, but exactly the degree of force that is required for his object. And he would point out the digger's habit, acquired by long practice, of placing himself in the position best suited for the effort of lifting the spade and turning the loosened earth. " Force, well-ordered, well-directed, calm without bustle or excitement, not to be diverted from its aim, that was what Millet loved, and that," adds his American friend, "was what he was." The pathetic significance of the digger's toil also impressed him deeply. Of all forms of labour none, he often said, spoke more plainly of the poverty, the hardship, the monotony of the peasant's lot. " In the sweat of thy brow thou shalt eat bread." The subject was much in his mind just then, for it was during that winter that he designed the picture of *Les Bêcheurs* which struck Wheelwright so forcibly in its unfinished state. Nowhere is the contrast between youth and age more finely expressed. Two stalwart labourers are seen digging in the field, with their hats and blouses lying on the ground at their feet. One of the two is young and vigorous, and his spade turns the clods with ease. For him the task is light, and the labour pleasant. The other, on the contrary, is growing old, and we see by his bent form and slow movement that

the work requires his whole strength, that his limbs will
soon be stiff and his body weary.

But there was one calling above all others which had
for Millet a peculiar charm. On the plain of Barbizon
there were shepherds watching their flocks at all seasons
of the year. That gaunt, solitary figure, wrapt in his long
cloak, and leaning on his staff, with no companion but
his faithful dog, might be seen from early dawn till night-
fall. All through the summer months he slept under the
stars, in his wooden hut at one corner of the fold. Even
on winter days, as soon as the snow and frost were gone,
he was seen again, anxiously searching for the first traces
of vegetation; and the returning spring brought round
his busiest days, when the ewes and lambs required his
most watchful care.

The loneliness of the shepherd's life, the long hours
which he spends under the sky, his silent musings with
Nature, his knowledge of the stars, and of the seasons,
stirred Millet's imagination deeply. He was never tired
of watching these solitary forms as they moved across
the plain. There was about them a touch of mystic poetry
that recalled familiar lines of Virgil or verses of David's
Psalms.

Several of his finest shepherd-pictures were begun in
the course of 1856. It was then that he painted the
shepherd resting in the shade of a clump of trees, on a
rocky mound, while his sheep nibble the short grass around,
and out in the blazing sunshine the labourers are at work
on the plain. In one picture we see him leading his flock,
in search of new pastures, in the dewy freshness of early
morning; in another he wends his way slowly homewards,
when the red sun is sinking to its rest, followed by the
long, straggling line of sheep and the dog that brings
up the rear. Again the painter shows us that familiar
form, standing under the bare trees at the chill close of

the brief November day, with his eye fixed on the distant horizon, waiting for the *étoile du berger* to rise in the far-off west. But the finest perhaps of all the pictures which belong to this year is the night-scene, known as the *Parc aux Moutons*. There, under the dim light of the moon, half-veiled in mist and cloud, we see the shepherd and his dog gathering the flock together to pen them in safety for the night. We see the silly sheep, crowding in together and crushing their sides against the wattled hurdles of the fold, and we seem to hear the cry of the night-owl and the croaking of the frogs in the wide, mysterious darkness of the great plain beyond. Nowhere is the profound stillness of night, the glory and vastness of the star-lit heavens more deeply felt than in this wonderful little picture.

"Ah!" he said to Sensier, "if I could only make others feel as I do all the terrors and splendours of the night; if I could but make them hear the songs, the silences and murmurings of the air: *il faut percevoir l'infini*—one must feel the presence of the infinite. Is it not terrible to think of these worlds of light which rise and set, age after age, in the same unchanging order? They shine upon us all alike, on the joys and the sorrows of men, and when this world of ours melts away, the life-giving sun will remain a pitiless witness of the universal desolation."

This consciousness of the awful and stupendous powers of Nature constantly haunted Millet's thoughts. One day when he was told of a frightful murder which had lately taken place in the forest, he exclaimed: "Horror of horrors! and yet the sun did not stand still in heaven! Truly those orbs are implacable!"

And this ever-present sense of greatness and vastness of Nature became an abiding principle of his art.

"Every landscape," he said to one of his American

friends, " should contain a suggestion of distance. We should feel the possibility of the landscape being indefinitely extended on either side. Every glimpse of the horizon, however narrow, should form part of the great circle that bounds our vision. The observance of this rule helps wonderfully to give a picture the true, open-air look."

Not in vain was he born within sound of the everlasting sea, within sight of those vast spaces which filled his soul with immortal longing. The infinite is always present in his pictures. He breaks up the forest shades to let in a glimpse of blue heaven above, and reminds us by the slender thread of up-curling smoke, or the flight of wild birds across the sky, of the far-spreading horizons which lie beyond our gaze and the boundless issues of human life. This largeness and majesty of conception was eminently characteristic both of the artist and of the man.

The young student from the New World was struck by the grandeur and natural dignity of the painter who had been described to him as a rough peasant. And this first impression only deepened, the more he saw of the man in his home life.

" There was much in Millet himself," he writes, " suggestive of the Bible and of the patriarchs, especially to those who saw him in the privacy of his home."

One day, when Wheelwright had been at Barbizon for about a month, Millet asked him to come and spend the evening at his fireside, saying that he would be always welcome, whenever he felt inclined to drop in. The young American gladly accepted this invitation, and found the painter and his family in the low room, which had formerly served as his studio, sitting round a large table, with a wood fire burning on the open hearth. Millet was reading, his wife was sewing, the eldest

daughter Marie and the maid-servant were knitting
at her side, and Pierre sat opposite, copying a draw-
ing. Before long, at a sign from Madame Millet, Marie
slipped out of the room, and a few minutes afterwards,
the visitor heard a slight rustle, and turning his head
caught sight of a slim figure in a white nightgown
disappearing under the counterpane of the big bed in
the corner of the room, where two other children were
already asleep.

" This," remarks Wheelwright, in a letter to his friends at home,
" will give you some idea of the primitive manners of the house-
hold. I could not help fancying myself, not in a house in France,
and in the nineteenth century, but far away in some remote age and
country—under the tent, perhaps, of Abraham the shepherd. Millet
himself, in fact, looks as though he had been taken bodily out
of the Bible."

He goes on to describe Madame Millet as:

" . . . a farmer's-wife-sort of body, brisk and active, though
no longer young, an excellent woman, and a good wife to Millet,
whom she seemed to regard as a being of a superior order.
. . . I shall never forget the tenderness of the tone with which
I have heard him address her as *ma vieille*, nor the affectionate
gesture with which I have seen him lay his hand upon her
shoulder."

At this first visit, Madame Millet took little part in
the conversation, but her shyness soon wore off, and she
talked freely to her husband's friend of her children and
family affairs. Her age at this time could not have
been more than eight-and-twenty, but like most women
of her race, she had aged early, and her face bore
traces of the hardships that she had undergone in the
first years of her married life. Her quiet cheerfulness
and serenity attracted the notice of all the visitors who
at different times found their way to Barbizon, while

her ready sympathy and unfailing courage were her
husband's best support in his frequent fits of depression.

Sensier tells us that Millet very rarely opened his
heart to others, or shared his deepest feelings with any
one but his wife. And Wheelwright was also struck by
his reserve. He was always courteous and kind, there
was a genial warmth in his welcome, and in his fare-
well, but his kindliness was held in check by the
native dignity and seriousness of his manners.

" Millet," the American artist wrote home, when he had spent
several months in the painter's company, "is not one of those with
whom it is easy to make acquaintance. He does not let himself
out to the first comer. Although the most kind-hearted of men,
and very gay at times, there is always a sort of grand dignity about
him which checks familiarity."

The gaiety of which Wheelwright speaks, and which in
spite of all that Sensier tells us does not seem to have
forsaken him during this gloomy year, was no doubt
chiefly apparent at the evening gatherings which took
place under his roof. There was nothing Millet liked
better than to see his children and his friends assembled
round his table. Rousseau and Barye were often there;
Diaz, Sensier, and Campredon, Corot, and the great
caricature painter, Daumier, came from Paris on occa-
sional visits, and were warmly welcomed. The gathering
was often a large one, and it was always pleasant.
Millet himself was the life of the party, and even
Sensier allows that on these occasions his cheerfulness
was really delightful, and his conversation full of wit
and brilliancy. While others talked, he would draw
all manner of shapes and figures with the point of his
knife on the table-cloth, and if any problem of drawing
or perspective turned up in the course of conversation,
he would take up a pencil and attempt to solve it then

and there. On Saturday evenings these gatherings gene-
rally took place at Rousseau's house, and here during
the summer months the little company of friends would
sit up discussing questions of art and literature until the
sun rose over the cliffs of the Bas-Bréau. But if Diaz
was present, with his wooden leg and his impatient temper,
he would often interrupt the discussion, and striking the
stump of his leg with a loud thump upon the table, cry
out: "By all the gods, hold your peace! Is it not
enough to paint pictures all day, without chattering
about them all night!" If his warning did not meet
with instant attention, he would leave the table and
march out in a furious rage, amid the shouts and
laughter of his comrades. Sometimes the guests played
at chess, or fox-and-geese. "Millet," writes Rousseau,
on one occasion, "has been playing at fox-and-geese
with me at Ziem's house. His vanity has become
insupportable, since this game has revealed the strength
of an intelligence which painting had failed to discover!
Now he thinks he has nothing more to learn! I mean
to play him a trick, and introduce whist next time as
a new game!"

But even in his home life, alone with his wife and
children, Millet was often charmingly gay. When he
was in good health, and things went well with him,
he would return from Paris with his pockets full of
toys and cakes for the little ones, and look with delight
at the joyous faces and dancing eyes which met him at
the door. Even when his errand had proved a fruitless
one, and his pockets were empty, he would say cheer-
fully in reply to the eager questioners who attacked
him on the doorstep: "Ah! my poor darlings, I was too
late this time. The shops were all shut!" And then
he would take them on his knees, and tell them old
Norman fairy tales, and sing the songs his mother and

grandmother had taught him at Gruchy, till the children forgot their disappointment, and went to bed happy.

As Wheelwright soon discovered, the painter had no lack of humour. He was fond of telling him good stories, and repeated with much amusement a *bon mot* of Barye's, who had described the new buildings of the Louvre as "high-class confectionery," in allusion to their elaborate ornament and sugar-like whiteness. By Millet's advice the American student had provided himself with two pair of wooden sabots to protect his feet from the damp of the cottage floors. One of these was a pair of common sabots as worn by the peasants of Barbizon; the other was of lighter and more elegant make, and was intended, as he explained, for use upon high days and holidays. "Ah! I understand," said the painter; "those are company sabots!" The idea tickled his fancy, and he was never tired of teasing his friend about those genteel sabots.

Millet paid frequent visits to Wheelwright's lodgings, where he inspected his studies, and gave him the benefit of his criticisms and corrections. He often took the pencil from his hand, and showed him what he meant when he said that every touch should have a distinct purpose and meaning. His idea of drawing was that it consisted not so much in handling the pencil as in seeing rightly. "To see," he often said, "is to draw. Seeing is to drawing what reading is to writing. You may teach a boy to make all the letters of the alphabet with perfect accuracy, but unless he learns to read he will never be able to write." Again, he constantly insisted on more deliberation and greater pains. "An artist should be sure that he knows what he means to do, before he draws a line, or makes a mark on his paper. You should, above all, *feel* what you are going to draw." He was never tired of insisting on the

necessity of bringing out the vital and essential quali-
ties of things. Nothing, he often said, must be intro-
duced but that which is fundamental. Every accessory,
however ornamental, which is not there for a purpose,
and does not complete the meaning of the picture,
must be rigidly excluded. For the whole is greater
than the parts; the man is more important than his
clothes; the woman is of more value than the jewels
she wears. You must concentrate all your powers of
attention on your principal subject, decide once for all
where the chief interest of the picture lies, and make
all other parts resolutely subordinate to that central
and essential fact.

These were the principles upon which Millet invariably
insisted in the informal lessons which he gave his pupil,
and in the talks which they had during their long walks
on the plain and in the forest. Fortunately the American
artist recorded many of the great master's utterances in
the letters which he wrote home at the time, and after-
wards published in an article in the *Atlantic Monthly*
(September, 1876).

"Millet," he writes, "thinks photography a good thing, and
would himself like to have a machine and take views. He would,
however, never paint from them, but would only use them as we
use notes. Photographs, he says, are like casts from nature, which
can never be equal to a good statue. No mechanism can be
a substitute for genius. But photography used as we use casts
may be of the greatest service. Once, *à propos* of a photographic
likeness we had been looking at, he said that this art would never
reach perfection till the process could be performed instantaneously,
and without the knowledge of the sitter. Only in that way, if at
all, could a natural and life-like portrait be obtained. He had
himself, he said, at one time painted a good many portraits at
Havre. His subjects were chiefly sea-captains, who invariably
insisted on being painted with a spy-glass under one arm. This
sort of thing, he added, was very distasteful to him. . . .

M

"When there is progress, Millet says, there is hope. Besides, anybody can learn to draw, just as anybody can learn to write; but it is only genius that can enable a man to be a painter. He assures me that the old proverb, 'Make haste slowly,' holds good in painting as in other things, and that those who have been celebrated as rapid painters have always been very slow workers. He instanced particularly Horace Vernet, whose rapidity of execution has passed into a proverb, and yet, as he had been told by one of Vernet's pupils, any one to see him at work would suppose him to be the slowest of mortals. He drew his figure with charcoal upon the canvas in the most painstaking manner, every touch was made slowly and deliberately; but as he took time to think, or in other words, looked before he leapt, he was as sure as he was slow, and lost but little time in replacing. Millet says of himself, that although he knows the human figure by heart, so as to be able to draw it perfectly without a model, he is still obliged to proceed very slowly and cautiously. The great thing is to bring your mind to your work. Rembrandt is reported to have said: 'When I stop thinking, I stop working.'

"Nothing is more dangerous for a painter than what is commonly understood by facility; that is, a happy, or rather *unhappy* knack of hitting off a tolerable likeness of the thing to be represented, missing for the most part its true character and sentiment, and producing something that has about the same resemblance to a drawing that a caricature has to a portrait. . . .

"One of the most essential parts of the education of an artist is the training of the memory. Here again, the analogy with the art of writing holds good. In order to learn to write, the child must not only learn to imitate the form of the letter *a*, as he sees it in his copy-book; he must remember that form, so as to be able to make it without a copy. Millet says of himself, that, not having naturally a strong memory, he has by practice so educated it that, with regard to his art at least, he has no difficulty in remembering anything he may desire to retain, and he thinks that any one may do the same. But in order to remember, we must first understand, unless we are content to be mere parrots, and in order to remember what we see, we must first learn to see it understandingly. In order to see it is not sufficient to open the eyes. There must be an act of the mind. . . .

"*À propos* of a sketch I had made of a corner of my room, Millet

remarked upon the individuality that every object in nature possesses, even the most insignificant, and discoursed for some time upon the character of my pencils and other implements lying on my table. Even my stove and a pile of books on the window-seat had for him *un grand caractère*, and as Millet is not one of those who despise the ancients, he, as he does constantly, cited one of them in support of his views, instancing the portrait of the mathematician, Nicholas Kratzer, astronomer to Henry VIII. of England, by Holbein, in the Louvre, in which the mathematical instruments, he said, play an important part, and have a character of grandeur and solemnity which to him appears perfectly marvellous."

The following paragraph contains some interesting notes of a conversation upon colour, which Wheelwright jotted down at the moment:

"Saturday, April 5, 1856.—Treatises upon colour, and harmony of colour, may be interesting, and even useful, if written by one who knows his subject—*par un des forts*, the term which Millet habitually employed in speaking of the great masters — but if by one having no practical knowledge, worse than useless. Harmony of colour, like harmony in music, is a matter of instinct, or natural talent. Discords in colour will be at once detected by the eye as discords in music by the ear, if there be a natural aptitude in either case. No theory of colour will enable a man who has no eye for harmony of colour to dispose colours harmoniously, any more than any theory of music will enable one who has not a musical ear to distinguish between concords and discords in music. The great colourists—Titian and Giorgione—were very simple in their choice of colours. Harmony of colour, in fact, consists more in a just balance of light and dark than in juxtaposition of certain colours. There must be perfect balance. The picture must be well composed. *Pondération enfin. La fin du jour, c'est l'épreuve d'un tableau.*"

These last words were a favourite maxim with Millet, and one which he is never tired of repeating in different forms. The twilight hour, when there is not light enough to distinguish details, is the time of day when you can best

judge of the effect of a picture as a whole,—can see in
fact if it is a picture, or merely a piece of painting. His
brother Pierre tells us that he was in the habit of looking
at the sky and landscape through a little black glass which
he kept in his pocket, and found of great use in the com-
position of his pictures. And many years before, he had
said in a letter to Sensier:

" Half-light is necessary in order to sharpen my eyes and clear
my thoughts—it has been my best teacher. If a sketch seen in
the dim twilight at the end of the day have the requisite balance—
pondération—it is a picture; if not, no clever arrangement of colour,
no skill in drawing or elaborate finish, can ever make it into a
picture."

These remarks, taken down on the spot in the painter's
own words, are of the greatest possible value. They set
forth in clear and concise language Millet's theories of
art, and they do more to explain his own pictures and
to make us realize the elements of his genius than whole
chapters of criticism from the pen of other writers. But
what struck his American friend, perhaps, more than any-
thing else in these conversations, was the natural elo-
quence of the man and his careful choice of words, quali-
ties that seemed the more remarkable in one who had
been born and bred a peasant. This had been already
noticed by Sensier and by many others. M. Charles
Bigot, a well-known critic and journalist, was surprised
to find when he met Millet for the first time, on his re-
turn from a journey to Italy, how well the peasant-painter
talked of Michelangelo. He spoke of the great Floren-
tine, who was only known to him by his *Slaves* and
drawings in the Louvre, and prints from his works in
Rome and Florence, with a vivacity and penetration, a
force and originality of expression that amazed his listener.
But Millet, as the American artist and the French writer

both found out, was a man of wide culture. He had
trained his mind by the study of the classics of all ages,
and had unconsciously formed his style upon the best
models. Wheelwright soon discovered that he was a great
reader, and often sat up till past midnight devouring some
volume which he had picked up cheap on the Paris book-
stalls. He knew Shakespeare and Milton as well as he
did Virgil and the Bible; and surprised the Boston artist
by his acquaintance with Emerson and Channing. Mil-
ton's Paradise Lost, which he had read in Delille's trans-
lation, impressed him greatly, and the famous passage at
the beginning of the Fourth Book, "Now came still evening
on, and twilight grey had in her sober livery all things
clad," filled him with delight. The poet's description of
natural objects struck him as marvellously accurate, and
he quoted the lines on the nightingale as an instance of
his close observation of Nature. In Delille's translation,
the words "Silence was pleased," are rendered by the
line:

"Il chante, l'air répond, et le silence écoute."

The idea struck him forcibly.

"What a silence that must be!" he remarked. "A
silence that hushes itself to listen, a silence more silent
than silence itself!" That, he added, was the kind of
stillness that he wished to express in his pictures.

In Wheelwright's mind, the idea was always associated
with a wonderful little picture which Millet painted at
this time, and which he afterwards called *La Veillée*. No
less than six different versions of the subject are in ex-
istence, but this one is perhaps the most beautiful of all.
A young mother is sitting at work in her cottage on a
summer evening, rocking the cradle where her baby
sleeps with her foot, while she plies her needle. The
sun's rays stream in through the window behind, and

fall in a halo of light round the head of the slumbering child, while the rest of the picture lies in shadow.

One Sunday afternoon, when Millet had gone to Paris, and Wheelwright was at work in his studio with Pierre, the house was invaded by Diaz, who had come over with a party of friends for the day. They were much disappointed to find "l'ami Millet" absent, but consoled themselves by asking Pierre to let them see his brother's latest work, declaring that this was a good opportunity, since if the painter were at home, he would assure them he had nothing to show them. Pierre entered a feeble protest at this invasion of the studio in his brother's absence; but Diaz and his friends would take no refusal, and with much noise and mirth they pulled down the canvases on the shelves, and examined them all in turn. At last they brought out the picture of the mother rocking her sleeping child, and placed it upon the easel. The solemn beauty of the subject, the deep hush of stillness on the face of the sleeping babe, produced a marvellous effect on the most boisterous members of the party. Their noisy talk and laughter died away, and no one uttered a word, until Diaz said in a deeply-moved voice: "Eh bien! ça c'est Biblique." Another work upon which Millet was engaged that spring-time was a figure of a young shepherdess, clad in the linen hood and white cloak of the Barbizon peasant-women, leaning against a rocky mound under a clump of trees with her knitting in her hands, while the sheep browse the grass at her feet, and the leaves overhead, and the peasants at work on the plain, alike tell of the return of spring.

The American artist lost his heart to this young girl with the pensive face and dreamy eyes, which recalled the Maid of Domrémy listening to the voices, and was so much charmed with the picture that he begged Millet to paint him a similar Shepherdess as a souvenir of Bar-

bizon. The painter consented, and Wheelwright eventually carried off the replica with him to America. Towards the end of June he returned home, and did not come back to France until fourteen years later; he paid a flying visit to Paris just before the war of 1870, and brought his wife to Millet's house. Excepting for that one brief interview, he never saw the painter again, but he treasured up his memories of Barbizon with the greatest care, and the Recollections which he published after Millet's death are among the most precious records that are left us.

VII

1854–1857

THE state of contemporary art, and the neglect to which it has been condemned in modern times, were frequently discussed by the little group of artists who met at Barbizon. Millet himself held strong views on the subject, and grew eloquent over the causes which had led to the decay of art in the present age.

"In our own days," he often said, "Art is nothing but an accessory, a pleasing amusement, while in the Middle Ages it was one of the pillars of society as well as its conscience and the expression of its religious sentiment. Things were very different in olden times. The Pharaohs did not allow the genius of old Egypt to die, and the Antonines encouraged art in so liberal a manner that it attained its highest development under their rule. Pericles chose Phidias to be the builder of the Parthenon, and even a conqueror such as Alexander respected the genius of Praxiteles. But what has the State done in our own days for the good of art? What, again, have our great men of letters done to assist its progress? Less than nothing. I saw Lamartine pick out his favourite picture in the Salon of 1848. His choice was entirely swayed by political and literary predilections. A picture by Rembrandt, for instance, would never have been admitted into his house! Victor Hugo puts Louis Boulanger and Delacroix on the same level. Georges Sand has a woman's prudence, and contents herself with

fine words and musical phrases. Alexandre Dumas re-
cognises Delacroix's talent, but it is only because he
illustrates Goethe and Shakespeare. I have never been
able to find a single page in the writings of Balzac, of
Eugène Sue, of Frédéric Soulié, or Barbier, or Méry,
which showed any true understanding of art." On the
other hand, Proudhon, the Socialist writer, who looked
with sympathy on Courbet, and published a treatise on
the Principles of Art, seemed to Millet's eyes to be equally
mistaken, since he had no real knowledge or love of art,
but judged it solely from the point of view of the demo-
cratic leader. One day, when Millet was at work finish-
ing a picture in the studio of Diaz, Proudhon came in
and talked eagerly of the misery of the poor, and of the
general ignorance of art that prevailed in France. But
he hardly glanced at the landscapes of Diaz around him,
and Millet, after listening a few minutes, went back to
his easel and continued his work in silence.

"That man's doctrine," he said afterwards, "would
lead to the tyranny of the few. What is to become of
individual impressions if we are never even to think
of the past? May not a story of olden time stir our
emotions? What would have become of Delacroix's
pictures of *The Bark of Dante*, or *The Crusaders of
Constantinople*, if he had been compelled to paint The
Storming of the Trocadéro, or The Opening of the As-
sembly?"

He often said that he failed to grasp the meaning of
Socialist doctrines, and that all revolutionary principles
were utterly distasteful to his ideas.

"My programme is work. That is the natural con-
dition of humanity. 'In the sweat of thy brow thou
shalt eat bread,' was written centuries ago. The destiny
of man is immutable, and can never change. What
each one of us has to do, is to seek progress in his pro-

fession, to try and improve daily in his trade, whatever
that may be, and in this way to surpass his neighbour,
both in the superiority of his talent, and in the conscien-
tiousness of his work. That is the only path for me.
All else is a dream or a lottery."

Wheelwright points out the folly of the critics who
persisted in classing Millet among the ranks of Socialist
demagogues, and says that in all the conversations which
he had with him, he never once touched upon political
questions. His interest in the life and sorrows of the
poor was the result of his own experience, but nothing
was further from his thoughts than the idea of protest-
ing against the unequal division of property. He never
expressed the least envy of the powerful and wealthy.
On the contrary, he was rather inclined to pity them,
and when his American friend came back from Paris,
full of the pomp and ceremony which had attended the
Prince Imperial's christening, Millet's only comment
was, "Poor little Prince!"

But his choice of peasant-subjects no doubt gave rise
to the impression that he was actuated by political
motives, and increased the hostile attitude of the fashion-
able world in the days of the Second Empire. Many
years passed by before this unfortunate impression was
removed, and in the meantime the painter had to suffer.
The Court and the public looked upon him as a dan-
gerous character. The critics spoke of him as a painter
who deliberately preferred ugliness, and had no sense
of beauty. His admirers remained limited to a small
circle of artists and men of taste, and his pictures would
not sell. His friends tried to help him by organizing
sales for his benefit, and Diaz, whose brain was fertile
in expedients for money-making, and had no difficulty
in selling his own works, was especially anxious to com-
bine with him in a public exhibition and sale of pictures.

He had made a proposal to this effect early in 1854, and both Sensier and Campredon advocated the plan which he had suggested. But nothing would induce Millet to agree to this. In the first place, exhibitions and sales were alike odious in his eyes: he looked upon them as dealers' tricks, and always said that pictures ought to be bought by real lovers of art, and go straight from the artist's studio into their hands. And in the second place, he was perfectly well aware of the small favour in which his works were held by the public, and was convinced that it would be a fatal mistake to throw a large number of his pictures upon the market at once. Accordingly, he explained his reasons to Sensier, in a letter which shows a very practical turn of mind and keener eye for business than usual.

" 16 February, 1854.

" My dear Sensier,—

". . . Campredon had tranquillized me effectually, but your letter revives my anxiety for reasons which I will try and make you understand. I know very well that you are perplexed about Diaz's plan, and I see that it is difficult for you not to do what he asks. But how is it that Diaz, who can earn so much money, does not see that in obtaining the sum which he needs, he will expose me to run the risk of serious loss, and that, too, when I am just beginning to make a living? For you will agree that this is not the moment for me to show myself in public sales, since my works have no value save in the eyes of their owners. Happily I have very few things in the hands of dealers, and I congratulate myself on this advantage. It seems to me a bad time to give them a chance of buying my things at a low price, if not for nothing ; or, at least, to provoke a comparison which cannot fail to be unfortunate for me, since my works have no importance, and do not in any way represent what I hope to accomplish in the future. It would be especially unfortunate to compare them with the works of Diaz, which, in the first place, are already valuable, and are certainly more important in every respect than mine. And even if my pictures should sell for a

good price, the exhibition must be disastrous for me. Reflect
upon all this, and you will see that I am not so very much mis-
taken. It seems hard to run the risk of failure for the sake of
affording Diaz a pretence to get the money which he can earn
so easily, at least much more easily than I can, and this, too, at
a moment when my affairs are beginning to mend, and are likely
to improve, if only my works are not made common until they
have acquired a greater value from the increasing appreciation
of their owners. I know that Diaz is a good fellow, but I doubt
if he would consent, even in his present position, to do what he
asks you to have me do. He asked me to tell him the price of
two of my pictures, and I did not hesitate to tell him, in spite
of the difficulties which this may cause. There is a great differ-
ence between a man in his position, with reputation and future
assured, and one in mine, who must needs risk all. I doubt
very much if any one in my situation would agree to his pro-
posal. I cannot even conceive what his purpose is. He seems
to make light of the injury that may happen to me as long as he
can succeed. I wonder, now that I know his intentions, what
he meant by the expression which he used to Campredon, when he
said that the sale was to be, above all, *in Millet's interests.* Cam-
predon has been indiscreet without knowing it, or intending to be
so. He told me very plainly, among other things, that Diaz said
to him, 'You ought to have a sale, and put a picture that I am
working at into it, and make the sale, *above all*, in Millet's in-
terest.' I very much hope that I am mistaken in my views re-
garding this sale, but I fear I am not."

Diaz and Campredon were, no doubt, sincere in the
wish to help their friend, but Millet's opinion of the
small estimation in which his works were held proved
only too correct. The proposed sale did not take place
in 1854; but in the autumn of 1856 Campredon died,
and eighteen of Millet's works, which he had bought at
different times, were included in the sale of his collec-
tion. On this occasion his friends did their utmost to
push Millet's works, and Rousseau especially exerted
himself to raise their value. He advertised the sale in

all directions, and was an active bidder himself, ill as he could afford to spare the money. But in spite of all his efforts, Millet's works sold for next to nothing. An oil painting of *Bacchantes and Satyrs* went for 265 francs; another, *The Return from the Forest*, for 122 francs! One drawing, a very fine moon-rise, was bought by a collector for the respectable sum of 200 francs; the rest went at ridiculously low prices. Rousseau bought three of the most important, *A Farm-boy*, *A Ship in Harbour* and *A Peasant-Woman in the Forest*, for 120 francs, or about thirty shillings apiece. The noble crayon-portraits of Victor Dupré and Vechte, *A Study of a Nude Woman*, and about ten others, were sold for a few francs. This unfortunate sale had the further effect of damaging Millet's reputation, and of diminishing the demand for his drawings. A dealer who had lately ordered two refused to give the modest price which the painter asked, and another constant patron declined to take them, preferring to reserve himself for the Campredon sale. As ill-luck would have it, Millet was at this moment in great need of money, and saw with terror the approach of the end of the year, when his creditors were always busy. Accordingly he wrote sadly enough to Sensier:

"Paris, Wednesday, 3 December, 1856.
"MY DEAR SENSIER,—

"I have brought two drawings here which were intended for Beugniet. They are of some importance, especially one of the two, but unfortunately I had not fixed the price with him before-hand. I asked him for 60 francs apiece, which he refused to give me. I, on my part, could not take less. So I brought away my drawings, which Leon Legoux showed to the merchant, M. Atger, who would gladly have bought them, if he had not been reserving himself for the Campredon sale, so that these drawings, which I counted upon, and expected to bring me in some money, remain

on my hands. I had positively promised to have this money ready
for the grocer, who persecutes me to pay his bill every time he
calls, and here I am with no money, and in a worse plight than
ever. I know not where to turn for help to meet my liabilities as
well as to keep us alive, since I shall return to Barbizon with only
ten francs in my pocket. I am exceedingly vexed at having to
tell you this, knowing that you are short of money yourself just
now, but if by any chance you could lend me 100 or 150 francs,
you see how grateful I should be. I am really in a great difficulty,
and cannot conceive what I ought to do next. Will better days
ever dawn for me? I dare not flatter myself with that hope. On
the contrary, I am conscious of fits of despondency, while at the
same time I feel that I cannot, and ought not, to give way, since
it would be only letting myself sink into a lower and more hopeless
condition. The drawings I mention are at Rousseau's house, in
Paris, in a portfolio on his couch.

"J. F. MILLET."

Sensier did what he could at the moment. He got up
a lottery of 100 francs for some of Millet's drawings, and
sent the money within the next few days to Barbizon.
On Sunday, the 7th of December, Millet wrote a grateful
letter, thanking him for his prompt assistance.

"MY DEAR SENSIER,—

"I have received the hundred francs, and thank you ten times
over. Rousseau is writing to you about the Campredon sale, to
mention certain drawings of mine for which he means to bid. I
know not which they are, for he says with reason 'it will not do to
bid for all, but for two or three only, if the sale appears slack.' He
must explain what he means himself. . . . If I have not actually got
a fit of the spleen, which you advise me not to take in as a perma-
nent lodger, I am certainly conscious of profound dejection. Not
that I feel any rage against any one, for I have not been more
hardly treated than many others. I am only afraid of getting tired
out. This sort of thing has lasted nearly twenty years! But if my
lot has been a hard one, at least it has not been the fault of my
friends, and this is a great consolation. Good-bye, my dear Sensier,
I do not know which day I shall come to Paris.

"J. F. MILLET."

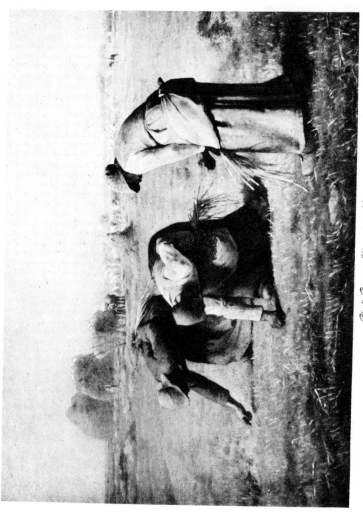

Les Glaneuses (The Gleaners)

A few days later the Campredon sale took place. Its effect, as already described, was disastrous as far as Millet's prospects were concerned, and the year closed gloomily for him. His wife had just given birth to another little girl, and he himself suffered from a succession of violent headaches during that winter. No wonder that his letters breathe a sorrowful strain, and that a kind of "settled weariness," as he says, seemed to take possession of his soul. Yet his creative powers did not languish for a moment, and during that melancholy winter he was engaged on one of the noblest and most famous of his pictures—*Les Glaneuses*. The first allusion we find to this great work occurs in a sorrowful letter to Rousseau.

"How much trouble I give you, my poor Rousseau! You are a living instance of the saying that 'kind hearts are condemned to become the victims of others.' All the same, I hope you will not think that I am not aware of the endless worry that I give you, but I cannot help imposing on your kindness. I seem to be under the spell of an enchantment. Bah! I will stop, for I neither can, nor dare, say what is in my mind on this subject.

"I am working like a slave to get my picture of *The Gleaners* done in time. I really do not know what will be the result of all the trouble that I have taken. There are days when I feel as if this unhappy picture had no meaning. In any case, I mean to devote a quiet month's work to it. If only it does not turn out too disgraceful! . . . Headaches, big and little, have attacked me during the last month with such violence, that I have scarcely been able to work for a quarter of an hour at a time. I assure you that both physically and morally I am in a state of collapse. You are right : life is very sad. There are few cities of refuge ; and in the end you understand those who sighed after a *place of refreshment, of light and peace.* And you understand, too, why Dante makes some of his personages say, in speaking of the days which they spent on earth, '*The time of my debt.*' Ah, well! let us hold out as long as we can."

When Millet wrote these words, he was in the act of

finishing one of the noblest works of modern art—that great picture of *Les Glaneuses*, which now, by the generous bequest of Madame Pommery, belongs to the Louvre. The fact deserves to be remembered for the consolation of toiling and suffering genius. But to the end of time it will be the same, and the greatest work will be produced under the same burden of sorrow, and at the same heavy cost.

The motive of the picture had long been in Millet's thoughts. A pen-and-ink sketch of a woman stooping to pick up an ear of wheat is to be found in one of his early note-books. In a second study, we have two women gleaning corn in a harvest-field: one walks erect, carrying a sheaf in her arms, the other bends down over her work, and in the background are the loaded waggon and horses, and the farmer and his men stacking the sheaves. A third drawing gives us the three figures of the picture: two women are seen, each holding a sheaf in one hand, and stooping to pick up an ear of corn with the other, while a third and older woman bends slowly, and with evident difficulty, to imitate their action. This third figure afterwards underwent many alterations, and was the subject of a variety of different studies. But in the end the right attitude was discovered, the exact gesture caught, and the painter's thought found perfect expression. In point of grandeur and completeness, Millet seldom excelled this picture. That solemn moment, the end of the harvest, has never been as finely represented. In the background we see the corn-field, with its groups of reapers and loaded waggons and horses bringing the sheaves to the ricks, the farmer himself on horseback among his men, and the homestead among the trees. The transparent atmosphere of the summer day, the burning rays of the sun, and the short stalks of yellow stubble are all exactly rendered. And in the foreground are the three

gleaners—heroic types of labour fulfilling its task until "the night cometh when no man can work."

Les Glaneuses was first exhibited in the Salon of 1857, and was at once recognised by the majority of artists and connoisseurs as the finest thing that Millet had yet done. The beauty of the landscape, the rich tones of the colouring, and the pathetic dignity of the figures, made a general and profound impression. Edmond About said its grandeur and serenity moved him as deeply as some great religious painting of old. But, on the other hand, it was fiercely attacked by another section of critics, who, with Saint-Victor at their head, scoffed at the "gigantic and pretentious ugliness of the gleaners," and called them the Parcæ of Poverty. Some journalists saw in these faces the mute appeal of the wretched and miserable; others described the three poor women as dangerous beasts of prey whose angry gestures threatened the very existence of society.

These hostile criticisms annoyed Millet, and hampered the sale of his works. But they did not make him alter his practice or swerve a step out of his path.

"They may do their worst!" he said to his friends. "I have ventured all on this one stake, and have risked my neck, and I do not mean to draw back now. I stand firm. They may call me a painter of ugliness, a detractor of my race, but let no one think they can force me to beautify peasant-types. I would rather say nothing than express myself feebly. Give me signboards to paint, yards of canvas, if you will, to cover by the piece like a house-painter, and let me work, if need be, as a mason, but at least let me think out my subjects in my own fashion, and finish the work that I have to do in peace."

Sometimes Sensier would urge him to make his peasants more attractive, and remind him that even village-

N

maidens had pretty faces, and that some labourers were handsome fellows.

"Yes, yes," Millet would reply, not without a touch of impatience, "that is all very fine, but you must remember beauty does not consist merely in the shape or colouring of a face. It lies in the general effect of the form, in suitable and appropriate action. Your pretty peasant-girls are not fit to pick up faggots, to glean under the August sun, or draw water from the well. When I paint a mother, I shall try and make her beautiful, simply by the look which she bends upon her child. Beauty is expression."

After all this controversy, the *Glaneuses* had some difficulty in finding a purchaser. But in the end, M. Binder, a wealthy merchant of l'Isle-Adam, to whom Millet had been introduced by his friend the painter, Jules Dupré, bought the picture for two thousand francs. It changed hands, as our readers will remember, in 1889, when it was bought for three hundred thousand francs by Madame Pommery, and eventually presented by her to the Louvre.

VIII

1857–1859

THE year of the *Glaneuses* was also that of the *Angelus*. The first sketch of this renowned picture was seen by Sensier early in 1858, and we find from a letter of the artist's, dated February 6th, that negotiations respecting its sale had already passed between him and one of his great admirers, Feydeau, who bought a large number of his drawings about this time.

" MY DEAR SENSIER,—

" Rousseau, who came back yesterday, tells me you are better. I am also ill, and write to you from my bed. I have been suffering for several days from a sick headache and influenza, a combination which produces a beautiful result ! As usual I await the end of the month with fear, and shall be obliged if you will tell me what arrangement for the payment of the *Angelus*, of which I spoke, will be agreeable to Feydeau and yourself."

The ringing of the Angelus bell at evenfall, when the peasants were still at work in the fields, had been one of Millet's earliest impressions. Even so he had seen his father standing with bared head and cap in his hand, even so had his pious mother bowed herself and folded her hands at the sound of the evening bell, and repeated the words of the angelic salutation : " Angelus Domini nuntiavit Mariæ : Ave Maria, gratia plena."

It was the painter's aim to record that impression, to give the quiet peace of the evening hour, the glow of the sunset steeping the fields, the sound of the church bell borne upon the air, and the silent devotion of the peasants.

"The power of expression ought to be able to realize all that," he said, as he brooded over the thought in his lonely walks. Then one fortunate day a sudden inspiration seized him, and, taking up his crayons, he made the first sketch of the *Angelus du Soir*. The great picture is familiar to us all. Every one has seen, if not the famous original itself, at least some print or photograph of the subject. Nothing can be simpler than the composition. There are no figures or houses in the background, no varied landscape to arrest the eye. The whole interest of the picture is concentrated on the two figures, the young labourer with his thick shock of curly auburn locks, holding his felt hat in his hands and bowing his head reverently, and his peasant-wife, in white cap and long blue apron, and short petticoats and sabots, clasping her hands together with a look of mute, prayerful recollection on her face. A fork is stuck in the ground at the man's side, and a basket of potatoes and wheelbarrow laden with sacks are lying at his wife's feet. They have worked hard all through the brief autumn day pulling potatoes, and now they pause as the sound of the Angelus tells them that the hour of rest is near. Above, the breaking clouds are touched with rosied light, and the rooks fly homeward through the evening sky. The rich sunset glow lights up the pink sleeve and folded hands of the peasant-girl, and falls on the bowed head of her companion. And far away behind them the great plain stretches in its solemn calm to the distant horizon where the little church of Chailly rises against the sky, and the bells are ringing the hour of prayer.

When Sensier first saw the picture on Millet's easel, the painter turned to him and asked: "Well, what do you think of it?"

"Why, it is the *Angelus*!" replied Sensier.

"Yes, that is the subject," said Millet, with a satisfied

air. "You can hear the bells? Ah, well!" he added presently. "I am content. You understand what I mean —that is all I want to know."

Afterwards he said, "*Mon ami*, you must try and help me to sell this picture."

He felt that his aim was accomplished, and that he had painted a great picture. But the world, which is generally slow to find out the merits of the best work, took many years to discover that Millet's *Angelus* was a masterpiece. The patron for whom the picture was originally destined, seems to have been disappointed with the picture when it was completed, and declined to buy it. The spring and summer passed away, Millet was ill and suffering, unable to work, and in sore need of money, and still the *Angelus* did not sell. In a letter of the 25th of September, 1859, Millet tells Sensier that he forgets the exact price agreed upon for the *Angelus*, and asks if it is to be sold for 2,000 francs, or 2,500 francs. In another letter, dated December 6th, he sends word to Arthur Stevens, the Belgian picture-dealer, and brother of the well-known artist, who lived in Paris, that he is going to bring the picture to Diaz's *atelier* in Paris, where he can see it whenever he likes.

"Tuesday morning, December 6, 1859.

"My dear Sensier,—

"As soon as you receive this little note, have the frame of the *Angelus* taken to Diaz's studio, as I shall bring the picture to Paris to-morrow. You will get this letter this morning. See that the frame is at Diaz's early morning. Go also to Diaz's early, in order that he may have time to send word to Stevens that I am coming with the *Angelus*, and that he can see it whenever he wishes. I shall leave here by the first coach to-morrow morning, and shall be in Paris about half-past ten or eleven o'clock. I count on finding the frame at Diaz's, so that I can fit the picture into it at once.

"J. F. Millet."

Arthur Stevens had a keen eye for pictures, and a keener one still for his own interests. From the first he saw the originality of Millet's genius, and saw too how he could turn the painter's talents to his own advantage. The sight of the *Angelus* made a deep impression upon him. He came to see it again and again—as many as ten times. Sensier tells us the subject seemed to fascinate him. After two months spent in bargaining over the price, it was at length sold to Baron de Papeleu, a Belgian artist who often visited Barbizon, and who bought it for 2,500 francs. Soon afterwards it passed into the hands of the distinguished connoisseur, M. Van Praet, then Belgian minister at the Court of Napoleon III. The future history of the picture, its repeated sales, and the strange course of events which raised the price from this modest sum to the extraordinary figure of £32,000, belongs to a later day.

This period of Millet's life was a very suffering one, and the year in which he painted the *Angelus* was among the darkest in his life. The letters to Sensier tell the same harrowing tale of ill-health and pressing anxieties. He was short of money as usual, and harassed by impatient creditors at every turn. Even when he sold his drawings, he was often kept waiting many months for the money which he needed so badly.

On the 13th of January, 1858, he sent Sensier a drawing of an *Ear of Wheat* for a lady who had begged for a sketch from his pen, with the following note:

"MY DEAR SENSIER,—

"There is the *Wheat Ear* at last. Will that satisfy your friend? Will you not come down here on Sunday and keep twelfth night with us? We are keeping the feast rather late in the day on account of Madame Rousseau's illness. Ask D —— to have a frame ready by the end of the month for one of the pictures which he has ordered. Try and negotiate that business promptly and

skilfully. I do not wish him to think that I am compelled to let him have my pictures. Try and guess what I mean if I do not express myself very clearly. I see with fear and trembling the approach of one of those terrible moments which you know so well. I might even say, 'The time is at hand.'

"J. F. MILLET."

In April he writes more cheerfully.

"Sunday morning, April, 1858.

" MY DEAR SENSIER,—

"I am very glad to hear that Rousseau has settled with Monsieur T——. If only that drawing might produce a similar impression on Monsieur H——; but I must not reckon on that. The men who dare admire things in advance of the rest of the world are not common.

"Do not imagine that I am not pleased with Corot's picture, *La Prairie avec le Fossé.* Rousseau and I, on the contrary, think that both his pictures should be studied together, each one giving a distinct impression of its own. You are quite right in your admiration of the one. What struck us particularly in the other is the effect which it produces of being the work of a man who is ignorant of the technical side of painting, and who works by the sheer force of great desire. The art of painting, in fact, has been acquired spontaneously. But both of the pictures are very fine. We must talk about them. Writing would be endless."

In point of fact, although Corot and Millet were very good friends, they were neither of them cordial admirers of the other's art. Millet ranked Rousseau's landscapes far higher than those of Corot, and Corot on his part owned that he could never understand Millet's work.

"He has an excellent heart," he once said to Sensier in speaking of Millet, "but his pictures are altogether too new for me. When I look at them, I do not know where I am. I am too fond of the old. I see great knowledge, fine atmosphere, serious intention, but it frightens me! I like my own little music better; and to say the truth, I take a long time to understand any new

art. I have only lately learnt to appreciate Delacroix, whom I now recognise to be a great man."

All the same when Millet died, Corot, in the kindness of his heart, sent his widow a gift of 15,000 francs, fearing that his friend's family might be in need of money.

In April, 1858, Millet received a singular commission. Pope Pius IX. sent him an order to paint an Immaculate Conception for his private railway carriage. The request reached Millet through M. Trélat, the Papal engineer, who had been recommended to apply to him by Rousseau. On the 23rd of this month Millet wrote to Sensier:

"I have at length heard from M. Trélat, who desires me to begin the *Immaculate Conception*, which must be finished by the 25th of June. I shall have time to manage it, and am considering the subject. Rousseau writes that he and M. Trélat have had a good deal of conversation on the matter, but that he did not expect any lasting results to come out of their interview. The impressions which he (M. Trélat) receives are, it appears, seldom durable, for his nature is so elastic that the last person he has seen entirely effaces the recollection of the former one. . . . *Au revoir*, I hope!

 "J. F. MILLET."

At the same time he wrote to Rousseau:

 "Barbizon, Saturday morning, April 24.
"MY DEAR ROUSSEAU,—

 "I have at length received an order from M. Trélat for the much-discussed picture of the *Immaculate Conception*. A few days ago I sent him a small sketch to give him a general idea of the composition.

 "The weather is very fine, but it is a pity the ground is so dry. When I cross the plain, I see the trees of your garden all white with blossom over the top of the wall. I do not say this to rouse your envy, but they are certainly a lovely sight, and make one say, 'How pleasant it must be in there!' Madame Rousseau

will be jealous when she sees my garden ! *Est-il beau ?* *Est-il beau ?*

"J. F. MILLET."

The Pope's picture was finished by the end of June and duly despatched to Rome. But it was never heard of again, and Millet and his friends had a shrewd suspicion that this virgin was of too modern a style to meet with the Holy Father's approval. Certainly this *Conception* was very far removed from the orthodox idea. His Madonna was a young peasant-girl with brown eyes and thick locks of curly hair falling on her forehead, clasping her child tenderly to her heart, and looking up with awe and wonder in her gentle face. Her head was encircled with a blaze of light, and at her feet the serpent lay dead on the globe of the world. When this commission was finished, Millet applied himself to execute the order which had been given him, according to Sensier, six years before by the Director of Fine Arts. After repeated delays and hindrances he began the picture, and wrote to Sensier as follows on the 2nd of August, 1858 :

"The Minister's picture is begun, and in case I can finish it as promptly as I wish, I send the measurements for the frame for you to forward to the proper quarter—0m73$\frac{1}{2}$ inches by 0m92$\frac{1}{2}$ inches. Adrien Laveille came yesterday to ask for some drawings which he could engrave. He is very solemn, and declares this is not to be talked about, but wishes it to appear as if it were a spontaneous production. Have you had any plates made of Olivier de Serres ? and will the portrait answer ? I should like to see a proof.

"J. F. MILLET."

This was a lithograph portrait of the seventeenth-century agriculturist, Olivier de Serres, a favourite writer of Millet's early years, which he had lately executed for a volume brought out by Sensier himself, under the pseudo-

nym of Reisnes. Impressions of the plate are now very rare, if they have not disappeared altogether.

A few days later, he sent Sensier a drawing of the picture which he intended to paint for the State, with the following note:

"I send you, my dear Sensier, a drawing which I should like the Director of Fine Arts, or his Secretary, to see. The subject is, a woman feeding her cow and knitting as she walks. Tell me what they say of it at the Beaux Arts, although I cannot think an old stocking in holes can be called a very democratic subject! But we shall see! It is impossible to say what ideas people may get into their heads. So I shall await your answer before I go on with the picture."

The Minister's reply was satisfactory, but Millet's work was interrupted by one of his terrible headaches, and on the 9th of August he wrote in a desponding tone to Sensier:

"The moment has come when I must cry out like Panurge in the tempest: 'Help! help! I am drowning!' with this important difference—that we drown on dry land. . . . In fact, I have reached the end of my tether. Good-bye, come!

"J. F. MILLET."

A fortnight later he wrote again in the same strain:

"Headaches, and nothing but headaches! Tell me how my request for an advance has been received by the Minister, for I am forced like the Psalmist to look *unde veniet auxilium mihi.* . . . I have read *Fanny*, alas! alas!

"J. F. MILLET."

"P.S.—I should have a weight on my conscience if I stood in the way of Delâtre's happiness. If he really only wants the few sketches on old sheets of which he spoke, let him have them and do what he likes with them. I have begun to work again. I am going to begin a picture of *Death and the Woodcutter.*"

November, Millet declared, was always the blackest
month in the year. His father had died in November,
and his worst troubles, he often said, all happened in that
month. In 1858, he suffered from a persistent series of
headaches, against which he struggled in vain. Again
and again he tried to work at the Minister's picture, but
his efforts were useless, and several weeks passed before
he was able to take up his brush.

" My head is absolutely empty, my memory fails me to such a
point that I forget what I am going to say, before I have had
time to write it down."

These frequent headaches were in reality the heaviest
trial of his life, interrupting his work, and often giving him
a perfect agony of pain for days at a time. He would often
make desperate efforts to go on with his picture, which
had to be ready by a certain date, especially if, as usually
happened, he was in need of money, and the dreaded end
of the month were approaching. But the more he strug-
gled, the more acute the pain became, until at length he
was forced to take to his bed. At the end of two or three
days the attack passed off, and he was generally able to
resume his work. But sometimes the mere effort of trying
to paint would bring back the pain with fresh violence.
Had it not been for this cruel affliction, says his brother
Pierre, he would have been able to produce at least double
the work which he actually accomplished. These head-
aches, besides wasting a large amount of precious time,
were also a constant source of expense. He consulted one
doctor after another, and took a great quantity of medicine
which, according to Pierre, never did him the least good.
The only thing which ever gave him relief was a cup of
strong black coffee, and this, strange to say, all the doctors
agreed in forbidding him to drink. But in spite of their
prohibition, he returned to it when every other remedy

failed. Often these headaches came on very suddenly; sometimes they attacked him on his visits to Paris, and he was obliged to go to bed on the spot, and remain there for a whole day in spite of his anxiety to return home. For, as Pierre remarks, these visits were usually undertaken at the end of the month, when he went to Paris to receive the payments that were due to him, and he prepared to meet the Chailly tradesmen when they presented their bills. The friends who saw him overnight and heard him talking with animation of a thousand different subjects, little dreamt that perhaps the next morning would find him utterly prostrate, and unable to raise his head from the pillow.

"Ah, Pierre!" he would sometimes exclaim, "if I had never left home and country life, I should not have had to endure these terrible headaches."

There can be no doubt that these constantly-recurring attacks were one great cause of the fits of depression from which he suffered, and help to explain the desponding tone of his letters. Sometimes his melancholy, Sensier tells us, increased to such a pitch that it drove him to the verge of self-destruction. Once, when thoughts of this kind oppressed him, he drew a sketch of an unhappy artist lying dead at the foot of his easel. But if the idea of such a crime ever actually came into his mind, the thought of his wife and children would have been enough to make him pause. "Suicide," he said one day, "is a cowardly act. Think of the wife and children! What an inheritance of woe for them!" And he added quickly, "Come, let us go out and see the sunset; that will do me good!"

These evening walks were his great refreshment. In summer he spent the whole day in his studio till supper-time, and afterwards set out for a walk with his brother, or Rousseau. He liked to watch the lovely effects of evening upon the plain, especially when during harvest-

time the peasants were at work till dark, binding the sheaves and loading the waggons.

"Look at the action of those men lifting the sheaves on their pitchforks," he would exclaim. "It is wonderful how grand those figures appear, standing out against the evening sky. Are they not like giants in the gathering darkness?" Or else: "See those figures moving in the shade yonder, creeping or walking along! Surely they must be the spirits of the plain! We know they are only poor human creatures—a woman bending down under her load of hay, or dragging herself along exhausted by the weight of her faggots. But far off they are superb! Look how they balance their load on their shoulders in the twilight. It is beautiful—mysterious!"

So he loved to linger there, watching the changing effects of light, long after the sun had sunk below the horizon, and the gloom of night had settled on the plain. The sense of mystery and loneliness, the profound stillness, broken only by the croaking of frogs, or the cry of a night-bird, the dim forms moving across the plain, all impressed him in a strange manner. In the same way, the weird shapes of the giant oaks and beeches of the forest, with their hollow trunks and spreading boughs, struck his imagination. Seen in the fading light, they seemed to him ghostly presences from another world, the spirits of primeval dwellers who haunted the caves and rocks in remote ages. As night fell on the scene, old legends would come back to his memory. "Do you not hear the witches keeping their Sabbath down there in the Bas Bréau?" he whispered to his companions. "I seem to catch the cry of strangled children and the madman's laugh. And yet we know that it is only the cawing of the rooks, or the screech of the owls. But terror and mystery descend upon us when night, the Great Unknown, follows the day." And growing eloquent in the

darkness, he would recall the origin of those old tales and dwell on the wonderful power of Nature and her strong hold upon the imagination.

"If I had to paint the forest," he said one day, "I would not try to make people think of emeralds or topazes or any other precious gems, but simply to realize the power which those bright leaves and dark shadows have to rejoice the heart or to move the soul of man. Only look at those huge masses of rock, tossed to and fro by the fury of the elements. They bear witness to some pre-historic deluge, or ancient reign of Chaos, grinding whole generations of man in its jaws! How awful it must have been, when the great waters covered the earth, and as the scene is painted for us in those three words of the Bible : ' The Spirit of God moved upon the face of the waters.' Poussin is the only artist who could have rendered that scene ! "

As a rule Millet seldom left his work before the evening meal at six o'clock. But sometimes on fine summer afternoons Rousseau would walk into the studio, and tell Millet that he had worked long enough and must come out with him at once. Then the two painters would set off on a long ramble through the forest. Together they climbed the rocky gorges of its wilder parts, and from the heights of Apremont or Bas Bréau looked down on the changing colours of the plain. They saw the sun set behind the forest trees and through the long avenues which seemed to Millet like the aisles of some great cathedral. And they did not return to Barbizon till it was dark and the deer were to be seen starting up beside them in the heather and bracken of the thicket. Then Millet would go home with his head full of new impressions, and taking up the first sheet of paper he could find make rough sketches of the scenes and effects of light which lingered in his memory. Visitors who

came to Barbizon often carried off these precious sheets
to which he attached no importance and which are now
of rare value. Several are still in the possession of his
family. His son-in-law, M. Heymann, has some which
are of especial interest, and contain the original studies
for many well-known pictures. We recognise the chil-
dren in the *Nouveau-Né*, the group of labourers in the
Moissonneurs, the young girl watching the flight of wild
geese, and the dog and sheep as well as the lovely head
of the peasant-maiden, in M. Chauchard's *Bergère*.

A similar page of sketches is reproduced by Sensier in
his book. A girl raking a heap of smoking weeds to-
gether, a labourer leaning on his pitchfork, a young
shepherdess sitting down with her staff at her side and
her cheek resting upon her hand, the profile of a woman's
face, a boat at full sail, a group of cottages in the forest,
and a row of ducks waddling on land or swimming in
a pond—such were the varied subjects which the painter
jotted down in his spare moments. And in the upper
part of the sheet, above the peasant-girl's head we read
the famous words: "Il faut pouvoir faire servir le
trivial à l'expression du sublime. C'est là la vraie force."
It was a favourite saying of his, and no better motto
could be chosen to illustrate his life and work.

IX

1859–1860

THE year 1859 found Millet in one of his most depressed moods. He had suffered severely from headaches during the last two months; his children had been ill, and his wife was again on the eve of her confinement. But what saddened him more than all was that M. Latrône, the friend of Rousseau's, who had bought four of his pictures five years before, now put them up to auction and sold them for very low prices. Millet felt this keenly. The world, it was plain, would never appreciate his work; his best pictures were despised, and he and his family were rapidly going downhill. He wrote sorrowfully to Sensier:

"Wednesday morning, January, 1859.
"A terrible sick-headache has prevented me from writing to you before to tell you the sad state of my affairs. What a complete collapse this sale of Latrône's has been! The future looks more and more hopeless. I feel this the more keenly because I do not see how I am ever to escape from the misery that holds me in its iron grip. I am constantly troubled with little debts in every direction. It is impossible for me to pay them; it is frightful to be stripped naked before such people, not so much that it hurts my pride, as because we cannot obtain necessary supplies. We have wood for only two more days, and we do not know how to get any more. It will certainly not be given us on credit. My wife will be confined next month, and I shall not have a penny. It is not even certain that I can get together the three hundred

francs which are needed to pay the bills which fall due at the
end of the month. Enough of this, however. I intend to try
and get M. Atger to advance something upon his drawings, al-
though he will very probably object. I am sad and suffering.
Forgive me for telling you all this. I do not pretend to be more
unfortunate than many others, but each has his own burdens. I
am very glad that Feydeau has bought my pictures, but Serville
will soon have my *Woman Putting Bread into the Oven* to sell.
What will Rousseau say to all this? It will trouble him also and
with good reason. If you can do anything to find new buyers who
will give me an order at once, I shall be more grateful to you than
ever. I shall not believe it until I see it! I am working at the
drawings. To-morrow or the day after I shall send you one for
Alfred Feydeau. Please send me the money as soon as you have
received it, for the children cannot be without a fire. So much
the worse for the end of the month !

"J. F. MILLET."

On the 20th of March he was threatened with another
visit from the bailiffs, and wrote to Sensier in abject terror.
Happily affairs were soon settled this time, and Millet's
spirits revived. Sensier obtained an advance of money on
some drawings which had been ordered, and Millet wrote
back joyfully, quoting the words of an old Norman
song :

> "T' es un homme salutaire,
> Pour les amis qu'en a besoin.

"Your proposal gave me the greatest possible pleasure and has
filled me with fresh courage for work. I will not fail to profit by it
to the best of my power. As soon as I have sent off my pictures,
I will hasten to deliver the drawings. . . . After all, quarrelling
is not a pleasant thing ! . . ."

The two pictures which Millet sent to the Salon of
1859 were the *Woman Leading her Cow to Feed* and
Death and the Woodcutter. The former, as the cata-
logue states, was already the property of the nation, and

at the close of the Exhibition was presented by the
Emperor to the Museum of the town of Bourg-en-
Bresse. It is a good and characteristic, but not especi-
ally interesting, example of Millet's peasant-pictures.
His other Salon picture was a far more ambitious work.
The subject, taken from La Fontaine's well-known fable,
had long occupied the painter's thoughts. Three years
before he had laid his hand by chance upon a volume
of Georges Sand's *Mare au Diable*, that belonged to his
American friend Wheelwright, and had read the book
with great interest. He was especially struck with
the first chapter, which describes an engraving by
Holbein, representing an aged peasant ploughing, while
Death stalks beside the frightened horses, and urges
them on with his whip. The words of an old French
quatrain were inscribed below :

> " À la sueur de ton visage
> Tu gagnerais ta pauvre vie,
> Après long travail et usaige
> Voicy la mort qui te couvie."

Millet told Wheelwright at the time that he had long
been thinking of painting a picture on Fontaine's well-
known fable of " La Mort et le Bûcheron." This
intention he had now carried out after long deliberation,
with great care and pains. The picture which he pro-
duced is, there can be no doubt, one of his most re-
markable works. He has painted the weary woodcutter
sinking exhausted under his load at the foot of a mound
by the roadside in the depths of the forest, and repre-
sented the skeleton Death, a veiled form bearing a
scythe and a winged hour-glass, laying her bony hand
on his arm. The look of terror on the tired labourer's
face, at the sight of the white and silent figure which
has risen in answer to his prayer, is rendered with

dramatic force, and the unusual degree of imaginative power displayed by the artist on this occasion made a deep impression upon his friends. To their astonishment, this picture, upon which Millet had spent infinite pains, was rejected by the jury of the Salon, while the *Woman with her Cow*, a smaller and distinctly less striking work, was accepted. The decision excited universal surprise, and two leading critics, Alexandre Dumas and Paul Mantz, took up their pens boldly in defence of the rejected picture. The *Gazette des Beaux Arts* published an engraving of *La Mort et le Bûcheron*, with an article by M. Mantz, doing full justice to its merits, and ending with these noteworthy words:

"Clever men may smile, Academies may be mistaken, the public may pass by without so much as a glance or attempt to understand the picture. This mockery, these mistakes, cannot alter the facts of the case, and the time will soon come, if indeed it has not already arrived, when M. Millet will be hailed by the whole world as a great master."

But at the time Millet himself felt the disappointment keenly. The decision of the jury was, in his opinion, the outcome of a deliberate effort to crush his art. *Vidi prævaricantes* were the words in which he told Sensier what had happened. Afterwards he said: "They think they can force me to yield, and drive me into their drawing-room art. But they are wrong! A peasant I was born, and a peasant I will die! I am determined to say what I feel, and to paint things as I see them. I mean to hold my own, without retreating so much as a sabot's length! If necessary, I too will show that I can fight for my honour." And then, as if half ashamed of his warmth, he added with a smile: "Come, Sensier, we must save the honour of the house!"

At the same time he begged his defenders to be moderate in their language, and above all not to make political capital out of this attack upon him, but to confine their remarks purely to artistic questions. There was nothing which annoyed him so much as to hear his name bandied about by political agitators, and to find his art dragged into the arena of party strife. But the worry and anxiety of mind which he suffered in connection with this unfortunate event affected his health. He fell seriously ill, and being unable to come to Paris himself, addressed the following letter to his brother:

<div style="text-align:right">"Sunday morning.</div>

"MY DEAR PIERRE,—

"A severe and entirely unusual illness has attacked me. Besides a painful headache, I am suffering from sore throat and fever. The doctor found it necessary to bleed me, so that although I am out of bed, I feel terribly shaken. All this has interrupted my work, and prevented me from coming to Paris to receive the money due to me at the end of the month. I have not strength for the journey. This then is what I want you to do for me. Go to Rousseau's on Tuesday, and you will receive a sum of money—450 francs, I think. Bring it here on the same day. Be at his house before noon, in order to see him at dinner-time. If you cannot do this, let me know at once, and I will find some other way of getting the money, as Wednesday is the last day of the month. You understand clearly how important it is that you should be here by Tuesday evening, with the 450 francs, which you will get from Rousseau. Tell him that I have not strength to come to Paris myself, but hope to be there early next month. Good-bye. Except myself, every one is well here.

<div style="text-align:right">"Your brother,
"FRANÇOIS."</div>

This attack of illness, unfortunately, affected his eyes, and proved a serious hindrance to his work. But in spite of all his own troubles, Millet showed no lack of

sympathy with others, and the letters which he addressed to Sensier at this time abound in kindly inquiries after his wife's health, and in allusions to the land which his friend had lately bought at Barbizon. If Sensier acted as Millet's agent in Paris, the painter on his part helped him materially in his negotiations with the inhabitants of the village. By degrees Sensier had acquired a considerable amount of property at Barbizon, and early in 1859 he bought Millet's cottage, and the neighbouring house formerly occupied by Jacque, from his landlord, Brézar. The terms of the purchase and the management of the estate seem to have been chiefly arranged by Millet, whose letters give many particulars of his dealings with the neighbouring peasants on his friend's behalf. All these details were suppressed by Sensier in his Life of Millet, but Mr. Bartlett has lately published several of these letters in full. They are of interest, not only because they show us that Millet had leisure to think of other matters besides his own troubles, but that where his friend's affairs were concerned, he could be more practical and business-like than in the management of his own. The actual purchase of land and improvement of property, the planting of trees and vegetables, were clearly far more suited to his capacities than his usual task of bargaining with dealers or collectors over the price of his pictures.

On the 14th of February, 1859, he suggests that Madame Sensier, who had lately given birth to a son, should come and occupy Jacque's old house, to enjoy the benefit of country air, and makes the following proposals for her comfort:

"MY DEAR SENSIER,—

"I have received the 100 francs which you send from Laveille, and will tell you when to send me the other twenty. This is what my wife begs me to say. As country air would do

Madame Sensier good, and she is not occupied with important affairs in Paris, why should she not come here with you as soon as she can bear the journey? We will arrange any of the rooms which she may wish to have. The one at the end of the house will perhaps be the best, as it has a fireplace. We will buy a sack of the same kind of coal that you used to burn with the wood, so that the fire will keep in and look more cheerful, and the room shall be furnished with your things. The walls must be hung with all kinds of draperies, and my large piece of tapestry shall go behind the bed, etc., etc. Madame Sensier can lead a life full of beautiful comfort! Think of this seriously. I do not think it is at all a bad idea, and it is quite practicable. As you wish Ernest to grow up healthy, it is necessary that his mother should have as much country air as possible to make her strong. This is the conclusion to which we have come. The drawing I am making will be whiter than ermine. As I write, Marie and Louise are teasing me with questions as to what I am saying to Madame Sensier. 'Tell her to come at once, without delay!' and in the meantime they kiss her with all their hearts. We wish you all good health.

<div align="right">"J. F. MILLET."</div>

Again, on the 2nd of April, after the rejection of his picture of *Death and the Woodcutter* by the Salon, and the acceptance of his *Woman with the Cow*, he writes:

"MY DEAR SENSIER,—

"Leave your bed at Doyen's Inn, Melun, and the Barbizon coach will bring it here. As the season is well advanced, your potatoes shall be planted as soon as the ground is ready. If we were to wait to dig the ground more, it would be very late to plant them, as the weeds must be given time to rot after being dug up. The latter plan would have been the best if the work could have been done sooner. The piece you wish to have planted is the one where Brézar's apple-tree stands, is it not? and the one which Antoine bought lately. We will buy potatoes for both of us, and plant them at the same time.

"I will make a picture for Etienne, and am going to do some drawings, too, as they seem to be my only resource at present. I will do them as well as I can, and take them as far as possible

from family life; but as you know, a little calm is necessary to enable me to reflect on new ideas when they first come into my head. The new thought must be allowed time to concentrate itself in the brain, in order that only its essential part may be expressed.

"Since my *Woman with the Cow* is, after all, accepted, can anything be done to prevent it from being hung out of sight? Who has the task of hanging the pictures? Is it the jury? or another committee? If the Inspectors of Fine Arts have anything to do with it, would it be possible to get a more or less good place through their influence? If this could be done, I should like to have it hung on the line and in one of the less dark corners. But if this is a difficult or impossible thing, it must be left to the grace of God. With you, I am much distressed about Madame Rousseau's health. All her strength seems to have left her. It is as cold as winter, and freezes in the night. The ice was very thick yesterday morning, and the surface of the ground is as hard as a crust. Some of your trees are in blossom—poor things!"

Next we have a short letter about the engraving of his rejected picture, *Death and the Woodcutter*:

"Barbizon, 3 April, 1859.

" MY DEAR SENSIER,—

"I do not see any objection to the reproduction of my picture, if only it is tolerably well done. I think that Hédouin will be able to do it better than most people. I think I had better come to Paris, as soon as I hear that my picture can be taken away from the Exhibition, and help Hédouin, as I have said before. I ask nothing better than to give publicity to this refusal, as long as this is decently done. Before I give Hédouin a positive reply, tell me what do you think of it. Tell me, please, what you think of the proposal which has been made to me, and of the manner in which I have replied. What impression does all this make upon you? Tell me at once, and if necessary, directly my picture is at liberty, I will come to Paris and help Hédouin as much as I can. I write this in haste for this letter to reach you to-night. . . .

"J. F. MILLET."

The next letter was written when he was still suffering from the effects of his illness, and was consequently in a very depressed state.

"Friday, 27 May, 1859.

"MY DEAR SENSIER,—

"Although my eyes are still in a deplorable condition, I am going to try and set to work to-day, in order to paint, as best I can, the little picture of which I spoke the other day. I know not if I shall be able to stand work, but as it is the only thing that I can accomplish before the end of the month, I beg you to see M. Moreaux (I believe that is his name), the dealer in old pictures, and ask him to see the gentleman whom he mentioned to you, and make an appointment with him. If you knew how my sight troubles me! Oh! how weary I am! I am not going to bore you with ten thousand lamentations, but yet my poor head has to hold all too many. Let us have patience, if possible. Try and come yourself. It is a selfish request on my part, but I make it all the same. Write to me—it does not matter what! When will He come who can say unto me, as He did to the cripple of the Gospel : ' Arise and walk ! '

"J. F. MILLET.

P.S.—" I must tell you that the pastel detained till now by L—— has been redeemed by Marolle, who places it at my disposal. At first, I refused to take it back, but in the end it seemed ungracious not to consent, so I told him that I would fetch it the next time that I come to Paris. It is the pastel of which you have heard Diaz speak—*The Riding Lesson.* Mention this to him, in case he may find me a purchaser. It is of the same size as my forty canvases. The subject is three life-size children at play. I painted it eighteen years ago. It is already very ancient history, but you will see that it is not bad. Yes, it is Marolle who has redeemed my pastel."

This is the only mention we find of Marolle in Millet's letters, but it shows that the old friend of his struggling Paris days had not forgotten him. The next letter is dated 25th September, 1859, and contains an allusion to

the price of the *Angelus*; which, however, did not find a purchaser for several months to come :

" MY DEAR SENSIER,—

"Your letter arrived just after mine was sent to the post. The thing to do with the money is to send some very quickly, but how can you send 250 francs ? I told M. Gimsberger that the price of the *Angelus* was 2,000 francs, or 2,500, I forget exactly which, but certainly not less than 2,000 ; the *Shepherd*, 3,000 ; the little picture for Alfred Feydeau, *Haymakers Resting*, 1,200 francs. Yours, *The Woman Rocking her Child*, 1,500. There ! If only my drawings would sell !

" It would be a good thing, a very good thing to have Jacque's studio, but what are his proposals ? Does he allow time for payment ? That is a question of great importance.

" M. Laure came in to say good-day, and I rose to receive him. Charles (the painter's youngest son, a boy of two years old), taking advantage of my absence, undertook to finish my letter, as you see below !

" Is it necessary to reply to Jacque at once, or can you wait until Sunday, so that we may talk it over together ? Perhaps the fact of his selling is a proof that he cannot wait for payment, although this is merely a gratuitous supposition on my part. Coffin (the village carpenter) asks me for a definite decision about the floor of the new room, whether it is to be of wood or tiles. I told him to make it of wood, and that will cost sixteen francs more. Nothing new since morning. We shall meet on Saturday."

Now that Sensier had become Millet's landlord, he agreed with the painter to make certain alterations and improvements in his house, which the increase of his family rendered absolutely necessary. His wife had given birth to a seventh child early in the year (1859), and two more were born within the next four years. Another bedroom was built in the place of the wood-hovel, a fireplace and chimney were added, and a door opened into the rest of the house. Jacque's studio,

which Millet mentions in this letter, was a low building with a thatched roof, only divided by a narrow pathway from Millet's own *atelier*. Soon after this it was bought by Sensier, together with a piece of land at the back, and converted into a living room for Millet's family, and another small *atelier* was built above it for the painter's use. This new studio afforded Millet a convenient retreat from the visitors who flocked to Barbizon during the summer months, and often intruded on his privacy to a disagreeable extent, watching him at his work from the street, and even pushing their heads through the window of his *atelier*. A winding stone staircase led up to it from the garden, between a tall elm and a fine old apple-tree with twisted stem and spreading boughs which was Millet's particular delight, and the windows commanded wide views of the forest and plain.

"The view from the upper studio will be glorious," he wrote to Sensier, when the plan was first proposed, in September, 1859. "I am longing to be there already, for it will be of the greatest use to me. Rousseau has started for Besançon this morning, and I am a prey to the usual headaches."

Another letter regarding the work which had been done for Sensier belongs to this autumn, and is among those published by Mr. Bartlett.

"Thursday morning.

"My dear Sensier,—

"Monday, Tuesday and Wednesday were most religiously consecrated to curing myself of a bad headache, and this is why I have not answered your letter sooner, although I went yesterday evening to see Père Ribouillard, whom I found seated in the corner of his fireplace, devouring a very large plate of soup. I mention this last fact because it was really a very fantastic picture. The room was dark and the candle was not lighted. As I have

just said, Père Ribouillard sat in the corner of the fireplace eating, while Eugénie Bélon was in the opposite corner, looking like a gnome, very busily engaged in eating soup out of an old kettle, and so intent on the task, that she never even turned her head as I came in. You can imagine what ornaments to the fireplace Père Ribouillard and Eugénie Bélon were! Though their faces were only dimly lighted by the little blaze on the hearth, you could easily see their general form. Mère Ribouillard, that old layer-out of dead bodies, sat between them. I asked Ribouillard what he wanted of you, and his wife replied that they heartily wished you would pay them a little money. Their bill was 15 francs for clearing the wood, and 17½ sous for half a day's work. But my wife thinks the wood-clearing ought not to be more than 11 francs. We will pay them 9 francs for the present. If Ernest Feydeau can, let him hasten to complete his order. Since you left, heavy bills have fairly rained upon me, and all I could do was to give promises in payment. If Feydeau sells a picture to Stevens, let it be *The Woman and Chickens*. Our best wishes for the cure of your cold and for Madame Sensier's perfect health."

The new *atelier* was built and various other improvements in the house and garden were effected in the course of the autumn. Sensier paid for the extension of the studio, but the expense of the other alterations was borne by Millet. At the same time the rent was raised to 360 francs, and remained at this figure until after the painter's death, when Sensier raised Madame Millet's yearly payment to 400 francs. These fresh expenses naturally proved a serious drain on Millet's resources, and did not improve the state of his affairs. Neither the *Angelus* nor *Death and the Woodcutter* had yet found a purchaser, although the latter had been not only engraved in the *Gazette des Beaux Arts*, but exhibited first in Charles Tillot's *atelier*, and afterwards at the shop of Martinet, a dealer on the Boulevard des Italiens. Millet was reduced as before to depend almost entirely upon the sale of his drawings, which did not always find

a purchaser, and when sold, were often not paid for immediately.

Under these circumstances the end of the year found him once more in difficulties. This time Diaz came to his help with a loan of 600 francs, which he welcomed with effusion.

"Long live Diaz and the sunshine!" he wrote to Sensier, in January, 1860. "This is a reprieve for me! I had left Paris with a heavy load of sorrow, and arrived here with my pockets as empty as I started. Now another bad place has been got over."

On the 27th of the same month he wrote again to say that he had almost finished a little picture of a *Woman with a Rake*, which he was painting for M. Doria. Ten days later he asked Sensier to order the frame, adding: "It is absolutely necessary that my picture should be delivered and *paid for* before the end of the month."

And at the same time he asks if anything more has been heard of the purchaser of his *La Mort et le Bûcheron*.

Both this picture and the *Angelus* were sold during the next few weeks. The *Angelus*, as we have seen, went to Brussels, and the noble vision of *Death and the Woodcutter*, after passing through many different hands, and being for several years in the Laurent-Richard collection, was finally purchased for the Royal Picture Gallery at Copenhagen.

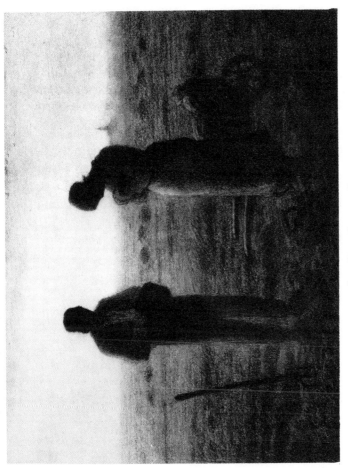

Swan Electric Engraving Co.

The Angelus.

From the Pastel in the Forbes collection.

X

1860–1861

DURING the last months of the year 1859, when Millet was in sore need of money and found it every day more difficult to sell his pictures, he entered into negotiations with the Belgian dealer, Arthur Stevens, and proposed to let him have all the paintings which he should execute during the next year, at a fixed rate of payment. The plan seems to have been originally suggested by Sensier, and was eagerly taken up by the painter in his anxiety to free himself from his present difficulties. Stevens, on his part, was one of the few dealers in Paris who recognised Millet's genius and the increasing value of his works. He had already bought several of Millet's smaller pictures, and in January, 1860, he found purchasers for both the *Angelus* and *Death and the Woodcutter*. At the same time he began to buy up all the Millets that were in the market, and in this way managed to secure a large number of the painter's works at a very low price. He lent a willing ear to Sensier's proposals, and in order to strengthen his hands, entered into partnership with a Paris picture-dealer, M. Blanc, the father-in-law of his brother, the artist Alfred Stevens.

A contract was finally signed on the 14th of March, 1860, by which Millet agreed to deliver all the pictures and drawings which he should execute during the next three years to the firm of Messrs. Stevens & Blanc, on condition of receiving 1,000 francs on the 25th of each

month. The price of each picture was to be placed to
his credit as it was delivered, and at the end of this
period the accounts between the contracting parties were
to be balanced. Another condition was that Millet should
not receive any payment until he had delivered six pic-
tures amounting in value to 7,900 francs. A list of the
partly-finished pictures which the painter had in his studio
at the time when he signed the contract was added to
the agreement. They were as many as twenty-five, and
their value, when completed, was fixed at the sum of
27,600 francs. Chief among these was the picture of
Tobit and his Wife awaiting the Return of their Son,
which was valued at 3,000 francs. The price of each
drawing was fixed at £4; that of the pictures varied
according to their size and importance, but none was to
exceed the sum of £120.

Millet's sensation, during the first few months after he
had signed this contract, was one of intense relief. He
had an assured income of £480 a year, and was free to
paint whatever subjects he liked to choose, without the
perpetual anxiety of finding a buyer for his pictures.
Peace, as he told Sensier, had descended upon his life,
and he was able to devote his whole powers to new con-
ceptions, or to the completion of pictures which had been
already begun. But this happy state of things did not
last long. Before the year was over, he found himself
involved in endless difficulties and misunderstandings, and
he lived bitterly to regret the reckless way in which he
had pledged his freedom. In the first place, Stevens and
Blanc quarrelled in 1861, and their disagreement, after
causing endless delays in their payments, finally led to an
interminable lawsuit. During this period, Millet could nei-
ther sell pictures to any one else, nor get the money that
was due to him from them. He had no means of subsist-
ence, and in his distress he was forced to make drawings

for a few friends, who promised to keep them in their own
hands. This led to mutual recriminations and accusations
of dishonesty, and became a source of continual annoy-
ance to the sensitive painter. M. Blanc thought fit to
pass severe criticisms upon his work, and to reproach
Millet with thinking anything was good enough to
send him. All this vexed Millet greatly, and interfered
seriously with his powers of production. Then his usual
headaches came to interrupt his work and retard the
delivery of his pictures. At the expiration of three
years, Millet owed M. Blanc the sum of 5,762 francs,
which he gradually paid off in pictures, and the whole
business was not finally concluded until the year 1866.
The history of this contract is involved in obscurity; but
difficult as it is to find out the truth, there appears little
doubt that in this instance, as in too many others, he
was duped by false friends, who imposed upon his credu-
lity, and took advantage of his ignorance and unbusiness-
like habits. Sensier, who acted as manager for Millet,
mentions the contract, but does not reveal a word of these
subsequent transactions. He himself seems to have pro-
fited by the contract, and is said to have sold many of
Millet's pictures that were in his own possession, to
Stevens & Blanc, at a commission of 10 per cent.

For the moment, however, Millet was saved from the
persecution of small creditors, and spent the year 1860
in comparative peace. His letters were tranquil and his
soul serene. "Were it not for this *chère migraine*," he
writes, "I should be quite happy and satisfied."

Among the most important works which were completed
during 1860 and 1861 were the *Tobit*, the *Shepherd in the
Fold by Moonlight*, *Sheep-Shearing* and the *Woman Feed-
ing her Children*, *La Femme aux Seaux* and *La Grande
Tondeuse*. The last-named picture was sent by Stevens
to the Exhibition held at Brussels in the summer of 1860,

where it attracted general attention. This life-sized peasant-woman, with her finely-modelled bust and arms, plying the shears deftly with one hand, while with the other she holds back the fleece, and the sheep lies passive on the barrel in the grasp of the old labourer, commanded general admiration. Her dignity of attitude, the truth and vigour of her action, and the serious expression of her face, impressed critics and public alike. This peasant-woman, in fact, recalled the great art of Greece, and was compared to Juno and to Pallas.

"Every subject," wrote the critic Thoré, "can be raised to the loftiest heights of poetic art by the power of the artist, if he brings an irresistible conviction to his work, and that universal element which connects his creations with the beautiful and true. This simple *Tondeuse* of M. Millet recalls the most admirable works of antiquity—the statues of Greece, and the paintings of Giorgione."

The writer, whose article appeared in the *Gazette des Beaux Arts* for October, 1860, had been one of Rousseau's most loyal defenders in the years when his pictures were banished from the Salon, and after his return from exile in 1860 was a frequent visitor at Barbizon. He took long walks in the forest with both artists, and had interminable discussions over the theory and practice of art, in which critic and artists invariably disagreed; Thoré maintaining that a picture depends upon its subject for greatness, Millet insisting that all subjects are great, if they are employed for a great end—the trivial, in fact, becomes sublime. The force and tenacity with which the two artists clung to their opinions impressed Thoré profoundly. "Do you know," he said to Sensier, "those two men are terrible! They are fierce and rugged as the rocks of the forest where they live. Their ideas are just as unchangeable, and nothing ever seems to modify them in the smallest degree."

"Thoré came from Fontainebleau last night," wrote Millet on the 11th of November, 1860, "with two of his friends, and was here for about five minutes. He told me that his article had appeared in Charles Blanc's journal. Try and find out what he says, and tell me how Diaz and his family are after their great loss."

This was the premature death of the painter's son, Emile Diaz, a youth of great promise, who died at five-and-twenty, to the great regret of his parents and friends.

"Thoré's article has arrived. I find it rather puzzling. Which is the best part of it? We must talk it over. Ask M. Niel if he knows an old book, published in French and called *Tableau des Visions Chrestiennes*; at least that was the title at the top of the pages, for in the copy which I remember both the first and the last page had been torn out. This book contained a number of legends which used to frighten me terribly when I was a child. It contained the opinions of different casuists on a variety of subjects belonging to another world, etc., etc. Is it a book that could be easily found? What are the finest old illustrated Bibles that he knows, and what does he consider the best translation? I beg you to pay him my respects.

"J. F. MILLET."

The love of the old picture-Bibles and legends of the Saints, with which he had been familiar in his childhood, was still strong in his breast, and a friend describes him as seated on a stool in his *atelier* buried in the study of an enormous Bible adorned with sixteenth-century plates. His own anxieties had only served to deepen his sympathy with the sorrows of others. He frequently asks after Diaz and his wife in their grief, and writes a letter full of affectionate concern to Sensier, on the death of his little boy:

P

" MY DEAR SENSIER,—

"We are much grieved at your sad news, and pity Madame Sensier for all she has suffered. We hoped for better news, I must say, but at least let her try not to grieve too much. Your grief must also have been very bitter, and only people who have gone through the same trials can feel for you. Ah ! well, there is no consolation to be found in such moments. Where can one look for it ? We can only reflect once more on the sad condition of man that is born of woman, whose short existence is but a tissue of misery. Why did I not 'perish in my mother's womb?' was the cry of Job. My dear Sensier, I must stop, for I become more and more gloomy. But you cannot imagine how, each time I hear of some great sorrow, especially when it falls upon those whom I love best, all my own troubles are revived and seem to come back with fresh force. Happily, other things come to distract my mind, but I slip back very easily into the old current of thought. My wife implores Madame Sensier not to allow her grief to agitate her too much. We embrace you warmly, and wish with all our hearts that you may be able to get over your sorrows. Be of good courage !

" J. F. MILLET."

Another of Millet's Barbizon friends, the artist Laure, had a daughter named Jenny, whose delicate health gave her parents great anxiety. Her charming nature and the shadow of early death which hung over her fair young face, made her a great favourite with both Rousseau and Millet. She was a privileged guest in Millet's house, and often sat in his *atelier* watching him at work, and trying to draw in her turn. He treated her with the greatest kindness, and made a fine study of a girl leaning against a tree, holding a bucket of water which she has just drawn from the river, for her instruction. But poor Jenny fell a victim to consumption at an early age, and she died in February, 1861, to the grief of the whole colony at Barbizon. After her death Millet painted her portrait from memory and

sent it to the heart-broken parents, who wept for the loss of their only child.

Besides the *Tondeuse de Moutons*, which had already been exhibited at Brussels, and the picture of *Tobit and his Wife*, which was completed in 1860, Millet painted a third subject—*A Mother Feeding her Children*—that winter. A woman is represented seated on the threshold of her door, feeding her three children with spoonfuls of soup from a bowl which she holds in her hand, like some hen feeding her chickens, while their father is seen digging in the garden behind. It was presented to the Museum of Lille, in the painter's lifetime, and is better known by its other name of *La Becquée*. Millet alludes to this work in a letter of December the 4th, 1860, in which he also mentions the distinguished artist Mèryon, who had begged to see his etchings, and expressed a desire to buy some of them.

"Since M. Mèryon is really so amiable, let him choose any of the plates which he likes to have. My picture of *Children Eating* is finished. I am waiting till it is sent for. I must find out if it is possible to bring it under the notice of the Director of Fine Arts (M. de Nieuwerkerke, whose influence with the Emperor was great at this time). Perhaps he will think the subject very dangerous and revolutionary !"

The three pictures were all exhibited in the Salon of 1861, but Millet heard, much to his vexation, that the members of the jury had been divided as to their merits, and that several leading artists had voted against their admission. Accordingly he sends Sensier a long letter on the subject, written in his usual over-sensitive strain.

"Tuesday morning, April 22, 1861.

"MY DEAR SENSIER,—

"Thank you for the information which you give me as to my Salon pictures and the opinion of the judges, in the letter which

Tillot has brought me. I must say I should have greatly preferred their rejection to an admission which will give these creatures a chance of hanging my pictures in the most unfavourable manner, as is clearly their intention. It is no use discussing the reasons which they advance as their motives, but none the less I feel that a new wrong has been done me, and I am forced to endure this as well as the fine chance their writers will now have to attack me in print, since, no doubt, the chief journals are under their control. What is to be done? My self-respect, as you know, will not suffer, even by a hair's-breadth, but none the less, I am vexed for other reasons ; for I am not alone in the world, and unfortunately I am no longer as young as S——. An idea, which is perhaps a very mad one, has come into my head. I will speak to you about it on Saturday, for if it were possible, not, of course, to appease the storm, but to moderate its effect by any tolerably practicable means, this would be the moment.

"Try and find out if the report of the share which Flandrin and Robert Fleury are said to have taken in the matter is absolutely correct. I should be greatly interested to know why and how they supported me, and if they gave any reasons for their action. This does not relate to my plan for allaying the violence of the storm which I mentioned above. Why in the world cannot I paint things that are to M. Nieuwerkerke's taste ? If only M. de Chennevières can succeed in hanging *Tobit* on the line in a good light, it will be a great thing. And you have heard nothing of that unfortunate *Jean* ? Perhaps he will have to learn in his turn that things are not always easy. Once more, if it is not too much trouble, try and get *Tobit* hung on the line.

"If you hear anything fresh that is likely to interest me, be sure and tell me, without waiting till Saturday. Tillot tells me that Rousseau's pictures are progressing, and look very well. Good-day to you and to Madame Sensier and Rousseau.

"J. F. MILLET."

In spite of Millet's fears and the opposition of his enemies, the opening day of the Salon proved a triumph for him. His *Grande Tondeuse* was especially admired, and his old friend, Charles Jacque, who had quarrelled with all the other Barbizon artists and now seldom saw

Millet, came up to him in the Salon and congratulated him warmly on this masterpiece. The *Tondeuse* passed from the hands of Blanc and Stevens into an American collection, and is now in the gallery of Mr. Brooks, at Boston.

On the other hand, the *Tobit*, which the painter himself considered the finer work of the two, was fiercely assailed by the critics—most of all by his old admirers, Saint-Victor and Théophile Gautier.

"To tell the truth," wrote Millet, "I prefer the way in which Saint-Victor now speaks of me to being loaded with his praises. His long string of empty words, his hollow flatteries, gave me the sensation of swallowing pomatum! I would just as soon be rid of him at the cost of a little mire. If I wore pumps, I might find the road muddy, but in my sabots, I think I can get along."

But he could not always meet his foes so gaily. There were moments when his courage failed and his heart sank within him.

"If I were not so firm in my own convictions," he said to Sensier; "if I had not a few friends, if in fact I were alone, I should begin to ask myself if I were not the dupe of my own imagination, and after all, nothing but a dreamer! Come, in good earnest, what can I find that is true and serious and might help to correct my faults in the invectives of these gentlemen? I look and find nothing but noise!—not a single piece of advice, not one hint which might be of use to me. Is this the sole office of the critic, to abuse a man and then to disappear?"

Sensier insists, and contemporary art-journals and newspapers, with one or two rare exceptions, attest the truth of his statement, that Millet was attacked at this period of his life, as little better than a criminal, whose whole endeavour was to stir up honest citizens to revolt. This perpetual persecution and sense of injustice made him assume an attitude of hostility to the outside world in

general, and to critics in particular, which explains the
bitterness of his remarks upon art-writers, and his re-
luctance to make their acquaintance. This consciousness
of being engaged in a hard battle left its impression
even upon his face, and is reflected in the portraits of
that time. There is a photograph of him, taken by a
friend at Barbizon in 1861, in which he is seen wearing
sabots and a grey jersey, and standing with his back
against his garden wall. His head is erect, his foot firmly
planted on the ground, his eye steadfastly fixed as it
were on the advancing foe. He might be some peasant-
hero of La Vendée, daring his enemies to do their worst.

"You look like some peasant-leader going to be shot,"
was Sensier's remark when he saw the portrait. The
expression pleased Millet. He was, as he often said,
the leader of a forlorn hope, a sad and lonely fighter
in a great cause. And one summer evening, as he stood
by his garden wall, watching the setting sun sink in a
blaze of fire over the plain, he exclaimed:

"There lies the truth! Let us fight for it!"

And so he fought and died, and Truth conquered.

XI

1861–1862

THE quarrel between the picture-dealers, Blanc and Stevens, which took place in the year 1861, involved Millet in endless troubles. During the lawsuit that followed, he was in constant difficulties, and could neither deliver his pictures, nor get the money which had been promised him by the contract. The correspondence lately published by Mr. T. H. Bartlett, abounds in allusions to these tiresome wrangles. M. Blanc complained to Sensier that a whole month had passed since the painter had sent him a picture, while Millet was left penniless, and did not know where to turn for help to supply his immediate needs.

"Barbizon, 17 July.

"My dear Sensier,—

"Your notices of the pictures which I sent to Brussels are excellent. Who could anticipate the slowness of an express train, or imagine that a parcel leaving Melun on Sunday evening would not arrive in Paris before Tuesday morning? I can well believe that Arthur Stevens would like to make more money out of my picture. What means is he taking to sell it? Has he spoken to you about it? I cannot see my way clear in this matter, although my first impression was that I should prefer him not to have it photographed. What is your opinion? The annoyance of all this jobbery about pictures completely prevents me from seeing anything clearly. My conclusion may sound very vague. At any rate, I shall agree to whatever you may think best."

 "Barbizon, 16 December.
"My dear Sensier,—

"Rousseau had already paid Harcus when I spoke to him about the 150 francs. He can lend them to me until the end of the week, when he goes to Paris. Can M. Niel buy the drawing, or is there any other way of selling it, so that Rousseau may not be embarrassed on my account? Shall I make some more drawings, and is there any prospect of selling them? It is a very grave matter if I do make them, because it prevents me from finishing my pictures; and what is still more serious, Messieurs Blanc and Stevens may hear of it, and say that as I am doing work for others, I am seeking to break the contract. All this is very troublesome, but one must have bread. What shall I do? It is evident that Stevens will do all he can to hinder the desired conclusion, but I beg you to urge the lawyers to do their task as rapidly as possible."

To add to his difficulties, his wife had lately been confined, and her infant son was seriously ill. In the midst of these domestic troubles he was working hard at the fine picture of *The Potato-Planters*, one of his less-known but most finished works. A man and woman are seen at work on the edge of the plain: the labourer turns the sod with his hoe, and his wife drops in the potato-seed. Beside them their child slumbers in a pannier on the back of a donkey, in the shade of a big apple-tree, such as grew in Millet's own garden at Barbizon, and the village roofs are seen in the background, steeped in the luminous haze of evening. *The Potato-Planters* was one of the pictures which appeared at the Great Exhibition of Paris in 1862, and changed hands for large sums during the painter's lifetime. It is now at Boston, in the collection of Mr. Quincy Shaw. Happily the sick child recovered, and Millet wrote cheerfully to tell Rousseau of his new picture:

 "Barbizon, 31 December, 1861.
"My dear Rousseau,—

"Our child is cured, or, at least, is almost well again; only

he does nothing but howl and suck, and leaves his mother no rest. But our anxiety is over, which is a great thing. I am working with all my might at my *Planters*, which means that you will no doubt see me arrive before long and upset everything in your *atelier*, as is only natural. You must have seen Eugène Cuvelier. He showed me some very fine photographs taken in his own country and in the forest. The subjects are chosen with taste, and include some of the finest groups of timber that are about to disappear. You have also seen Bodmer, who is delighted with what you have shown him. This morning we have had a hoar-frost of marvellous beauty, and which I will not attempt to describe. I have a letter from Vallardi clamouring for his little picture. Tell him he need not distress himself, for I mean to bring it with me when I come to Paris.

"The children have been engaged since yesterday in composing New-Year letters. They really toil in the sweat of their brow to produce things which for all their pains are hardly to be called masterpieces. I do not intend to give myself so much trouble, and will content myself with wishing you, Madame Rousseau and all of yours the best of possible years, and will add that if the coming year is all I wish it, you will not have much reason to complain. My wife and children join with me. *Au revoir*, my dear Rousseau.

<div style="text-align:center">"Yours affectionately,</div>

<div style="text-align:right">"J. F. MILLET."</div>

But the vexatious worry of his affairs with Blanc and Stevens still pursued him, and filled his mind with haunting terrors. On the 3rd of January, 1862, he writes to Sensier :

"MY DEAR SENSIER,—

"The New Year is not to be one of the seven fat kine of Pharaoh's dream. I fear the long series of lean cattle is not yet over, for this one has opened gloomily. Our child is cured. That is the bright side. But this business drags on, and I find myself compelled to await the end of a lawsuit in which I take no part, and that without having any other means of subsistence. It is a horrible complication! Are there then no laws, no judges who can help me out of this? Try and find out, and let me know.

This state of things cannot last. M. Templier assured us of the lawsuit's speedy end. He seemed sure of that, but till then how am I to live and await the good pleasure of the judges? O Solomon, surely you were more speedy! I am coming to Paris in a few days, when my sick headaches have departed. In spite of these I am working with all my might. . . .

"My whole time has been so rigorously devoted to work that I have not had a moment to plant our trees. But I mean to take a day and put in our apple-trees, so that they may not suffer. There will be two in our old garden, and two more in Ribouillard's plot. We are afraid you may be put to inconvenience by keeping our big Marie for so long. She does not seem to complain, which is not to be wondered at since Madame Sensier loads her with treats of every description. When you hear that a young girl of her age has already seen a bazaar, that she is in ecstasies over the sign of Biche the baker, and that she has seen lions eat! Franfrance (François Millet's eldest son) intends to make her give him a minute description as to the manner in which Messieurs the lions open their jaws to discharge this function. Tell her that we all embrace her warmly."

The next letter contains the first mention of his famous *Homme à la Houe*, a picture which he foresaw would not be likely to please the public taste, and which apparently M. Blanc did not appreciate.

"Barbizon, January 11, 1862.

"The two pictures which M. Blanc does not seem to care about are my Norman landscape and the Man leaning upon his hoe; but I have worked so hard at them that perhaps when he sees them he may find them more to his taste than he expects. My *Man with the Hoe* will get me into trouble with the people who do not like to be disturbed by thoughts of any other world than their own. But I have taken up my position, and mean to make a stand here.

"I am preparing the drawing for M. Niel. Let him know, so that he may be prepared to receive it soon. Do you think it would be too much to ask for 150 francs? It is a water-colour drawing. . . . I have received a letter from Pierre. He

tells me that nearly the whole of the United States population has taken up arms, and that recruiting is still going on. He says that the Northern States have about 500,000 men under arms, and the South about as many. . . . I am working at my picture of a man and woman planting potatoes, which would be finished tolerably quickly if I were not constantly interrupted by other things."

"March 4, 1862.

"We were horrified at the death of Madame J——. It is frightful to see the number of friends who have fallen round us in the last few months. However much we prepare our minds to bear all these ills that flesh is heir to, we are none the less taken by surprise and overcome when they happen. It will be a great kindness if you can bring me what I want when you come at Easter. What wretched weather! Everything is hard-frozen. I know not if anything will escape. Oh *primavera* of the poets—*triste, triste !*"

"March 27, 1862.

"Père Verdier has brought us some thorns; for you some hornbeams, beeches, and service-trees, and also some little elms, all twisted, and of the right sort, which we must plant the first time you come here. They have fresh and shining stems, and look like healthy beings. As for the laurels you speak of, I am not so modest as to dislike laurels! Bring as many as you like, and if the choice of varieties depends upon you, let there be one at least of the tree kind. I always remember the one which grew in my parents' garden, and which lives in my imagination as the perfect type of a laurel. The trunk was as big as a man's body, the leaves rather dull than shiny, and of a fine dark-green colour. In short, it was a laurel worthy of Apollo himself. My wife is sowing seeds in your garden and in our own. The weather is magnificent and very hot, but beware of the April moon!"

"May 12, 1862.

"MY DEAR SENSIER,—

"I have just devoted Saturday, Sunday, and Monday to one of my most famous headaches. I cannot get over it yet. We did not know that you had been upset on your return to Melun. As for the explanation of which you speak, we will talk of that on Sunday. Some means must be taken, and materials collected

to meet the charges of these eternal barkers. The best way would be to remind people quietly of what they have said, throw their own words in their teeth, and humbly ask for an explanation. We must talk of that seriously on Sunday. And please keep your ears open, and let me know what people are saying of my *Potato-Planters.*"

Rousseau and Sensier had decided to write an article in defence of Millet, in order to answer the charges that were being constantly brought against his work and intention. At the same time an exhibition of three of his pictures was held that summer at Martinet's rooms on the Boulevard des Italiens. Thoré wrote a descriptive notice, and Millet supplied both him and Sensier with notes explaining his ideas and intention. The three pictures had all been painted in the course of the last two years, and were the property of Blanc and Stevens. One, the *Becquée*—now in the Lille Museum—had already been exhibited in the Salon of 1861. The others—*La Tonte des Moutons* and *La Femme aux Seaux*—were remarkable examples of his finest thought and execution. The sheep-shearing takes place in a picturesque farmyard, shaded with large trees, such as belonged to the Norman yeomen in the neighbourhood of Gréville, which Millet had known so well in his youth. Two peasants—a man and a young woman—ply the shears, and the sheep, some of them already shorn, others awaiting their turn, and bleating after their wont, are penned inside the enclosure. In the background, between the boughs of the trees, the cows are seen feeding on a green hillside that rises behind the peaceful homestead.

" I have tried," said Millet, " to paint a happy corner where life is good, in spite of its hardships. The air is pure ; it is a lovely August day ! "

The *Femme aux Seaux* was at once recognised as a worthy companion to the *Grande Tondeuse*, and, like that

picture, was destined to find a home in the New World.
It formed part of the Hartmann collection for many years,
and is now in the Vanderbilt Gallery at New York. The
subject is simple enough. A young peasant-woman has
been drawing water from the well, and is in the act of
bearing home her pails. Her figure and attitude, the
movement of her arms, and the way she balances the pails,
are all given with the utmost fidelity, while the rustic
charm of her face and form is set off by the richly-
coloured background, with its old stone well and clusters
of hanging ivy.

Millet himself has explained the meaning of the picture
in the following letter—one of the most characteristic
expressions of his favourite theories that we have :

" MY DEAR SENSIER,—

" This is the substance of what I have written to Thoré
about three of my pictures which are now on view at Martinet's
rooms :

" In the *Woman Drawing Water*, I have tried to show that she
is neither a water-carrier nor yet a servant, but simply a woman
drawing water for the use of her household—to make soup for her
husband and children. I have tried to make her look as if she
were carrying neither more nor less than the weight of the buckets
full of water ; and that through the kind of grimace which the load
she bears forces her to make, and the blinking of her eyes in the
sunlight, you should be able to see the air of rustic kindness on
her face. I have avoided, as I always do, with a sort of horror,
everything that might verge on the sentimental. On the con-
trary, I have tried to make her do her work simply and cheer-
fully, without regarding as a burden this act which, like other
household duties, is part of her daily task, and the habit of her
life. I have also tried to make people feel the freshness of the
well, and to show by its ancient air how many generations have
come there before her to draw water.

" In the *Woman Feeding her Chickens*, I have tried to give the
idea of a nest of birds being fed by their mother. The man in
the background works to feed his young.

" In the *Sheep-Shearing*, I tried to express the sort of bewilderment and confusion which is felt by the newly-sheared sheep, and the curiosity and surprise of those who have not yet been sheared, at the sight of those naked creatures. I tried to give the house a peaceful and rustic air, and to make people see the green enclosure behind, and the sheltering poplars ; in fact, as far as possible, I have tried to give the impression of an old building full of memories.

" I also told him, in case he chooses to say so, that I try to make things look as if they were not brought together by chance or for the occasion, but were united by a strong and indispensable bond. I want the people I represent to look as if they belonged to their place, and as if it were impossible to imagine they could ever think of being anything but what they are. People and things should always be there for a definite purpose. I want to say strongly and completely all that is necessary. What is feebly said had better not be said at all, for then things are, as it were, spoiled and robbed of their charm. But I have the greatest horror of useless accessories, which, however brilliant they may be, can only weaken the subject and distract attention.

" I hardly know if all this was worth saying—but there it is. You must give me your advice. Will you come on Saturday, as you had almost decided ? Here, there is no news. The children's whooping-cough seems to be a little better. Our salutations.

<div align="right">" J. F. MILLET."</div>

The exhibition at Martinet's met with great success, and materially improved Millet's position in the public eyes. On the 24th of May he wrote again to Sensier on the subject :

" MY DEAR SENSIER,—

" I should have answered your letter yesterday, but was unable to do so owing, as you will easily divine, to my everlasting headaches. Do not lend anything to Martinet's Exhibition before we have looked over your drawings together, for I intend to go to Paris for this purpose before long. Let him wait a little. If you are still coming for Ascension Day, I will arrange to return here with you. I must own that I am very glad to hear what you tell me of my pictures at Martinet's, for a contrary report

would by no means have surprised me. I shall be very well satisfied if M. Blanc could sell my *Potato-Planters*. Would this not be a good opportunity to bring out the article which you were preparing a little time back? Talking of articles, last Sunday I received the annual of *La Manche*, which contains a flaming account of me from the pen of Simeon Luce, the author of *La Jacquerie*; and since then I have had an extremely flattering letter from the same quarter. He gave me Rue des Poirées 5, Hôtel de l'Europe, which must be a boarding-house, as his address, —a proof that he does not always reside in Paris. I have answered his letter."

"8 June, 1862.

" Please see that my drawings are not too badly hung at Martinet's. I wrote to ask Simeon Luce for the name of a work on Poussin, which he mentioned to me the last time I was in Paris. [He replies by sending him a book entitled : *Les Andelys et Nicolas Poussin, par Gandar, Membre de l'Académie.* Caen, 1860.] I have not had time to make fresh researches among my old letters to see if I can find one or two more from my mother and grandmother, but I am going to attack them some evening. When are you coming? *Au revoir ;* before long, I hope.

"J. F. MILLET."

Sensier was already meditating a record of Millet's life, and was anxious to collect all the material that was available for his purpose. He came to Barbizon for the summer holidays, and spent the days in long walks and talks with his friend. Millet was always glad of an excuse to talk of his old home, and on this occasion he gladly wrote down the touching account of his early impressions, which forms so precious a chapter of Sensier's volume.

Better times now seemed to be in store for the painter. The success of his little exhibition, and his increasing fame, had made buyers more frequent and dealers civil. M. Blanc found it easy to sell his pictures, and had become surprisingly amiable in consequence, as Millet innocently tells Sensier :

"Barbizon, 21 July, 1862.

"My dear Sensier,—

"A week ago Monsieur Blanc and his wife came to spend the day with us. We are better friends than ever. He seemed enchanted with what he saw in my *atelier*. The man leaning on his hoe seems to him magnificent !—these were his very words. It he were in the Government's place, he would buy all my pictures which are chapters of the same story, and hang them all together in the same gallery. Once more he expressed his usual regrets that circumstances had not thrown me among other surroundings, where I might have received more agreeable impressions. But things being as they are, there is nothing that should be modified, by so much as a hair's-breadth, the more so that these things *are also worth doing*. He said many more things in the same strain, all very flattering; but if I tried to put them down, they would fill a volume! Last of all, he said this : ' My dear Millet, let Sensier help me to sell your pictures. I do not say all of them, but as many as will suffice to cover my expenses; and there is no reason we should not continue in partnership for the next ten years. Really, I am very fond of you. You are a profound thinker ! '

"So poor Adrien Laveille has reached the end to which his illness was bound to come. I believe he leaves several children, which is very sad."

The next letter alludes to an application which had been made by a new dealer for some of his etchings:

"Barbizon, Sunday, 3 August, 1862.

"My dear Sensier,—

"This is what you must do with Cadart: if he wants some of my plates, he must buy them, and take as many copies as he likes. Only I hardly know what price I ought to ask. But I give you *carte blanche* in this matter, and in all others. Do whatever you think best; or do nothing at all, if that seems better to you. Once more, act according as you think appears best for good or evil. Madame Rousseau seems well. Rousseau came back from Paris on Friday, but he was so much taken up with business, that he could not go to your house. He only saw Feuardent and Alfred Feydeau. What you say of Madame

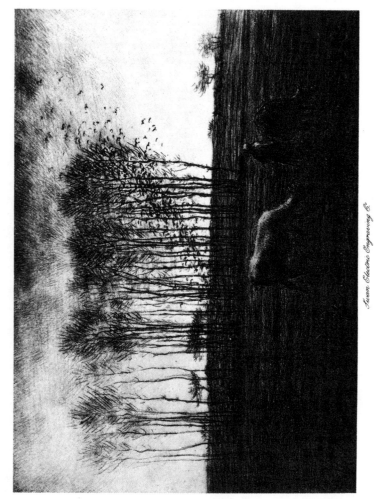

La Nuée de Corbeaux (The Flight of Birds)

Swan Electric Engraving Co.

Diaz does not sound lively. The poor woman must suffer greatly ! We are anxious to see you established here. The children are dying to see Madame Sensier and her little girl. Good-bye to you both and to Jeanne, and *au revoir* very soon.

"J. F. MILLET.

"P.S.—If you have not had time to settle anything with Cadart, so much the worse. *Bon voyage !* and on Thursday the holidays !"

And a little later he asks anxiously again for news of Madame Diaz, and of her daughter Marie, and condoles with them on the sad state of Madame Diaz's health with his usual warmth of heart.

The summer months sped happily by, and Millet worked hard at several pictures. One was a winter scene of rooks flying across a snowy landscape. Another represented a stag standing by the crumbling stones of the old wall which once formed the boundary of the forest, and looking out with startled eyes and ears erect at the unknown country before him. The dark shadows of the forest were finely contrasted with the brilliant light of the open plain, and the rich hues of the old stones, with their ferns and grasses and creeping lizards. This poetic little picture, sometimes described as the *Cerf aux Écoutes*, sometimes as *Le Vieux Mur*, was eventually bought by Sensier, and sold after his death in 1877 to an American collector. The artist was still working at *L'Homme à la Houe*, when, towards the end of October, a sudden attack of fever interrupted his labours, and compelled him to take to his bed.

"Always evil !" he wrote sorrowfully. "When will the good come ? Ah, life ! life ! how hard it sometimes is ; and how much we need our friends, and yonder heaven to help us to come back to it !"

And he pointed to the strip of blue sky which he saw through the trees of his garden.

Q

Before he had recovered from this illness, a terrible event took place in his immediate neighbourhood, and plunged him into the deepest gloom. Early in November his friend Rousseau, who had not yet left Barbizon for Paris, was gratified by a visit from an eminent lover of art, M. Frédéric Hartmann, who expressed the liveliest admiration for his landscapes, and induced him, a week afterwards, to pay a visit to him in Alsace. Rousseau had gone there, intending to proceed with his wife to visit her relations in Franche Comté, and had left a cousin, Adèle Rousseau, together with his friend Vallardi, in charge of his house at Barbizon. The tragedy which followed is best told in Millet's own words:

"Barbizon, November 18, 1862.

"My dear Sensier,—

"The wretched Vallardi has killed himself! Yesterday morning, towards eight o'clock, Louis Fouché came hurriedly to my *atelier*, which I had just entered. He told me, still trembling as he spoke, that he had gone into Vallardi's room to rub him as usual, and had called him to see if he were still asleep, but receiving no answer, he had put in his head and had seen him lying on the bed covered with blood. He had not dared look any further, and had hastened here to tell me. Imagine the blow this was to me! I ran back with him and Luniot whom we met on the way, and found the wretched man bathed in blood, and lying quite dead.

"How, and why did he kill himself? we asked ourselves. I saw on a table by his bed a pair of scissors covered with blood, and have no doubt that he stabbed himself with these. The mayor and doctor of Chailly came on the spot. We opened his shirt to see where he had struck himself, and found seventeen wounds at the heart, besides many others all around. It is impossible to describe the horrible appearance of the unhappy man, the way in which he had struggled on his bed, which was all in disorder, the prints of his hands in blood on the sheets, on the pillow, and everywhere—even on the curtains of the bed which he had grasped, and which were torn and bloody. I will

try and tell you all about it. The *gendarmes* and the *Procureur Impérial* have arrived, and there is a complete revolution in Barbizon. I wrote immediately to Rousseau, who will feel the shock severely. I am so much distressed that I must stop here. Vallardi killed himself during the night between Sunday and Monday. He was not yet quite cold when we arrived.

<div style="text-align:right">" Yours,
"J. F. Millet."</div>

<div style="text-align:right">" Barbizon, 20 November.</div>

"I cannot get over the fearful impression which this death, under such awful conditions, has made upon me. Yet this wretched man never knew any real suffering ; he was merely unhappy because he had not a large enough income. He could not bear to face poverty. Poverty! why, the poor fellow had never even seen its approach from afar. He was unmarried, with only himself to keep, and a small fortune of his own. He had Rousseau for his friend, and others besides in Paris. He had never known that fearful thing—poverty, and all that accompanies it. The mere terror of suffering had turned his brain. He must have been mad, and we have accordingly signed a certificate to that effect. The *Curé* did all he could to help us, and has obtained from the Dean of Melun permission to use the services of the Church, which had at first been refused. Our certificate of insanity has removed that difficulty.

"Imagine what would have become of the unfortunate Adèle, all alone with the body, if, as might easily have happened, Tillot and I had been absent. We have, so to speak, never left the place, and have answered all inquiries, and given all necessary orders. We kept watch by the corpse. In short, I think, we have been of use. I should never stop writing if I tried to tell you half the strange things which were done by the people who were there at the time, or who came afterwards. The grotesque is mixed up with everything, even with death. He was buried yesterday. The funeral procession was not a long one — two gentlemen of the Maison Didot, M. Rousseau, *père*, and ourselves, perhaps ten persons in all. He certainly killed himself from fear of dying in poverty. His Paris friends told us so.

"This horrible end is always before me. Imagine what his agony must have been. It is easy now to see how it all happened.

Since he was unable to sleep again that night, he resolved to put an end to the story. He went into the dining-room, took Madame Rousseau's scissors, and standing by the bedside, struck himself until his strength was exhausted, and he fell with his face against the table and his knees on the floor, as was evident from the bruises upon his nose and knees. The blow overturned the candle, which happily went out in falling. Imagine the struggles of the unhappy man, groping about in the dark, trying to rise and being unable, slipping in the pool of blood, and at length hoisting himself with infinite difficulty on to the bed. Think of this fearful struggle going on in the dark. If you could have seen how he had struggled on his bed! He left terrible traces of his agony. If he could have seen, before he killed himself, the hideous scene upon which the morning rose, I think he would have stopped short. It is a miracle that the house was not burnt down. The candle fell first of all on the sheets, and then rolled on the ground just underneath the curtains, against which it lay. What a horrible affair that would have been for Rousseau! for if the fire had broken out, it would have been impossible for the *atelier*, which is overhead, not to have caught fire. Think of Rousseau's canvases, drawings, and sketches, all on fire—everything which he had begun and finished destroyed in his absence, and nothing left but a heap of ashes! I am still quite dazed. Come on Sunday if possible. I need some one to bring me to my senses, for I have never felt anything like this. Oh! how difficult it is to breathe in this atmosphere of suicide! I am surrounded with perpetual nightmares.

"J. F. MILLET."

For days and weeks Millet was haunted by the horrors of that awful scene. He could not forget the frightful details of the murder, and the horrible sight which had met his eyes that morning. At length, in order to clear his brain, he sat down and drew a pastel of the unfortunate man on his death-bed, an awful but strangely powerful rendering of the reality. By degrees, however, his saner nature got the better of his tortured imagination. Courage and calm came back to him, and he set to work again and put the last touches to his picture of the stag looking over the breach in the old wall. On

the 28th of November he wrote to Sensier in his usual strain:

"I could not come to Paris, for I wanted to let my picture alone for a day or two, and then look at it again for a little while before I delivered it. So I will come about the 8th of next month. You had not spoken to me of the *Courier du Dimanche*, nor yet of Ulbach, so I fail to understand your allusions. Please explain this. I have resumed my search for my mother's letters. I have found one which was dictated by her, and there are still some other things. . . . I was going to copy it out for you, but I must have laid it down by accident with the block. I will look again. I have no news of Rousseau. How are they all at his house? Good health to you both!

"J. F. MILLET.

"P.S.—I have received a note for 1,000 francs which I send to Marchand to be cashed. Call on him, please, and send me the money at once. I am giving you a great deal of trouble."

"Barbizon, Wednesday, 3 December.

"MY DEAR SENSIER,—

"I start to-morrow, Thursday, morning for Paris. I shall bring my *Old Wall*, which I hope will meet with the approval of M. Blanc and his clients. I have informed him of my arrival, and shall, no doubt, see him in the course of the day. If you can, come to Rousseau's. Anyhow, I will come and see you on Friday morning. Jacque is here."

XII

1862–1863

THE successful exhibition of Millet's pictures and drawings which had been lately held on the Boulevard des Italiens, had encouraged Sensier to repeat the experiment on a larger scale. With this intention he applied to M. Goupil, who received his overtures favourably, as we learn from the following letter :

"Barbizon, December 19, 1862.

" MY DEAR SENSIER,—

"The result of your interview with M. Goupil seems to me very satisfactory on the whole. I think that it will be a decided advantage if we can have the use of his rooms, seeing that the high reputation of his firm is, in itself, a recommendation of the pictures which he allows to be exhibited there. He may be certain that my pictures have not been much seen before they appear in his rooms, and you may truthfully assure him that he will have been, as it were, the first promoter of this enterprise. I think the proposal to engrave the pictures is an excellent one, since it will give them a wide publicity, and, if the plan answers, ought to produce some material profit. Once more, I am very well satisfied with the result of your application to M. Goupil. If he wishes to have some of my pictures at once, perhaps he had better begin with the *Shepherd and Potato-Planters*, rather than with the larger works. Their turn would come later on. Let him ask Alfred to varnish the *Potato-Planters* before he sends it to him. If you think it of any use, next time I come to Paris, we will go to M. Goupil's together. I have nothing more to say on the subject. When I came away from Paris I left 50 francs for you with Madame Rousseau. You know its destination. I have nothing more to

say but that we are fairly well, and that I am working like a slave. I am finishing my winter landscape with the crows, and the man leaning on his hoe, and will bring them to Paris by the end of the month. Good-bye, and good health to you, Madame Sensier, and Jeanne."

<div align="right">" Barbizon, 29 December, 1862.</div>

" MY DEAR SENSIER,—

" I have put off my journey to Paris till after the New Year, which I like to spend with my family. We were present in spirit at the baptism of your little Jeanne, and we all wish that she may renounce the devil and all his pomps, not only in words, and grow up a good and virtuous girl. If that ceremony were gone through with heart-felt sincerity, and not as in most cases as a mere form, nothing could be more touching or more solemn. . . .

" I have had a visit from M. M——, as you announced. Of course I knew nothing, and he assumed the air of a man who is merely seeking information, but let me find out his secret by the way in which he spoke of his plans. One thing I strongly recommend you to do: that is, to prevent him from destroying this enclosure, which is most beautiful, and which he proposes to ruin with his improvements. First of all, he intends to plant some pine trees and other evergreens in the little wood, because he thinks that bare stems look too gloomy in winter. His other plans are too elaborate to tell by letter, but he has the most revolutionary ideas.

" I should like to hear what you and Jacque have been discussing. We all of us join in sending you all three those good wishes for the New Year which we cherish for those whom we love best.

<div align="right">" J. F. MILLET.</div>

" Tell the Laures that I will bring their drawing when I come."

This drawing was the portrait of their dead child, Jenny Laure, which Millet had lately finished for her parents. Monsieur M——, to whose visit Millet refers, and whose intended improvements he regarded with such dismay, had apparently entered into negotiations with Sensier as to renting Jacque's old house next door. He is never mentioned again, so that his proposals were probably not

accepted. In any case the field at the back of Millet's
house, with the "little wood" and the path leading
towards the plain, remained unchanged. Some years
afterwards the painter made a beautiful picture of this
"corner" which he loved so well, with the apple-trees of
his garden flowering in the foreground, and a rainbow
spanning the black storm-cloud behind the wood—the
same picture which now hangs in the Louvre, and bears
the name of *Le Printemps*. He had, Sensier tells us in
quoting this letter, the utmost horror of any attempts to
embellish nature, and a perfect passion for allowing trees
and creepers the most entire liberty. To see clematis or
honeysuckle pruned gave him real pain ; and if he had
been allowed his own way, ivy and creepers would have
forced their way into the rooms of his house. We remem-
ber how he made his brother promise never to cut the ivy
which grew on the old house at Gréville, and how great
a part the ancient elm, "gnawed by the teeth of the
wind," and the laurel, worthy of Apollo, still played in the
recollections of his childhood ; and visitors describe his
Barbizon cottage as thickly overgrown with a mass of
Virginia creeper, of jessamine, and clematis and ivy, while
climbing roses and honeysuckle trailed along the garden
walls, and sweet-smelling flowers were mingled with the
vegetables and fruit-bushes.

This same passionate love of Nature made Millet take
an active part in resisting all attempts to spoil the Forest
of Fontainebleau, whether they were made by the Govern-
ment or by private individuals. His zeal in defending
the beauty of earth, and in resisting unjust encroach-
ments, more than once brought him into conflict with
his friends, especially Jacque, who was less scrupulous in
these matters, and whose high-handed dealings often ex-
cited the animosity of his neighbours. In January, 1861,
he wrote the following letter to Sensier, complaining of

Jacque's attempt to close one of the chief entrances to the forest, and begging him to give him his powerful help in defending the public rights:

"MY DEAR SENSIER,—

"You know the piece of land that Jacque bought, near the Mazette Gate of the forest, and remember that a path has run through it for a long time. Now he does not like the way in which this path divides his land, and he has bribed the Mayor, Bélon, by painting a little picture for him, and a brooch for his wife, and promising one hundred francs to the Commune, to give him permission to close this path. The public crier has already announced that the voters are to meet next Sunday to vote on this matter. All Barbizon is in a flutter. It appears that Jacque has promised all sorts of favours to those who will vote for his project. Many votes will be swayed by the influence of the Mayor, because the people are cowards and afraid of him, and Jacque has no doubt secured the Prefect's support. I do not know what entrance to the forest is to be made instead of the Mazette, nor what will be gained or lost by the change; but it seems to me right to prevent, if possible, any one from acting just as he pleases, regardless of public interests, especially when he tries to make rain or sunshine just as it suits himself! Cannot you put a spoke in the wheel through the Office of the Minister? Look into it and act quickly, for next Sunday will decide the question. If there is any means of fettering their hands, let us try it. Jacque's plans are by no means limited to this enterprise. He also wishes to close the path that runs at the back of our fields. I do not know the right name, but it is the one that runs just at the back of his studio, through your land, and by Père Lefort and Cuffin's apple-trees. Rousseau and I talked over this matter last night, and wish that we could prevent this ass of a Bélon from being at the mercy of every whim that comes into Jacque's head. It is really more a question of principle than anything else. Personally I care nothing about it; but it is impossible to consent to everything that he wishes to do, either in his own interests or else to annoy others. In any case, could not you and Tillot send your votes against closing the Mazette Gate. Fortunately he has his enemies, and Bourgignon is one of them. Imagine the indignation of Bodmer! Incredible as it seems, he actually came to see me to talk over

this matter. Lastly, if you have, either directly or indirectly, any rapid and powerful means of influence at your disposal whereby you can hinder this matter, put it into force, and show this new Robert Macaire that he has no right to throw dirt at every one, as it happens to please his fancy. Give Bélon a lesson also if it is possible. Fool that he is to side with Jacque in this thing, and help to close the forest gates which have been left open by the Administration !"

But the step which roused Millet's indignation to the highest pitch was the threatened desecration of the churchyard at Chailly, on the edge of the plain. This ancient cemetery, which stretched for nearly an acre round the old church that figures in the distance of the *Angelus*, had been during centuries the burial-place of the inhabitants of the Commune. It was a quiet and peaceful spot, dear alike to Millet and Rousseau from the antiquity and sacredness of its associations. No wonder they were full of dismay and anger when they heard of the vandal projects that were on foot for the ruin of this time-honoured graveyard under the shadow of the old church.

"Barbizon, 21 November, 1863.
" MY DEAR SENSIER,—
 "Perhaps you do not know that they are going to destroy the little cemetery that surrounds the church at Chailly, and prepare the site for dancing on fête days. It is, as you remember, one of those rare little places that remind one of the memories of other days. Nothing stands in the way of the rage for embellishment that takes hold of people ; and the inhabitants of Chailly, stupid as idiots and utterly heartless, mean to fatten their land with the bones of their relatives. As long as it enriches them, they care little from what quarter the money comes ! This earth made of bones is to be sold by auction ! and yet it is only a short time since their own friends were buried there. Is there no possible way to put a stop to these things ? Is there no specified time that must elapse before sepulchres can be destroyed, especially when,

as in this case, there is no urgent necessity for the deed? These wretches actually intend to scatter the bones of their own families over the fields to make the potatoes grow! Oh, shameful and brutal hand of man! If the work is not already begun, it will be very soon. Go; if anything can be done, it must be done quickly. Baseness of heart seems to stop at nothing and to show itself in every form."

A little later Millet wrote a second letter to Sensier on the same subject:

"MY DEAR SENSIER,—

"I have had a little talk with Rousseau about the Chailly cemetery, and have decided to write a letter to the Préfet, although there may be little chance of success, especially as we hear that he himself, when he was in Chailly, saw the old churchyard, and said that it ought to be destroyed. The Mayor, like a foolish courtier, did not fail to improve the occasion by agreeing with his superior. The trees that surrounded it are already sold. Tillot cannot help us, as he is gone to Paris to-day for at least a month. I hope you will see him now and then. After what I have said about the Préfet, do you think we had better write to him or to the Minister? Give me your advice."

Millet exerted himself to the utmost to save the old churchyard, but his efforts were in vain. The work of desecration was ruthlessly carried out, and the remains of the forefathers of the village were dug up. A few bones only were removed to the new cemetery; the rest were scattered to the wind. The graves were filled up with earth, and the inhabitants danced on the spot, or drove in their cattle to graze there. Fortunately a new Curé came to Chailly in 1888, and applied himself vigorously to reform this abuse. He threatened the Mayor with legal proceedings; and since this step did not produce much effect, he armed himself with a big stick, and drove out the cattle and their herdsmen. In course of time he raised a cross on the spot, planted trees

around it, and once more consecrated the ancient God's acre which in Millet's eyes had seemed so rare and holy a place. And on the cross he carved these words, which may still be read: "*À nos pères, qui dorment ici, en attendant la Résurrection.*"

XIII

1863-1864

THE year 1863 was remarkable for the variety of reforms introduced in the Department of Fine Arts by the energetic Director, M. de Nieuwerkerke. Salons, it was now decreed, were henceforth to be held every year. The purely official jury was abolished, and the election of three-fourths of the body was granted to those artists who had received medals at the Salon. Lastly, all exhibitors who had received a first or second medal in previous years were pronounced exempt from examination by the jury. This enabled Millet to exhibit three pictures in the Salon of 1863. One of these was the famous *Homme à la Houe*, which he felt sure no jury would ever have admitted. The others were *A Woman Carding Wool*, and *A Shepherd Driving Home his Sheep at Evening*,—a picture to which M. Blanc alludes in one of his letters to the painter, as an altogether charming work that would not take long to sell. Millet expressed his satisfaction on the subject of the new regulations in the following letter :

"Barbizon, 20 January, 1863.

"MY DEAR SENSIER,—

"I am very glad to think I shall not have to go through the ordeal of trial by jury for the Exhibition. You have forgotten to tell me one thing that is of importance—the time when pictures are to be sent in. I will regulate my work accordingly. I shall now be able to exhibit my *Man with the Hoe*, which would most

certainly have been refused by the jury whom we know but too well !
I also hope to send my *Shepherd Returning Home at Evening*, and
A Woman Carding Wool, on which I am at work at this moment.
I hope to give her a grace and a calm which are not seen in the
workwomen of the suburbs. I have still a great deal to do to her,
but the memory of the peasant-women at home, spinning and card-
ing wool, is still fresh in my mind, and that is better than anything.
Please give me the information I want, for there may be such a
thing as mistakes which are not involuntary, and which may result
in throwing me overboard and making me responsible to this good
jury ! Answer me soon for fear of delays. Ah ! it is good all the
same to feel yourself free and able to say what you like. But how
I shall be attacked ! "

Millet's forebodings proved correct. The appearance of
L'Homme à la Houe at the Salon was the signal for a
perfect storm of abuse and insolence. The old cry was
revived, and Millet was once more reviled as a dangerous
agitator and democrat. The man who could paint such
subjects must be a Socialist of the worst type, an Anarchist
whose evident object it was to stir up popular strife, and
set the masses against the classes. His former admirers,
Théophile Gautier and Paul de Saint-Victor, were the
fiercest among his assailants, and a torrent of abusive
language was heaped upon the painter's head. To him
all this angry clamour seemed very strange. The *Homme
à la Houe* was merely the representation of his central
idea. In this lonely figure both sides of peasant life—the
hardship of daily toil and the simple dignity of labour
—are truthfully set forth. The man with the hoe is no
degraded beast of burden, far less is he the purely orna-
mental peasant of the poet's Arcady. His clothes may
be patched and worn, but they are neither ragged nor
squalid. He wears the blue trousers and stout sabots of
the French peasant; his hat and blouse, thrown off in
the heat of his toil, lie on the ground at his side. His
hands are hard and seamed, his stalwart form is bent

with fatigue. All day he has been at work on the stony ground, and now he leans heavily with both arms upon his hoe, and snatches a brief moment of repose. Behind him, stretching far away to the horizon, is the great plain where peasants of all ages are at work—men and boys guiding the plough, and a young girl raking the weeds into heaps. We see the thistles that spring up on the barren soil, the hard dusty clods, the tufts of coarse herbage, with a yellow daisy here and there, and the smoke of burning weeds curling up against the grey sky. Everything helps to give the same impression of dull, monotonous labour, the same sense of "weariness," of which he himself spoke as being "the common and melancholy lot of humanity." The old text, "Thou shalt eat bread in the sweat of thy brow," was in his mind when he painted that picture; the same thoughts which came back to him whenever in his evening walk across the plain he saw those solitary figures hoeing the ground, from time to time raising themselves and stopping to wipe their foreheads with the back of their hand. "No light and playful task this!" he had said, "nevertheless to me it is true humanity and great poetry."

It was one May evening, in the midst of all the heated discussion which had sprung up round this great poem of labour, that Millet sat down and wrote the famous letter which has been called his confession of faith. The original MS. is now preserved in the British Museum

"Barbizon, 30 May, 1863.
"My dear Sensier,—

"I have done your commissions here. Père Robin is very much pleased, and assures us that, next to *le bon Dieu*, he loves no one half so well as he does you."

Père Robin was an old soldier who had fought in the battles of the first Empire, and was living in want and

poverty at Barbizon. Millet took great interest in the veteran, and at his request Sensier succeeded in obtaining a pension for him from the Government.

"All this gossip about my *Homme à la Houe* seems to me very strange, and I am grateful to you for reporting it to me. Certainly, I am surprised at the ideas which people are so good as to impute to me! I wonder in what Club my critics have ever seen me! They call me a Socialist, but really I might reply with the poor *commissionnaire* from Auvergne, 'They call me a Saint Simonist. That is not true, I do not even know what it means.' Is it then impossible simply to accept the ideas that come into one's mind, at the sight of the man who 'eats bread by the sweat of his brow'? There are people who say that I see no charms in the country. I see much more than charms there—infinite splendours. I see, as well as they do, the little flowers of which Christ said: 'I say unto you, that even Solomon in all his glory was not arrayed like one of these.'

"I see very well the *auréoles* of the dandelions and the sun spreading his glory in the clouds, over the distant worlds. But none the less I see down there in the plain the steaming horses leading the plough, and in a rocky corner a man quite worn-out, whose *han* has been heard since morning, and who tries to straighten himself and take breath for a moment. The drama is surrounded with splendour.

"It is not my invention, and this expression—'the cry of the ground'—was heard long ago. My critics are men of taste and instruction, I suppose, but I cannot put myself in their skin, and since I have never, in all my life, known anything but the fields, I try and say, as best I can, what I saw and felt when I worked there. Those who can do this better than I can are fortunate people.

"I must stop, for you know how talkative I become when I am once started on this subject. But I must also say how much flattered and encouraged I felt by some of the articles which you sent me. If by any chance you happen to know their authors, please express my satisfaction to them. I hope you will soon come. Wish Rousseau good-day for me.

"Yours,

"J. F. MILLET."

One of the few authors who had dared to take Millet's part in the attacks that were made upon him and his art was Théodore Pelloquet, who published a spirited defence of *L'Homme à la Houe* in his *Journal de l'Exposition*, and stoutly maintained that, whatever might be said, its painter was a great and original artist. Millet was so much pleased at the sympathetic way in which he wrote of his pictures, that he sent him the following letter, a few days afterwards

<div align="right">" Barbizon, June 2, 1863.</div>

" MONSIEUR,—

"I am very much gratified by the manner in which you speak of my pictures in the Exhibition. This has given me the more pleasure, because of the way in which you discourse upon Art in general. ! You belong to the exceedingly small number of writers who believe (all the worse for those who do not!) that Art is a language, and that all language is intended for the expression of ideas. Say it, and say it over again! Perhaps it will make some one think a little! If more people shared your belief, there would not be so much empty painting and writing. / That is called cleverness, and those who practise it are loudly praised. But, in good faith, and if it were true cleverness, should it not be employed to accomplish good work, and then hide its head modestly behind the work? Is cleverness to open a shop on its own account? I have read, I cannot remember where, 'Woe to the artist who shows his talent more than his work.' It would be very ridiculous if the hand were greater than the brain. I do not remember the exact words that Poussin uses in one of his letters about the trembling of his hand, at a time when his head was at the height of its powers, but this is the substance of his remark: 'And although the hand is weak, it must all the same be the handmaid of the other.' If there were more people who shared your belief, they would not devote themselves so resolutely to the task of flattering bad taste and evil passions for their own profit, without any thought of the right. As Montaigne says so well: 'Instead of naturalizing Art, they make Nature artificial.'

"I should be very glad of a chance of talking over these subjects

<div align="right">R</div>

with you, but as this does not seem likely at present, I will, at the risk of wearying you, try and tell you as best I can, certain things which are matters of faith with me, and which I should like to express clearly in my work. The objects introduced in a picture should not appear to be brought together by chance, and for the occasion, but should have a necessary and indispensable connection. I want the people that I represent to look as if they belonged to their place, and as if it would be impossible for them to think of being anything else but what they are. A work must be all of a piece, and persons and objects must always be there for a purpose. I wish to say fully and forcibly what is necessary, so much so that I think things feebly said had better not be said at all, since they are, as it were, spoilt and robbed of their charm. But I have the greatest horror of useless accessories, however brilliant they may be. These things only serve to distract and weaken the general effect. It is not so much the nature of the subjects represented, as the longing of the artist to represent them which produces the beautiful, and this longing in itself creates the degree of power with which his task is accomplished. One may say that everything is beautiful in its own time and place, and on the other hand that nothing can be beautiful out of its right place and season. There must be no weakening of character. Let Apollo be Apollo and Socrates remain Socrates. Do not let us try to combine the two; they would both lose in the process. Which is the handsomest—a straight tree, or a crooked one? The one that we find in its place. I conclude therefore that the beautiful is the suitable.

"This principle is capable of infinite development, and might be proved by endless examples. It must, of course, be understood that I am not speaking of absolute beauty, for I do not know what that is, and it has always seemed to me the vainest of delusions. I think that people who devote themselves to that idea only do so because they have no eyes for the beauty of natural objects. They are buried in the contemplation of the art of the past, and do not see that Nature is rich enough to supply all needs. Good souls! they are poetic without being poets. Character! that is the real thing! Vasari tells us that Baccio Bandinelli made a figure intended to represent Eve, but that as he advanced with his work, he found his statue a little too slender for the part of Eve. Accordingly he contented himself with giving her the attributes of

Ceres, and Eve was transformed into Ceres! We can no doubt admit, that since Bandinelli was a clever man, his figure may have been superbly modelled and marked with great scientific knowledge. But all that could not give the statue a decided character, or prevent it from being a very contemptible work. It was neither fish, flesh, nor fowl.

"Forgive me, sir, for having written at such length, and perhaps said so little; but allow me to add that if you should ever happen to be travelling in the environs of Barbizon, I hope you will be so good as to stop at my house for a moment.

"J. F. MILLET."

This letter, which contains so full and remarkable a statement of the painter's principles, was published by M. Pelloquet in the *Moniteur de Calvados*, together with a sonnet addressed to Millet by a friend of the artist Troyon, a retired officer named Lejosne, who hailed the painter of the *Semeur* and *L'Homme à la Houe* as the Dante of peasants and the Michelangelo of rustic art.

These fresh tokens of sympathy and appreciation encouraged Millet, but as usual he was in need of funds, and was obliged to raise money to satisfy his creditors. On the 5th of June, 1863, he wrote to Sensier:

"To-night I am going to send you two drawings, which you will no doubt receive to-morrow morning. I do not know if they are likely to be popular. One is *The Mill*, which I was about to begin when you left Barbizon. The other is a very literal transcript of a place in my own country. I do not say it is the better for that, but at least I think it is a rare kind of landscape. Nor do I think *The Mill* is by any means an ordinary subject. You must tell me what you think of them. Have you been able to sell the two last? And will these sell? Without making any actual complaint as to our condition, I must confess to you that we are again on the verge of trouble. I fear scandal of all kinds while Madame F—— is here. We live on a volcano! I have said enough to make you understand what I mean, since you are well acquainted with the intricacies of the seraglio. But in point of fact, what am I to do? I can only

work, but that will not suffice! . . . We wish you all good
health.

"J. F. MILLET.

"P.S.—I have written to Pelloquet."

The difficulty which Millet found in carrying out the
terms of his contract with M. Blanc weighed heavily
upon him at that moment. The three years during which
he had bound himself to work for the dealer had expired
in the preceding March, and no more payments were
due to him; but he was still considerably in his employer's
debt. The three pictures which appeared in that year's
Salon were described in the catalogue as the property
of M. E. Blanc, who disposed of them all before long.
L'Homme à la Houe was sold to a Belgian collector, and
has remained in Brussels ever since. The *Cardeuse*, which
Pelloquet pronounced worthy of a place by the side of
Raphael and Andrea del Sarto's Madonnas, found its way
to America. But still Millet remained in the dealer's
debt, and M. Blanc clamoured for more pictures. Two
letters of August, 1863, show the disagreeable state of
affairs in which this unfortunate contract had involved
the painter, and the unpleasant terms on which he found
himself with his dealer.

"Barbizon, 10 August, 1863.

"M. BLANC,—

"If you had simply said that I did not send you pictures
enough, or anything else of that kind, your reproaches would be more
reasonable than those which you now make. Because the picture
that I have sent does not please you, you draw hasty conclusions,
which I must say are really outrageous. First of all, and naturally
enough, you have seen it but a very short time; and it seems to me
that you were too much in a hurry in pronouncing it to be a work
knocked off by a student to make up for lost time. Perhaps this
picture is something more than that. From this hurried judgment you
pass at one bound to bring charges against me, and accuse me of

saying, 'It is good enough for him; I always do enough for him,' etc. Really these suggestions of yours are purely gratuitous. What reasons have you for making them ? If it should happen that, after a time, this picture should appear less objectionable in your eyes, will it not pain you to have said such things? I think there is always time enough to make such charges later, and that they should not be made at so early a stage. Tell me, then, that you uttered them thoughtlessly, and that I may consider them as coming from a man who was out of temper, and as having no serious meaning. I can hardly believe that a reflecting man, such as you are, can seriously think so badly of me. In any case I need your assurance one way or the other before I can definitely believe what you have said."

M. Blanc's reply apparently failed to satisfy Millet's injured feelings, and in a second letter he resumes the contention, and defends himself from the imputation of sending the dealer bad work and keeping his best pictures for other patrons, which seems to have been the charge brought against him.

"23 August, 1863.

" M. Blanc,—

" You know that I am never offended at any criticism, however severe it may be, which has for its sole object the merits of a work of art. This, I think, would never really offend me. What pained me in your letter was the intention which you imputed to me of thinking anything good enough to send you. As you ask me to let you have your own words, here they are : ' In seeing this canvas, I am reminded of my childhood and the tasks which I knocked off in haste to make up for lost time.' Further on, you say that I ought to remember who had placed the conditions and power of creation in your hands—' *Time, care and suffering, that is labour.*' Again you say : ' *It is impossible for me to help saying that I am not satisfied with you.*' And you end up with the words, ' I remain always your good friend,' although I see clearly that you are not any longer my friend at all.

" If this is what you wish, I am ready to give you my word of honour that I have not made any painting, small or large, for any

one save yourself—The *Woman Bathing*, which you have lately received, and a very much more important picture on which I am now engaged, *A Shepherdess and her Flock*. My spare time has been employed, as I told you when I was in Paris, in making drawings, and under such conditions that they will not get into circulation. As I have no other resources by which I can gain my bread, I am forced to do this, since in order to work one must live. It is also very easy to imagine that the time which I devote to these tasks cannot be spent in your service. The price of the *Woman Bathing* is 800 francs. Be well assured, M. Blanc, that I never do things in the dark, and accept my salutations.

<div align="right">" J. F. MILLET."</div>

Happily the period of his bondage was almost ended. Before long his debt to M. Blanc was paid off, and he found himself released from the contract which had of late weighed upon him so heavily. He made use of his recovered freedom to work on the *Shepherdess*, which had been ordered by a new patron, M. Tesse, and devoted his leisure hours to the study of Burns and Theocritus. He had lately received copies of these poets, in a French translation, from a young author, M. Chassaing, an ardent and intelligent admirer of his works, who had recently made his acquaintance.

The three following letters are addressed to this new friend:

<div align="right">" Barbizon, 20 July, 1863.</div>

" MONSIEUR,—

"I have received the two volumes which you have sent me, Theocritus and Robert Burns, and am doubly grateful to you, both for the kindness of your thought and for the pleasure which the works themselves have given me. First of all, I must tell you, I seized upon Theocritus and did not let him go until I had devoured his poems. There is a *naïf* and peculiarly attractive charm about them that is hardly to be found, to my mind, in the same degree in Virgil. It is when I take the text, word for word, that I enjoy it the most. I understand that much better than the translation at the end. Why are not words used for description, instead of

making them serve merely to weaken the meaning under the cloak of a sonorous obscurity, or else a pretence at conciseness? If I could talk this over with you, I might succeed in making you understand what I mean; but I know it is a mistake to start a discussion of this kind in a letter. I will, however, try and give you a little instance of what I mean.

"In the first idyll, on the vase adorned with all kinds of sculptures, you see, amongst other things, a vine loaded with ripe grapes, guarded by a lad sitting on a fence. On either side are two foxes. One goes up and down the rows devouring the grapes. Does not this expression, '*goes up and down the rows*,' help you to see the way in which the vines are planted? Does it not make the scene actually visible, and do you not see the fox trotting up and down between the rows, going from one to the other? There is a true bit of painting—a living image! You see the thing before you. But in the translation this living image, it seems to me, is so much weakened that one might read the passage without being struck by its force: 'Two foxes—one penetrates into the vineyard and devours the grapes. . . .' O translator, it is not enough to know Greek; you should also have seen a vineyard, in order to understand the truth of your poet's image and to render it exactly! And so on through it all. But I come back to that. I cannot see the fox trotting up and down the rows of vines in the translator's vineyard But I must stop—my paper has come to an end.

"I must, however, add that Burns pleases me infinitely. He has his own special flavour; he smacks of the soil. We will talk of him soon, I hope. My friend Sensier writes that you have been to see him. He tells me that he will very soon have some proofs taken of my plates, and that he is only waiting for some particular solution which you may perhaps be able to help him to obtain. That is what he says. For my part, I am working hard, and the reading of Theocritus shows me every day more and more that we are never so truly Greek as when we are simply painting our own impressions, no matter where we have received them; and Burns teaches me the same. They make me wish more ardently than ever to express certain things which belong to my own home, the old home where I used to live.

"Once more, dear sir, accept my thanks; and if it is at all possible, come here now and then, and spend a day with me.

"J. F. MILLET."

M. Chassaing was profoundly impressed by the truth and originality of the remarks which Millet made, not only upon Theocritus and Burns, but also upon Dante and Shakspeare. The painter was already familiar with both these poets, and had taught himself sufficient Italian to read the *Divina Commedia* in the original. His friend now lent him interleaved editions of these poets, begging him to let him see the notes which he made upon them. He also sent him the writings of several modern French authors, all of which Millet devoured with his usual eagerness. And he himself paid repeated visits to Barbizon, and spent many pleasant hours in conversation with this earnest and thoughtful artist, who had for him so rare an attraction.

On the 4th of August Millet writes to him :

" DEAR SIR,—

" I am exceedingly glad to hear that you are soon coming here, for two reasons : I shall have the pleasure of seeing you, and shall be able to tell you more of my thoughts in five minutes' conversation than I could in two hours' writing. Here I will only say that it is long since I have read anything of such fine quality in a modern author. Even if I were capable of doing it, I would not try to measure him (Victor Hugo) with Homer, Dante, Shakspeare, etc.; but I am persuaded, whatever his exact height may be, he is none the less a member of their family. We must talk about him. It is quite worth while. And we will also talk of the little volume *au village*, which you sent with *Mireio*. I will say no more here, for talking is better than writing. Believe me when I say that your visit will give me the greatest pleasure, and receive my thanks beforehand.

" J. F. MILLET."

" Barbizon, October 14, 1863.

" MONSIEUR CHASSAING,—

" The pleasure which you have given me in sending me Shakspeare is very great, both because of your kind intention, which I appreciate warmly, and also because it would have been

impossible to choose anything that I like better. But, as there is no pleasure without pain, one thing distresses me, and that is the trouble and expense to which you put yourself on my account : I am quite overwhelmed and ashamed at the thought. And to think that this is not all, and that Dante is to follow Shakspeare! If the work of interleaving the Dante is not begun, I beg you not to go to that expense, as I owe you too much already. But I will certainly not return Shakspeare to undergo a similar operation. I like him as he is, and am not going to part from him! Once more, I am profoundly touched with all that you have done for me. I am afraid my poor woodcuts are giving you a great deal of trouble, by what Sensier tells me. Try and make Delâtre and Bracquemond take a few impressions by hand. You have no doubt talked this over with Sensier, and have already arrived at some decision. If it is possible, come and spend a few more minutes with us before you leave this country for good. Arrange your affairs so as to manage this, if it is not impossible. I am already reckoning on your coming. But in any case, accept my very cordial salutations, with the best wishes of my whole family and myself, that you may succeed in all your undertakings, and meet with as few scratches as possible from the briars along the roadside.

"J. F. MILLET."

One of Millet's plans, into which M. Chassaing entered warmly, was his wish to illustrate the idylls of Theocritus. The Sicilian poet's pastoral fancies had fascinated his imagination, and he was seriously thinking of publishing a series of engravings on subjects taken from the idylls. M. Chassaing paid him a flying visit in November, and listened with the keenest interest to his ideas on the subject.

On the 8th of November, 1863, Millet wrote to Sensier :

"M. Chassaing arrived here on Thursday morning and stayed till Friday evening, when he left by the seven o'clock train. We have made an attempt at a wood-cut, the *Little Digger*, that you know, and the result is very good. I will slip in a few proofs in

the first parcel that I send. M. Chassaing thinks that the best
plan for the Theocritus would be to offer a publisher one of the
idylls ready printed and illustrated, such as would make a volume
of the work. He thinks that no publisher would be able to re-
sist the sight, but would be anxious to continue the work. He
told me that he and his friend Rollin would unite to provide the
necessary funds. He explained his methods a little to me, but
the devil take me ! if I can remember those kind of things, which
I do not even understand when I hear them explained ! Still
he thinks that the cost of printing and engraving would not be
anything very enormous, and that we should at least have the one
idyll, if we could not afford to continue the publication. He
will no doubt write to you, and you can judge if his idea is at
all practicable. In any case, I am already drawing compositions
for the first idyll : Thyrsis and a goat-herd sitting by the cave of
Pan, Thyrsis playing the syrinx while the other listens. Then
there is a vase with sculptured subjects which I shall reproduce
in realistic fashion : a beautiful woman, a divine form, over whom
two men are quarrelling ; an aged man fishing with a net in the
sea from the top of a rock ; a child seated on a wall to keep
watch over a vineyard, but who is so intent on making a snare
of straws to catch grasshoppers that he does not see two foxes,
one of which eats his breakfast, while the other devours the
finest grapes in the vineyard. Such are the three subjects of the
vase. There remains the death of Daphne, the subject which
Thyrsis sings to the music of his flute, and at whose death
Hermes, Venus, Priapus, the goat-herds and shepherds, are all
present. Five subjects in all, and none of the five can well be
left out. But all of the idylls would not require so many illus-
trations. One subject, or two at most, would be enough for the
greater part of them.

"Yet another important thing I have to mention ! I am happy,
exceedingly happy, to hear how well you have managed in dis-
posing of all three of my drawings. All the same, if you could
obtain another loan of 1,000 francs, by successive instalments,
that would give me time to get on with my work without anxieties
for some time to come—in the first place, M. Tesse's *Shepherdess*
and *The Calf*, and then my etching, *Allant Travailler.* I am
in the act of simplifying the composition. Consider if my plan
is practicable or not. If it is, I shall think it famous ! "

Whatever Sensier thought of Millet's plan for raising money, he was quite decided that M. Chassaing's idea of illustrating Theocritus was altogether impracticable. No publisher in Paris, he replied, would listen to such a suggestion. Millet reluctantly abandoned his intention, and devoted his whole time and thought to his pictures for next year's Salon. One was *The New-born Calf*, the other, the life-size figure of a young shepherdess knitting, as she leads her flock home in the gloaming.

XIV

1864

EARLY in 1864, Millet's constant friend, Alfred Feydeau, the architect, asked him to paint four large subjects for the decoration of a dining-room in a house that he had lately built for a Colmar merchant in the Boulevard Haussmann. These paintings were to represent the Four Seasons. Spring and Summer were to occupy the walls; Winter was to be set in a recess above the mantel-piece; and Autumn was to adorn an octagonal space in the centre of the ceiling.

The idea pleased Millet, who had never received so important a commission before, and whose recent readings from Theocritus had inspired him with classical fancies. But, as usual, there were delays and difficulties in the matter, and it was some time before the definite order was given.

The first letter we find on the subject is dated January 23, 1864:

"MY DEAR SENSIER,—

"I have not by any means refused the work of decoration of which you spoke. I merely told Feydeau that, considering the enormous work it would entail, I thought that the price ought to be from twenty-five to thirty thousand francs. I said that on the spur of the moment, and only considering the importance of the compositions which I had already sketched out in my mind's eye, without reflecting if this price or another were likely to be fixed; and indeed this would not be too high a price if you re-

member that these decorations will be placed close to the eyes of
the spectator, and must therefore be as highly finished as pictures.
If the probable price had been named to me at first, I should
have composed some designs of a much simpler description, and
should have seen how I could have executed them in a more
rapid manner. The prices which I mentioned to Feydeau were
merely a suggestion, and by no means an absolute demand. On
the contrary, I only want advice on a subject in which I do not
see my way clearly, since it is the first work of the kind which
I have ever had to do. On the other hand, it is impossible for
me to disturb myself about a thing which has been so vaguely
mentioned, all the more since, as you know, I must be prepared
to meet the end of the month, and my only resource is to finish
M. Tesse's picture. God knows I have little enough time for
that, especially if I continue as ailing as I have been for some
time past. I do not mean to complain,—far from it,—but I
reason out the thing, and still think that the proposal has not
been definitely made.

"Feydeau told me that he would not recommend me before
he knew my charges, and that what he said was by no means
positive, since he had little influence with his client, who un-
fortunately takes counsel of all manner of persons, but that he
would do his best to bring this about. In a second letter, he
repeats that he has not yet mentioned my name, and wishes first
of all to know my prices, so that there should be no mistake,
etc.

"I tell you this, in order that you may not think I have been
too fastidious, nor yet that I have tried to make a good bargain
of the job. The only idea which came to my mind when you
mentioned it was the pleasure it would be (if the plan prospered)
to be able to design these compositions on a large scale, and my
imagination at once began to start off on that track. But I
hope nothing that I have said can make you accuse me of
foolish and extravagant pretensions. I am very sorry I have not
been able to talk it all over with you, for you might have ex-
plained what I really think. As for Faustin Besson, when I
mentioned him, it was only with the intention of showing that
it is hardly likely persons who think of employing him should
dream of giving me the same work.

"M. Tesse's picture (*La Bergère*) is finished, but you know

what the last days at a work of this kind always are. Fresh
scruples arise, and I try hard to strengthen the subject, and to
express my idea with my whole might and main. I have suffered
very much lately, both by day and by night. All this makes me
ask you this—Would it be possible to make M. Tesse under-
stand that, since I have these scruples, and that it is, after all,
as much in his interest as in my own and for the good of his
picture, I should like to keep it until the first week in February,
so as to look at it again at my leisure?"

M. Tesse seems to have agreed to his request, and the
painter was allowed to keep his *Shepherdess* for another
fortnight. Four days later he writes again, saying that
he has heard no more from Feydeau, and therefore con-
cludes the thing to be at an end. But he was wrong, as
the sequel proved.

"Barbizon, 27 January, 1864.
"My dear Sensier,—

"I must begin by thanking you for the trouble which I
have given you as to the request which I made to M. Tesse, for
I imagine that it was not an easy task. When you have to do
with an amateur, the result is never certain.

"I must really see the exhibition of Delacroix's works before
his sale. Please tell me on which day it is to be held.

"When you hear who is to do the decorations of Feydeau's
hall, let me know who is chosen and what is the price fixed. I
still think I might have found some designs which would not
have been ill-suited to the occasion! But my regret cannot be
so great as if any proposals had actually been made to me. The
weather is as dark as if it were the end of the world.

"I am glad you approve of my two last daubs. Advise the
gentleman not to hide half of them with the frames. They really
ought not to be covered up at all; but, if necessary, strips should
be nailed on to the edge of the canvas. Our best love to you
all."

"Barbizon, 30 January, 1864.
"My dear Sensier,—

"Many thanks for the 100 francs, which reached me at the
same time as a letter from M. Tesse enclosing 300 more. The

post-mistress was struck dumb with wonder when she saw how much money I received. She said to me when I arrived, 'Two letters, two good letters at a time!' They certainly are good letters. Rousseau is going to Paris, and starts at one o'clock to-day. How dark it was yesterday! To-day it is light, and I am setting to work as quickly as possible. Tell me all the news."

The next intimation which Millet received from Feydeau was sufficiently encouraging to make him sketch out the subjects which he had planned for the decoration of the room in question, and to apply for permission to visit Fontainebleau and study the frescoes with which Rosso and Primaticcio had adorned the halls of Francis the First's stately palace. But at the same moment he was depressed by the news that a collector who owned several of his pictures had sold them all to the dealer Petit. This sense of the fickleness of fortune drew from him a touching burst of affection towards the friend whom he had trusted through all the changes and chances of his troubled life.

<div align="right">" Barbizon, 5 February, 1864.</div>

"MY DEAR SENSIER,—

"I am very glad to hear what you tell me. There can be no doubt that now my pictures belong to Petit, it is his interest to praise them. He has already sold some of them, and Rousseau told me yesterday that a man whom he knows has bought three or four. The only satisfaction which this can give me is the sense that in future there will be a possibility of life becoming a little more easy. But, on the other hand, this has stirred up anew all the sorrows which lie buried deep down in my heart. I ask myself, Why have I been so long attacked on all sides to gain a little praise in the end? And then, when a good chance comes, nothing will prevent them from throwing me aside like a dirty stocking! This treatment is common enough, I know, and what I say here is only the result of my reflections on the vanity of those who build a monument on these unstable foundations. Once more we must be

satisfied, very well satisfied with the prospect of living more comfortably in future, but all the same we must not forget that we are surrounded with snares.

"One of these days I want to tell you the consolations that I have had from time to time in the midst of my sorrows, and leave you an acknowledgment written as best I can, of the good which you have done me. I want you to feel how well I know that you have been, if not my only helper, at least the chief one that I have had. Should the sheep ever come over in a flock to my side, I could only consider that among things *vana et falsa*.

"M. Moureau has been here. I am to make him seven drawings for 1,000 francs, and from the end of April he is going to give me 200 francs at the end of each month until the whole sum is paid off. I did not mention the subject of your letter. He was here when it arrived. I am glad to hear that you have been asked for a drawing.

"I have not yet heard anything of my *permit* for Fontainebleau. If you see Feuardent, ask him if he has applied for it. I went there a few days ago as a visitor, and satisfied myself that there were many interesting things to examine at leisure. I renew my persecution and clamour for a *permit*. The work I have prepared for the ceiling is not yet upon canvas, but the subject of my composition is chosen, and I am going to begin directly. I am only waiting for a fresh supply of colours. Do not tell any one that I have not yet painted the sketch for the ceiling. In point of fact the work is more advanced than if I had begun with that. Feuardent has sent me two catalogues of the Pourtalès sale, but not that of the pictures.

"J. F. MILLET."

The next letter announces the final completion of M. Tesse's *Shepherdess*. This beautiful picture, the most famous of all his *Bergères*, had filled his time and thoughts for the last six months. Again and again he had delayed its completion and had begged leave to keep it a little longer. Now the last touches were given, and he could no longer reasonably keep it back from the impatient owner. Yet when it came to the point, his courage failed him, and he was filled with doubt and

misgiving. What will M. Tesse think of it? Will he be satisfied with his long-expected purchase, or will he look at it with critical eyes and repent of his bargain? Poor Millet was so much accustomed to hear disparaging remarks on his works, he was so painfully conscious of his failure to reach the ideal after which he strove, that he was never satisfied even when he had painted a masterpiece. And so he writes diffidently to Sensier, begging him to come to his help and encourage M. Tesse to look favourably upon the picture which he was sending him:

" Barbizon, February 12, 1864.

" My dear Sensier,—

" To-morrow, Saturday the 13th, I shall give Lejosne M. Tesse's picture to go by the six o'clock train in the evening. I shall be very much obliged if you will go and see him on Sunday morning and cheer him up, if his heart fails him too much at the sight of my picture. Who can tell how it will strike him? Try and make him look on it from some distance, as I think that it depends a good deal upon the general effect. If, by chance, he offers to give you the rest of the money, please take it and when you have kept back 200 francs, send me the rest here, addressed either to M. or Madame Millet. If M. Tesse says that he is going to send it to me, tell him to address it as I have said, for I shall probably come to Paris for the Delacroix exhibition, and do not wish my wife to have any difficulty in getting the money in my absence. The 200 francs which I tell you to keep back are, the one-half for Lecarpentier, notary at Sainte Croix, the other half for a payment that I have to make in Paris. Rousseau will no doubt come with me to see the Delacroix pictures. I shall also probably bring with me Louise, my daughter, to consult a doctor about an eruption on her face. There is nothing else to say, since we shall soon be able to talk, excepting perhaps to beg of you once more to go to the help of M. Tesse in case of a sudden fainting fit! Good-bye and good health to you all.

" J. F. Millet."

The exhibition of Delacroix's works opened on the 16th

of February. Millet was deeply stirred by the power of
this master whom he had long admired and whose great-
ness was now recognised by all but a few envious rivals
or carping critics. But his indignation was excited by
the attacks which were made upon the dead master, and
he defended him repeatedly both in his letters and con-
versation. He also succeeded in buying as many as fifty
of Delacroix's sketches at the sale which followed, and
kept them among his most precious treasures. On the
4th of March he writes to Sensier:

" I have actually received a letter from Feydeau, in which he
says that he is trying to get me the order for the decorations of the
hotel in the Boulevard Haussmann. I hope that he may succeed.

"Shall I, like Lazarus, be able to pick up some of the crumbs
which fall from your table at the Delacroix sale? I am very glad
to hear that you have got the *Lara*, which is a very fine thing. I
remember the drawing of Ovid among the Scythians which hung on
a screen in the middle of the hall, between the *Socrates* and the
Spartan Woman. If that is the one about which you ask my
advice, I think it *very fine*. When I come to Paris, I must see your
purchases. But try and get me a sketch. So Burty is going to
make facsimiles of the album that he has bought. It will be a
very interesting volume. Who has bought the lithographic stones
of the Goetz? Is it M. Robert? In the end our poor Delacroix
seems to have taken all Paris by storm! The sentences which you
discovered on the drawings are very true. Tillot, who came last
night, also told me about the remarkable success of the pen-and-ink
drawings.

" I am glad to hear what you tell me of Petit's exhibition in
the Rue de Choiseul. I told Rousseau the part that concerned
him, and he was much pleased. I am working like a slave to finish
my *Calf*, but as the days are going by, I must rush to work and
end my letter here. The weather is unsettled and even rainy. I
will attend to your garden."

The next letter alludes to a curious little disagreement
which had arisen between Rousseau and his friends,

about some Japanese prints belonging to Sensier, which Millet had brought back from Paris. A perfect frenzy for the art of Japan had lately seized the great landscape-painter. He bought up all the specimens of Japanese work on which he could lay hands, and distressed his best friends by his attempts to introduce Japanese skies and effects into his own pictures. On this occasion his jealousy seems to have been aroused by the sight of Sensier's recent acquisitions, and he denounced both him and Millet in no measured language. Upon this Millet wrote, full of concern, to Sensier:

"Barbizon, March 16, 1864.

"My dear Sensier,—

"What a cursed wind this is that blows upon us from Japan! I too have almost had a very disagreeable affair with Rousseau about the prints which I brought back from Paris. Until you can tell me what really happened between you and Rousseau, please believe that I have not played you any dirty tricks. I want to clear up this, when I next come to Paris, for I should be the most miserable of men for the rest of my life, if for one cause or another, the least cloud should arise between us. I leave my work to tell you this. If you do not hear from me before then, come on Sunday to Rousseau's and see my picture before it starts.

"J. F. Millet."

Happily Rousseau's anger did not last long, and the passing cloud was soon cleared away. Meanwhile Feydeau had not forgotten his promise, and on the 4th of April Millet was able to tell Sensier that he had at length received the long-delayed commission:

"I was exceedingly happy to hear your good news about the order, which has been confirmed to-day by a letter from Feydeau. I feel as happy as if it were altogether a surprise, for really I have been so little accustomed to things of this kind, that although I knew the thing was not impossible, I did not dare count upon it. *Laus Deo!* I must now do my best in the interval that is allowed

me, and which I must get Feydeau to extend as far as possible. A great deal of time has been already wasted. I must mention this to Feydeau in writing; but please say the same to him too, for it is very important. He tells me that he is going to send me the exact dimensions of the panels, that I may begin my compositions on the proper scale, and bring them to Paris as soon as they are sufficiently advanced. I do not therefore know when I shall come to Paris, but it will be tolerably soon, for I do not mean to pledge myself absolutely to keep to my designs without the right of modifying them.

"Now the bear is actually killed, please look about to find me some cultivated epicures—people who enjoy the pleasures of the table and all that belongs to it. They may perhaps help to give me some suggestions for the decoration of the ceiling. And then are there any old poets who have celebrated these themes? I know Anacreon and Horace have, and must read them again, but perhaps there are others as well. In fact, what have the poets of all ages said on the subject?

"You have my full permission to give or not give my letter to *Figaro*. You are free to do exactly as you like. In any case you can show it to any one who ought to see it, and perhaps it might be as well for it to appear in *Figaro* before the Exhibition, on account of Jean Rousseau, whose mouth might then be stopped."

The letter to which Millet alludes was his famous *Credo* of May 30th, 1863, which Sensier had asked his leave to publish, and which appeared in the journal of *L'Autographe*, during the summer, together with a sketch from Millet's pen.

"I am very glad," he continues, "to have had a talk with Castagnary [one of the younger critics who understood Millet's aims] —and especially as it came about quite by accident on my part, and that he had already written to me. I think that he was a good deal moved. He took my hands in his own several times, and said how much he regretted that he had not met me before, and that he looked upon me as another Palissy. Yes, my dear Sensier! Well, I cannot repeat all he said here, but I will tell you some day. He ended by taking me upstairs to show me a pamphlet on the

Salon of 1857, which was his first work, and wrote upon it, *À François Millet*, and below, *Et nunc et semper*, signed with his name. It is a pledge of his good faith. He is coming here for a few days, in order that we may talk everything over.

"When I got home at midnight the other day, my wife told me that M. Pelloquet had been here to see me. He waited two days, and left the very morning of my return. He was in despair at not seeing me, because he had come here on purpose, he said, and felt inclined to tear out his hair with 'rage.' He left his card. He was staying, I believe, with Luniot, and intends to return in three or four days. A Belgian artist, M. Louis Evenepoël, was with him. Since his address was on his card, I wrote to him begging him to tell M. Pelloquet how vexed I was to have missed him, and asking him, in case he came back, to let me know, so that I might be at home. I am very sorry not to have been here, but on the other hand, as he is already on our side, it was more important that I should meet Castagnary, so I am not sorry to have stayed in Paris one more day. If I had left, as I intended, the day before, I should have found Pelloquet, but I expect I shall see him again. And now that he has gone out of his way to see me, nothing need prevent my going to call upon him in Paris, and indeed it would only be fair.

"His visit with a companion has reminded me that I have no paintings here to show, and if by chance an intending purchaser were to come here, he would see nothing which would encourage him to order a picture. So I have thought that I had perhaps better set a thing or two going; but if I do this, it will necessarily delay the drawings. Still it is very vexatious to have nothing to show, and it will be still more so, if my pictures in the Salon should happen to attract notice, and bring new visitors to Barbizon. What do you think of it? I will do some pen-and-ink sketches and send them to you, for we have not a penny left, and we are worried on all sides for money in a very annoying manner. You will see if it is possible to sell one or two of these. My wife is suffering from a violent pain in her liver. I have had one headache already, and I am hatching at least one other.

"J. F. MILLET."

A fortnight later he writes again, this time to say that he is bringing the drawings in question:

"Barbizon, April 19.

"I shall start for Paris with you on Sunday, my dear Sensier, bringing the three dinners that I have to sell, three that is to say out of the four, since you assure me that the one of children eating is already disposed of. I shall not be present at the opening of the Salon. All the same, remember to give me the information that I require. Since I appear to be doomed to play the part of the disagreeable man, here is a very tiresome question : Would it be possible for me to have 100 francs in advance for the drawing which you asked me to make for a friend of yours? If you can, bring me the 100 francs on Saturday, or if possible send them before then, which would be better still. I need not give you particulars of the anxieties with which I am overwhelmed, and will only say that I am going to plunge into work . . .

"Can I at length exclaim, 'The order has come!' as the companions of Æneas cried, *Italiam! Italiam!* At least it would be a friendly rock, where I might take shelter for awhile, before I set out again on the perilous seas.

"J. F. MILLET."

These last words probably refer to the terms of the commission for the panels of the house on the Boulevard Haussmann, which were to be finally arranged when Millet brought his designs to Paris. Happily the sketches which he had made in pastel met with the approval of Feydeau and his employer, M. Thomas, and Millet was able to continue the work without further delay.

Meanwhile the Salon opened on the first of May, and Millet's *Bergère* was hailed with general enthusiasm. This picture, which had cost him so many anxious days and sleepless nights, is in reality one of the finest which he ever painted. Nowhere else is his colour so rich and glowing, nowhere else, saving it may be in the *Angelus*, is the effect of evening light so admirably rendered. A young girl with a pure and lovely face and gentle expression is seen leading her flock home in the quiet

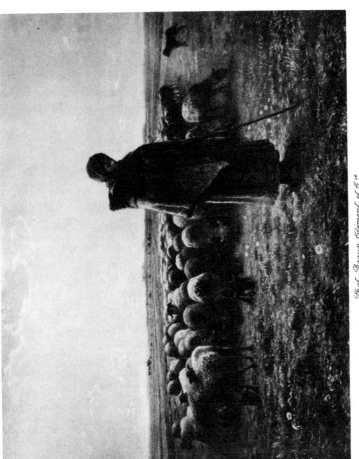

Phot. Braun Clément et Cⁱᵉ

La Bergère (The Shepherdess)

evening, knitting as she rests for a moment on her staff. Her skirt is blue, the cap on her head is bright red, and the dying rays of the sunset turn her cloak to a deep golden brown. The sky is dark overhead, but the radiant glow of sunset breaks through the clouds and lights up the streaks of green and yellow and russet in the fields, the long line of low blue hills in the distance, and the daisies and dandelions in the short grass at her feet. The faithful dog at her side keeps a watchful eye on the sheep behind her, while, lost in dreams, she forgets the present, and muses of some far-away future. From the first the critics were unanimous in their praises. Before the month was over, Millet had received an offer for the picture from the Government. The Director of Fine Arts wrote from the Tuileries, offering the painter the sum of 1,500 francs, which was, in point of fact, eight hundred less than M. Tesse had already given. Millet replied in the following note:

"Barbizon, 23 May, 1864.

" MONSIEUR LE DIRECTEUR,—
 " You have done me the honour to say that you wish to purchase my picture, No. 1,362 in the Exhibition of Fine Arts, at the price of 1,500 francs. This picture is no longer mine. It was bought at the opening of the Exhibition. However flattering your offer may be, it is no longer in my power to dispose of this work. This being the case, I have the honour to remain,
 " Your very humble and obedient servant,
 " J. F. MILLET."

The painter must have felt some satisfaction in refusing this tardy and parsimonious offer from the officials who had looked so coldly upon his art for many years. But it is at least consoling to reflect, that although Millet's *Bergère* does not belong to the French nation, this beautiful picture has returned to France, and is now, to-

gether with the *Angelus* and the *Parc aux Moutons*, in the collection of M. Chauchard. While Paris was ringing with the fame of Millet's *Bergère*, and the best critics vied with each other in giving eloquent descriptions of this rustic idyll, his other picture, the *New-born Calf*, experienced a very different fate. The subject of this work was hardly calculated to meet with approval from Paris journalists. Two strong-limbed peasants are seen bearing the new-born calf on a stretcher to the door of the farmhouse, where a group of children await its arrival with eager faces. The cow follows behind, licking her young with tender anxiety, while the serious expression of the bearers, and the ruddy glow on the face of the young girl who leads the cow, alike impress us with a deep sense of the solemnity of the occasion. But this seriousness was the very thing which excited the scoffs and jeers of the critics. M. Millet's peasants, they exclaimed, carry the young calf with as much solemnity as if he were the bull Apis, or the Blessed Sacrament itself. Millet met their attacks in silence, and only defended himself in the following letter to his friend:

"Barbizon, May 3, 1864.

"My dear Sensier,—

"As to what Jean Rousseau says of my peasants carrying a calf as if it were the Holy Sacrament or the bull Apis, how does he expect them to carry it? If he admits that they carry it well, I ask no more, but I should like to tell him that the expression of two men carrying a load on a litter naturally depends on the weight which rests upon their arms. Thus, if the weight is even, their expression will be the same, whether they bear the Ark of the Covenant or a calf, an ingot of gold or a stone. And even if these men were filled with the most profound veneration for their burden, they would still be subject to the law of gravity, and their expression must remain the same. If they were to set it down for a moment and then take it up again, the sense of weight alone would make itself felt. The more anxious these men are to take care of the

object they carry, the more cautiously they will walk and keep step together; but in any case they would not fail to observe this last condition, as, if not, the fatigue would be doubled. And this simple fact is the whole reason of this much-ridiculed solemnity. But surely there are plenty of examples to be seen in Paris; for instance, when two *commissionnaires* are to be seen carrying a chest upon a stretcher. Any one can notice how carefully they keep step. Let M. Jean Rousseau and one of his friends try to carry a similar load, and yet walk in their ordinary way! Apparently these gentlemen are not aware that a false step on their part may upset the load! But I have said enough. . . ."

The Paris of 1864 was not converted, but when the *New-born Calf* appeared again in the International Exhibition of 1889, the admirable truth and power of the work was recognised by all the critics.

For the present Millet had to content himself with a medal of honour, and with the gratifying evidence of his *Bergère* popularity which he received on all sides. Numerous applications were made for leave to reproduce this favourite subject in the illustrated journals of the day, and the editors of *L'Autographe* begged the artist for another sketch from his pen. On the 11th of May he wrote to Sensier:

"I wrote this morning to say that I should come to Paris to-night, but I am very unwell, and really not fit to run the risk of the journey. Besides, Sunday is the fête here, which would not leave me much time, for I must be here that day, and cannot leave the house empty when the place is full of people. This being the case, I will put off my journey till next week. I will let you know the day as soon as I can, and if before that there is anything which you wish to tell me, please write. I am going to do the Geese for your brother, and the drawing for M. Mame before I start for Paris, and then if I can begin some things for Moureau, I will."

Three days later he sent another letter in reply to a missive from Paris:

"Barbizon, 14 May, 1864.

"One of the letters which you forwarded yesterday is from Belly, who asks the price of the *Bergère* on behalf of a friend. I have replied that she belongs to M. Tesse, and enclosed his address. The other is from the editor of *L'Univers Illustré*, asking leave to reproduce my picture. Which of the two pictures that I have exhibited does he mean? The necessary permission is hardly likely to be refused, although the reproduction will probably be a bad one. I send a written permission which you will kindly forward to his address, if you think there is no objection, and leave you to decide this. Neither can the new request from *L'Autographe* be declined, but I have no record of either of the pictures by me at present. Still, I suppose all that is required is a sketch recalling the composition. I will make one. While I think of it, I authorize you to open any letters that are addressed to me at your house, and to answer them as far as you are able. I mention this now we are speaking of these subjects. Keep me informed of the latest news. Wish Rousseau good-morning.

"J. F. MILLET."

XV

1864–1865

THE next year of Millet's life was almost entirely devoted to the decorative paintings for M. Thomas's dining-room in Paris. The commission pleased him, and he was allowed complete freedom, both as to the choice of subjects, and style of execution. Before setting to work, he consulted the best authorities among ancient and modern writers, and examined the wall-paintings at Fontainebleau and in the Louvre. But he learnt little from either Renaissance or contemporary masters, and these symbolic representations of the Seasons were distinguished by the same originality as his peasant pictures. In spite of their allegorical meaning and classic draperies, the stamp of the painter's individuality was plainly written in every line.

Spring was a pastoral in the style of his early pastels. Here Daphnis and Chloë were seen caressing a nestful of young birds, in a woodland landscape, at the foot of an altar reared to the god Pan, on the shores of a calm blue sea. Summer appeared in the form of Ceres crowned with ears of corn, and bearing a sickle in her hand as she walks through the golden harvest-field where the reapers are at work. Autumn, the subject destined to adorn the centre of the ceiling, was a Bacchanalian group of joyous vintage-gatherers and topers, making merry together. Winter was represented by a subject from Anacreon: the boy Love saved

from perishing of cold and hunger on a snowy winter's night, and fed and warmed by kind peasants in a cottage home.

Millet's letters abound in details as to the progress of these paintings, which absorbed his whole time and thoughts during many months. The task was a congenial one, and afforded him genuine delight; but the difficulties of executing such large compositions in the narrow limits of his Barbizon *atelier* were great, especially in the case of the octagonal ceiling; and, as before, illness and suffering interfered sorely with his work. During the course of 1864, he was repeatedly interrupted by severe headaches, his children were often ailing, and worse than all, his wife was seriously ill. Madame Millet had given birth to her youngest child, a daughter named Marianne, in November, 1863, and had never thoroughly recovered from her confinement. She behaved with her usual courage and patience, and went about her daily duties with her ordinary cheerfulness; but the sight of his wife's suffering plunged Millet into the deepest dejection.

On the 6th of June he writes to Sensier, full of the importance of the task upon which he was engaged. " Be of good cheer," he says to himself on the threshold of his labours. And like Fra Angelico of old, he begins with a silent lifting up of his heart to the heavenly Powers.

" Thank you for the number of *Figaro*, which is certainly a very curious production, and which, by the way, gives me the wish to meet Jean Rousseau, if this could be easily managed. It might be of real use. He does not know that things exist and are of value only by reason of their fundamental qualities, and he persists in believing that the care with which a work is done, even if it is without aim or purpose, is sufficient in itself. In short, it would be a good thing to make him understand that things only exist by

reason of the stuff they contain. Reflect in what way this may be managed! I am going to do a sketch for *L'Autographe.* You can tell whoever ought to know.

" Blanchet has brought the canvases, which are in my *atelier* now. Let us pray Him who gives us the power to work not to leave us now, for we have need of all our strength to bring this task to a good end. Once more, let us gird up our loins and go forward —*Viriliter agite et confortetur cor vestrum.*

"Can you find out for me if M. Andrieu (a pupil of Delacroix) is in Paris? I should be glad to know, for I am not sufficiently acquainted with Haro's colours, and should like to talk to some one who has tried them. Find out as soon as you can, and tell me all that you hear."

On the 15th of June he reports progress:

" My three panels are fairly started, and, as far as I can judge, my compositions do not look very bad. I am working with common oil paints. I did not venture to embark upon Haro's colours, as my first attempt did not altogether answer. I hope in another week to be able to judge of the effect of my compositions. I am working as hard as a slave, and am entirely buried in my task. I work till the end of the day and do not go out at all, for I cannot take any rest until I have got the thing well into shape. But one of these mornings I must send you the sketch for the *Autographe.*

"J. F. MILLET."

So all goes on well for a few weeks. The *Seasons* are well under way. His friends are sanguine as to the result; his own hopes are high. Then illness comes to interrupt him. His wife is laid up, the children are ailing. On the 20th of July he writes:

"Since my return, I have lived in the midst of sick people. My wife suffers horribly with her head. Several of the children have been very unwell. The greater part of my time has been spent in consulting doctors and in nursing the patients. I have seen M. Comte and M. Moureau, as you may have heard already. When

are you coming? I have also seen Commander Lejosne (the author of the sonnet published in the Nain Jaune, in praise of Millet)."

In the midst of his own troubles the sad news of the death of Sensier's little daughter, Jeanne, reached him, and he put his work aside without delay to hasten to his friend.

"13 August, 1864.

"I have just heard the news. We start at once, Rousseau and I, to see you. Courage, if you can!

"Yours,

"J. F. MILLET."

Millet painted the portrait of the dead child, and did his utmost to soothe the grief of her broken-hearted parents, with his gentle and thoughtful sympathy.

That August, the writer, Alexandre Piedagnel, paid a visit to Barbizon, and spent several days under Millet's roof. He had recently made acquaintance with Rousseau and Millet at the house of a friend in Paris, and had gladly availed himself of Millet's cordial invitation to come and see him at Barbizon. The sight of the painter and his family impressed him deeply, and his account of his visit is one of the pleasantest pictures that is left us of Millet in his home life.

M. Piedagnel describes the low rambling cottage overgrown with the clematis and ivy that Millet would never allow to be pruned, the garden full of roses and fruit-trees, the honeysuckle arbour and the thicket beyond which had been spared at the painter's request. He tells us how he found Millet at work with the door of his *atelier* open that he might hear the voices of his children at work or play, and how his six-year-old daughter, little Jeanne, would lay her finger on her lips, and whisper, "Hush! father is working." And he

tells us how he sat down to the evening meal with Millet, his wife, and all their nine children—from Marie and Louise, who were by this time tall and handsome maidens of seventeen and eighteen, down to the last baby who was being fed by little Jeanne. The simple habits and happy cheerfulness of that patriarchal household impressed the Paris journalist as deeply as the American artist. He saw the grave and silent painter giving his little boys a ride *au pas, au trot et au galop* on his knee, and watched them press around to hear his Norman songs and fairy tales. Often Millet read aloud while his wife and daughters sewed, or else, if the evening was fine, the whole party took a ramble in the forest, singing and talking as they went, and sat on the grass under the King's Oak, or among the rocks of the Bas Bréau.

M. Piedagnel speaks warmly of Madame Millet's attention to her children, of her kindness and thoughtfulness for her guests. He realized how much her husband depended upon her ready help and sympathy, and the constant support which she had been through all his trials. " She was at once," he tells us, " the companion of his life and the guardian angel of his home." What impressed him most in Millet himself, was his wide reading and his rare powers of memory. During their walks together in the early morning or late evening, he would often repeat passages from his favourite authors and dwell with unfailing delight upon Virgil and Theocritus, Shakspeare and Victor Hugo, Chateaubriand and Lamartine. But the Bible, he said, still remained his favourite book, and he was never tired of studying the illustrations of the big seventeenth century folio of the Old Testament which came from Gruchy. He had lately been learning Italian in order to read Dante in the original, and was constantly quoting lines from the *Divina Commedia*. The originality of his remarks, and

the brevity and vigour of his expressions, lent an additional charm to his conversation, whether he pointed out the beauties of the forest, or explained his theories of art, and his horror of false convention and artificiality.

At the time of M. Piedagnel's visit to Barbizon, Millet had already almost completed three of his *Seasons* for the Paris hotel, but had not yet attacked the ceiling. The panel of Spring especially excited M. Piedagnel's admiration, while he was even more favourably impressed with a Norman landscape—a group of cottages with cows feeding in the foreground, and a clear stream flowing through the meadow—which stood on his easel. Before leaving Barbizon, Millet's guest accompanied him to Rousseau's house and saw the pictures of the forest upon which the artist was then engaged. On the last morning of his visit, Millet, who seldom allowed any of his guests to depart empty-handed, made a rapid pen-and-ink sketch of a pair of sabots which he presented to M. Piedagnel as a souvenir of Barbizon. A reproduction of this drawing, bearing the words: "À mon ami, Alexandre Piedagnel, Barbizon, 26 Août, 1864," and signed, " J. F. Millet," appeared three years afterwards in the *Constitutionnel*, together with an article from M. Piedagnel's pen, entitled "Histoire d'une Paire de Sabots," giving a pleasant account of the week which he had spent at Barbizon. A copy of the number was sent to Millet, who acknowledged its receipt in the following letter:

" MY DEAR PIEDAGNEL,—

"I must beg you to forgive me for having been so long in telling you how much I was touched by the kindness of your article, ' The History of a Pair of Sabots,' and by the accompanying letter. I should hardly mend matters if I tried to tell you all the good reasons I have had for this delay. I must confess I am often guilty of putting off till the morrow. Yet my intentions were good. But I always remember how my grandmother used to say: ' My

poor François, hell is paved with good intentions.' If this is indeed the case, I am certainly fated to provide the pavement for those regions. Do not let me, I beg of you once more, reach so sad a destiny for lack of your pardon! I am awkwardly placed, you will allow, and can hardly give you an opinion on the Sabots or their maker. If I say the work is well done, you will say, ' Ah! that is because it concerns himself.' If, in order to appear modest, I say it is badly done, no one will think it either true or civil. So all I will say is that it seems to me to come from your heart! The whole family send you and Madame Piedagnel their respect until our next meeting. Accept a cordial shake of the hand from myself."

That summer Sensier and his wife also paid their usual visit to Barbizon, and spent some weeks in Millet's company. On their return to Paris, Millet wrote asking for news of his friends, and telling Sensier of a visit which he had received from M. Thomas, the owner of the house which his *Seasons* were to decorate:

"Barbizon, October 9, 1864.

"Give me news of yourself, my dear Sensier, for we are anxious to hear how you have been since your return to Paris. Here every one is tolerably well, excepting myself. I suffer continually from headaches, and am at moments quite disabled. This state of things makes me very sad. I work as much as I can, but often the pain is too bad, and as I have not a sufficient dose of the virtue we call patience, the natural result is impatience.

"I have just had a visit from M. Thomas, of Colmar. He seemed pleased at the first sight of my panels, but his satisfaction appeared to increase more and more at every moment, and in the end he became quite enthusiastic. When you see Feydeau, try and find out what were his real impressions. He told me that although he expected the things would be good, he had never dreamt they would so far surpass his expectations. He says that an immense number of persons have already asked to see the paintings, and that great curiosity is felt about them. Some people said to him, 'You must really be a man of great taste to have dared to ask M. Millet for those paintings!' And he congratulates himself on the boldness of his taste, and does not seem to reflect that Feydeau

T

may have had some influence over him. Well, whatever the
source of his satisfaction may be, let us be thankful. Summer
seemed to please him especially."

The next three letters relate to Delacroix's Exhibition,
and to the attacks which had been made upon the dead
painter—a subject upon which Millet was always sensitive,
especially when any of his friends were in question.

"Barbizon, October 13, 1864.

"Is there anything fresh in Delacroix's Exhibition? Will it be
kept open long? I ask that to know if I am likely to see it again.
I should think that Martinet's Exhibition must pale beside it. I do
not know if Diaz is still at Chailly. We have not seen him. I was
told at Rousseau's the other day that M. Lecreux had got hold of
him and persuaded him to paint a panel for Barbey (the inn-
keeper). Can that be true? If he has really painted a panel for
Barbey, it is an unjustifiable action. I am working at my panels
again. My landscape must wait for the present, but now and then
I mean to work at it for half a day.

"My poor Sensier, I know not what to say as to your sad state,
excepting that I pity you. What doctor can cure such sickness?

"Yours,

"J. F. MILLET.'

"Barbizon, 21 October, 1861.

"I am glad to hear that Diaz has refused to paint a panel for
Barbey, in spite of Lecreux's solicitations. All honour to Diaz!

"A few days ago I received a letter from Feydeau, announcing
his intended visit. As soon as he has been here I shall begin
M. Robaut's drawing. You may tell him that he will have it very
soon—by the 15th of November at latest. He may take this as the
same security as a note of hand.

"I certainly mean to pay a second visit to the Delacroix Exhibi-
tion, to see again what I have already seen, and make acquaintance
with what I have not yet seen. What you say of Couture and his
companions does not surprise me, although their conduct is infamous.
It reminds me of two lines of Hugo; I forget where they come
from:

'Lâche insulte, affront vil, vaine insulte d'une heure,
Que fait tout ce qui passe à tout ce qui demeure!'

"My memory does not serve me well, for *insulte* does not come twice over in the first line, but the sense is the same. These people are well aware that they have produced nothing really good; for to have painted things that mean nothing is to have borne no fruit. Production and expression go together. Like most feeble persons, they try to revenge themselves on those who are stronger than they are. I suppose, as you say, the great mass of artists are very apathetic, or else these men would not dare to behave as they do. Rousseau, with whom I was discussing this the other day, told me that he believed Delacroix had been attacked on all sides. He judged by a number of *Martinet's Journal*, in which Silvestre's defence of Delacroix was quoted, a defence which Rousseau thought very poor, and rather likely to help Delacroix's enemies than to demolish them, since Silvestre gave no really good reasons in support of his argument. You have probably read that I no longer see *Martinet's Journal*, and Rousseau has mislaid the number, and forgets how it was worded. According to him, it appears that Silvestre was forced to take this step, by the number and violence of the attacks upon Delacroix, with which Rousseau is justly indignant.

"You may be sure that on every occasion I shall not fail to say what I feel it my duty to say, and I had one such occasion, the only time that I visited this Exhibition. I will tell you what happened if I remember to mention the subject. Tell me what you hear.

"Yours,

"J. F. MILLET."

"Barbizon, November 8, 1864.

"Meanwhile, I am attending to our gardens, where nothing seems to go right. R—— has dug holes for the trees, but has not planted any yet, and makes an excuse of a sprain, which, he says, prevents him from working. S—— promises to bring the manure and never comes. D—— has sold us some wood, has thrown it into Jacque's *atelier*, and has never come to stack it up. We shall be obliged to set to work ourselves. My dear Sensier, nothing is so strong as indolence.

"Feydeau told me of a journal which his brother Ernest is going to bring out. If you could make some serious answer in its pages to the attacks upon Delacroix, it would be an excellent thing. We must talk of it. *Au revoir* to you and yours,

"J. F. MILLET."

November, as before, brought a fresh crop of troubles. In 1862, poor Vallardi's suicide had happened in November; this year Madame Millet became seriously ill, and Rousseau had a painful attack of rheumatism, from which he never entirely recovered. Millet himself suffered with his head and eyes, and often had to lay down his brush.

"Barbizon, November 18, 1864.

" Please do not forget the Mont de Piété. . . . Give us some particulars of Proudhon's sanctification, and the effect which it has produced. Ask Daumier to find out all he can about the perspector of whom he told me. He spoke of him as very clever. If so, he would be able to help me design my ceiling, which is to represent Autumn, the fourth of my compositions.

" I have asked Rousseau about the reproductions of Giotto's works, which you mentioned, but have found out nothing definite, except that they were superb and touching. Where are the originals? How many subjects are there, and by whom are they published? Send me the Salon rules, and I will think about exhibiting. Please tell me whether M. Martel is willing to let his *atelier*. It might be available for my decorations. My wife has had another violent attack of pain in the stomach and liver. I am concerned at seeing her in this condition; and if she has another attack, I will bring her to see a Paris doctor.

"Yours,

"J. F. MILLET."

"Barbizon, 27 November, 1864.

"This unhappy Rousseau was attacked a little time back with violent pains in the thigh. Now these pains have spread into his back and loins, and attacked the other thigh. The pain is almost unbearable, and leaves him no rest. He can neither lie down nor sit up. He has spent several days without rest, and has not closed his eyes a single instant during the night. Tillet and I have scarcely left his bedside, and have sat up all night with him, so that we are all tired out, which by the bye will explain my delay in sending M. Robaut's drawing. And I have also had two days of violent headaches, brought on, no doubt, by want of sleep. Last night we did not sit up after one o'clock, as he seemed a little better. I have

not yet heard if he was able to get a little sleep during the rest of the night.

"This morning I am going to do a sketch of the drawing of the Couturier sale. I will send it with M. Robaut's, and beg you to give it to M. Couturier. My head feels hollow. Another sick headache is at hand. When you can manage it, see Daumier about the perspector. Good health to you all.

"J. F. MILLET."

"Barbizon, 29 November, 1864.

"I have sent M. Couturier's drawing to the train. Please send him a little note at once, telling him that he can call at your house for the sketch. If I ask you to write instead of doing this myself, it is because the tone of his letter is very embarrassing, and that I am puzzled how to reply in a suitable tone. His address is: Rue des Dames, 52, Batignolles. M. Robaut's drawing is with that of M. Couturier. It is not highly finished, but done as you wished. I have merely indicated the general effect with a few touches of *pastel*. I hope he will be pleased. Rousseau is almost restored to health. My wife and I mean to come to Paris some of these days to consult a doctor, for she does not get well. Console Forget, if it is possible, for the theft of his picture, and tell him that his panel is begun. I do not know if it is my fancy, but it really seemed to me as if the drawing for M. Couturier had some character. If you agree with me in this, could you not get one of your friends to buy it? I leave you to decide this, and trust to your judgment. If it were not ridiculous to be always complaining, I would tell you that I am not well. . . . *Au revoir*.

"J. F. MILLET."

"Barbizon, December, 1864.

"Tillot and his family have started to spend the winter in Paris. Rousseau and his wife also left at the same time. Rousseau wants to see a doctor about the pains in his back. I must see the perspector, M. Mahieu, who is said to be a very clever man, and M. Andrieu (Delacroix's pupil), who may give me some useful hints on the subject of large decorative work. I must see the Louvre again, Paul Veronèse, and the Italian masters who were so strong in decorative art, and Poussin, who also tried it. In short, I mean to spend a week in Paris, running about and studying. I should like,

if possible, to see the Chamber of Deputies, where Delacroix has done some great things. Before I put my hand to the canvas, I want to fill my mind with these masters who were so strong and so learned. I dread the day when I must begin to work definitely."

Unfortunately the week in Paris brought on an attack of inflammation in his eyes, and after his return to Barbizon, he wrote to Sensier on the 28th of December:

" The day after my return from Paris, I woke up with my left eye as big as a walnut, and as red as blood. It was very painful. I could not see to work, and my attempts to give my mind to what I was doing brought on a violent pain in my forehead and eyes. This lasted several days, and my sight is still very feeble. But I have managed to work a little, and have hardly anything more to do to Forget's picture. Last night I tried to take a little walk on the plain, but the effect of the air was like a knife cutting through my eyes, and this morning they are very painful. Forget shall not have to wait for his drawing later than the first of January. My eyes are quite dim after writing these few lines. We all of us wish you all whatever can be desired for those whom we love well, and we ask Him who alone can help us to keep away from you such sorrows as that which you have experienced this last year.

" Yours with all my heart,

" J. F. MILLET."

With this letter Sensier's Life of Millet ends. The work was cut short by his death in 1877, and the task of completing and publishing the unfinished biography was left to the eminent writer M. Paul Mantz. Sensier had left behind him a few notes and other fragments, quotations from newspapers, a few dates and descriptions scribbled on the margin of catalogues. But the chief material at the disposal of M. Mantz were Millet's own letters to Sensier. Several packets of these, carefully sorted and dated, lay ready to his hand, and enabled him to continue the story of the painter's life without a break. He has, he tells us, omitted many passages of

less general interest — details as to the cultivation of Sensier's garden, directions for the sale of his drawings, or payment of his bills, particulars of his wife and children's health, but has carefully preserved every line relating to his work. Naturally, this portion of the narrative loses some of its interest. We miss the vivid personal impressions, the scattered fragments of Millet's conversation and recollections which are the charm of Sensier's pages. But every one will agree that M. Mantz acquitted himself of his difficult task with tact and ability, and to his careful revision the work probably owes whatever literary merit it may possess.

XVI

1865—1866

THE failing health of Rousseau, and the dangerous illness of Millet's little son Charles, were the painter's chief causes of anxiety during the winter months of 1865. His wife also suffered from her old complaint, and was constantly seeing doctors, whose prescriptions gave her little relief. But in spite of these manifold anxieties, Millet worked on with absorbing interest at his Autumn, the last of the four *Seasons*, which were to decorate M. Thomas's new house. The work, as we learn from the following letters, was actually begun in January, 1865, and finally completed in September.

"Barbizon, 6 January, 1865.

"MY DEAR SENSIER,—

"On Monday, the perspector, M. Mahieu, came. We had to clear out my *atelier* in order to lay the canvas down flat, and to make a tracing of the balustrade of the ceiling. We worked all day and part of the evenings, from Monday till last night (Thursday). I was very unwell, but did what I could. I am much pleased with M. Mahieu."

"Barbizon, 10 January, 1865.

"MY DEAR FORGET,—

"I am just going to begin my ceiling. It is a very difficult task, because of the want of space here. Yet without counting that, the difficulties are great enough, in all conscience ! But *à la guerre comme à la guerre*. My panels have got on pretty well. You may be certain that as soon as they are in Paris, you shall be one of the first persons invited to see them."

"Barbizon, 10 January, 1865.

" MY DEAR SENSIER,—

"You spoke to me of a M. Champollion, who holds some high office in the palace of Fontainebleau. Now I want to look at the paintings there at my leisure. You would oblige me by sending him a line begging him to get me this permission. If you send me a letter for him and he is absent, the journey would be wasted. Would it not be possible, in case of his absence, for him to give orders to the custodian, to show me what I want, and let me have time to inspect it thoroughly ? "

"Barbizon, 26 January, 1865.

" MY DEAR SENSIER,—

"It is evidently difficult to see the Fontainebleau paintings. Please draw up a request for the necessary permission. Only, unless it is absolutely necessary, do not mention any special rooms, as, for instance, the Salle Henri II., but get me a general permission to inspect the paintings of the palace. If you are obliged to name particular rooms, the Salle Henri II., and the chapel with Martin Fréminet's paintings, are what I must see.

"I should like to have seen the *Antonello di Messina* and the other Primitives of which you speak ; also the *Claude* and the Greek antiques, which are by no means to be despised. Where will they all go?"

[These works of art belonged to the Pourtalès collection, and were dispersed at the coming sale.]

"My wife is not well to-day. She suffers more than usual. We are soon coming to Paris. I have just been writing to M. Chassaing, who has placed his good offices at my wife's service, in case she has to go to Vichy. He is really full of devotion and kindness."

"Barbizon, January 30, 1865.

"The weather is grey and rainy, the sky dark, and the clouds low ; but, as you know, I prefer this kind of weather to sunshine. All is of a melancholy and rich colour ; very soothing to the eye and calming to the brain. . . . I have seen Rosso and Primaticcio once more at Fontainebleau. There is a strange power about them. They belong to the decadence, it is true. The

accoutrements of their figures are often ridiculous, their taste is doubtful, but what vigour of conception! How forcibly this boisterous mirth recalls early ages. Their art contains at once reminiscences of Lancelot and Amadis, together with the germ of Ariosto, of Tasso and Perrault. I could spend hours before these kindly giants."

"Barbizon, 11 February, 1865.

" MY DEAR SENSIER,—

"I must first of all speak to you of Rousseau, who does not seem to me so terribly ill as Diaz told you. He is decidedly better; and I am convinced that if the weather improved, and he could get out a little every day, he would soon recover some degree of health. Now he is beginning to work for a good bit at a time, which he could not do a few days back. He leaves on the 15th or 17th, so you will soon see him. But his wife becomes more and more of a trial every day.

" M. Mahieu, the perspector, comes to-morrow to correct the mistakes caused by the wrong measurements that were given him for the balustrade. I am glad to hear what you say of the Exhibition in the Rue Choiseul, and to have your impressions of my sketches. Who is this M. Gavet who has bought my *Bergère*? Tell me anything of interest about him."

"Barbizon, 9 March.

"I shall send nothing to this year's Salon, since I could not do what I wanted. I am very sorry for this; but since I could not carry out my ideas, I think it best to keep away."

"Barbizon, 14 March, 1865.

"You did well to settle with M. de Villemessant. You have my full permission to act for me in these matters. When it is time to send the sketch of *La Bergère* to the printer, let me know if any description is required. I am glad to hear that Rousseau is well, and that Diaz's sale was a good one. I have received a letter from Simeon Luce, from Marseilles, where he has been for the last eighteen months. He tells me that he often sees Jeanron, who is Director of the School of Fine Arts there. 'I do not share all the ideas and tendencies of this excellent man,' he writes, 'but he is a good fellow who loves Art passionately, and knows its history thoroughly. He is always very amiable,

and he knows all that is happening here. He speaks of the *Angelus*, of which he has heard "wonders."' I did not know that M. de Morny was dead."

"Barbizon, 29 March, 1865.

"MY DEAR SENSIER,—

"I am very glad that you are going to do the articles on the Salon. You may be sure that I will tell you everything I can think of, either about Art in general, or any particular works. It seems to me that you might show, by going back a little, that Art began to decline from the moment when the artist no longer leant directly and simply upon impressions taken from nature. Then clever execution rapidly took the place of nature, and the decadence began. Force departs directly you turn aside from nature, as we learn from the fable of Antæus, whose powers failed when his feet no longer rested on the ground, and who recovered his strength every time he touched the earth. Say that briefly but fully, and repeat it as often as possible. Show your readers that for the same reason Art has steadily declined in modern times, and give as many examples as possible. I am only sorry we cannot talk it over. I will send as packing for the Mame drawing some extracts from Montaigne, Palissy, Piccolpassi, and his translator, Claudius Popelyn, which will supply you with a few good quotations, and some ideas that may be of use to you. I will try if I can find some more. I am going to think this over, and tell you whatever comes into my mind. In the end, it always comes back to this—a man must be touched himself before he can touch others; and work that is done as a specu- lation, however clever it may be, can never effect this, because it has not got the breath of life. Quote St. Paul's expression : *æs sonans et cymbalum tinniens.*"

"April 7, 1865.

"MY DEAR FEUARDENT,—

"So you are off for Italy at last ! If you should happen to find any photographs, either of the well-known antiques or of paintings, from Cimabue to Michelangelo, which are not too exorbitant in price, buy them, and we will take them off your hands. Each place you will visit has its own particular school of art. You must see them all by degrees. As for the old masters, be sure only to buy photographs that are taken directly

from the originals, and not from engravings. Get nothing of Raphael—he can be studied in Paris. Make careful inquiries at Naples as to whether the paintings of Herculaneum and Pompeii have been reproduced. In short, bring whatever you can get there—works of art or landscapes, human beings or animals. Diaz's son who died brought home some excellent ones of sheep, among other subjects. In buying figures, you will of course select those that have the least flavour of academic art and models. But get whatever is good, ancient or modern, proper or improper. Enough ! Send us your little ones. . . . One more piece of advice—if you find any old illustrated books, get them if possible. *Bon voyage*, health and happiness ! "

"Barbizon, 10 April, 1865.

" MY DEAR SENSIER,—

"Feydeau and M. Thomas came yesterday, and seemed satisfied. . . . I cannot remember what Michelangelo said about academies. I have not got a Vasari. If you look through his work at leisure, you will find many good things. . . . You should glance at Rousseau's volume, *Le Moyen Âge et la Renaissance*. He has an article, if I remember right, on the history of French art. Look at Le Tourneur's preface to his translation of Shakspeare. He has said some good things as to what constitutes the real superiority of creative minds over those who are only good workmen, and have been well taught. Rousseau possesses the book. You might discourse upon all of these subjects, in order to prove the gulf that lies between work that is merely well reasoned, and that which is sincerely felt."

The next letter refers to a letter from M. Mame, acknowledging Millet's drawing, and expressing his approval of the work, but which the painter seems to have left in doubt as to his real feelings on the subject. Millet, it must be confessed, was singularly sensitive on this score.

"Barbizon, 2 May, 1865.

" MY DEAR SENSIER,—

"I have received this letter from M. Mame : 'Sir, I received yesterday, through M. Sensier, the pastel which he asked you to make for me. I am extremely well satisfied with it; and all the

amateurs who have seen it agree with me in recognising the excellent qualities of this drawing. Accordingly, I hope you will accept my thanks, and the assurance of my most distinguished sentiments.—MAME.'

"I shall be obliged if you will acknowledge the receipt of the enclosed 200 francs, the price which you named.

"This letter satisfies all polite requirements, but does not show me if M. Mame is really pleased, and seems to me as if it might have been written beforehand. Try and get at the real facts through your brother. This may be the way in which some persons express their satisfaction. I hope in this case it is so."

"Barbizon, May 12, 1866.

"MY DEAR SENSIER,—

"What you tell me of poor Rousseau is very sad. I fear he is completely breaking up. Does his illness increase? What does he himself say to this? It is enough to make one despair, however strong one's head may be. But sufficient unto the day! Although it cannot be called a surprise, this confirmation of our fears is none the less a new blow. . . . I am impatient to see Jean Ravenel's article."

[Sensier had been writing articles on the Salon in the *Époque*, under the *nom de plume* of Jean Ravenel.]

"Do you know what people think of them? I must not quite omit to visit the Salon. It is always a curious experience. If Jean Ravenel dares not always say all that he thinks, I hope you will, if you can find time, supplement his remarks upon some worthy artists. For instance, Courbet and Daubigny, whom you say it is not easy to bring before the public, have surely painted pictures which would help to remove these prejudices. M. D——'s delay in advancing the usual sum at the end of the month is annoying, I assure you, for I am compelled to leave my ceiling, and am dismayed at this fresh hindrance. . . . Sunday week is the *fête* of Barbizon. A big advertisement announces this event to the village in fine style. . . ."

"22 August, 1865.

"MY DEAR SENSIER,—

"We visited Corot and Commairas with Rousseau, and had the kindest of welcomes. Our day was very pleasantly spent. We

dined with De Knyff, who treated us in princely fashion, to quote Diaz's expression. As to the dinner, Alfred Feydeau's was quite put in the shade! There were fresh plates for each course. First-rate wines, etc., etc. I must confess that I was more embarrassed than delighted with this fashion of dining, and that I often watched my neighbours out of the corner of my eye, to see what I ought to do next. Corot's pictures are beautiful, but express nothing new. We are pretty well. I have almost finished my ceiling. . . ."

"Barbizon, 5 September, 1895.
"My dear Sensier,—

"I have had some frightful headaches. M. Gavet came here yesterday with Rousseau. He asked me for twenty drawings, but does not mean to stop there. He said, I should like to have fifty as well as twenty, but you must begin by doing the twenty. I asked him for 350 francs for each drawing of ordinary size, but those which are very important are to be 500. There! . . ."

"Paris, 29 September.
"My dear Sensier,—

"Here is almost a week which I have spent in Paris for the King of Prussia's sake! This is the state of things which I found at the hotel. The ceiling has been fixed in its place, but is sadly damaged by the operation. If merely some portions of the work had been spoilt, I could have restored them, but the workmen have smeared the whole with whitewash, so that this unfortunate ceiling looks as if it had been trodden under foot for several days by masons. This will give me a great deal of trouble. I am vexed, and plunged in despair. . . . We tried to put the panels in their frames with a few nails, and held them up at arm's length, but that did not help me to judge of their effect. To-day I shall for the first time be able to see the four paintings in their proper place."

The work upon which he had been so long engaged was finally concluded, and the *Four Seasons* were minutely described in four long articles, from the pen of Sensier, in the next number of the *Époque*. An engraving of Spring, which seems to have been the most generally

admired, also appeared in M. Piedagnel's *Souvenirs of Barbizon.* Unfortunately these interesting works, the most important example of Millet's classical style, did not long remain in the house for which they were intended. The new hotel of the Boulevard Haussmann was dismantled in 1875, and Millet's *Seasons* were sold by auction at the Hôtel Drouot on the 16th of April, 1875. M. Mantz tells us that on this occasion they provoked much discussion and a little disappointment; but Mr. Wyatt Eaton, who studied them attentively, describes them as affording a fresh proof of Millet's comprehensiveness and power.

"Although not painted in the usual manner of large decorations," he writes, "the effect of the panels in the room where they had belonged must have been complete and surpassingly fine. But to judge them in the strong light of a gallery, and without the requisite distance, was to ignore Millet's intuition and accomplishment."

Millet was now free to devote himself to the series of drawings which had been ordered by the architect, M. Gavet. He was at work upon these one day in November when the new patron paid him a second visit, and had a long conversation with him. M. Gavet's admiration for his art was great, and he offered him excellent terms if he would consent to work for him. But Millet had suffered too much annoyance from his contract with Blanc and Stevens ever to pledge his freedom again. M. Gavet, however, as he soon discovered, was a genuine lover of art, and before long the two men came to an agreement, as we learn from the following letters:

"Barbizon, Saturday.

" MY DEAR SENSIER,—

"The postmistress seemed very grateful for what you have done to help her, and I am certain that the poor old blind woman in Gréville will be the same. I ought to come to Paris to talk

over a visit which M. Gavet paid me the day before yesterday. He wishes me to make an innumerable quantity of drawings for him, and to engage to work very little for any one else. I told him first of all that there were certain persons for whom I would never refuse to work, himself, of course, being one of them!— and so on. I did not wish to make any hasty reply. He will return here perhaps next Thursday, and try to come to some kind of an agreement. As you will be here before that time, we can talk over this, and see what is the best thing to be done. There are certain things to be said for and against the plan, which we must consider as far as possible. It is of no use to write more about it, as we shall soon be able to talk. Try, if you can, to find out what I am *worth* in Paris. That would, at least, give us a point of departure. It will be a good thing for you to be away from Paris during the cholera."

The following passage belongs to a letter addressed by Millet to his absent friend, M. Feuardent, on the 5th of December, 1865 :

" The same amateur who asked me for twenty drawings some time ago, now wants a number of others, and into the bargain a whole string of pictures, so much so that he would like me to work for no one else. We spent yesterday in discussing the matter, and have succeeded in making an agreement. This amateur is an architect called M. Gavet. So now I have pictures to paint for him during three good years, and shall be well paid, if I do nothing else. But I have reserved my liberty on all points, —liberty both in the choice of my subjects, and liberty to work for others. He is perfectly insatiable! He wants everything of mine that he can get, and is going to make a gallery for my pictures. He will give me 1,000 francs a month from the end of the year, and will pay me the balance when I deliver the work."

The result of this agreement was that during the next two years Millet made no less than ninety-five drawings for M. Gavet. These drawings were executed in every variety of material—in crayons, charcoal, pastel, and water-colour. The subjects represented were of the most

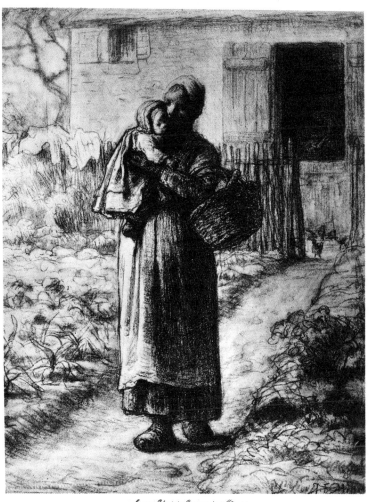

La Sortie (The Departure)

different kinds, shepherds and shepherdesses, cowherds
and goatherds, peasant-women churning and milking cows,
labourers sowing and reaping, going out to work in
the morning or coming home at nightfall, mothers watch-
ing by their sleeping infants, teaching their little ones to
knit or sew, or nursing their sick children. There were
deer starting from their lair in the forest, sheep browsing
on the edge of the thicket, rabbits scuttling out of their
holes, flights of crows darkening the winter sky, bouquets
of daisies, and pots of dandelions. And there were beau-
tiful effects of landscape : winter scenes when the snow
is deep and the forest trees are bare ; autumn evenings
with the leaves lying thick on the ground, and the sun
setting in the fog, storm-clouds rolling up from the plain,
or the rainbow breaking out over the meadows after a
passing shower. Many of these subjects were inspired
by Barbizon and its neighbourhood; others were recol-
lections of the painter's beloved Normandy ; a few were
suggested by his visits to Auvergne. And among them
we find some of the finest things which Millet ever
did, some of the most complete and significant pages of
his great poem. A warm friendship, it is pleasant to
learn, sprung up between the artist and his employer.
Several of Millet's letters during the next two years are
addressed to this patron, who appreciated his genius so
fully, and shared the delight with which he noted the
changeful aspects of earth and sky.

On the 28th of December, 1865, he writes:

"MY DEAR MONSIEUR GAVET,—

"We have had some superb effects of fog and some hoar-
frosts so fairy-like that they surpass all imagination. The forest
was marvellously beautiful in this attire, but I am not sure the
more modest objects, the bushes and briars, tufts of grass, and
little sprays of all kinds were not, in their way, the most beautiful
of all. It seems as if Nature wished to give them a chance, and

U

show that these poor despised things are inferior to nothing of God's creation. Anyhow, they have had three glorious days. I have finished M. Brame's little picture. He must have received it by this time. I am going to set to work on your *Night*, and some other pictures for you ; while I go on working at M. Brame's larger picture, which I hope to send to the Salon. You will receive several drawings in the course of January."

The picture here mentioned was the *End of the Village of Grêville*, a view of the little street of Gruchy looking over the sea, which naturally aroused many tender memories of the past.

" My dear Sensier," he writes on the 3rd of January, 1866, " I have not had my usual New Year's headache. I am certainly rather complaining, but I can bear with myself, and that is saying a great deal. I am working at my *End of the Village*, looking over the sea. My old elm begins, I think, to look gnawed by the wind. How I wish I could make it stand out in space as I see it in my thoughts ! Oh, wide horizons, which so often filled my mind with dreams when I was a child, shall I ever be allowed to make others feel your power? Your laurel is bound round with straw. If it has not yet been hurt by the frost, it is to be hoped that, now it is well protected, it will be able to bear future ones. Tillot must have spoken to you of the hoar-frost. No words can give an idea of its beauty. To compare it to the tales of *The Arabian Nights* would be trivial and commonplace. These things form part of the ' treasures of the snow ' which are spoken of in the Book of Job."

While Millet was at work on his Gréville picture, he received a sudden summons to his old home. His beloved sister Emilie was dangerously ill, and not expected to live. He set off at once for Normandy, and wrote a melancholy letter to Sensier from his sister's home.

" Gréville, Hameau Le Fèvre, 6 February, 1866.
" I found my poor sister in a desperate condition. I am very glad to have seen her once more, especially since my presence gave the poor dying girl a moment of joy. When I arrived, my

brother, Jean-Lòuis, told me that she no longer knew any one.
I came near her bed and spoke to her, telling her my name.
She remained some time apparently unconscious. At last she
opened her eyes with an expression of surprise. I repeated my
name, and then a thrill passed over her poor face, drawn and
wasted as it was by the fever. Her eyes filled with tears, big
tears which ran down her cheeks. She clasped my hand con-
vulsively between her own, and said with all the strength that
was left her, *François* !

"Poor dear girl ! her heart was still sufficiently alive and full
of love to overcome her weakness and make itself felt. You can
imagine, my poor Sensier, what an impression this made upon
me. . . .

"This hamlet has as many as thirty-five inhabitants, and more
than half of them are in bed. And yet how beautiful and healthy
the situation is ! When I begin to recover my calm of mind, I
must tell you more about this country. The whole aspect of the
place is pleasant and homely, like some old Breughel. Last
January there was a gale here such as had not been known since
1808. The ground is still strewn with fallen trees, and among
them is my poor old elm, which I was hoping to see again. So
this world passes away, and we too are passing with it ! My poor
Sensier, I am very sad."

On the 11th of February his sister died, and a few days
afterwards he returned to Barbizon to finish his picture.
On the 16th of March, he wrote to Sensier, and an-
nounced its completion.

"I shall come up on Monday morning with my picture. You
know about the time when I am likely to arrive. If you can be
there to see it, I shall be very glad. I should like to hear your
impressions. . . . I ought really to have kept the picture here
all the summer, and after it was thoroughly dry have worked at
it again from time to time ; but this is out of the question now,
and it must be exhibited in its present condition. You will tell
me if I need not be too much ashamed of it."

The picture was so badly hung that when the Salon
opened Millet's friend, Bodmer, declared that he could not

find it in the galleries. This disturbed Millet, who wrote
to Rousseau for information.

"Barbizon, 29 April.

"MY DEAR ROUSSEAU,—

"Bodmer, who has returned from Paris, and has visited the
Salon, has just been here to tell me that he looked for my picture,
but could not find it, either under the letter 'M,' or in any other
part of the rooms. He was there with Mouilleron, and both of
them hunted everywhere in vain. Can you by any chance explain
this? I cannot conceive what has happened. However badly
my picture may have been hung, it must be hung somewhere.
My wife is ill, and the doctor has just said that she must go to
Vichy, and be there by the 15th of May. This is a great trouble
and anxiety for me."

The critics were severe upon the Gréville picture, which
Millet owned was still unfinished and had not been var-
nished, owing to his intention of working at it again later
on. Edmond About reproached him with alternately ex-
hibiting masterpieces and worthless daubs. But even this
canvas had its admirers.

"M. Gavet came here the day before yesterday," wrote Millet
to his friend Sensier, on the 18th of May, "and seems at least as
eager as ever for pictures. He spoke of the critiques of my
Salon picture, which he thinks stupid, and declares that once
my picture has been varnished it will be superb, and says that
if it were hung in another gallery it would make everything else
look insignificant. But he agrees with you in thinking that I
ought not to exhibit my pictures unvarnished. He has ordered
more drawings and pictures, and wishes to have an exhibition of
his whole collection. If that day ever comes, he declares my
enemies will hold their peace. He is much struck by the last
drawings which I have sent him, and those which he saw here,
and at which I am working now, have produced the same effect
upon him. As long as I can make a living, the strictures of the
critics are not likely to hurt my pride."

M. Gavet's prophecy proved true. There came a day

when these ninety-five drawings by the hand of Millet
were exhibited to the wonder and delight of Paris, and
every critic in France joined in the chorus of admiration.
But by that time the artist himself was beyond the reach
of human praise or blame.

Another letter addressed by him to Sensier in the
spring of the same year reveals the great master in a
new and amusing light. The simplicity of his habits,
his regard for his old friends, and the natural sensitive-
ness of his feelings are all displayed in this characteristic
effusion :

<div style="text-align: right">" Barbizon, April 24.</div>

" My dear Sensier,—

" We received your letter, and by the same post one from
Madame F——, in which she announces the marriage of Louise.
In spite of all our troubles, I think we must not fail to go to the
wedding. This being the case, there is a question which I beg
you in all seriousness to answer at once, in order that when the
invitation comes, we may take measures to appear properly on
this occasion. What kind of dress is suitable ? I do not think
any one has the right to show himself on such an occasion in
shabby clothes. My intimacy with the F——s makes it the more
important that I should not abuse their kindness in the sight of
others. . . . Tell me, then, what is the most suitable and
simple dress that will shock no one, without being in the least
degree official. Give me particulars—what kind of coat, what sort
of waistcoat, what their colour should be, and so on. I suppose
their invitation will arrive in time for me to get what is necessary
made to order, because I do not wish to go to such an expense
beforehand. Anyhow, let me know what I ought to wear, and
then I have only to act when the moment comes. I need hardly
tell you that I shall go alone, for my wife is in no condition to
accompany me."

The doctors, as already mentioned, had ordered Madame
Millet to Vichy, and Millet, feeling his wife's health to
be of vital importance, determined to leave Barbizon,

sorely against his will, and take her to Auvergne him-
self. Once the move had been safely accomplished, he
was happy enough at Vichy. The sight of a new part
of France interested him greatly, and his letters to
Sensier and his other friends abound in characteristic
description of the place and people. The following was
written to M. Gavet on the 17th of June:

"MY DEAR MONSIEUR GAVET,—

"I have not troubled myself much about the gay world at
the Baths, but I have made acquaintance with some of the
environs of Vichy, and have found several very pretty subjects.
I make as many sketches as I can, and hope they will supply
me with drawings of a different kind from those which you have
already. This country, in many respects, resembles the part of
Normandy that I know, with its green meadows enclosed by
hedges. There are a good many streams, and consequently a
good many water-mills. The women spin as they watch their
cows, a thing which I have never seen before, and of which I
intend to make use. They do not in the least resemble the
shepherdess spinning with her distaff whom you see in the pastorals
of the last century, and have nothing of Florian about them, I can
assure you. Do not expect to see many finished drawings on
my return. I mean to provide myself with as large a store of
documents as possible, and I have to look about me, since I do
not know the country well. But when I come home you shall
have the first-fruits of my impressions. The peasants' carts here
are all drawn by cows. The waggons which carry the hay have
four wheels, and are also drawn by oxen or cows. Once more, I
mean to take in as much as possible, and let you have the result
of my observations."

A week later he wrote to Sensier, saying that he had
made about fifty drawings, water-colour sketches, and
adds the following remarks:

"The country is green, and a little like some parts of Normandy.
The people are far more like peasants than those at Barbizon.
They have that good, stupid kind of awkwardness, which does not

in the least smack of the neighbourhood of the Baths. The women have, as a rule, faces which are by no means bad, and which agree with the type of head that you see in Gothic art. The race cannot be a bad one. The people always speak when they meet you. The other day I began a sketch near a house: I had not been there long before a man brought me a chair, saying that he could not allow me to remain standing when I was so near his house. I must talk to you about these people and their ways when I come home. There is much to say, and much more to be done with them."

Early in July, Millet and his friend, M. Chassaing, took a few days' tour in Auvergne. Together they visited Clermont and Mont-Dore. By the 19th the painter was back at Barbizon, and wrote to the companion of his travels:

"My head is full of all that we saw together in Auvergne. Everything is jumbled together in my brain—volcanic mounds, pointed rocks, chasms, barren wastes, and green slopes! the glory of God dwelling in the heights, the topmost peaks wrapt in storm and cloud! I hope that all these confused impressions will settle down in course of time, and be stowed away each in its own pigeon-hole."

Then he went back to work, and spent the autumn in making drawings for M. Gavet. His love of natural beauty seemed to deepen every year of his life. Each season brought its own record to add to the wealth of lovely sights and deep emotions that were stored up in his brain. Each month he found new poetry in the woods and in the fields. Winter itself could not rob these familiar scenes of their charm. That December he painted his wonderful pastel of the sun setting in fog and cloud over the plain, which he describes in a letter to M. Gavet:

"The *Sunset* of which I spoke is a very simple thing, but I am trying to give it a certain sense of sadness."

Some years before he had told his brother Pierre that he would not care to live in a country where it was always summer, since he could not bear to miss the impressions and emotions that we receive in winter. And now he wrote to Sensier:

"I must confess that the things one sees out of doors at this gloomy time of year are of a very moving nature, and this is a great compensation for the few hours of daylight, and the little time there is for work. I would not miss these impressions for all the world, and if I were asked to spend the winter in the South, I should refuse at once. 'O sadness of fields and woods! I should lose too much if I could not see you!'"

XVII

1867–1868

THE great event of 1867 was the International Exhibition. Millet, by right of the medals which he had won at former Salons, was entitled to send a selection of the works which he had painted during the last twelve years. The difficulty of collecting his scattered pictures and of obtaining permission from their owners to exhibit them, was, in his eyes, an impossible task, but kind friends came to his help, and eight of his finest works were eventually sent to the Champ de Mars. They were *Les Glaneuses, La Jeune Bergère, La Grande Tondeuse, Le Berger, Les Planteurs de Pommes de Terre, Le Parc aux Moutons, La Récolte de Pommes de Terre,* and the *Angelus,* which had lately passed into M. Gavet's hands. At the same time Millet sent two small pictures on which he had been at work during the past winter to the annual Salon, which opened, as usual, on the 1st of April. One of these was a view of the plain of Barbizon in winter, with crows pecking the heaps of manure on the plough-land, and a hillock, with bare trees spreading their naked boughs against the sky. That sense of sadness and loneliness which appealed to him so powerfully in these winter scenes, made itself felt in the wide desolate landscape, in the heavy clouds moving slowly across the leaden sky. It was the fruit of his lonely walks and silent meditations during the short December days. The other was a more lively subject—a

little goose-girl driving her geese to the pond, and is mentioned in the following letter:

"Barbizon, 27 January, 1867.

" MY DEAR SENSIER,—

"I have received a printed circular, signed by several artists, Barrias, Hillemacher, and others, asking me to contribute to a sale which is to be held for the benefit of Louis Duveau, who is ill. I have agreed to join them, and will send some little drawing. I had not heard of the ceremony at Ingres' funeral, or of the speeches at his grave, but from what you say, can imagine the nature of the scene. I am very glad of what you tell me about Rousseau's picture. The mountain background was splendid the last time I saw it, and inspired me with much the same feelings that you describe. I hope he will finish it in time for the Salon, for this fine work cannot fail to make a deep and enduring impression. I am at work on my *Geese.* The picture must be ready soon, or else I could spend any amount of time over it. I want to make the screams of my geese ring through the air. Ah! life, life! the life of the whole!"

The Salon, however, was naturally thrown into the shade by the Exhibition. Here Millet's pictures attracted a considerable degree of attention, not only from his own countrymen, but from the foreign visitors, to whom he was as yet comparatively unknown. He himself had looked forward with a good deal of trepidation to the effect which his assembled works might produce; but the result justified the most sanguine expectations of his friends. The letters which he wrote to Sensier from his quiet home at Barbizon during the first weeks of the great exhibition, bear witness to these alternations of hope and fear:

"Barbizon, 26 March, 1867.

"What you tell me in your last letter about my pictures in the International Exhibition, and especially of Meissonier's opinion, has given me great pleasure. As for the Cross of the Legion

of Honour, I assure you, I do not flatter myself, or imagine that I am in the least likely to get that. Besides, there are plenty of people more eager than I am, and more persistent than I care to be in their efforts to move the wheels. All I now desire is this : to gain a living by my work, and be able to educate my children, and after that to produce as many of my impressions as possible, and at the same time to feel that I have the sympathy of the people I love best. . . . Let this be mine, and I shall feel that I have the best things that life has to give."

"Barbizon, 1 April, 1867.

"MY DEAR SENSIER,—

"So to-day is the opening of the Exhibition, if the programme remains unchanged. I am not without emotion, you may be sure, when I think of it. It is an anxious moment for myself and for many others."

"Barbizon, 7 April.

"MY DEAR SENSIER,—

"I wish with all my heart that you could get over the uneasiness that oppressed you when you wrote. I think if you could only come here for a while, it would do you a great deal of good. The weather will be milder in a few days, and the air good to breathe. Many of the fruit-trees are only waiting for a little sun to open their flowers, and everywhere the silent life of the earth is making itself felt. In fact, there is a breath of resurrection in the air which ought to be as good for man as for plants. Try and manage this if you can. What you say about my pictures is a relief to my mind. But I am still waiting to see the definite character of the impression which they produce.

"How is it that I receive this invitation from the Director of Fine Arts? I have replied in the way you advised, and said that I could not accept because I lived so far from Paris. Tillot suggests that I should go and see him and talk over the question, and ask him not to present me. This bothers me very much, and nothing can ever induce me to change my habits. If I am too much pressed, I shall be obliged to send a formal refusal. I shall very soon come to Paris, and we can discuss the matter, and try to arrange it so as to meet the wishes of all parties.

"Diaz and Eugène are here. He says that people tell him that my pictures look very well. I invited them to dine with me to-day,

and they accepted. Diaz says that they are all coming here in May, with Détrimont and Marie. M. Gavet has not yet been to fetch his drawings, and so Diaz has seen them. He seemed much pleased, especially with the lamp-light study (*La Veillée*). If you see him, ask what he thinks of them. Your own letter, my dear Sensier, is very melancholy. Come here soon. We will talk over the vanished years together, for I too go back to them continually. As the prophet-king David said : '*Annos antiquos in mente habui.*' "

 " Barbizon, 23 April, 1867.
" MY DEAR SENSIER,—

 "What you tell me is, as you say, new and encouraging. But do not tire yourself too much, for interviews such as you have had with M. Silvestre do not always produce a calming effect. I place full confidence in your wisdom, and since you ask my advice, am very glad that you laid stress on the *rustic* side of my art, for to say the truth, if this side is not brought out in my work, I have failed. I reject with my whole might the democratic idea, as it is understood in the language of the clubs, which some persons have tried to impute to me. I have only tried to make people think of the man whose life is spent in toil, and who eats bread in the sweat of his brow. You can honestly say that I have never tried to defend any cause. But I am a peasant of peasants. As for any explanation of my method of painting, that would take a long time, for I have never paid much attention to this; and if I have a style of my own, it has only been the result of entering more or less fully into my subject, and knowing the difficulties of life by my own experience. If I come to Paris, as I probably shall on Thursday evening, could you ask M. Silvestre to come to your house one evening ? and we might talk this over together. Sometimes rather lengthy explanations are necessary to arrive at a very brief conclusion. If his article cannot wait for that, you must do the best you can without me."

The Exhibition had, in fact, proved a triumph both for Millet and Rousseau, who was elected President of the Jury, and received a Grand Medal of Honour. He was continually urging Millet to leave his work, put on his black coat and cravat, come to Paris, and see the Ex-

hibition. At length Millet obeyed his friend's summons, and came to Paris, where he met with a warm welcome, and was able to realize the extent of his success. He was awarded a first-class medal, but not the coveted Cross, which Rousseau stoutly maintained should have been his by right. Millet himself, however, was quite content, and on his return to Barbizon, he wrote to Sensier :

" 30 April, 1867.

" You may imagine that I am very much pleased to hear I have got a first-class medal. Rousseau had already written to tell me this. I did not go to the Ingres Exhibition after all ; when I left you, I found Silvestre with Rousseau, and as Rousseau was going out, I went back with Silvestre, who was anxious that I should revise his descriptions of my pictures. This was decidedly of use. With certain exceptions, his descriptions are on the whole good, but they always incline towards his particular bent. I tried, timidly and discreetly, to suggest some things as to the sense in which I should wish my works to be understood, but when it is a question of oneself, it sounds conceited, and one seems to be making a fuss about nothing. His idea of the peasant is rather like Proudhon's notions. One detail—of no importance for the public, and which has none except in my own head—is that, in describing the *Potato-planters*, he speaks of an old piece of sheepskin in the man's sabots. If I tried to indicate anything there, it must have been straw. In my country, a man who had lined his sabots with sheepskin would have been an object of scorn. I let this little mistake pass, as I did not dare to make any more corrections. What he read me, it is true, were only notes, and not the whole of his article."

Théophile Silvestre, the critic, who had been so profoundly impressed with Millet's pictures at the Exhibition, became from that time one of the master's stoutest defenders, and the articles which he devoted to his work are among the truest and most eloquent criticisms that have appeared in print. And if Millet himself, in his scrupulous regard for absolute truth, did not always

relish the language in which the writer expressed his admiration, he was grateful for the warmth of feeling which prompted his remarks. Early in June Silvestre sent him the articles on his pictures in the Exhibition, with a graceful little note, saying that however unworthy of their subject, they were at least the honest expression of a man who realized the truth and greatness of his art.

Millet was then on his way to Vichy, with his wife, who had been ordered to take the baths the second time. On the 13th of June he wrote to Sensier:

" The heat of yesterday was terrible. If it lasts, good-bye to my drawings! Never will I go into a hot country unless I am absolutely obliged! But we managed to take a little drive yesterday, and saw some wonderful things. It was a pity I could not work. The place we visited was called Malavaux—it is above Cusset. There are some exquisite subjects of every description. Only it is a long way off, too far to walk, and carriages are dear, 18 francs a day. But I shall go back there some day, when it is possible to work, for it is well worth the journey. I must also explore a place called l'Ardoisière, which seems to be very fine. What a drawback this heat is!"

In spite of the heat, however, Millet managed to make several sketches in this neighbourhood, and the names of the different localities are familiar to us from his drawings. The *Chapel of La Madeleine, near Cusset*, the *Farm on the Heights of l'Ardoisière* and the *Fields of Malavaux*, are among the water-colours of 1867. The hamlet of Cusset afterwards became the subject of an important picture.

On the 26th of June, he wrote to Rousseau about an Exhibition of his friend's smaller studies, which had been opened in the Rue de Choiseul, and which had impressed him deeply:

" My dear Rousseau,—

"Here we are again, renewing our acquaintance with this gay world of Vichy. I have put off writing, day after day, fearing it might humiliate you to hear of us from here, you who are only in Paris ! The day after I left you I went to see the Exhibition. And I must tell you that knowing, as I did, both your Auvergne studies and your earlier ones, when I saw them brought together, I was once more struck with the sense that power is power from the very beginning. From the first you show a freshness of vision that leaves no doubt of the joy which you find in nature. It is easy to see that she has spoken to you directly, and that you look upon her with your own eyes. *C'est de vous, et non de l'aultruy,* as Montaigne says. Do not think that I am going to follow your progress, picture by picture, down to the present time. I only wish to name the point from which you started, which is the important thing, for it shows that you are a man of the true race. You were, from the first, the little plant which was destined to become the great oak. There ! I felt I must tell you once more that I have watched your growth with emotion. . . . We wish you and Madame Rousseau the best possible health, and embrace you.

" Ever yours,
"J. F. Millet."

When Millet wrote this letter, he knew that his friend was ill and suffering. On his return home he found Rousseau in a melancholy state. His fits of excitement were followed by long periods of complete prostration, from which nothing could rouse him. His unhappy wife was out of her mind, but he refused to allow her to be removed and placed in charge of a doctor as his friends wished. Millet and his wife, filled with compassion for his forlorn condition, watched him tenderly, and spent the greater part of their days with him. For a week or two he seemed to get a little better.

"Rousseau," wrote Millet on the 12th of August, " continues to improve, although yesterday was not a very good day. To-day he is better, and the doctor is satisfied. I hope that he may

recover, even if it is but slowly. Alfred Stevens and Puvis de Chavannes came this morning to inform Rousseau that he has been made an Officer of the Legion of Honour. My wife and I received them on the stairs, and begged them not to come up, for fear of disturbing him. I told him the good news, and he seemed very much pleased."

A week or two later his doctors recommended a trip to Switzerland, in the hope that change and mountain air might arrest his malady. At first he refused to go, but Millet and his wife finally persuaded him to start, and themselves brought him to Paris. Here he had a paralytic seizure, and soon became too ill to go any further. His friends brought him back to Barbizon, and watched carefully over him during the sad weeks that followed. Millet came in regularly every evening to spend an hour or two with him, and the presence of this old friend seemed to cheer him more than anything else. But towards the end of September softening of the brain set in, and his condition became hopeless. In his lucid intervals he still talked of the pictures which he meant to paint, and one day he asked Sensier to send him some etchings. But on the 16th Millet wrote that it would be of no use to send them, for he was quite unable to look at them. All that week Millet and his wife remained at his bedside. They nursed him with the tenderest care, and sat up with him through the long and sleepless nights. Both of them were present when he died, on the 22nd of December. In his wanderings he spoke repeatedly of Millet's pictures. "You have been to Millet's house," he said; "what fine things you must have seen there! You were pleased, were you not? Ah! how beautiful they are!" A few minutes afterwards he passed away. That morning Millet sent the following telegram to announce the sad news to Sensier: "Rousseau died this morning at 9 o'clock.

Come." At the same time he sent the following notes to him and to their mutual friend, M. Feuardent:

"MY DEAR SENSIER,—

"I am all of a tremble, and feel quite unnerved. Our poor Rousseau died at nine o'clock this morning. His agony was very painful. He tried to speak several times, but his words were choked by the rattle in his throat. It is now half-past nine. Tell all those who ought to know. Tillot has sent a telegram to Besançon. I am also telling Silvestre."

"MY DEAR FRIEND,—

"Our poor Rousseau died at nine o'clock this morning. We knew, by what the doctor said, that the end could not be far off, but we are none the less dismayed and overcome. His burial is fixed for next Tuesday, at one o'clock punctually. Come, if you can. We all embrace you.

"J. F. MILLET."

Three days later he wrote to another friend:

"25 December, 1867.

"DEAR MONSIEUR CHASSAING,—

"My poor friend, Théodore Rousseau, has just died at Barbizon, in the house where we once went to see him together. His illness was softening of the brain. You can imagine how it grieved us to hear him talk of all that he would do in the future! For we knew, from the doctor, that his fate was sealed. He was conscious up to the last moment, and never dreamt that he was dying, unless it may have been quite at the end. But although I never left him, I saw no signs of this. He thought that his death-agony was only another seizure. Poor Rousseau! his work killed him. And to think, my dear M. Chassaing, what an innumerable number of miserable men and fools are in excellent health! This will explain why I have neglected you for so long, ever since we returned from Vichy, for, from that very moment, I have been completely taken up with my poor Rousseau, and have hardly been able to do any work."

The next letter begins with an allusion to a petition

X

which Millet and several of his friends had addressed to the Empress Eugénie, begging her to use her influence in preserving the picturesque part of the forest near Barbizon, known as the Bas Bréau, which the Administration had doomed to destruction. M. Silvestre had drawn up the petition at Millet's request, and forwarded it to him for his signature:

"Barbizon, 31 December, 1867.

"MY DEAR SENSIER,—

"I signed the petition to the Empress which Silvestre sent me. It seemed very well written. François [Millet's eldest son] is preparing a canvas upon which he intends to try and reproduce Rousseau's *Sunset*. Since you have, as I suppose, seen Tillot, he has no doubt given you all our news. The death of Rousseau haunts me still. I am so overcome with sadness and weariness that I can hardly work. But I must by some means or other try and conquer this feeling. Eight days have already passed since he was buried. Poor Rousseau! How does he feel in his cold bed?

"I have received a letter from M. Hartmann, saying that he has sent off three of Rousseau's pictures, although they have not as yet arrived. How do matters stand as to Rousseau's inheritance, and will the seals on the doors be soon taken off? Silvestre sends me a hastily-written note, to say that he has delivered my drawing to M. Piétri, who declared himself not only satisfied but amazed, and added some more very flattering expressions. The chief thing is that he should be satisfied. And so another year is gone where so many others have gone before! Which of us can tell if he will live to see the end of the next one? We wish you and yours everything that you may desire in the coming year."

M. Piétri was the head of the police in Paris, and Silvestre, who was anxious to introduce Millet to the Emperor's notice, hoped to effect this through him. Unfortunately nothing could be done without the help of Count Nieuwerkerke, the all-powerful Director of Fine Arts. This important personage was supposed to have

an invincible dislike for Millet, whether it was that he looked upon him as a republican agitator, or whether, as is more probable, he expected the artist to solicit his favour in person. This, as we have already seen, Millet could not be induced to do. He would not stoop to court the protection of the great, or go a single step out of his way to gain the minister's good offices. But at last the noise of his fame reached the Emperor's ears, and one day he asked Count Nieuwerkerke to let him see some of these peasant-pictures that were so much praised. The Director sent for Millet's pictures from the Salon, and brought them to the Tuileries. His Majesty was not particularly impressed with the sight. "Enough!" he said: "the noise about this painter of sabots is a vulgar one."

Millet himself was comparatively indifferent to the result of his friends' efforts. By this time he was independent of Court patronage. To bring up his family in comfort and record as many of his impressions as possible were henceforth his sole aims. But he was much more seriously concerned at the destruction of his favourite corner of the forest, which to his grief he witnessed that winter.

"Yes, my poor Berger," he wrote to a friend in Paris, "they are cutting down part of the forest, in the Bas Bréau. The Administration insists, and must be obeyed. For some distance around nothing is to be heard but the blows of the axe and the noise of falling trees."

In the same letter, which was originally published by M. André Michel in the *Gazette des Beaux-Arts*, 1887, he speaks of his dislike for Paris and town life—a feeling which grew upon him more every year of his life.

"It is always a great effort for me to go to Paris. I far prefer the walks that I take, when my day's work is done, in the forest or

on the plain, than those which one is forced to make on your asphalt or your macadam. I had rather see the peasants—men and women—at work on the plain watching their sheep or cows, or the wood-cutters in the forest (alas! only too many are to be seen there now!) than all the pomade-washed heads of your clerks and city folk!"

During that winter, Millet was engaged in winding up poor Rousseau's affairs. He took charge of his friend's unhappy wife, now an incurable lunatic, and helped Sensier look over the dead man's papers and dispose of his pictures. Finally, he reared a monument over Rousseau's grave, in the new cemetery at Chailly, such as the painter himself would have chosen. Rocks were brought from the forest, and young trees were planted among them. A simple wooden cross was placed at the head of the grave, and as long as Millet lived the enclosure was kept bright with flowers.

"I have had a fine young oak brought there with the rocks from the forest," he wrote to Sensier on the 20th of March, "which is likely to flourish and spread its boughs out well. The holly must be planted after the stones are set in their place, for it would be in the way before that, and might be injured by the work."

So he paid the last offices to this friend whom he had loved so long, and whose well-earned rest he was half inclined to envy.

"Let us talk of our dear dead together," he said to Sensier. "But be well assured that they have reached a place of refreshment, of light and peace."

But his own health suffered severely from the shock, and those who knew him best said that he was never the same again after Rousseau's death. His headaches became worse than ever that winter. He wrote few letters, and could only work at intervals; but he commenced several pictures for Rousseau's friend, the Münster

manufacturer, M. Frédéric Hartmann. On the 17th of April he wrote to Sensier:

" My headaches have been so bad that till to-day I have not had the courage to send you the measurements for M. Hartmann's pictures. Here they are: four canvases, measuring 1 metre 10 by o m. 85. Three of these are to be of a dark shade of pinkish lilac. The other, yellow ochre. Please send them as soon as possible."

A month later, Sensier wrote to tell him of M. Marmontel's sale, in which his *Washerwoman*, a small picture which has been repeatedly engraved, sold for 4,000 francs, and his *End of the Village of Gréville* for 4,900 francs. He replied on the 14th of May:

"I should certainly have liked my *Village* to have fetched a better price, but I am satisfied with that of the *Washerwoman.* You must tell me the price of the Diaz, Duprés, Fromentins and Daubignys. If you can find time, please urge Blanchet to send my canvases, for I am anxious to set to work at M. Hartmann's *Spring.*"

The return of spring, and the sight of opening leaves and flowers, had once more stirred fresh life in him. He set to work on this picture of the favourite meadow at the back of his house, and painted the rainbow spanning the storm-clouds behind the flowering apple-trees. But he soon had to lay down his brush and take his wife to Vichy to complete her cure. Here the country seemed to him as before, full of interest and beauty, but he was too unwell to work, and made very few sketches.

"Vichy, 3 July, 1868.

"MY DEAR SENSIER,—

"The children will have told you that we were rather vexed to find our old rooms taken when we arrived here. My headaches have been incessant, and as yet I have not been able to work. I am in despair at having done nothing, and it is already more than a week since we left home. We have taken two drives, and seen

some beautiful things. The country round Cusset is superb. If I had not been so suffering, I would have told you my impressions of this part of the country, as well as of the people at the Baths. If my brain can retain them, I will let you have them some day. I can only give Burty the date of my birth, October 4. It is impossible for me to say the exact date of my arrival in Paris. But I think it must have been early in 1837. I can remember certain facts of that troubled period which have survived the lapse of years, but the dates have absolutely vanished from my mind."

<div style="text-align:right">"Vichy, 18 July, 1868.</div>

"MY DEAR SENSIER,—

"We took two or three drives during our first days here. We paid another visit to the Château of Busset-Bourbon. The house has still a character of its own, although it has been a good deal restored. But the beautiful thing is the situation. What primitive and melancholy landscapes one sees in those parts! I hope to go back there, and perhaps even spend a day at the place, so as to make as many sketches as possible. But who can tell what may happen? How well those people knew how to choose the site of their houses! I must tell you about it all when I come home."

<div style="text-align:right">"Barbizon, 24 July, 1868.</div>

"MY DEAR SENSIER,—

"We got back to Barbizon on the evening of the day before yesterday, rather tired by the fearful heat in the railway and the immense amount of dust we had to swallow. I am in despair at the time I have wasted. I have brought back so little that it is hardly worth talking about. But I believe that certain things have sunk into my soul, which I will try to put down while they are still fresh in my mind."

That year Millet sent nothing to the Salon; but when the medals were distributed at the close of the Exhibition, he was made a Knight of the Legion of Honour. The ceremony took place in the great hall of the Louvre; and when the Maréchal Vaillant, the new Minister of Fine Arts, read out the name of Millet, there was so loud and unexpected an outburst of applause that the

venerable President lost his presence of mind, and was
unable to go on with his speech. That day was a signal
triumph for the peasant-painter, and its memory lived
long in the hearts of his friends. But Millet himself
recked little of imperial rewards or popular applause.
He worked on silently at home, content if he was only
well enough to paint. In September he took a week's
holiday, and, after visiting M. Hartmann in Alsace,
went on with Sensier to Switzerland. They saw the
museum and the cathedral at Bâle, and visited Lucerne,
Berne, and Zurich. But the weather was bad, the rain
fell in torrents, and Millet was homesick. " I am long-
ing to be back at Barbizon," he wrote to his wife; and
the next day he says, " The *mal du pays* continues, and
I must return."

Still this little journey seems to have done his health
good, and M. Hartmann wrote to Sensier on the 29th of
October:

" I am glad to hear that Millet's health is better. I heard with
concern of his recent troubles. We will take great care of him
here if he ever pays us another visit."

His letters throughout the autumn were few and far
between, and the troubles of which M. Hartmann speaks
were probably caused by illness in his family. Four
short notes are all that M. Mantz could find belonging
to this period. The first two relate to a volume, entitled
Sonnets and Etchings, which was published that winter
by M. Lemerre. M. Burty was the editor, and at his
request Millet was asked to contribute a plate. At the
same time M. Albert Mérat composed a sonnet on a
drawing which the artist had made for M. Gavet re-
presenting two young peasant-girls watching a flight
of birds across the sky. Millet had meanwhile made an
etching of an Auvergne peasant-woman spinning and

watching her goats, and was surprised to find that his drawing had been expected to correspond with the poet's verses.

"Barbizon, 8 November, 1868.

"My dear Sensier,—

"M. Albert Mérat has sent me his sonnet in print. He imagines that I have made, or am going to make, an etching on the same subject. I must tell him that this is not the case, and inform him of what I am really doing. His letter is very amiable. I am working at my etching, and the copper is half finished. If my headaches are not too bad, you will find it ready by St. Martin's Day."

"Barbizon, November 11.

"My dear Sensier,—

"I start at two o'clock to-day to go to Paris and have my etching printed. If I do not see you to-night, I will see you to-morrow morning before I go to Burty's house."

"Barbizon, 23 December.

"My dear Sensier,—

"Yesterday the service for the anniversary of Rousseau's burial was held at Chailly. Of course, the Tillots and all of us were there. Of artists, only Lainé and Lombard were present. From Paris, no one. After the service in church we all went to the churchyard. I forgot to say that the eldest of Bodmer's sons and Babcock were also present."

The last day of the year had come round once more, and, constant to his practice, Millet wrote a few lines to Sensier on the 31st of December:

"So another year will be ended to-night. I am not going to moralize on the subject. I will only tell you that I write at the close of the day, and that I am recalling old memories, and think-ing of those who are gone. O sad thoughts ! We wish you and yours the fewest possible troubles, and the most complete fulfil-ment of your desires. And, young and old, we all of us embrace you."

XVIII

1869–1871

THE book of *Sonnets and Etchings* proved a source of great annoyance to Millet. When 350 copies had been printed, Lemerre's plan was to destroy the plates, so that no further proofs could be published. Forty-one of the contributors—among whom were Corot, Jacquemart, Daubigny, Bracquemement, Ribot, and Seymour-Haden—had consented to this. Millet alone objected being unable to see why a work of art should be doomed to destruction in order to raise the price and increase the rarity of the publication; but since the other artists had agreed, and he did not wish to be treated with exceptional favour, he consented in the end. The whole thing, however, was sorely against his will, as we learn from the following letters:

"Barbizon, 9 January, 1869.

"My dear Sensier,—

"The publisher Lemerre first wrote to me about the destruction of my plate. I did not reply. Then Burty wrote in his turn, and gave a whole pile of reasons, good and bad, in order to make me consent to the proposed destruction. As I do not wish to ask favours, or to be treated differently from others, I wrote to Burty, three days ago, begging him to treat my plate exactly as they treated the rest. It seemed to me that they might raise endless difficulties if I took any other course, and it was better to have done with them."

"15 January.

"I have received the book of Sonnets. My etching comes out very badly."

"24 January, 1869.

"As I told you, I have consented to the destruction of my plate in spite of my desire to preserve it. Between ourselves, I think this destruction of plates is the most brutal and barbarous thing possible. I do not know enough about trade to understand its object, but I reflect that if Rembrandt or Ostade had each made one of these plates they would all the same have been destroyed. Enough of the subject, however!"

The death of Rousseau's unhappy wife, in February, 1869, renewed Millet's sadness, and recalled many tender memories of the past. On the 16th he wrote to Sensier:

"The terrible death of poor Madame Rousseau has made us very sad. It has stirred up many thoughts of old days in my mind. This poor creature has been hardly used by the course of events. I cannot think without emotion what care she used to take of me when I was ill. God knows I only remember now the good that she has done me! I pray for the peace of her poor soul. You will know that I am very unwell if you do not see me at Charenton to-morrow."

"Barbizon, 17 February, 1869.

"DEAR MADAME FEUARDENT,—

"Sensier will no doubt have informed you of poor Madame Rousseau's death. Naturally I meant to attend her funeral to-day, but a bad headache prevented me from starting as I had intended. I am quite distressed at this. I did not wish to seem indifferent to the disappearance of this poor fragment of Rousseau."

Sensier sent him a portfolio of Japanese prints to look at, in the hope of diverting his thoughts; but, much as he admired some of the Japanese work, these examples did not appeal to him.

"I agree with you," he wrote on the 25th of February, "in thinking the album which you have sent me very rich and splendid in the arrangement of colours, but that is about all that pleases me. I do not see that fidelity to nature and humanity which, as a rule, lies at the root of all Japanese art. It is a rare and curious

object rather than anything else, and I should prefer to spend my money in buying some more natural Japanese drawings (if you should happen to see any), or some fifteenth-century woodcuts. It is impossible for me to send anything to Bordeaux. I am working with all the strength I have left to finish my *Knitting Lesson* in time for the Salon. If I cannot bring it up to a certain point, I shall not send it, you may be quite sure. I fancy this picture has improved since you saw it."

<div align="right">" 10 March.</div>

"I forgot to tell you that I have received an important order for the Museum of Montpellier, through M. Bruyas. Nothing is yet settled, for M. Bruyas asked Silvestre to find out if I would undertake it, and I am waiting to see him before I settle the terms of the commission. I will copy the passage from M. Bruyas' letter which Silvestre quotes. It sounds very formal. . . . I am sending to see if there are any flowers on Rousseau's grave. I hope to have finished my picture by the 20th. Some days I am very much discontented with it, others I am less so. To-day I think it is tolerable."

Five days afterwards he wrote:

"My picture seems to me empty and insignificant."

Fortunately the critics thought differently; and when this picture of the peasant-mother teaching her little girl to knit appeared at the Salon, it was hailed as one of the best of Millet's domestic subjects—a true poem of the peasant-hearth.

We hear little of Millet's private affairs at this time. The daily struggle for bread, which at one time occupied so large a part of his thoughts, was over; his daily needs were no longer pressing. We find no urgent requests for money, and hear no more of that terrible end of the month which at one period seemed to be always coming round. He had as many orders as he could execute, and was fairly paid for his work. Madame Millet had recovered her health. The children were

growing up. His son François had become an artist, and was working hard at his profession. He shared his father's *atelier*, and was his constant and devoted companion. The two eldest daughters were already married. Marie had become the wife of a son of Millet's old friend, M. Feuardent—the young clerk who used to lend him books at Cherbourg long ago, and who, in the prosperity of his later years, had never lost sight of this comrade of his early youth. Louise had married M. Gilbert Saignier, and, like her sister, lived in the more immediate neighbourhood of Paris, but was often at Barbizon. The old home was a bright and cheerful place, gay with the presence of children and grandchildren, and of the guests who were always coming and going. It was a peaceful, happy time, only darkened by Millet's own ill-health, and those constant headaches which interrupted his work and threw a gloom over the whole household. But he still executed new drawings for M. Gavet, and spent the first months of 1870 in working at two pictures for the next Salon. One of these was the large autumn landscape, called *November*, in which the painter-poet gave utterance to the sad and solemn thoughts that haunted him at the close of the year. The other was *La Grande Baratteuse*—the picture of a handsome young *fermière*, with bare arms, churning butter by hand in the primitive fashion of Gréville. She is represented wearing the white cap, the long apron and sabots of the Norman peasant. The massive beams of the oaken roof, the pots and pans along the shelves of the dairy, are all exactly reproduced. Even the cat is there, pressing up against his mistress, evidently on the look-out for any drop of cream which may chance to fall on the dairy floor. The picture itself is now at New York, but has been excellently reproduced in many different forms. One fine version in pastel is now in the Luxembourg; another

belongs to Mr. J. S. Forbes, and was lately exhibited at the Grafton Gallery. During this winter Sensier was engaged in writing his *Souvenirs sur Théodore Rousseau*, which appeared in monthly instalments in the *Revue Internationale des Arts* in the course of 1869 and 1870, and were afterwards published in a separate volume. Millet helped him in preparing the work, and was able to supply much valuable information. A letter which he wrote to Sensier on the critic Thoré, and the discussions which he used to have with him and Rousseau twenty years before, is a striking instance of his powers of memory.

"Barbizon, 1 February, 1870.

"My dear Sensier,—

"It would be hardly possible to sum up our conversations with Thoré in a few words. I will tell you more than you want to know, and if you find anything I have said is of use, you can pick it out for yourself. Thoré, whom I had never met before, seemed to me to look at art like a learned catalogue-writer, rather than a man touched by the meaning of a work of art, even when he spoke of Rembrandt, which was his especial subject. He would say of a picture: That was painted in such a year, in such a medium; and tell us how certain masters signed themselves, up to a certain date, or explain that Hemling was no longer called Memling—a highly important discovery made, he informed us, by the learned X——. Rousseau used to whisper to me: 'He is not Thoré any longer! the wise men have quite spoilt him!' It irritated Rousseau to see Thoré look at his pictures and say: 'This one is painted in the same style as Rembrandt,' and then proceed to explain his reasons. Rousseau thought that his pictures might have suggested some more interesting remark! In the end we had a very animated discussion with Thoré on his theory, that the elevation of a work must depend entirely upon the nature of the subject. Here, Rousseau and I were both against him. I let Rousseau talk, as he was quite strong enough to defend himself, and I did not know Thoré well, but eventually I was dragged into the fray. I tried to show Thoré that greatness consisted in

the artist's thought, and that everything became great when it was
employed for a great object.

"A prophet comes to threaten a people with plagues and terrible
desolation, and God speaks in this way by his mouth : 'The locust
and the caterpillar, my great army that I sent among you,' etc.
And the prophet gives such a description of their ravages that it
is impossible to imagine a scene of greater desolation. I asked
him if the threat would have seemed more terrible if instead of
locusts the prophet had spoken of kings and chariots of war. He
goes on to show how great and complete is the devastation—nothing
is spared. 'The field is wasted, the land mourneth ; be ye ashamed,
O ye husbandmen; howl, O ye vine-dressers, because the harvest
of the field is perished ! And the wild asses and all the beasts
of the field cry out, for there is no more grass.' There the fulness
of desolation is realized, and the imagination is at once impressed.
I know not if he was convinced, but at least he was silenced.
You saw him, however, on his return to Paris, and may remember
what he said to you. I always thought he was a little provoked
when he left us.

"Here is the thaw. As soon as it is possible, I will see that
your trees are planted."

On the 16th of March he wrote again, before the Salon
opened :

"MY DEAR SENSIER,—

"Be so kind as to find out the dates of the medals, etc.,
which I have received, by the catalogue of last year's Salon, as I
must mention this, when I send in my pictures to the Palais de
l'Industrie. I have no Salon catalogue by me, and do not know
where to find the information for which I ask, and I shall probably
only arrive in Paris at the last moment. My pictures are in the
atelier of De Knyff, since he insisted on having them placed there.
I am not sorry to see them in a larger studio than my own. They
look best at some distance, but then the light *there* is good, and
in the Exhibition it is detestable. If you do not know it already,
I must tell you that De Knyff has bought my *Woman Churning.*"

A week later the jury of the Salon was elected, and
Millet, to his surprise, found his own name fourth on the

list. So the man, whose own pictures had been so often rejected, became himself a member of the jury, and took his seat among the judges. His own pictures at the Salon that year were generally commended, especially the *Baratteuse*. But he spent little time in Paris, and was busy putting the last touches to two works which had been for some time in his *atelier* at Barbizon. The first, *La Fileuse*—a young peasant-woman sitting at her spinning-wheel in her cottage home—was one of those charming little pictures of domestic interiors in which Millet excelled, and which he had painted, as he said, with the sound of the spinning-wheels of his home still in his ears. The other was an altogether new and original subject—*Les Tueurs de Cochons*. At first sight the theme hardly seemed to lend itself to pictorial representation. Two peasants, in blue hose and sabots, are seen trying with all their might to drag a large hog from its stye. Their efforts are assisted, on the one hand, by a young woman who tries to tempt the pig with a bucket of green stuff, while on the other, an old man, armed with a large knife, leans his whole weight against the refractory animal. The different actors in the scene are brought before us, and their various sensations are realized in a masterly way. The sullen obstinacy and despair of the poor brute, who, conscious, as it were, of the fate awaiting him, plants his feet firmly in the ground and refuses to stir, the half-frightened, half-amused look of the small child behind, the very attitude of the family cat, arching his back and hissing as he surveys the scene from the top of the wall, all help to make us feel the tragic nature of the incident. Even the leafless trees, at the back of the courtyard, and the leaden hues of the winter sky overhead seem to heighten its solemn meaning.

An old friend of Millet's early Barbizon days, the

American artist, Edward Wheelwright, has told us how, in the summer of 1870, he came back to Paris with his wife, and brought her to see the famous village and its yet more famous painter. One day in June, they knocked at the door of Millet's *atelier*. It was opened by the master himself, who welcomed his old friend cordially and invited him and his wife to come in. The place looked just the same as when Wheelwright had left Barbizon fourteen years before. The only difference he noticed was that Millet's books had greatly increased in numbers, and lay piled up together upon the floor. And Millet himself was hardly changed in appearance. He had grown a little stouter, and there were a few more silver threads in his hair and beard, but his face and expression had not altered in the least, and he wore the same loose jersey and sabots in which his friend had seen him last. The picture of *Les Tueurs de Cochons* stood on the easel. Millet was working at it when his visitors arrived, and trying to deepen the shadows and bring out the rich tones of red in the picture. His guests were much impressed by the power and reality of the group, and the artist's wife spoke of the deep pathos of the subject. "Madame," replied Millet, "c'est un drame."

Before the picture was finished, war had broken out between France and Germany, and the peace of Millet's home at Barbizon was rudely disturbed. The terrible events of that summer-time were felt in every household. Both of Millet's newly-married daughters saw their husbands go out to fight for their country, and Sensier was sent to Tours and afterwards to Bordeaux, by order of the Minister of the Interior. When the enemies marched on Paris, Millet felt that Barbizon was no longer a safe place for his family. On the 27th of August, a few days before the catastrophe of Sedan, he left home with his wife and children, and all the pictures that he

could carry with him. They moved to Cherbourg, where M. Feuardent, his son-in-law's father, having taken refuge in England himself, lent them the use of his house. Here they remained for nearly a whole year, while the tide of war rolled over the land. Millet was deeply moved by the national disasters and the sorrows of his own friends, and for some time he was too much agitated to be able to work. By degrees, however, he recovered his calmness of mind, and began to paint the sea and boats, from a window on the third floor overlooking the coast. The sight of the old country had stirred his love for these scenes of his boyhood. He gazed with passionate yearning on the wide sea and vast horizon which had filled his young heart with longing, and felt nearer to the infinite.

The letters which he wrote to Sensier at Tours and Bordeaux, and to Feuardent in London, at this time, are strangely pathetic, both in their lamentations over the woes of his unhappy land, and in the tender love which they breathe for every corner of his old home:

"Cherbourg, 22 September, 1870.
"My dear Sensier,—
"I have only to-day received your letter of the 17th. I am glad to know you are at Tours and not in Paris. We are well in health, but full of anxieties. . . . All correspondence seems to be interrupted. Alas! how long is this to last! And when we hear news, what will it be? Our heads and hearts alike seem fixed in a vice. Here the Prussians are daily expected to invade us. Every one is arming, but Cherbourg, however formidably defended on the side of the sea, is not fortified by land. It is said the Cotentin is to be flooded. . . . It is absolutely impossible for me to draw a single pencil line out of doors. I should be strangled or shot on the spot. One day I was arrested, dragged before a military tribunal, and only released after application had been made to the mayor for information about me, and then not without a caution never to hold, or even pretend to hold, a pencil in future."

Y

To M. Feuardent:

"Cherbourg, 4 October, 1870.

"MY POOR FRIEND,—

"Here we are, encamped in your house of the Rue Hervieu. If the horrible reason of our presence here could be removed, we should not be unhappy in our present quarters. How the tempest of affliction has scattered and divided us all, my poor friend! We must put a bridle upon our lips, not to give way to idle complainings, for really it is necessary to do violence to our feelings if we are not to be in a perpetual state of lamentation. And to think that the authors of all our miseries are not even touched by them, and continue to enjoy all the luxuries of life as if nothing had happened! Ah! indeed, they deserve the curses of France!

"I have done very little since we came here. My poor head is tormented with anxiety and sadness. What would certainly have stirred me up to work are the things which I cannot help seeing whenever I go out, either in the country or on the seashore. But, just imagine, I should be immediately seized and probably torn in pieces, if I were seen with merely a note-book and a pencil. Even without a note-book, and with only my walking stick in my hand, I have been stopped and questioned half-a-dozen times, in the sternest way. Every one is in the greatest state of terror. There is far more alarm than resolution. . . . But to come back to my work. I have three little sea pictures in progress, which I work at on the third floor, where the light is good, as long as one window is stopped up. Really our old country is beautiful, and every day I feel the more how great a pleasure it would be to see it again in any other circumstances! But really, when I forget myself a little, and begin to take pleasure in the sight of these things, I feel that I am selfish and begin to hate myself! The Barye family are here, and also the Silvestres. . . . My poor friends, we embrace you with open arms.

"Ever yours,

"J. F. MILLET."

"Cherbourg, January 9, 1871.

"MY DEAR SENSIER,—

"You cannot imagine the joy with which I received your letter. I thought that you must be at Bordeaux. . . . When?

ah! when shall we ever get out of this horrible condition? Ah! how I hate everything German! I am in a continual ferment. Curses and ruin upon them all! I feel that my strength is exhausted, but with what little I have left I wish that neither you nor yours may be too rudely shaken by this fearful blow. Death is reaping a fine harvest! The past year and the coming one have been two fruitful seasons!"

"Cherbourg, 27 February, 1871.

" My dear Sensier,—

"We have just received a telegram with the news of peace, which you, of course, know already. We have not yet heard the conditions, and our ignorance, alas! helps us to imagine that they are sweet and gentle! At least we may be thankful to think that Barbizon and our houses there have escaped ruin. I dare not think of the German entry into Paris, nor of all they will do there. When will our poor Paris recover its usual aspect? for we have still good reason to fear the action of the different parties in the State. Nothing, we know, stops them, and they try to get on by making use of the people's miserable condition. Oh! horrible wickedness!

"I have not been able to work much since we have been here, partly owing to my bad health and the trouble in my head; partly because I could not make the smallest sketch, for fear of being torn in pieces as a Prussian! I do not imagine this will last long, and hope that soon I may be able to draw a little. What beautiful things there are to do, if my thoughts were not so distracted! I have lately sent two pictures to Durand-Ruel, one big and one little. We embrace you all very heartily."

The art critic, Silvestre, who was also at Cherbourg, has left us a description of one of these pictures, which were sent by Millet to London, where M. Durand-Ruel, the dealer, had taken refuge, carrying with him the *Angelus* and a number of the finest works of the Barbizon painters. The following letter, which he addressed to Millet's old Gréville friend, Doctor Asselin, gives us an interesting glimpse of the great master and his family in their tem-

porary home, and describes the picture of the sea and rocks of Gruchy which he had painted after a two-days' visit to his old home.

"Cherbourg, 25 February, 1871.

"DEAR M. ASSELIN,—

"You will have found Millet at table with his wife, his nine children and his two sons-in-law (who have lately returned from the defence of Paris)—a patriarchal gathering for this year 1871, and in these days of shame, of ruin and massacre. I am sorry you were not with our dear great master two days earlier. You would have been struck by the sea-pictures which he has just sent to London. Would you like to know the subject, or at least hear the impression which it produced upon me? It is an intense and vivid recollection of the cliffs of Gruchy, near the Castel (a well-known promontory of rocks on the Gréville coast), with the sea, the wide sea as it is seen from the top of the towering rocks in its calm and infinite extent, under a far-reaching horizon bathed in misty sunlight. . . . The loneliness of earth, sky and sea so rendered the more striking by the presence of a few living creatures. Sailing boats lost in the dim sea-fog, sea-gulls screaming and circling in the air, sheep wandering over the desolate pastures,—these solitary figures are all that speak to us of life in the vast, Ossian-like landscape. . . . This poetic picture, this great canticle of praise, as powerful as it is original and yet bound by spiritual affinity to all that is beautiful in the Bible, in Dante and Michelangelo, ought to be called a psalm of earth, sea and sky. Millet has reached the height of his career and has shown us how the sublime is to be found in the simplest and commonest subjects. The more he simplifies this theme, the more deeply he moves us. From the top of the cliffs of Gruchy, what flights he takes! *Qui dat pennas?*

"Ever yours,
"TH. SILVESTRE."

"Cherbourg, 16 March, 1871.

"It would be impossible, my dear Sensier, to tell you the moment of our return to Barbizon. I should not be surprised if we were to remain here for part of the summer. The absolute impossibility of doing anything from nature hitherto, and the sight of so many

beautiful things which I may never see again, and which are very precious when they are noted down, all this I feel compel me to remain here. On the other hand Paris is not likely to trouble its head at present about works of art. As my whole household is here, I will at least try that this ill wind which blew me here shall be of some good, and imitate the children who make use of a fall to pick up something on the ground."

While Millet lingered on in his beloved Normandy, he little dreamt that a new revolution had broken out in Paris, and that the horror of the coming weeks would overshadow all the past horrors of that terrible year. The news of the Communist revolt filled his mind with fresh dismay, and on the 9th of April he wrote to Sensier:

"We are glad to hear that you are at Barbizon. What a terrible mess we are in ! What is going to happen to us? I will not even talk of it, for it seems to me that all the powers of hell have been let loose. . . . My dear Sensier, take as much pleasure as you can in nature, for she at least endures. For my part I try as far as possible, but not as much as I should like, to divert my thoughts from all these horrors which I cannot prevent, and throw myself into my work. Happily Durand-Ruel asks me for pictures, but as yet I have not been able to send him many. I am working at one which I hope to finish as soon as possible, and at the same time, to the best of my ability. This country is really very moving and retains much of its old character. If you shut your eyes to a few modern innovations, you might fancy yourself in the days of Breughel. Many of the villages remind me of old tapestries. These lovely velvet meadows! What a pity the cows cannot paint ! "

Amidst all the tales of horror and bloodshed which filled the newspapers during those spring days, Millet was surprised to read in *La France* that a group of Paris artists, who had banded themselves together in the cause of anarchy, had enrolled his name in their list, and

blazoned it upon the standard which they raised. He wrote at once to several papers, saying that he totally declined the honour which had been done him without his knowledge or sanction.

<div style="text-align: right;">"Cherbourg, 25 April.</div>

"SIR,—

"The number of the journal, *La France*, for Sunday, the 23rd of this month, informs me that I have been named a member of an association of artists, styling itself *La Fédération des Artistes de Paris.* I refuse the honour which has been offered me. I shall be obliged if you will kindly insert this note in your paper, and accept my best thanks and compliments.

<div style="text-align: right;">"J. F. MILLET."</div>

At the same time he wrote to Sensier on the 2nd ot May:

"Is not all that is going on in Paris too miserable? Did you see that I was elected a member of the *Fédération des Artistes*? What do they take me for? I have replied: 'I do not accept the honour which has been offered me.' What a set of wretches they all are! Courbet, of course, is their President. Our age may well be called the time of the great slaughter. We might cry with the prophet, 'O sword of the Lord, wilt thou never rest?' I have not courage to speak of the spring, which returns all the same in the midst of these horrible events."

On the 27th of May, the day after the destruction of the Tuileries and Hôtel de Ville and massacre of the Archbishop, he wrote with a breaking heart:

"MY DEAR SENSIER,—

"Is it not awful to think what these wretches have made of Paris! These enormities are without all precedent. The Vandals were public benefactors by the side of these men. They, at least, only sacked the cities of their enemies. Poor Delacroix, who was so anxious to decorate the public buildings! What would he have said?"

"Cherbourg, 20 June, 1871.

" MY DEAR SENSIER,—

"We have been spending two days at Gréville, where we had not yet been all together. I had been there for two days, all alone, in November, but not since then. It filled me with deep and sad emotion to come back as a stranger to the house where I was born, and where my parents lived and died. When I look at that poor house, my heart seems as if it would burst. Oh, what thoughts it recalls! I also walked through the fields, where I used to work. Where are those who worked there with me? Where are the dear eyes that gazed with me over the boundless seas? To-day these fields belong to strangers, who have the right to ask what I am doing there, and, if they choose, can turn me out. I am full of sad and melancholy thoughts, my poor friend. I can think of nothing else just now. All this takes hold of me and oppresses me."

But sad as were the memories which the sight of Gréville stirred in the painter's heart, the place had for him an irresistible attraction, and a few weeks later he moved with his whole family to the village inn, close to the church at Gréville. On the 12th of August he wrote to Sensier:

"We have been for some time past at the inn of Gréville. I am going to accomplish, at length, what has long been my wish, and make a picture of some part of the coast near my home. I am taking sketches for this purpose. During the first part of our stay here, I was much hindered by the rain and wind; now I am equally troubled by the great heat and the glare of the sun, which make my eyes painful. If the wind which interfered with my work at first had only blown from the north, it would have supplied the effect that I want for my picture, but we have always had these south-west winds, which, blowing off the land, meet the tide and prevent the waves from rising. And lately the wind has kept in that quarter with amazing persistence. But I hope it will soon consent to go round to the north, were it only for a few minutes, and that will suffice to recall the effect which I have so often seen, and know so well. Oh, how I wish, my dear Sensier, that you could see my

native place with me! I fancy this country would please you in
many ways, and that you would understand how it is that I grow
more and more attached to it. No doubt I have reasons to love
the place which other people cannot have—the memory of my
parents and of my youth ; but I think that its natural beauty alone
would be sufficient to attract any man who is open to these im-
pressions. Oh, once more, how truly I belong to my native soil !"

When Sensier received this letter, he himself was very
sad and weary. He had lost many of his friends, and
had suffered much in the war. The thought of seeing Millet
again, and visiting the painter's native village with him,
was full of consolation. " In these sad times," he wrote,
" when all seems crumbling into ruin around us, we will
find comfort in meeting and speaking of our dear dead."
In September he wrote the concluding pages of his book
on Rousseau, and dedicated it in affectionate terms to
Millet. On the 3rd of October, he arrived at Cherbourg,
and accompanied Millet to Gréville. Together they
visited the church of Gréville and the hamlet of Gruchy.
Millet showed his friend the graves of his parents and
grandmother under the tall poplars of the little church-
yard, and the house and garden of the old home. Tears
stood in his eyes as, step by step, he pointed out each
familiar scene, and Sensier felt as if he were walking in
the midst of Millet's pictures. After that, they made
expeditions in the neighbourhood, and visited Eculleville
and the valley of Sabine, the priory of Vauville, and the
Hameau Cousin, which afterwards became the subjects of
some of Millet's last works. At the end of ten days, Sensier
went back to Barbizon, and his friends prepared to follow
him in the course of another fortnight. Two notes were
written by Millet from Cherbourg, where he and his
family spent a short time on their way to Paris.

On the 26th of October, he condoles with Sensier on
the death of another friend, the artist and writer, Joly

Grangedor. "How busy death is! I did not know poor Grangedor much, but he seemed to me a very sympathetic man. I have always heard you speak of him as a good fellow, and Barye used to say the same." On the 5th of November, he announces his speedy return:

" MY DEAR SENSIER,—

"We intend to leave here on Tuesday evening at 5.20. If the train is not late, we ought to be in Paris by Wednesday morning, at four or five, and hope to reach Barbizon in the course of the morning. *Au revoir* then very soon, my dear Sensier."

And so, for the last time, Millet left his beloved Normandy. He took away with him a store of valuable notes and sketches, which supplied him with material for the works of the next three years, and was not exhausted at the time of his death. He had renewed acquaintance with many old friends, and left a pleasant memory behind him. Madame Polidor, the wife of the landlord at Gréville, still points out the window where he sat to paint the church, and laughs when she remembers the straits to which she was reduced in her endeavours to find room for the large family of children in her small house. "But they were all very happy," she adds, "and we should like to have kept them always."

The kindness which he and his wife had shown to their poorer neighbours was fondly remembered, and there was one old woman in particular, who never failed to pray for their return.

When Millet left Gréville, it was his firm intention to come back there with his family another summer. But work and illness interfered with these plans, and he never saw the fields of his home again.

XIX

1871–1874

ON the 7th of November, 1871, Millet returned to
Barbizon. The house and *atelier* had been hastily
dismantled twelve months before, when the German in-
vaders were hourly expected, and he came back to find
everything in confusion. Some of his pictures had been
taken to Cherbourg, others were rolled up and stowed
away in cupboards or garrets. By degrees, however, he
succeeded in reducing this chaos to order and began to
work at his Gréville subjects. Some of these are men-
tioned in his letters to Sensier:

"Barbizon, 1 December, 1871.

"I have hunted all through my big oak chest, without being
able to find Madame Sensier's little portrait. Everything has
been turned so completely upside down, that it will be impos-
sible to find anything, without examining its contents one by
one. I am going to spend my evenings in reducing this chaos
to some kind of order. I shall be glad to have the frame for
my *Cliffs of Gruchy* as soon as possible. I have not yet dared
to unpack my pictures. I am going to attack the *Old House of
Nacqueville.*"

"Barbizon, 12 December.

"My dear Sensier,—

"I have at last found the little drawing of Madame Sensier.
It had been placed between the leaves of a note-book, which
made it difficult to find. If you see Détrimont, tell him that I
am working at his *Little Shepherd*. Only the days are so short

and dark, it is hardly possible to see, and accordingly I do very little work. I have just received a letter from Beugniet, in which he asks me to send something to a sale, which takes place next January, for the benefit of Anastase, who has become blind. Have you heard of it? One of the pictures which I am doing for Brame is in a tolerably forward state. It is neither the church of Gréville, nor yet the Lieu-Bailly, but a subject which I find in a little valley near Cherbourg. I am beginning the *Old House of Nacqueville*; the effect will, I think, be pretty good. I cannot work at my *Cliffs of Gruchy* until I get the frame which you ordered from Durand-Ruel. I have no wish to send anything to the Exhibition at Nantes—no wish, I repeat whatever, and shall be sorry if any of my pictures are shown there. Did I tell you that the Director of the Museum of Lille wrote to inform me that one of my works, *La Becquée*, had been presented to the Gallery?"

"Barbizon, 8 January, 1872.

"My dear Sensier,—

"We are much distressed to see that you only have fresh illness by way of consolation for your other troubles. If, as some Christians believe, God afflicts those whom He loves the most, and thereby prepares them for a higher place, you will have a very glorious seat in Paradise. . . . I saw M. Durand-Ruel the other day. He asked me to send him as many pictures as possible, and as you told me, canvases of all sizes. An American gentleman and lady, M. and Madame Shaw, of Boston, came a little while ago to ask me for a picture which I have promised to paint for them. They chose the Priory of Vauville as the subject from among the drawings they saw here. Détrimont and his wife have been to fetch their *Little Shepherd*. He asks for another picture. An *employé* of Durand-Ruel's whose name I did not catch, but whom you know well, came here yesterday to unpack my pictures. They are none the worse."

Times had changed since the days when Millet had to seek work from reluctant dealers and take thankfully whatever price they chose to give. Now orders poured

in upon him from all sides, and he had only to name his own prices. As a rule he was paid four or five thousand francs for his large pictures, some hundred francs for his drawings. The expenses entailed by the war and his move to Normandy had been considerable; his own frequent attacks of illness, and the necessary outgoings of a large family, were a constant drain upon his resources. He was still in need of ready money, and depended upon the payments that were made by his employers in advance. But although splendid offers were made him by dealers who wished to retain his services, he steadily refused to sacrifice his freedom. He loved to linger over his work, to keep his pictures by him and go back to them again. The longer he lived, the less his work seemed to satisfy him and the more earnestly he strove after greater simplicity and force of expression. M. Hartmann's *Spring* was still in his *atelier*; the companion pictures of *La Récolte du Sarrasin* and *Les Meules* were only sketched out, although they had been ordered some years before. The *Church of Gréville* and the *Cliffs of Gruchy*, which had been partly executed in Normandy, were still in his studio at the time of his death, three years afterwards. So, too, was his *Cowherd Calling his Cows,* and a new version of the *Shepherdess Bringing Home her Flock.* Among the other pictures on which he was now engaged, were his *Woman Sewing by Lamplight*, his *Peasant-Woman Feeding Turkeys*, and his *Young Mother Nursing her Child*, sometimes called *La Maternité*, a life-size picture for which his daughter Marguerite, now Madame Heymann, sat to him. Among the other studies which his visit to Normandy had inspired, were a pastel of the farm of *Lieu-Bailly* which was bought by Sensier, the *Priory of Vauville*, which Mr. Quincy Shaw had ordered, and a fine drawing of a peasant-girl walk-

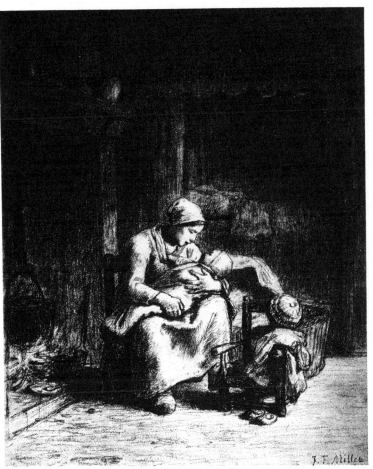

Le Retour (The Return)

ing home, through the meadows, with a copper jar on her shoulder. Many more were begun, but never finished. His headaches troubled him sorely, and he was often in bed for several days at a time. It became impossible for him to satisfy all his customers, but he was really sorry when he had to refuse the requests of old friends and employers.

On the 25th of April, he wrote to M. Alfred Bruyas, who had begged for another picture:

"Sir,—

"You will believe how much honoured and flattered I feel by your letter of the 8th. I regret exceedingly that I am unable to do what you ask, at once, owing to the numerous orders which I have received since my return here. But you may be sure that I will not forget your request, and will apply myself to the task of satisfying you as soon as I can find time. You may also be sure that I shall be very happy to make your acquaintance in person. What you say of Barye's works is no surprise. Here I entirely agree with you. He is one of the artists who seems to me undoubtedly destined to accomplish great things. I am very glad to hear you like the little things which I have done for you. Receive, sir, the assurance of my profound consideration."

On the 1st of May, he wrote to thank Sensier for his report of a sale at which his little picture of *Le Parc aux Moutons* had sold for a high price:

"Tillot has given me your letter with the prices of the Carlin sale, which give me great satisfaction. He has also brought me the book on Constable. I am still in bed and cannot get my pen to write. Good-bye till Saturday or Sunday. Oh, why cannot I get well?"

All through the summer he was ill and suffering. On the 6th of August he wrote:

" MY DEAR SENSIER,—

"I have not yet finished my *Church of Gréville.* I can do very little work. I groan more than I paint, and have only sketched out my next picture. You know the subject : a cowherd blowing his horn at the end of the day to call his cows home. I have also worked at my *Woman Sewing by Lamplight.* Barye is here. I have not yet seen him. I mean to pay him a visit, for he cannot get out yet, although he is better."

Three months later, and it is still the same story :

"25 November, 1872.

" MY DEAR SENSIER,—

"It has been impossible for me to answer your very kind letter of the 17th before this. Louise read it to me at my bedside. I have been here for the last two days, and have to spend my whole time on my back. You will have much to say in writing of Michel. As for——'s article, I asked Tillot if I was expected to give any signs of life. He said, ' No.' I do not know the customs of journalism, and trust entirely to you to do what is right. You know what I always feel on these subjects ; I do not wish to throw myself at people's heads, nor yet to assume indifference. You say some things in your letter that move me deeply, my dear Sensier : they stir up the melancholy that lies deep down in my heart, and bring back memories of the vanished years. I will say no more on the subject to-day, for once upon that track I do not know where it may lead me."

On the last day of the year, faithful to his old habit, he wrote to Sensier, but he was suffering again with pain in his eyes, and could only send a few lines :

" My eyes have been very bad. They are certainly better now, although my left eye is still inflamed. But I am oppressed with pains of all kinds. I work very little, which distresses me greatly. My *Priory* remains just where you saw it. I will have exact measurements taken for the cross on Rousseau's grave. Here goes the old year 1872, where all the other years are gone ! We embrace you and Marguerite, and wish you all that we desire for those whom we love best."

Early in 1873, a Belgian art-critic, M. Camille Lemonnier, who had spoken with warm sympathy of Millet, sent the painter a pamphlet on the Salon of 1870. Millet replied in the following characteristic epistle:

"Barbizon, 15 February, 1873.
"SIR,—

"I am very much honoured by your letter, and thank you for introducing me to your work as art-critic. The most enviable reward of an artist who tries to do his best is to find that he has roused the sympathy of intelligent men. This is equivalent to saying that I am very glad to have supplied you with an occasion for expressing certain truths about art. Only you find in my work qualities which are in my eyes so desirable, that I dare not believe in their presence. I do not doubt the correctness of your judgment, but I distrust myself. But putting myself aside, for fear of stumbling over my own toes, let me say at once how much I commend you for looking at things from the fundamental side. That is the only true and solid ground. Many people, far from taking this point of view, seem to think that art consists in a sort of show of professional cleverness. *You* understand that the artist must have a great and high aim. Without it, how can he seek to attain a goal of which he does not even dream? How can a dog follow game without scent? It is then by the nature of his aim, and the manner in which he reaches it, that an artist is to be judged. I assure you, sir, that if I could do what I wish, I should express the typical with all my might, for in that direction, to my mind, lies the highest truth. You are right in thinking that this, at least, is my intention. But I see that I am entering on a difficult road, and will not go any farther. If you ever come to Paris, and can spare time to visit Barbizon, we might talk of this. Only, if you should come, please let me know, since, although I am seldom out, some unlucky chance might prevent me from being at home that particular day. In fact, this has happened to me several times. You will forgive me for cutting off the address at the top of your letter, but I am not sure if I have read it correctly, and am afraid of copying it out wrong. Accept, sir, my repeated thanks and most cordial salutations.

"J. F. MILLET."

Three days afterwards he wrote to M. Hartmann in reply to an inquiry about his pictures:

"You may reckon upon taking your picture of *Spring* back with you. I promise *positively* that you shall have it in May. By that time I shall have made some progress with *The Wheat-ricks*, and worked at the others. Allow me to keep Rousseau's pictures a little longer. I have not yet been able to do what I wish to them. My son is very glad to have your order for two pictures. He is going to choose his subjects. You may be sure that he will do his best. He has no wish to throw dust in people's eyes, and I am very glad of it. He does what he can, as well as he is able. I am working at a picture for Durand-Ruel, and hope to let him have it by the beginning, or at latest, by the end of next week. It is a hillock, with a single tree almost bare of leaves, and which I have tried to place rather far back in the picture. The figures are, a woman turning her back, and a few turkeys. I have always tried to indicate the village in the background on a lower plane."

During that spring all the artist's strength and time were given to his work. He seldom wrote letters now, even to Sensier, but news of a sale of pictures belonging to M. Laurent-Richard, a collector who had lately bought his *Woman Sewing by Lamplight*, moved him to write the following lines:

"Barbizon, 1 April, 1873.

"MY DEAR SENSIER,—

"I have made a drawing for the Giraud sale—a Shepherd. Last Sunday M—— gave me the catalogue for the Laurent-Richard sale. He told me that it was a very fine catalogue. I needed his assurance to be convinced of this. As I have only two pictures in this sale, I should be glad if those two were not hung at the end of the hall. The light has always seemed to me less good there than on the side walls. Your beautiful Rousseau, *Les Sables à Jean de Paris*, hung there at his sale, and lost much of its fine effect in consequence. I trust to you to do what is best; and please see that my *Femme à la Lampe* is varnished. I am anxious, very anxious!"

This time Millet's fears proved groundless. The pictures were exhibited at the Hôtel Drouot, on the 7th of April, and sold the next day. The small *Lessiveuse* was sold for 15,350 francs, and his *Femme à la Lampe* for 38,500 francs. This beautiful picture of a young mother sewing by the light of a lamp, with her babe asleep beside her, was hailed with acclamation alike by the critics and the public, and was sold for the highest price which had as yet been given for any of Millet's works. Still greater surprise was excited when, a few months afterwards, the *Angelus* was bought by Mr. J. W. Wilson for 50,000 francs. This seemed an enormous sum in the eyes of Millet, who in 1859 had vainly asked 2,000 francs for the picture. When he heard of the sale, he remarked that the price was far too large, and that he was glad to think that he, at least, had nothing to do with it. Again in May, 1873, his *Grande Baratteuse* sold for 14,000 francs, and his *Flock of Geese* for 25,000 francs. These prices were the more remarkable when we remember the disturbed state of political parties in France at the time, and the disquieting rumours that prevailed.

On the 18th of May Millet wrote to Sensier :

" I suppose the political situation is alarming, since the Faure sale is put off, after all the expenses of publishing the catalogue. Silvestre has sent me his first two articles. I will tell you what I think of them when I have read more, for I suppose the others will soon follow. My *Spring* for M. Hartmann is almost finished. I am going to let him know this, and ask him if he will allow it to be shown for a little while at Durand's rooms. If political affairs look too threatening, please tell me, and I will give up the idea for the present. Has not the fragrant odour of the cakes for the fête here reached you ? "

During the past winter and spring Millet's health had kept fairly good, and he had been able to make con-siderable progress with the pictures which he had in

z

hand. But in June he had a sudden attack of hæmorrhage, and the asthma, from which he had suffered in former years, returned with fresh violence. The only letter which he wrote to Sensier that autumn was this short note :

"Barbizon, 22 September, 1873.

" MY DEAR SENSIER, —

"Since I saw you I have been very suffering. This cough is killing me. I have only begun to feel a little better during the last few days. The fact is, I am breaking down completely."

The dreaded hour was rapidly approaching, but he rallied for a time that autumn, and was able to go back to work. There were still days when he was bright and cheerful alone with his children, and talked with all his old animation to the friends who came to see him.

A young American artist, Mr. Wyatt Eaton, has lately given some extremely interesting recollections of Millet in these last years of his life. He had seen the *Femme à la Lampe* at the Laurent-Richard sale, and had come to spend the holidays at Barbizon, full of enthusiasm for this master, who was, in his eyes, the greatest of modern painters. But, to his disappointment, he found that, unlike the other artists who lived at Barbizon, Millet never came round to the inn to drink a glass of beer or play a game of billiards. The only people who seemed to know him were the peasants, who spoke of him as an excellent neighbour, and said that if any one was in trouble they had only to send for Madame Millet. On his evening walks the young American often passed Millet's house, and heard the merry talk and laughter of his children through the window opening on the street. Once he even caught a glimpse of the painter's profile as he sat at table. But one Sunday afternoon

in September, conscious that his time at Barbizon was
drawing to an end, he took courage, and, knocking at
the door of Millet's house, boldly asked François Millet,
whom he had met occasionally, to allow him to visit
his father's *atelier*. The request was at once granted,
and, about half an hour later, Millet himself entered
the room, and greeted his visitor with a friendly shake
of the hand. He showed him about a dozen pictures,
upon which he was at work ; amongst others, *The Cow-
herd*, *A Woman Carrying Home her Faggots from the
Forest*, and the *Priory* that he was painting for Mr.
Quincy Shaw. The evident admiration and delight of the
young man pleased Millet, who called him nearer, and
bade him notice the simplicity of his execution, and the
infinite variety of effect that can be produced by a few
touches. He was especially struck by a still-life study
of three pears on a plate, which the painter had ren-
dered with consummate truth.

"In those pears," writes Mr. Wyatt Eaton, "I found all the tones
of a landscape. In the twisted stems I seemed to see the weather-
beaten tree. The modelling of the fruit was studied, and rendered
with the same interest that he would have given to a hill, or a
mountain, or human body. Millet seemed well pleased at my
declaring this to be equal in interest to his other pictures." [1]

The ice once broken, Millet talked to the young student
with rare friendliness, and spoke of his own loneliness
and isolation since Rousseau's death; and answered his
questions upon the relative value of different branches
of study. Was anatomy of use? Yes, distinctly so ;
all study was valuable, if only the larger constructions,
the planes and surfaces, were kept in mind. But the
art-student, as a rule, had much both to learn and to
forget, before he gained full command of his powers.

[1] *Century*, May, 1889.

When Mr. Wyatt Eaton alluded to the master's early
picture of *Œdipus being Taken Down from the Tree*, which
he had lately seen in Paris, Millet laughed, and told
him that he was very young when he painted that. He
criticised some sketches which the young artist produced,
found fault with his lack of simplicity, and unnecessary
detail, and made much the same remarks on technical
points as Gérôme and Munckacsy, who had also seen them.
They talked much of art and nature, and in the end Mr.
Wyatt Eaton asked him if it could be said of anything in
nature that it was not beautiful. Millet replied with em-
phasis: " The man who finds any phase or effect of nature
that is not beautiful, may be quite sure the want is
in his own heart."

That winter Mr. Wyatt Eaton returned to Barbizon
and saw a great deal of François Millet. He was re-
peatedly invited to drink coffee with the painter's family
of an evening, and saw Millet sitting at his hospitable
board, surrounded by his children. His broad, muscular
form reminded the young American of George Fuller,
while his large and easy manner recalled Walt Whit-
man. When he saw him in sabots and short cloak
striding across the fields at the back of his house,
absorbed in the contemplation of the evening sky, he
seemed to him as grand a figure as his own Sower.
Very interesting is the description of the painter which
he gives of the artist's personal appearance at this time
of his life :

" His face always impressed me as long, but it was large in
every way. All the features were large except the eyes, which at
the same time were not small; they must have been very blue when
young. The nose was finely cut, with large, dilating nostrils, the
mouth firm ; the forehead remarkable for its strength—not massive,
but in the three-quarter view of the head, where usually the line
commences to recede near the middle of the forehead, with him it

continued straight to an unusual height. A daguerreotype, made
when he was about thirty-five years of age, without a beard, showed
him to have a large chin, and strong lower face, expressive of great
will and energy. The hair and beard were originally a dark brown,
the beard strong and heavy ; in his last years they were of an iron grey.
His voice was clear and firm, rather low in pitch, and not of that deep
bass or sonorous quality one might have expected from so massive a
physique. Apart from sabots, which he always wore in the country,
he in no way affected the peasant dress, as has been stated by the
English, but wore a soft felt hat and easy-fitting clothes, such as
you might see anywhere among the farmers or country people of
America. It was only on going to Paris that he would put on
leather shoes, a black coat, and silk hat, his apparel on these
occasions causing much discomfort. To his family he never seemed
himself when dressed for Paris. His general appearance, although
not really that of a peasant, but perhaps more his manner, his heavy
tread, and his apparent absorption in all that surrounded him, gave
me the feeling that he was part of nature, as he so well conceived
the peasant as a part of the soil which he worked." [1]

But although Millet still worked hard, and was in
good spirits, he was hourly conscious of failing strength.
On the 18th of March, 1874, he wrote a last letter to
Sensier, beginning with the following words:

"How long is it since I have written to you, my dear Sensier?
I am so weak and languid that I put off what I ought to do from
one day to another. Please believe that I have been thinking of
you all the same. If my body is feebler, my heart has not grown
colder. M. Hartmann wrote, some time ago, to say he would come
here towards the end of the month. His picture of the *Wheat-ricks*
is nearly finished, and I am pushing on the *Buckwheat Threshers*
as fast as I can. Every one here embraces you."

A few weeks afterwards he received a letter which
gave him great pleasure. It was an order from M. de
Chennevières, the new Director of Fine Arts, informing
him that the Government had decided to adorn the

[1] *Century*, January, 1889.

Pantheon with wall-paintings, and offering him the sum
of 50,000 francs for a series of eight subjects in the
chapel of Sainte Géneviève. The task was one after
Millet's own heart. He accepted it gladly, and set to
work at once to sketch out the different compositions in
charcoal. A letter which he addressed a fortnight later
to his old friend, the schoolmaster of Gréville, shows
the mingled feelings of joy and fear with which he
entered on this important work. He was keenly
alive to the honour which had been done him. No
prouder task could have been assigned to him, and yet
his heart sank at the prospect of the long and laborious
toil to which his physical strength was altogether un-
equal. And he felt that for this year, at all events, the
hope of seeing his old home must be abandoned.

<div style="text-align: right">"Barbizon, 26 May, 1874.</div>

"MY DEAR SIR,—

"Since you have kindly become Jeanne Marie Fleury's secre-
tary, I hope you will also act as my *commissionnaire*. Employment,
you see, comes to you in both capacities at once! Please tell
that poor Jeanne Marie that we are very grateful for her kind
thought of us, but that we are sorry she should take so much
trouble to let us know this. When we return to Gréville, we will
certainly eat one of her geese. She may depend upon that! But
when will this feast take place? 'Man proposes, but God disposes.'
Last summer we meant to take this journey, and were preparing
to start, but I fell ill, and my wife had a fall. This year other
hindrances have come to stop us; happily, they are pleasanter
ones. A letter dated the 15th of May brought me an order from
the Ministry for a great and important work. Here is the text
of the letter:

"'Sir, I have the honour to inform you that *M. le Ministre* has,
on my recommendation, desired you to execute the paintings for
the decoration of the chapel of Sainte Géneviève, in the church of
that saint in Paris. A sum of 50,000 francs has been allotted to
you for this work,' etc.

"This letter is addressed to me by the Director of Fine Arts.

It will be a long and very fatiguing work. Oh! my poor Gréville, when shall I see you again! But to come back to Jeanne Marie. If she can live in tolerable comfort, we shall be very thankful, and only ask her to think of us sometimes, as, indeed, she does already. My dear monsieur, . . . My son François and I both press you hard and cordially, and the whole family joins in wishing you and yours good health. Remember us all to Polidor and his family. I particularly wish to be remembered to Barthélemy, to Jean Paris and Lacouture. "J. F. MILLET."

He had not forgotten his friends at Gréville, and sent a little allowance regularly to the good old woman who was fattening her geese for the day of his return. And it was with genuine pleasure that he sent the news of the great national work, for which he had been chosen, to his native place. A week or two after this he came to Paris with his wife and son to see M. de Chennevières, and visit the chapel which he was to decorate with his paintings. Mr. Wyatt Eaton met them at the Duval Restaurant in the Rue Montesquieu, and looked out the Director's address for Millet's benefit. That day the master seemed in good spirits, and was evidently gratified at being selected for the work, although he complained laughingly of being obliged to put on his best clothes, and come to Paris. As they sat together in the Palais Royal, drinking their coffee out of doors, his thoughts went back to the old days when he first came to Paris, and had a hard struggle to earn his daily bread. He told his companions how print-sellers would come and offer him twenty francs for a pastel, and how he would paint a girl bathing or a child at play in a couple of hours. The Gréville peasant-boy had not starved and toiled in vain. He was a great man now, and dealers and collectors from all parts of the world were ready to stake their thousands on the pictures which he had once sold for a crust of bread.

He went back to Barbizon and worked all the summer at the wall-paintings for Sainte Géneviève. The Miracle des Ardents and the Procession to the Shrine of Sainte Géneviève were two of the subjects assigned to him. He sketched these out in charcoal on small canvases, indicating the movement of the figures with a few broad strokes. His great wish was to make the story plain and intelligible to the unlearned without the help of books. But the chapel which he was to decorate was so dark that it would be necessary to bring out the figures in strong relief if they were to be seen at all. He applied himself earnestly to overcome this difficulty during this last summer of his life. But the order had come too late.

On the 9th of July, Sensier and M. Hartmann went down to Barbizon. They found Millet still at work on the *Priory of Vauville*. M. Hartmann's own pictures, the *Récolte de Sarrasin*, and the autumn landscape of *Les Meules*, were almost finished. In this last picture Millet had painted the cornfields under a new aspect. Summer is past, the harvest is ended, and earth rests from her labours. Reapers and gleaners alike are gone: only the newly-made ricks are left to tell of the precious grain safely stored up for the use of man. A few sheep browse the short stubble, and a flight of white pigeons wing their way across the sky in front of a black thunder-cloud that darkens the foreground. Beyond these threatening shadows the October sun, struggling out, touches the farmyard roofs with light, and gilds the edge of the plain with the last glow of the dying summer. Something of the peace that the near approach of death brings with it was in Millet's thoughts when he painted this last harvest-picture. " He suffered much," wrote Sensier, " and knew that the great day of rest was at hand."

But there was one other picture on the easel which struck Sensier even more when he and M. Hartmann paid their visit to Barbizon. It was that view of the cliffs of Gruchy which Millet had gone to his old home to paint, and to which he alludes repeatedly in the letters of 1871 and 1872. The subject was dear to his heart. He had lavished all his best powers of brain and hand upon the work, and was loath to part from it. The grass-grown cliffs close to his old home were in the foreground, and the posts of an old gateway framed in the wide stretch of green waves beyond. A dun cow feeding in the pastures at the foot of the steep cliffs was the only living creature in this vast expanse of sea and sky. But the colours of rock and wave, and the brilliant effect of summer sunlight on the sea, were painted with a force and depth of tone rarely seen in Millet's pictures. The whole life of Gréville, the picturesque charm of the country, and the hard struggle oi the peasants for daily bread, the romance of Millet's boyhood, and the yearning of later years for the old home, are all gathered up in this last picture, which hung on the easel in his *atelier* at the time of his death. *Les Falaises de Gruchy* was eventually sold to M. Hartmann, and after his sale in 1881 it passed into the hands of a Glasgow collector. Two years ago it was exhibited in Bond Street, and offered for sale at the price of £5,000.

M. Hartmann returned to Paris well pleased with the sight of his pictures, but Sensier remained at Barbizon for another week. Millet was no longer able to take long walks in the forest, but he liked to stroll slowly through the village, or in the fields at the back of his house; and he had pulled out some bricks in his garden wall that he might watch the sunset from his favourite seat.

Later on Sensier came back to Barbizon for the fête

of the Assumption, and spent the next day with Millet. All the painter's family—his children and grandchildren —were assembled on this occasion, and the whole party set out on an expedition into the forest. The young people drove in a large open carriage ; Millet, his wife, and Sensier followed in a low chaise. The day was soft and balmy, and Millet's spirits rose. He delighted in seeing his children around him, and rejoiced in the happy laughter and innocent mirth of his little grandson Antoine. The most beautiful parts of the forest were all visited in turn, and Millet recalled the first summer which he had spent at Barbizon. He spoke of the ineffaceable impression which the sight of these wonders had made upon him, and of the influences which had led him to break for ever with academic art and enter on a closer and truer study of nature. When they parted, he spoke warmly to Sensier, and called him the truest and oldest of his friends.

"Most friends," he said, "grow weary, and leave us in the hard places of life. Others die, or pass out of sight. You have remained ; you have always supported me, encouraged me, and understood me."

It was a generous tribute from the loyal and simple soul who never thought evil of others, but trusted his old friend to the end.

XX

1874–1875

THAT summer Mr. Wyatt Eaton spent the holidays again at Barbizon. He met with a warm welcome, and was constantly at Millet's house. The painter was absorbed in the composition of his scenes from the legend of Sainte Génevière, and after meals would remain alone at the table, fixing his eyes on the cloth, and passing his finger over the surface as if he were drawing, and then moving his hand as if to rub out what he had drawn. If a visitor came in, he would beg him to excuse his silence, and would go on with his invisible sketches. The evenings were generally spent in the garden, where Millet and his family had their supper in fine weather, and the painter often amused his children and grandchildren by making sketches of the fairy tales which he told them. A whole series on the story of Red Riding Hood was made about this time for his youngest daughter, Marianne, then a child of ten. Another set, describing the adventures of Le Petit Poucet, was originally designed for his eldest son, François. The ogre was represented in one drawing opening his mouth, showing how he would devour little boys and girls; while in another he lay asleep on his bed, and Le Petit Poucet was deftly pulling off his boots. But the most touching of the series was the one in which the poor wood-cutter and his wife were seen sitting together in their bare room, with the empty

soup-pot lying upturned on the cold hearth. "We have no more bread for our little ones; let us go and lose them in the forest." In these sorrowful faces François recognised the portraits of his own parents, and knew that his father was describing the scene from his own experience. Even so Sensier had found him and his wife sitting all alone in the garret of the Rue Roche-chouart, where they had been for two days without bread or fuel.

After dark, Millet generally played at dominoes, since he was no longer able to draw or read by candle-light. Mr. Wyatt Eaton frequently played with him, and so often lost the game that one evening Millet amused himself by drawing his recumbent effigy upon a tomb-stone, labelled with his name. They generally sat up till twelve or one o'clock, especially on days when some of the family had gone to Paris, and were expected by the last omnibus from Melun. As the evening wore on, Millet would grow lively, and talk in his old strain of the relations of art and nature.

Mr. Wyatt Eaton was struck, like most of Millet's acquaintances, with his concise and well-chosen language, and the pains which he took to find the right word to express his thoughts. One evening the young artist consulted Millet about a view of the plain which he was painting, with a road running towards another village. He had brought in the wall of a house to show that this was the beginning of the village, but had been advised by an artist-friend to take this out, as injuring the beauty of the composition. Millet had no sooner heard this criticism than he broke into an indignant exclamation. This false idea of beauty was, he declared, the ruin of all true art. He could not listen to it calmly. "Beauty was the fit, the appropriate, the serviceab'e character well rendered, an idea well wrought

out with largeness and simplicity." If a picture did
not express the artist's idea, it was a failure ; and
in support of his argument he took up a lamp, went
across to his studio, and brought back some photographs
of Giotto's frescoes at Padua, which had been given him
by a friend who had lately returned from Italy. There,
as he pointed out triumphantly, the expression, the charac-
ter of the face and action was everything. " Was not
the suitable always beautiful ? Was not the naturalness
of an action fine, even if it were only that of one man
washing the feet of another ? " And, by way of contrast,
he led the way up to his bedroom, and showed his guest
an engraving of a *Nativity* by Titian hanging on the wall.
There, he said, the figures lacked the roughness of the
peasant-type, the room was quite unlike a stable, above
all, the child was naked, instead of being warmly wrapt
up in woollen clothes. " There, you see the beginning of
la belle peinture ! " Then he turned to another engraving—
a death-bed scene, by his favourite Poussin. " How simple
and austere the interior ; only that which is necessary,
no more ; the grief of the family, how bitter ! " he said.
" Notice the calm movement of the doctor, as he lays his
hand upon the man's heart. Look, too, at the dying man,
at the care and trouble in his face, at his hands—perhaps
your friend would not call them beautiful, but they speak
of age, of toil and suffering. Ah ! to me they are infi-
nitely more beautiful than the delicate hands of Titian's
peasants."

His love for the early Florentines had never wavered
since the day when he first climbed the steps of the
Louvre and found himself suddenly in the presence of
these old masters. Their expressive faces and movements,
the very simplicity and directness of their art, appealed
to him far more than any modern painters, and from
the first he recognised in them his true kindred. One

day Wyatt Eaton asked him if he did not think the art
of Japan superior to the work of the fashionable Paris
painter. "Most decidedly," he replied; "but their work
is far from having the beauty of Fra Angelico." Another
old master whose work interested him intensely was Il
Greco; and a picture by this vigorous and dramatic artist,
who forms, as it were, the link between Tintoret and
Velasquez, was an unfailing source of pleasure to him
in his last illness. He had little sympathy with the latest
developments of contemporary art, and was fond of say-
ing that he should like to close the Salon for five years,
to give artists more time for study and teach the critics
to be less self-sufficient. "At the end of that time I
would make each artist send in a study of the nude
figure. You would see how many of our young boastfuls
would decline the contest, and realize how much ignorance
there is among them all!"

Another evening, early in October, Millet came into
his son's studio to look at a block which he had prepared
for his brother Pierre, who had returned from America,
and was spending a few weeks at Barbizon. The draw-
ing represented a peasant resting both hands upon his
spade; every touch was full of expression, and as a
picture it was complete. It seemed to gratify the master,
and he told Mr. Wyatt Eaton that he would make a
painting of the subject. Then he sat down and talked
in melancholy tones of the beauty of the autumn, and
of the many sad memories which the season awoke in
his breast. After a little while his thoughts went back
to the drawing, and he brightened up as he spoke of
the qualities which appealed to him the most in art.
"Repose," he said, "expressed more than action. The
man leaning upon his spade was more significant of
work than one in the act of digging; he had worked,
and was fatigued; he was resting, and would work again.

In the same way, he preferred to paint a middle-aged man rather than a young or an old one. The middle-aged man showed the effect of toil: his limbs were crooked and his body bent, yet years of labour were still before him. Again, in type, the labourer must show that he was born to labour, that labour was his fit occupation, that his father and grandfather had been tillers of the soil, and that his children and children's children will do the work their fathers have done before them. The artist," he always insisted, " should paint the typical, not the exceptional."

The American artist never forgot that conversation in the dusk of the autumn evening. It was the last time that he ever heard Millet talk of those subjects. The next few evenings they played at dominoes, and then Wyatt Eaton went back to Paris, leaving Millet, to all appearance, quiet and contented, busy with his Sainte Géneviève pictures, and full of hope for the future. Sometimes he complained of his want of energy, and said laughingly that he would rather sit still and go on working with the dry paint on his palette than get up to fetch fresh colours. But the American artist little dreamt when he left Barbizon that he would never see Millet again.

He worked on through the autumn at his unfinished pictures, and sketched out a new one of a mother teaching her child to sew in a cottage home, with a casement opening on a garden full of leaves and flowers. But his working days were almost over. The evening shadows were fast closing on the long day of toil, and the night was coming when no man can work. Early in December he had an attack of fever, and before the end of the month he took to his bed. Nights of delirium were followed by days of extreme prostration, and he himself became aware that his end was approaching. He told

his wife his last wishes, and asked to be buried by
Rousseau's side in the cemetery at Chailly. He spoke
much of his children, and grieved to think that he had
not been able to make better provision for them in his
lifetime. But he entreated them to hold together, and to
stand by their mother when he was gone. And he spoke
of his painting, and said sorrowfully that he was dying
all too soon, for that he was only now beginning to see
his way clearly, and to understand the true meaning of
nature and of art. One day he asked to have some
passages from his old favourite, *Redgauntlet*, read aloud
to him again. Another time, only a little while before
the end, as he lay with his face turned towards the gar-
den and his *atelier* door, he told François that he was
longing to paint a green hill and a bank of trees by the
roadside in his native Normandy. He had still so much
to say, if he could only live a little longer.

He lingered on into the new year, tenderly nursed by
his wife and children. That Christmas was a sad one
for the home that used once to be so gay, and the
" Jour des Rois," which had always been kept as a family
festival, was spent in mournful silence. One morning,
when the dying man had fallen asleep, he was rudely
awakened by the firing of guns and the barking of
dogs under his window. A poor stag, flying before the
huntsmen, had jumped over a wall and taken refuge in
a neighbouring garden, where it was torn to pieces by
the dogs. Millet, who made no secret of the horror
which he had for sport, heard of its fate with a shudder.
" It is an omen," he said. " This poor beast, which comes
to die beside me, warns me that I too am about to
die."

He was right. A few days afterwards, the painter of
the *Angelus* breathed his last, at six o'clock on the morn-
ing of the 20th of January, 1875.

The next day a neighbour went from house to house through the village, as was the custom in Norman villages, and announced his death and the time of his burial. Millet had begged to be buried like a Gréville peasant, as his father and mother before him, and his last wishes were faithfully obeyed. On Saturday, the 23rd of January, his family and friends, followed by a large company of artists, bore him to his grave in the cemetery of Chailly.

It was a cold, gloomy day, and the rain fell heavily as the mourners paid him the last sad offices and left him to sleep by Rousseau's side. No better resting-place could have been found for him than this quiet spot, near the old church which he had so often painted, on the edge of that plain where the sound of the Angelus still seems to float in every wind that blows.

A burst of lamentation followed upon the death of Millet. France, it was generally felt, had lost her most illustrious painter, and there was no one left to fill his place. At the same time, there was an uneasy feeling in many hearts that the great master had not been fully appreciated during his lifetime. Among the critics especially there was an evident anxiety to repair the injustice which had been done him in the past. Their articles upon his life and work showed a deep sense of his genius, together with a generous recognition of his simple and noble character. On every side, tokens of sympathy flowed in upon the brave and faithful woman who had proved so true a helpmeet through thirty years of married life, and who was now left widowed and alone. The painter Corot, his old friend, in the kindness of his heart, sent her a gift of 15,000 francs, telling the dealer who owed him the sum to make her believe that her husband had sold him pictures to that amount.

M. Gavet opened an exhibition of Millet's drawings at
the Hôtel Drouot for her benefit. The State made tardy
amends for its neglect of Millet in the past by allowing
his widow a small pension of £48 a year. Happily, in
the end, Madame Millet did not have to depend upon
either public or private charity for her support.

In the following May the unfinished pictures, draw-
ings and pastels that were in the painter's *atelier* at the
time of his death were sold at the Hôtel Drouot, and
produced the considerable sum of 321,034 francs. This
fortunate and unexpected result enabled Madame Millet
to discharge all her husband's obligations and left her
in possession of a comfortable income. During the next
thirteen years she lived on with her children in the old
home at Barbizon, which became the goal of many pil-
grimages. A constant stream of visitors from all parts
of the civilized world found their way to Millet's house,
and begged leave to see the *atelier* where he had painted
his famous pictures. These enthusiastic travellers, it
must be owned, were apt to be a little trying. Some-
times resolute intruders would force their way into the
house without introduction of any sort. One American
lady appeared at the door with a large troop of friends,
and, having brought the terrified maid to the door by
her ceaseless knocks and calls, demanded admittance on
the strength of being a citizen of the States, adding that
one of her companions had narrowly missed being elected
President! But Madame Millet was invariably kind and
courteous to all reasonable persons, and as long as she
lived at Barbizon, no lover of Millet's art was ever
turned away. They were free to see the *atelier* where
he had worked, and were offered the key of the cemetery
of Chailly if they wished to visit his grave. And any
one who had known her husband or had any other claim
on her attention, met with a ready and cordial welcome.

Those who saw her did not soon forget the simple and kindly charm of her presence. She would talk freely of old times, of her husband's long struggle for recognition, and of the glad day when success came at length to reward his toil, and he began to be " *un peu célèbre.*" But sometimes, as she spoke of those bygone years, and recalled the love and happiness of her now desolate home, those memories of the cherished past would rush upon her with overwhelming force, and she would burst into a flood of tears.

Madame Millet lived to witness her husband's rapidly growing fame, and to see enormous prices paid for the pictures which he had vainly tried to sell for bread. She heard with strangely mingled emotions of the extraordinary sensation excited by the sale of the *Angelus* in 1889, and before her death she saw the world-renowned picture come back to France once more, and after all its wanderings find a home in Millet's native land. One by one her daughters married, and her sons left her to seek their fortunes in Paris. But her elder son François, who had been for so many years his father's companion and pupil, and was now himself an artist of some repute, remained under her roof until the sad day when they were both forced to leave the old home.

After Millet's death, Sensier, who, it will be remembered, was the owner of his house, had raised the rent to 500 francs, and granted his widow an extension of the lease. But two years later, Sensier himself died, and the houses and land which he owned at Barbizon became the property of his only child—the Marguerite mentioned in Millet's letters—now Madame Duhamel. In November, 1888, Madame Millet's lease came to an end, and she was unable to obtain its renewal from the owners. Some of Millet's American admirers subscribed to buy the pro-

perty for her use, but they failed to come to terms with Madame Duhamel, and the plan was ultimately abandoned. So, sorely against their will, the painter's widow and children were forced to leave their beloved home, and move into another house across the street.

It was a sad day for the whole family, and both François Millet and his mother felt the parting keenly. Every stone in the old walls, every corner of the house and garden, was full of precious memories. The *atelier* had been kept unchanged since Millet died. His easel was still standing there, and near the door was the old armchair where Rousseau and Diaz, Corot and Barye, Decamps and Daumier and Dupré and many other illustrious men of his generation had all sat in turn. The names and heights of Millet himself and of most of his friends were written behind the looking-glass, and the wall was covered with sketches and mottos. François Millet effaced most of these interesting records before he left, unwilling that these intimate recollections of his father's private life should be exposed to public gaze. The older portion of the house itself was pulled down, and only the dining-room which Millet had added and the *atelier* were left standing. These underwent an entire transformation. The outhouses and walls of the garden were destroyed, and the flowers and fruit-trees, which Millet had planted with his own hands, perished.

All these changes were grievous to see, but Madame Millet met them in the same brave and patient spirit which had helped her through the trials of former years, and lived on, supported by the love of her sons and daughters, and happy in the sacred recollections of the past. The death of her youngest daughter, Marianne, the pet and plaything of Millet's later years, in 1890, was another blow, and she never recovered from the shock. During the last four years she suffered severely from heart

disease. For a time she battled with this painful ill-
ness, but at length she was compelled to leave Barbizon
and seek a warmer climate in the neighbourhood of Paris.
On the 31st of January, 1894, she died at Suresnes, in
the house of her son-in-law, M. Edgard Landesque, and
on the 3rd of February she was buried at Chailly, by
the side of the husband whose work she had helped so
nobly during his lifetime, and whose glory is her best
reward.

There they sleep, under the shadow of a tall pine,
in a quiet corner of the cemetery outside the village,
a little apart from the central walk where the notables
of Chailly and Barbizon lie. A few rose-bushes,
which have a hard struggle for life in the sandy
soil, are planted round the grave, and the boughs of the
young birch and beech-trees, which Millet himself planted
on Rousseau's tomb close by, droop over the cross at
the head of their resting-place. The tombstone bears the
following inscription:

JEAN FRANÇOIS MILLET, Peintre,
Né à Gréville (Manche) le 4 Octobre, 1814:
Mort à Barbizon le 20 Janvier, 1875.

Ici reposent, avec JEAN FRANÇOIS MILLET,
PIERRE LANDESQUE,
Né le 8 Juillet, 1883:
Mort le 17 Août, 1884. Son petit fils.

MARIANNE JULIE MILLET,
Née à Barbizon le 28 Novembre, 1863:
Morte le 19 Juillet, 1890. Sa fille.

CATHERINE MARIE JOSÈPHE LEMAIRE,
Née à Lorient (Morbihan) le 28 Avril, 1827:
Morte à Suresnes le 31 Janvier, 1894. Son épouse.

Barbizon itself is now an altered place. The great
masters to whom it owed its renown are dead, and the
present generation of artists has almost ceased to fre-

quent the once famous village. The life of the past is
gone as completely as if it had never been. But the
spell of a mighty presence still lingers in the air. The
quiet village street, the path leading to the forest, the
great plain where the peasants still go out to work at
break of day and the shepherds bring home their flocks
in the gloaming are all eloquent of Millet.

The old houses with their paved courtyards and an-
cient wells, their dove-cotes and poultry feeding in the
shade of the big walnut-trees, are the same we see in
his drawings; the wheat-ricks and haystacks at the end
of the village street, the ruined wall on the edge of the
forest where the deer listen at dusk, remain exactly as
they were when he painted them in his *Moissonneurs* or
Cerf aux Écoutes. The woodcutters at work by the road-
side, the rabbits starting out of their sandy burrows
among the rocky boulders, the peasant-women picking
up stones or hoeing potatoes on the plain, the shepherd
with his staff and felt hat, followed by the long file
of straggling sheep, might have stepped straight out of
his pictures. Each feature of the familiar landscape
recalls some well-known painting. Every figure we
see reminds us that here Millet lived and died. And
when the sun has sunk below the blue hills in the
horizon, and the mysterious gloom of twilight settles on
the plain, then the great master seems to live again,
and we feel his presence near us in this his favourite
hour.

> " He is made one with Nature. There is heard
> His voice in all her music ; . . .
> He is a presence to be felt and known
> In darkness and in light, from herb and stone,
> Spreading itself where'er that Power may move
> Which has withdrawn his being to its own ;
> Which wields the world with never-wearied love,
> Sustains it from beneath, and kindles it above."

PART IV

1875—1895

" Les gens d'esprit pourrent sourire, les académies pourrent se tromper, les indifférents pourrent passer sans regarder et sans comprendre ; ces moqueries, ces méprises, ces dédains ne changerent rien au résultat définitif, et, dans un temps qui viendra bientôt, qui, peut-être, est déjà venu, M. Millet sera salué comme un maître."
—PAUL MANTZ (*Gazette des Beaux Arts,* Juin 15, 1859).

" La prophétie s'est réalisée tout entière. Les académies se sont trompées, les gens d'esprit ont souri, mais l'œuvre est là, toujours éloquente."
—A. MICHEL, 1887.

I

IN these days, when every one thinks and paints as he
pleases, it is difficult to realize the fierceness of the
outcry which forty years ago met any departure from
the beaten track. Yet here in England the same storm
was aroused when the pre-Raphaelites raised their pro-
test against false and conventional art. Their practice
was different from that of Millet, but they took their
stand on the same ground. Like Mr. Holman Hunt and
his comrades, the Norman peasant-painter started with
the stubborn conviction that " it is at first better, and
finally more pleasing, for human minds to contemplate
things as they are than as they are not."

Dante Rossetti recognised this spiritual kinship with
generous warmth when he saw Millet's works at Paris
in 1863, and came home full of interest and sympathy
in the peasant-pictures of this unknown master. " Paint
things as you see them—as they actually happen," cried
this heaven-born leader of the movement which brought
life to the dead bones of English art, " not as they are
set down in academic rules." " Go to nature for your
impressions," said Millet ; " it is there, close at hand, that
beauty lies. All you see there is proper to be expressed,
if only your aim is high enough."

But such rank heresy as this was not to be endured
in those days, least of all in France, where the traditions
of the Schools reigned supreme. And because the young
peasant-artist who came to Paris with his *idées toutes
faites sur l'art* was in advance of his age, because he

dared to think for himself and was resolved at all
hazards to paint in his own way, he found himself
treated as a barbarian and a demagogue. The critics
were intolerant of new ideas, and the public resented
what it could not understand. We have followed him
through the long years of his brave struggle with fate,
and have seen how he drained the cup of suffering to
the dregs. But in the end his work, like that of all great
and original minds, has received full recognition. Out of
the weary days of waiting and loneliness, out of the
failure and despair the great results came. When he
died, the tide was already turning, but no one could have
dreamt what triumphs were in store for him. The exhi-
bition opened by his generous friend M. Gavet, three
months after his death, was visited by four thousand
persons, and a few weeks later these ninety-five draw-
ings were sold for upwards of 430,000 francs. And that
same spring the sale of the pictures and drawings in his
studio, as we have seen, produced a sum far beyond the
highest expectations of his friends. Already his country-
men were beginning to realize the greatness of the mas-
ter whom they had lost.

During the next ten years the prices of Millet's pic-
tures rose by leaps and bounds. *Le Semeur* changed
hands for £5,000, *Le Greffeur* was sold at M. Hartmann's
death in 1881 for £5,300, and the *Angelus* reached the
figure of £8,000. Small pastels and drawings which he
had sold for a few pounds were bought for as many
hundreds, and collectors readily paid £20 or £30 for
proofs of etchings which were to be had for half a franc
in his lifetime. But the first public recognition which
Millet received from his countrymen was in 1887, when
an exhibition of his works was held in Paris. Other
masters, Corot, Manet, Bastien-Lepage had been paid the
same honour in the year after their death. Millet had

to wait twelve years before his day came. But if the
act of reparation was tardy, it was complete. The Exhi-
bition was held in the École des Beaux-Arts, and here
the painter, who had been reviled as a revolutionary,
and an enemy to the sacred traditions of art, was hon-
oured with a great display of banners and mottos, of
laurel wreaths and immortelles, and all the festal show
with which France delights to do homage to her mighty
dead. All Paris crowded to see the once-despised and
rejected works. Unfortunately, many of the most famous
pictures were missing. *Le Semeur*, *La Grande Tondeuse*,
La Femme aux Seaux had already crossed the Atlantic,
and found a home in the country where Millet's worth
had been long ago appreciated. But the *Angelus* and *Les
Glaneuses*, *La Jeune Bergère*, *L'Homme à la Houe* and
L'Homme à la Veste, and many other equally representa-
tive works were there, while, besides sixty-seven oil-
paintings, as many as one hundred pastels and drawings
hung on the walls.

The exhibition proved a great popular success, and
every Frenchman was proud to think of Millet as his
countryman. The critics and journalists—those *éternels
aboyeurs* who had worried poor Millet's soul with their
noisy recriminations — were loud in their acclamations.
The very papers which had formerly denounced him as
a painter of *crétins* and savages, a Socialist and dema-
gogue of the most dangerous type, helped to swell the
chorus of praise. One and all they showed the same
desire to bury the past in oblivion. "Let us forget Mil-
let's sufferings," they cried, "and think only of his glory."
And the motto, "Victory should be merciful," was in-
scribed on the catalogue which M. Paul Mantz compiled.

"So the cripple Justice," wrote M. André Michel, "hobbling
along on her crutches, arrives at last, and with a mournful smile lays
her crown on the brows of the dead."

A statue of Millet was raised out of the proceeds of the exhibition on the Market Place at Cherbourg, and the great peasant may be seen looking over the seas and the coast which he loved so well. Two years before a bronze plaque bearing portraits of Millet and Rousseau, modelled by the sculptor Chapu, had been placed on a rock at the entrance of the forest of Fontainebleau, so that Barbizon should not be left without a memorial of her greatest painter.

But the record of Millet's triumphs does not end here. In 1889 came the great International Exhibition, and the upper galleries of the Champ de Mars were filled with a goodly show of pictures and drawings, illustrating the progress of French art during the nineteenth century. Once more we were brought face to face with the painting of the Revolution and of the First Empire, with the theatrical attempts of David to revive the glorious days of the ancient Romans, and the huge battle-pieces which were the natural expression of Napoleon's times. Old quarrels were revived, and the war which waged so fiercely between Classics and Romantics came back to our minds when we saw the works of the bold innovator Delacroix side by side with those of his cold and academic rivals.

But the most striking feature in the show was the splendid display made by the men of 1830—that gallant little band who first raised the banner of revolt and dared to paint what they saw and felt rather than what others had seen and felt before them. Chief among that illustrious company was Jean François Millet, the master who shared this revived sympathy with nature, and found a new and higher inspiration in the teachings of humanity. This time a special effort had been made to bring together a representative collection of his works. *La Grande Tondeuse* had been brought back across the Atlantic for

the occasion, and *Les Glaneuses* and *L'Homme à la Houe* hung side by side with the tragic *Tueurs de Cochons* and the idyllic *Parc aux Moutons*, with the charming young *Fileuse* and the pathetic autumn landscape of *Les Meules*. Even more characteristic of his genius was the noble collection of pastels and drawings which hung on the screen, and included his beautiful dream of the *Angelus*. Then we realized, not only the high place which he holds among the painters of the century, but the important part which he has played in the evolution of modern art.

There was no longer any doubt as to Millet's popularity that day. The gallery where his pictures hung was crowded with *bourgeois* and peasants from the provinces. Many a working-man in blouse and sabots who had brought his family into Paris by the *train de plaisir* to see the wonders of the great Exhibition, might be seen showing his little children *Les Glaneuses* and the *Parc aux Moutons*, and telling them the name of the great Norman master who had painted them.

By a strange chance the *Angelus*, the chief of Millet's works that was absent from the Champ de Mars, was offered for sale that summer in Paris, and became the object of the most dramatic and exciting contest ever known in the auction-room. This picture, as our readers will remember, had been painted in 1859; and although Millet himself considered it to be one of his best works, Arthur Stevens had great difficulty in finding a purchaser who would give the modest sum which the painter asked. It was ultimately bought, as I have said, by M. de Papeleu, but soon passed into the collection of M. Van Praet, the Belgian minister in Paris. This distinguished connoisseur, who owned many of the finest works painted by Barbizon masters, afterwards exchanged the *Angelus* for M. Tesse's *Bergère*, another of Millet's masterpieces. M. Tesse, in his turn, sold it to M. Gavet, who parted

with it to Durand-Ruel for what seemed to Millet the extravagant sum of 30,000 francs. During the war of 1870, it was brought to England by M. Durand-Ruel, and hung for twelve months in a dealer's shop in Bond Street. But although the picture was freely offered for sale, there was no one in London who would give the price of £1,000, which Durand-Ruel asked. One well-known collector went as far as £800, but his offer was refused, and the *Angelus* went back to Paris, where it was soon afterwards bought by Mr. J. W. Wilson, another Belgian collector, for £2,000. At his sale in 1881, it was bought for £6,400 by the dealer Petit, who had been commissioned to buy it by two different collectors, M. Secrétan and Mr. Vanderbilt. They agreed to draw lots for the picture. M. Secrétan won, and sold it to Petit for £8,000. A few years afterwards he bought it back again for £12,000, by which time the *Angelus* had become so famous that another American collector, Mr. Rockafeller, is said to have offered him £20,000 for the picture. This offer, however, was refused, and the *Angelus*, which was now described as the most beautiful picture of modern times, remained the property of M. Secrétan until it was put up to auction with the rest of his collection on the 1st of July, 1889. The great interest and curiosity already aroused by the sale was increased when it became known that the French Government, moved by the celebrity which the *Angelus* had attained, and the general sense of regret that was expressed in 1887 at the loss of so many of Millet's masterpieces, had desired M. Antonin Proust, the Director of Fine Arts, to secure the picture, if possible.

From early morning the pavement of the Rue de La Rochefoucauld was thronged, and crowds stood *en queue* at the doors of the gallery, as at some popular theatre, waiting patiently for admission. The auction-room was

packed with eager faces, and the result of the sale was awaited with the most intense interest. When Millet's *Angelus* was brought forward, the whole assembly rose to their feet and saluted the masterpiece of the dead painter. The bidding rose rapidly to 300,000 francs, when M. Proust appeared on the scene, acting on behalf of the Government, and a keen international struggle began between him and two American dealers, who were bidding for the Washington Museum and a private collector. When the figure of 451,000 francs was reached, the two Americans retired from the fray; but before the picture could be knocked down to France two new American dealers, who had just arrived by special train from Havre, entered the lists, and the battle began with renewed vigour. As each fresh hundred thousand francs was reached, there were loud shouts of applause, and when at 504,000 francs, the *Angelus* was knocked down to M. Proust, cries of *Vive la France!* rent the air. But one of the American agents who was bidding on the part of an Art Association, came forward and explained that he had offered 1,000 francs more, upon which, after some discussion, the bidding began again. At length M. Proust reached the figure of 553,000 francs. There was a moment's breathless pause. For the space of a few seconds Paris heard the beating of its own heart, and then the hammer fell, and the *Angelus* was declared to be the property of France for all time. An outburst of frantic excitement followed. Men tossed their hats to the ceiling; women sobbed and fell into each other's arms, and the curtain fell on a scene of wild enthusiasm, such as had never been known within auction-room walls, in the memory of man. So the long injustice of Millet's life was repaired, and he at length received his due.

But unfortunately, when the first moment of enthusiasm was over, the French Government declined to ratify the

purchase which M. Proust had made at so enormous a price, and the *Angelus* was resigned to the American agent, who had been the next highest bidder. After being exhibited for some days in Paris, the now world-renowned picture was taken to America. Here, however, the Custom House officials fixed the duty payable on this work of art at £7,000, but consented to waive their claim on condition that the picture did not remain more than six months in the country. Accordingly the *Angelus* was exhibited during the autumn and winter in the States, and was then brought back to France, where it was finally purchased by M. Chauchard for the immense sum of £32,000.

That a small picture, so simple in subject and subdued in colour, should kindle such extraordinary enthusiasm, is a remarkable tribute to the completeness with which the painter had realized his impression and to the truth and power of the idea which he had expressed on canvas. Even the statesman, Gambetta, a professed agnostic and avowed enemy of the Church, paid homage to the sincerity of the painter's intention, and acknowledged the religious tradition which had inspired his picture as a great and living force.

"The *Angelus*," he wrote in an interesting letter to a friend, "that masterpiece in which two peasants, bathed in the pale rays of the setting sun, bow their heads, full of mystical emotion at the clear sound of the bell ringing for evening prayer, compels us to acknowledge the still powerful influence of religious tradition on the rural population. You feel that the artist is not merely a painter, but that, living ardently amid the passions and problems of the age, he has his share and plays his part in them. The citizen is one with the artist, and in this grand and noble picture he gives us a great lesson of social and political morality."

The words confirm the truth of Millet's own conviction that the *Angelus* was one of the most religious paintings

of modern days. Scoffers may interpret it after their own fashion, and say that it might just as well represent a father and mother burying their baby, or deploring the rottenness of their potatoes ; but the fact remains the same.

The sensational incidents of the Secrétan sale and the singular adventures of the *Angelus* have eclipsed the fame of Millet's other pictures. But their value has risen in proportion, and their fate is not without interest for his admirers. The *Glaneuses*, which in technical excellence probably surpasses the *Angelus*, while in poetry and pathetic meaning it can scarcely be called inferior, was bought by Madame Pommery, as I have said before, at the close of the International Exhibition, for the sum of £12,000, and presented to the Louvre. Before this the Government had already acquired the *Church of Gréville* and sixteen drawings at the painter's sale, and had also purchased the beautiful picture, *Le Printemps*, from M. Hartmann's collection.

M. Chauchard, whose collection of the Barbizon School is now the finest in existence, and includes all the gems of the Van Praet Gallery, has as many as seven Millets in his possession : the *Angelus*, the *Bergère*, which he bought after M. Van Praet's death, three years ago, for £28,000 ; *Le Vanneur* of 1848 ; the Auvergne *Fileuse* spinning out of doors, her goats around her ; the winter version of the *Parc aux Moutons*, with the moon struggling out of the black clouds ; another little *Bergère* turning her face away to watch the sunset ; and a fine pastel of a girl pouring water into a pitcher at a cottage door.

A pastel of the *Bergère* was sold at the Secrétan sale for upwards of £1,000, and a drawing of a peasant watering two cows, which had been purchased for £172 at the Gavet sale, reached about the same figure. These

B B

high prices have naturally placed Millet's works beyond the reach of public galleries of late years, and here in England the only Millets of which we can boast are to be found in private collections. M. Ionides counts among his treasures the finely-coloured picture of the *Wood-Sawyers*, and the blue-cloaked shepherdess under the trees of Barbizon. Mr. Alexander Young owns another *Bergère*, the charming little picture called a *Rêverie*, representing a girl sitting on the ground at the foot of a spreading beech tree, while the flickering sunlight plays upon her face and form. Mr. J. S. Forbes is the fortunate possessor of as many as forty works of Millet, including that rare and splendid specimen of his early style, *L'Amour Vainqueur*, the pastel of the *Angelus* and many of his finest drawings. A few others are in Scotland and Belgium, while a far larger number, amounting, it is said, to more than half of his whole works, are in the United States. Many of these crossed the Atlantic in the early days, as far back as 1853, when William Hunt first introduced the work of the Barbizon painter to his fellow-countrymen, and American collectors, wiser than other men of their generation, bought such masterpieces as *Le Semeur* and *Le Greffeur* for comparatively trifling sums. Mr. Brooks, of Boston, owns *La Grande Tondeuse*, Mr. Martin Brimmer has *Les Moissonneurs* of 1853, and the fine *Récolte de Sarrasin*, which Millet painted for M. Hartmann in the last year of his life. Mr. Quincy Shaw has no less than twenty oil paintings, and forty or fifty pastels, including *Le Nouveau-Né*, and the original *Semeur* exhibited in 1851. Mr. Vanderbilt, of New York, owns the later *Semeur* and *La Femme aux Seaux*. The earliest and by far the finest version of *Le Parc aux Moutons*, that poetic rendering of the Barbizon shepherd penning his flock in the fold on a summer night, which formerly belonged to M. Gavet, is now in

the Gibson Gallery at Philadelphia, while Mr. Rockafeller and Mr. Dana, of New York, Mr. Walters, of Baltimore, Mr. Leiter, of Washington, Mr. Astor and Mr. Morgan all have important examples in their collections. Nine years ago M. Durand-Gréville gave an interesting account of the Millets in America, but since then many of the pictures have changed hands, and it is almost impossible to identify their present owners.

II

IT is too early, as yet, to determine the place that Millet will ultimately hold in the eyes of posterity, but the very slowness of the steps by which his fame has been won is the best pledge of its endurance. And however the tide of popular favour may ebb and flow in years to come, one thing is certain: by painting the peasants of the field as he saw them, and steadfastly refusing to beautify and idealize them, Millet opened a new path and proclaimed a principle of vital importance in the history of modern art. Others were to carry out this principle on a wider scale and apply it to new subjects, but he was the first who boldly laid down this law and made all future progress possible. Beauty is truth —*le beau c'est le vrai*. This was the one article of faith from which he never swerved, to which he testified both in his writings and in his art, for which he lived and died. Of this glory he can never be deprived. But when we come to consider his actual achievement, we must acknowledge its limitations. His conception is of the highest order; composition and style are alike admirable, but the execution is distinctly unequal. And this applies especially to his oil-paintings. Here his technique, it must be owned, is of a decidedly old-fashioned kind. As a colourist, Millet never rose to the first rank. Bright hues and vivid colours were not much to his taste. The gay side, as he said, never showed itself to him. He never seeks to dazzle the eye, or appeal to the imagination by this means. But the very

soberness of his tints, the solemn tones of his landscapes
agree with the seriousness of his intention and with the
character of his subjects. And here and there he has
shown us what he might have done in this line, had he
been so inclined. The brilliant tones of the flesh-paint-
ing in his *Amour Vainqueur* are Venetian in their splen-
dour, and the golden glow and rich harmonies of colour in
the *Angelus* and the *Bergère* will not easily be surpassed.
But he rarely rises to these heights. There is, as a rule,
a certain heaviness about his colours, a thickness and
woolliness in his paintings which must be counted as a
defect. His tones are too often dark and muddy; his
brush-work lacks the lightness of touch, the subtle deli-
cacy which distinguishes many a far inferior artist. The
atmosphere is too solid, the texture too massive, and the
general effect laboured and unpleasant to the eye. And
for this reason his pastels and drawings are distinctly
superior to his oil-paintings. Here we find none of
these drawbacks. The thoughts which filled the great
peasant's sleeping and waking hours are expressed with
a clearness and directness, an ease and charm which
nothing can disturb. All his noblest qualities are pre-
sent here. His wonderful powers of draughtsmanship, his
thorough mastery of form, his tender and profound feel-
ing—we find them all. The passionate sympathy with
toiling and suffering humanity, the loving observation
of earth and sky in all their varying aspects, the power
and pathos of his art are, as it were, concentrated in
these slight sketches, that were the fruit of the long
years which he had spent in close communion with
nature. The subject may be only a single figure drawn
with a few strokes of charcoal, or an expanse of open
plain under the sunset sky dashed in with coloured
chalks, but the impression is as vivid and complete as
possible. We feel the man's whole soul is there, and

those small figures and simple landscapes have more power to move us than the most finished pictures of academic masters.

Many of Millet's so-called pastels are nothing but crayon studies, heightened with a tint of colour in sky or water, and it is often hard to say where one ends and the other begins. But his consummate knowledge of the laws of light enabled him to produce the finest effects with these simple means. The delicate gradations of rose and violet in the evening sky, the silver rays of the moonlight on the water, the fog that clings to the river-banks in the early morning, the flying scud and breezy clouds on the sea-shore—are all rendered with perfect truth and accuracy. A few touches of colour, a few pencil-strokes, are enough to bring the whole scene before our eyes, and to make us realize that *grande harmonie* which sank into the painter's soul as he watched the sun go down over the plain. In these pastels Millet has helped to solve the problems of light and air which have occupied the attention of recent artists, and has justified his right to a place by the side of Manet and his fol-lowers. Many of these pastels are replicas or slightly altered versions of subjects which Millet had already treated in oil-painting. The pastel of the *Angelus*, for instance, which now belongs to Mr. Forbes, was painted many years after the picture, and represents an alto-gether different effect. While in the oil-painting we have the *Angelus du Soir*, and the plain is growing dim under the deepening twilight, in the pastel the hour chosen is six o'clock in the morning, when the sunrise is flooding the sky, and the season of the year is no longer autumn, but early spring, as is evident by the appearance of the first signs of vegetation. Such, too, are the pastels of *Le Semeur*, *Les Glaneuses*, *L'Homme à la Houe*, and *L'Homme à la Veste*. The last-named

shows us the tired labourer pulling on his coat with a
gesture at once expressive of weariness, and relief that
the long day's toil is over and the hour of rest at hand.
Here, again, the glow that lingers in the western skies
and the slowly fading light are admirably rendered. We
see the dimness creeping over the plain, and the distant
forms of horse and plough as they loom darkly through
the twilight, reminding us of Virgil's line on the
lengthening shadows which had made so deep an im-
pression on the painter's childish fancy. Another pastel
—one of the largest and finest that Millet ever executed,
and which, as far as we know, exists in no other form
—represents an aged vine-dresser snatching a brief in-
terval of rest in the noonday heat. The utter exhaustion
of the old, bare-footed labourer, who, throwing hat and
coat aside, sinks worn out on a heap of stones, in the
blazing sun, is rendered with almost painful reality. His
hoe is in the ground, hard by, and his seamed and
wrinkled hands clasp the empty bottle from which he
has sought to slake his thirst. And all around, in
strange contrast to this picture of exhausted humanity,
nature renews her youth, and the leaves wave in all the
beauty of spring verdure.

One subject, we know, on which Millet was never
tired of dwelling, was the shepherd of the plain. Infinite
is the variety of forms in which he has illustrated
this favourite theme in his pastels. There is the familiar
form of the Barbizon shepherd in the long cloak, lean-
ing on his staff, while his sheep nibble the short
grass, or wending his way home in the pale light of
the crescent moon. And there is the young *bergère*
with the grave eyes and gentle face, not yet seamed by
age, or hardened by long exposure to air. We all seem
to know that pathetic little figure, whether she is seen
sitting on the stile at the edge of the copse, where the

young trees are bursting into leaf, or whether, as in the pastel of the Secrétan sale, she walks homeward in the dusk, knitting as she goes, sure that the sheep will follow her to the safe shelter of the fold. Among sundry other versions we will only mention two more. One is that sweetest of spring pastorals, where the little shepherd-girl, scarcely more than a child herself, bears the new-born lamb home in her arms, and turns with tender thoughtfulness to look at the bleating ewe which follows close behind. The other is an autumn picture, and the sheep are scattered over the plain, while the two young girls who are watching them, look up with eyes intently fixed on a troop of wild geese winging their way across the darkening sky, as if they, too, longed to follow them in their distant flight. This little pastel, in its sober tints and exquisite simplicity, is a poem in itself.

All forms of peasant-labour, we have seen, are illustrated in Millet's pastels. But not labour alone. Millet knew as well as any man living that hard, monotonous toil does not make up the whole of the peasant's life, that there is a brighter side to the picture. The thought of home, the presence of the wife and child, who cheer the labourer's toil and gladden the cottage hearth, has supplied him with a whole cycle of subjects for pastel and pencil. His picture of the young husband and wife going out to work was reproduced in many of his slighter sketches, and was always a popular subject. The same cheerful air and frank enjoyment mark the pastel of the labourer's noonday rest. Here the young man is sitting on a wheelbarrow, in the act of striking a flint to light his pipe, while his wife, who has been helping him to pull up the potatoes in their own carefully cultivated plot of ground, rests on the grass at his side. The *Retour au Village* is another theme which he

frequently illustrated. There we see the young couple who started so blithely in the early morning, wending their way slowly home up the narrow path through the cornfield. There the tired wood-cutter, who has borne the burden and heat of the day, staggers along under his load of faggots; there again the man leads the donkey, on which his wife rides, along the banks of the winding stream, when the moon has risen and the stars are bright. Then we have the interior of the cottage home, where the wife is busy at her household work, and the baby slumbers in his cradle. Sometimes it is night, and the mother is sewing by the light of her lamp, while her husband is making baskets. Or else it is a summer evening, and through the open window we see the man digging his garden, and we catch the scent of the flowers and hear the murmur of the bees outside, while the young mother sits at her knitting within, and rocks the cradle with her foot. Again we see the good wife and mother gathering her little ones around her for their mid-day meal, feeding them all by turns—as in the Lille picture—from the same bowl, or blowing the spoonful of broth to make it cool for her youngest-born. Children of all ages are represented—from the earliest phases of babyhood to the big boys and girls who herd the geese and cattle, and take their share of field-work. There is the baby-boy in the arms of the little sister hardly bigger than himself, sitting under the walnut-tree in the yard, blissful in his unconscious enjoyment of the sunshine and open air and the company of the chickens and ducks. There we see him again a few months older, making his first attempt to walk, and toddling from his mother's side towards the proud father, who stretches out his arms to welcome his tottering footsteps. Even more touching than *Les Premiers Pas* in its exquisite simplicity is that other pastel where the young

father stands sadly in the doorway, holding out a cup of *tisane* for the sick child whom the anxious mother clasps in her arms. It is hard to describe the tender feeling of this little picture, the anxiety expressed in the hesitating air and sorrowful face of the strong-limbed youth, and the passionate love in the embrace of the poor mother, whose whole thoughts are absorbed in her child.

But Millet's knowledge of country life and his sympathy with toilers in the fields was not limited to the human race. His keen powers of observation, his familiarity with peasant-life in all its varied phases, led him to look with interest on all living things, more especially on the dumb creatures which divide the labours, and share the affections of the peasant's home. His sympathy with animal life appears in a hundred different ways. The family cat—that privileged member of the poorest household, who has her own place on the hearth, and arches her back at the sight of an intruder—who rubs up against the skirts of the *fermière* and catches the drops of cream that splash from the churn; the house-dog, who, with eye and ear alert, keeps watch at night in the courtyard, ringed by the low fence, when the world is plunged in sleep and the full moon rises over the broad plain; the rooks flying home across the winter sky on a snowy day; the rabbits burrowing in the rocky caves of the gorges d'Apremont; the startled deer, roused from his lair in the forest—each and all have a place in his drawings. In one pastel he paints a flock of hungry sheep all huddled together, nibbling the leaves off the boughs as far as they can reach; in another he shows us the stout little horse battling with the raging wind on the top of the cliffs, or the patient donkey lying down with drooping ears as the rain beats upon the open plain.

Elsewhere he has shown us the little goose-girl driving

her flock to the pond, and the geese hurrying down to the water with outstretched necks and flapping wings; the peasant-woman standing on the edge of the brook where her cow is drinking, and careful to let the poor little beast go as far as possible into the water without wetting her own feet.

This sympathy with living things was extended to the trees and the flowers, to the rocks and the soil under his feet. "*La terre! il n'y que la terre!*" he would exclaim; "*rien n'y meure!*" He loved it all; the scant, coarse herbage of the plain, and the young wheat springing up in the furrow, the fallow ground breaking up under the labourer's hoe, the wildflowers in the meadow-grass and the moon-daisies at the cottage door, the very cabbages growing in rows—all had for him a meaning. The old elm, "gnawed by the teeth of the wind," in the garden at Gruchy, the apple-trees laden with blossom, and the budding hawthorn in the hedges, the deep lanes and rich grass of the Norman pastures, he looked upon them all with the same delight. He takes an arable field with a harrow lying among the heaps of manure in the foreground and a ploughshare beyond for his subject, and paints it with a truth and accuracy that compels our admiration. Even frost and snow had their charms for him. He loved to paint the pine-trees of the forest when the snow lay thick on the ground, and no less than seven winter scenes were among the pastels that were sold by M. Gavet after the artist's death.

But full of charm and variety as Millet's pastels are, his charcoal drawings strike us as being in some ways even more remarkable. Here, in a few inches of paper, without the help of colour, but by sheer force of drawing and skilful management of light and shadow, he makes us realize the immensity of the horizon, the vastness of sea and sky, and depth and clearness of the atmosphere.

" The most important part of colour," he once said to a
friend, " what is called tone, can be perfectly expressed in
black and white." And this tone is exactly what he ren-
ders with such incomparable truth in his drawings. Take
Les Porteuses d'Eau, for instance—that study of women
drawing water from the river which attracted so much
attention at the Paris Exhibition. The cool atmosphere
of the early morning is given with marvellous reality;
we see the mist that lies thick along the marshes, while
the fiery ball of the rising sun hangs in the eastern
heavens. And in the foreground are those two wonderful
figures, the kneeling woman swinging her jar over the
water, and her companion standing on the bank beside her,
watching her with folded arms. The motive is simple
enough, but the superb action of the one figure, and the
majestic pose of the other, lift this common-place subject
into the loftiest realms of ideal art. So it is with *Les
Lavandières*, a group of women kneeling by the river-side
wringing out their clothes, while the full moon rises behind
the tall poplar-trees on the opposite bank; and with that
admirable drawing in the Forbes collection, where one
washerwoman is piling up the linen on her companion's
shoulder, and through the gathering mists of evening we
see a boatman rowing across the stream under the light of
the crescent moon. Still finer is the figure of the panting
girl who has just set down her water-pails and pauses to
recover her breath, leaning against a stunted tree on the
bank of the river. Here you have everything that makes
a picture—tone, atmosphere, and human feeling. In the
background there is a group of trees and farm buildings,
and the whole is set in a frame of light and spacious skies,
which contrast finely with the dark figure in the fore-
ground. The same brilliant effect of light lends its charm
to the drawing of the young peasant-woman rocking her
baby to sleep in her arms. All the details of the cottage

Swan Electric Engraving C°

Les Lavandéres. (The Washerwomen)

interior—the small window-panes, the jars on the shelves, and the clothes hanging on the chair to dry—are given with Millet's habitual accuracy, but the charm of the whole is the look of infinite love which the mother bends on her babe. As he said himself, "Beauty is expression. If I am to paint a mother, I shall try and make her beautiful, simply because she is looking at her child." The solemn simplicity with which the subject is rendered might well make Diaz say that these peasant-drawings of Millet's were taken straight out of the Bible. This young mother, nursing her sleeping babe, might be the Madonna herself with the Christ-child in her arms. These peasants going home might easily be taken for the Holy Family on their flight into Egypt. One drawing of this subject was in the Paris Exhibition of 1889, and differed so little from a *Retour au Village* hanging close by, that at first sight it was difficult to distinguish the one from the other. The Virgin, wrapt in a flowing veil, sat on the donkey, while Joseph, looking exactly like some aged peasant, walked along the narrow path on the river-side, bearing the Child in his arms. Only the glory round the Child's brow, and a certain mystic beauty in the Virgin's face marked the difference, and gave a divine meaning to this group of travellers journeying under the starry skies.

To the end of his days the sacred story had a strong attraction for Millet, and he often spoke of incidents in the life of Christ which he should like to paint. The first drawing which he made as a boy, and took with him to the Cherbourg artist, Mouchel, was taken from a parable told by St. Luke. And at the end of his life, in one of the last talks which he ever had with Mr. Wyatt Eaton, he spoke in forcible language of a picture of the Nativity which he meant to paint. The text, "There was no room for them in the inn," appealed to him in a peculiar manner, and he longed to represent

the poor travellers from Nazareth turned away from the doors of the house at Bethlehem, and not knowing where to lay their heads on that first Christmas night. But he died before he could carry out his intention. A pathetic drawing of Christ upon the Cross, with his arms raised high above his head, now the property of his son-in-law, M. Heymann, and a singularly impressive study of the Resurrection, remain to show us what great work he might have done in this line. In the last-named sketch, Christ is seen rising from the tomb, bursting the bonds of death and ascending heavenwards in a blaze of glory, while the keepers fall as dead men to the ground. The originality of the conception is as striking as the power and truth with which the action is rendered.

These drawings, we repeat, are Millet's supreme technical achievements. All his sense of rhythm, his keen instinct for beauty of line, his unerring vision and sureness of hand are present in these sketches, where, with means of the simplest kind, he has attained such great results. Each is in its way a complete picture, full of unity, strength, and significance. And taken as a whole, they represent the finest qualities of his art and are the very flower of his genius. Here, in his own words, the trivial becomes sublime, and the little day of life loses itself in the boundless spaces of the infinite.

III

" THE artist," Millet himself has said, " is not to be judged by his work, but by his aim." In his eyes the medium which he employed was comparatively insignificant to the message which he had to give. Whatever he produced, paintings in oil or water-colour, pastel or crayon drawings, his aim remained the same. " Every one," he said to Sensier in the early days of their friendship, " ought to have a central thought, *une pensée mère,* which he expresses with all the strength of his soul, and tries to stamp on the hearts of others." This he insists upon repeatedly, in the letters and conversations which have been recorded here ; and in an unpublished fragment in his handwriting, now in the Print-room of the British Museum, we find the following words :

" I have often met people who say with assurance, ' You must at least allow that there *are* certain rules of composition.' And they assume an air of importance, and are confident that what they say is true, because they have really seen it in a book ! But since I have long felt that composition is only the means of telling others our thoughts in the clearest and most forcible way possible, and since I am convinced that ideas will of themselves find out the best means of expression, you may judge of my embarrassment ! "

His horror of conventional methods, of the clever execution which takes the place of serious purpose, and of the ornamental accessories that distract attention from the central thought, is more fully expressed in the following notes upon art which he wrote at Sensier's request, and which were found by M. Paul Mantz, among his friend's papers :

"When Poussin sent his picture of *The Manna-Gatherers* to M. de Chantelou, he did not say to him, 'See, what fine painting! Look how cleverly that is managed!' Nothing of the kind. He says: 'If you remember what I wrote before as to the action of the figures which I meant to introduce, and consider this picture as a whole, I think you will recognise the different persons who suffer, or wander, those who take pity on others, and who are in sore need themselves, and so on, for the seven figures on the left will explain all this, and the rest is of the same kind.' Too many painters fail to consider the effect produced by a picture, when it is seen from a distance, which allows us to judge of the whole. You always find people who say of a picture in which the general impression is complete: 'Ah! but when you come nearer, you will see it is not properly painted.' And of another which produces no effect at a distance: 'Look how fine the execution is, if only you are near enough!' But they are many. Nothing counts except what is fundamental. When a tailor tries on a coat, he stands back to judge of the whole effect. If that satisfies the eye, he then turns his attention to details; but a tailor who devoted his attention to fine button-holes, and produced masterpieces of this description on a badly-cut coat, would do a very bad business. Is not this the same with an architectural monument, or any other work of art? The manner in which a work is conceived is the great thing, and everything else must follow the same lines. The same atmosphere must pervade the whole. The environment may be of one character or another, but whichever aspect of the scene you choose must remain supreme. We should be accustomed to receive our impressions direct from nature, whatever their kind, and whatever our own temperament may be. We should be steeped in her, saturated with her, and careful only to think the thoughts that she inspires. She is rich enough to supply us all. And where else should we turn but to the one true source? Why are we for ever to go on setting the discoveries of other great minds, who, in Palissy's words, 'searched out her entrails with unremitting zeal,' before our students, as the final goal and aim of their endeavour? These were never intended to take the place of nature herself. And yet we try to make the productions of a few masters the type and pattern of all future art. Men of genius are, as it were, endowed with a divining-rod. Some discover one thing in nature, some another, according to their temperament. Each finds what he is destined to find. But once the

treasure is dug up and carried off, it is absurd to see how others come and scratch in the same spot. You must know how to find out where the truffles are! A dog who has no scent cannot be a good sportsman, since he can only follow in the track of another. And when it is only a case of copying others, you cannot run very eagerly, since there is nothing to move your enthusiasm. The mission of men of genius is to reveal that portion of nature's riches which they have discovered, to those who would never have suspected their existence. They interpret nature to those who cannot understand her language. They might say with Palissy, 'You will find these things in my treasure-house.' If you abandon yourself to her service, as we have done, she will give you of her store, according to the measure of your capacity. All you need is intelligence and a great desire.

"It is only an immense pride or an equally immense folly which makes people think they can rectify the supposed faults and bad taste of nature. What authority have they for this presumption? It is easy to see that with men who can neither love nor understand her beauties, she hides her face and retires into her shell. At best she can only meet them on terms of constraint and reserve. And so they say the grapes are sour. Since we cannot understand nature, let us slander her by way of revenge. The words of the prophet might be applied to them: 'God resisteth the proud, but giveth grace to the humble.' Nature gives herself without reserve to all who come to inquire of her. But she is a jealous mistress and must be loved alone. If we love works of art, it is because they come from her. All the rest is pedantry and emptiness.

"We can start from any point to reach the sublime, and everything is proper to be expressed, if only your aim is high enough. Then what you love with the greatest power and passion becomes the ideal of beauty which you impose upon others. Let each of us have his own. A profound impression will always find out a way of expression, and naturally seeks how to declare itself in the most forcible manner. The whole of nature's arsenal has been at the disposal of men of might, and their genius has made them employ, not what we may think the most beautiful things, but the most suitable. Has not everything in creation its own place and hour? Who would venture to say that a potato is inferior to a pomegranate? Decadence set in from the moment that Art, which was in point of fact the child of Nature, became the supreme goal,

and men took some great artist for their model, forgetting that his eyes had been fixed on the infinite. They talked of working from nature, but they approached her in a conventional form. If, for instance, they wished to paint an open-air subject, they copied the model indoors, without reflecting that the light of the *atelier* had little in common with the all-pervading light of open day. Artists would never have been so easily satisfied had they been moved by a really deep emotion. For since what is infinite can only be expressed by a faithful record of actual fact, this falsehood nullified all their efforts. There can be no isolated truth. From the moment that technical merits were made the first object in painting, one thing became clear: any one who had acquired considerable anatomical knowledge tried to bring this side of his art forward and was loudly praised. No one reflected that these admirable qualities ought to have been used, like everything else, to express ideas. Instead of trying to express definite thoughts, the successful artist drew up his programme and chose subjects which afforded opportunities for the display of his own skilful handicraft. And instead of using knowledge as the handmaid of thought, thought itself was stifled under a brilliant display of fireworks. One artist copied another, and the fashion became general. But want of practice and skill in writing makes my language obscure; so try and discover what I want to say without making use of my actual words. What I meant to say has not been sufficiently considered, and I have left a great deal unsaid. But I will try and come back to the subject when I have more leisure."

These principles lay at the root of all Millet's work. Go to nature for your impressions, steep yourself in her, let your whole being be saturated with her!—that is the cry which he is never weary of repeating, the one word which he would hand on to future generations. Nature had indeed been his one great teacher, from the days when as a boy he stood on the cliffs of Gréville and gazed in silent awe over the seas; and up to the last days of his life his love and sympathy for her increased more and more.

"Before I knew Millet," writes Mr. Wyatt Eaton, "I had suffered

much pain in finding that few artists really loved nature. They seemed to care only for that which it suited them to paint; but in Millet I found a man who adored the stars, the moon, and the sun, the earth, the air, and everything that the sun shone upon. And through this love everything that he touched—frequently the least things of the earth—became monuments."

So well had he learnt her great lesson, so rich was the store of natural facts which he had laid up in his mind, that in his latter years he could reproduce effects of atmosphere, the texture and colour of objects, or particular attitudes and gestures, with the most perfect accuracy, without having the landscape or model before him. In fact, in these last years he remarked that he worked little from nature, adding, "for she does not pose." His ordinary practice was to take small sketches or memoranda of landscapes or figures, indicating the principal outlines and shadows, and accentuating any prominent features which were to give the picture its character, and supply all the rest from his memory. For instance, he would draw a group of wheat-ricks in one of these little sketch-books, about two and a half by three inches in size, carefully noting the shape of the ricks, the sinking and bulging which were the result of exposure to weather, and from this rough pen-and-ink outline afterwards produce a complete and accurately-modelled picture. In drawing figures, he often regretted the difficulty of obtaining living models at Barbizon. Madame Millet herself frequently sat to him, and wore the roughest of peasant clothes so as to be ready to pose at any moment when her services were required. Sometimes she complained of having to wear the same skirt for weeks together, in order that the rough linen should take the right folds, and "become," Millet said, "as it were part of the body, and express, even better than the nude, the larger and more simple forms of nature." For the same purpose, he

had a large mirror fixed in his *atelier*, in order that he might study movements or details of drapery from his own person.

"Working, as he did, almost without models," writes Mr. Wyatt Eaton, "he was his own model for everything, feeling deeply and giving the action with intensity and reality. In fact, what has been said of the saints experiencing in their own bodies the sufferings of Christ, was true of Millet in his art."

It was never his habit to make elaborate studies of his pictures. As a rule he drew the figure in charcoal upon the canvas, in the most careful and painstaking manner. Every touch was added slowly and deliberately, but the process was as sure as it was slow, and no time was lost in rubbing out what had been done. The general impression, he always insisted, was the great thing in a picture.

"One man," he remarked, "may paint a picture from a careful drawing made on the spot, and another may paint the same scene from memory, from a brief but strong impression, and the last may succeed better in giving the character and physiognomy of the place, even though all the details may be inexact." *Il faut bien sentir*—we must feel deeply if we are to paint at all, he always insisted. "A man must be touched himself if he is to touch others; or else his work, however clever, will never have the breath of life, and he will be nothing better than sounding brass or a tinkling cymbal."

All his life he was condensing and simplifying facts, striving to attain greater force and clearness of expression; in his own words, trying to render his ideas with largeness and simplicity. We have already seen how fond he was of making sketches for the amusement of his children and grandchildren. In the last months of his life, he took especial delight in drawing pictures for his eldest grandson, before the boy was able to talk, and

seeing if he recognised the objects that were placed on paper before him. It was touching to see the pains which the great artist took to reach the child's infant imagination, and what pleasure it gave him when little Antoine knew the figures or animals which his grandfather drew. One evening Millet made a sketch of the child himself, in the act of blowing out a gigantic candle. Little Antoine looked earnestly at the drawing for a few moments, and then, turning to the table, tried to blow out the candle that was nearest to him. Millet was delighted with the success of his experiment, and pointed out the great principle which had been illustrated by the unconscious child, saying that just as he had represented the candle three or four times larger than its natural size, in order to attract little Antoine's notice, so it was necessary to bring certain forms and movements into strong relief, in order to create a vivid impression. This is exactly what Millet does in his own drawings. He fastens on the central and fundamental idea to the exclusion of all irrelevant detail, and allows nothing to distract the mind from the principal subject. And in this he showed himself the inheritor of the great traditions of classical art. This man, whom his enemies reviled as a hater of the antique, who worked, they declared, in direct antagonism to the received principles, had in reality a truer appreciation of Greek art than any of his academic rivals. He was a true classic, who, as we know, loved Virgil from his boyhood, found in the idylls of Theocritus a poetry after his own heart, and kept the marbles of ancient Hellas ever before his eyes.

To suppress the accidental and enforce the essential was his constant endeavour. No pre-Raphaelite was ever more conscientious in avoiding all useless accessories and in confining himself to strictly significant details. " *Mon rêve,*" he once wrote, " *est de caractériser le type.*" In all

his work he keeps this aim steadily before his eyes. The individual gives way to the typical, and the lower truth is deliberately sacrificed for the sake of the higher. In his own words: "Nothing counts but what is fundamental."

This way of seeing things, or, as M. André Michel has said, "*cette façon de voir grand, simple, et d'ensemble,*" is the keynote of all Millet's work, and the secret of the unity and grandeur which is never absent from his smallest sketch. It was this which Decamps felt when he said: "I paint a peasant at the edge of a brook: Millet represents a man standing on the bank of a river." And it is this largeness of style which gives his works their monumental character. His *Semeur*, his *Homme à la Houe*, his *Jeune Bergère*, are heroic types of their order, and sum up the story of whole generations of toilers. They represent all that is noblest and most pathetic in that peasant-life which Millet knew so well, all the deeper meanings and larger truths which lie hidden beneath the surface. All that Carlyle has told us of the dignity of labour, all that Wordsworth has sung of the beauty of rustic homes and the poetry of common things, lives again on the canvases of the Norman peasant-painter. Here Millet has proved himself the true child of his age. First among artists he opened our eyes to the unregarded loveliness that lies around us, to the glory of toil and the eternal mystery of that "cry of the ground" which haunted his soul. First among them, he realized the artistic capabilities of modern life and the profound significance of those problems of labour and poverty which this generation has been compelled to face. Others were to change the scene from the country to the town, to apply the same principles to the crowded streets and hurrying life of our great cities. For Millet the life of the fields was enough.

He painted man, not as a separate being, but as part of a great and changeless order, and showed us the closeness of the tie that links human joys and sorrows with the changes of the seasons and the beauty of the natural world. And this message he delivered in no hasty and unconsidered spirit, but with consummate knowledge and mastery, in obedience to eternal and unalterable laws.

The dream of his life has been realized, although he was not allowed to see its fulfilment, and the power and passion with which his work still speaks to the hearts of this generation has not been in vain. The range of art, we feel, is for ever widened by this man's genius. Never again can we look on those hewers of wood and drawers of water, never again can we see the sower scattering his seed, or the gleaners stooping to gather the ripened corn, without recalling the majestic forms of Millet's types. His place with the immortals is sure. His fame rests on secure foundations, and his work, modern as it is to the core, has more of the true Greek spirit than any other of our age. His pictures of seed-time and harvest, of morning and evening, will rank with the great art of all time—with the frieze of the Parthenon and with the frescoes of Michelangelo.

INDEX